DREAM HOMES

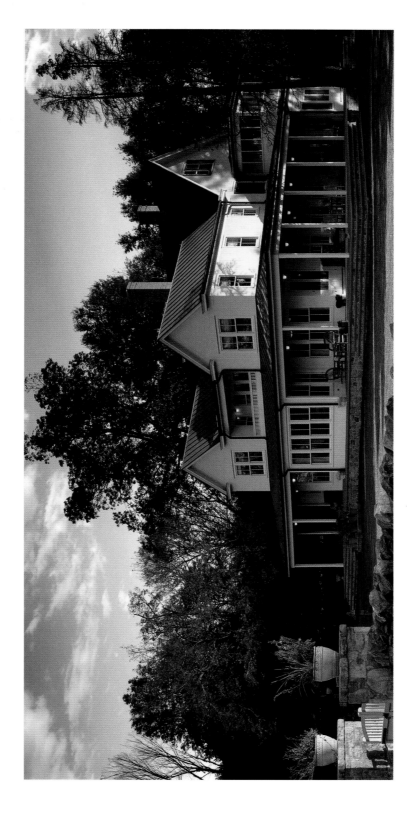

GREATER WASHINGTON, D.C.

A SHOWCASE OF THE FINEST ARCHITECTS IN MARYLAND, NORTHERN VIRGINIA AND WASHINGTON, D.C.

Published by

PANACHE
PANACHE PARTNERS, LLC

1424 Gables Court
Plano, TX 75075
972.661.9884
f: 972.661.2743
www.panache.com

Publishers: Brian G. Carabet and John A. Shand
Executive Publisher: Phil Reavis
Senior Associate Publisher: Kathryn Newell
Editor: Amanda Gibney Weko
Designers: Ben Quintanilla and Mary Acree

Printed in Malaysia

Distributed by IPG
800.748.5439

PUBLISHER'S DATA

Dream Homes Greater Washington, D.C.

Library of Congress Control Number: 2007930823

ISBN 13: 978-1-933415-45-1
ISBN 10: 1-933415-45-2

First Printing 2007

10 9 8 7 6 5 4 3 2 1

Previous Page: Barnes Vanze Architects, Inc., page 145
Photograph by Anice Hoachlander/HDPhoto

This Page: David Jones Architects, page 221
Photograph by Erik Kvalsvik

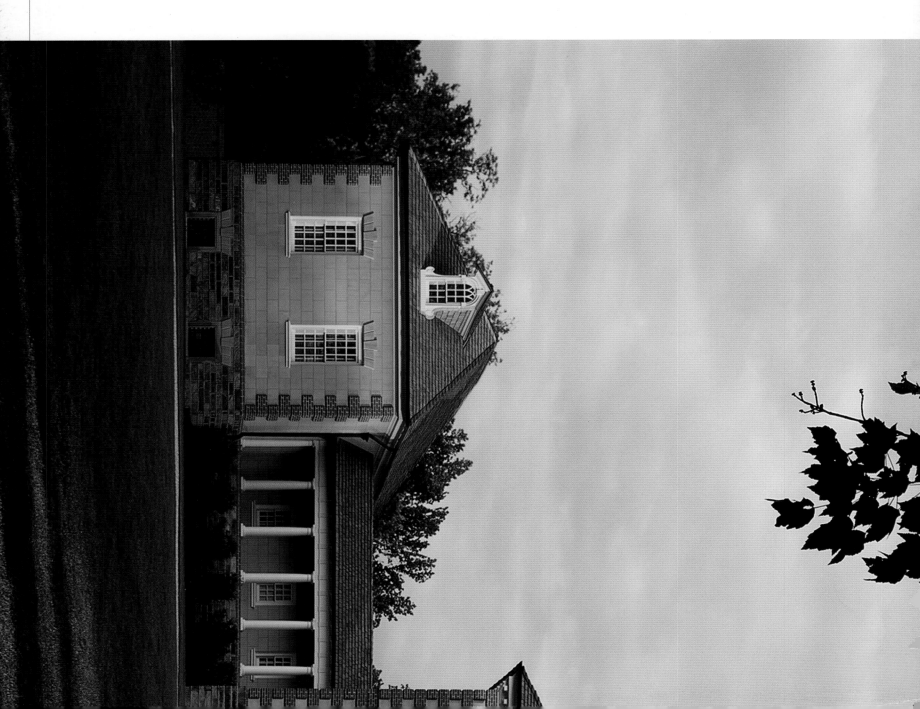

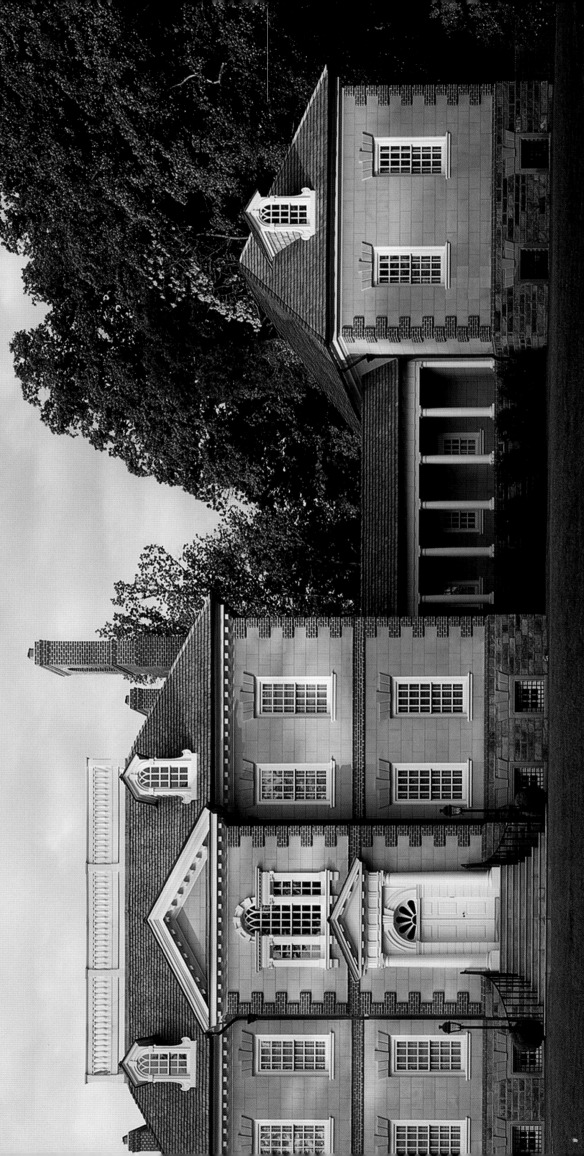

DREAM HOMES

GREATER WASHINGTON, D.C.

A SHOWCASE OF THE FINEST ARCHITECTS IN MARYLAND, NORTHERN VIRGINIA AND WASHINGTON, D.C.

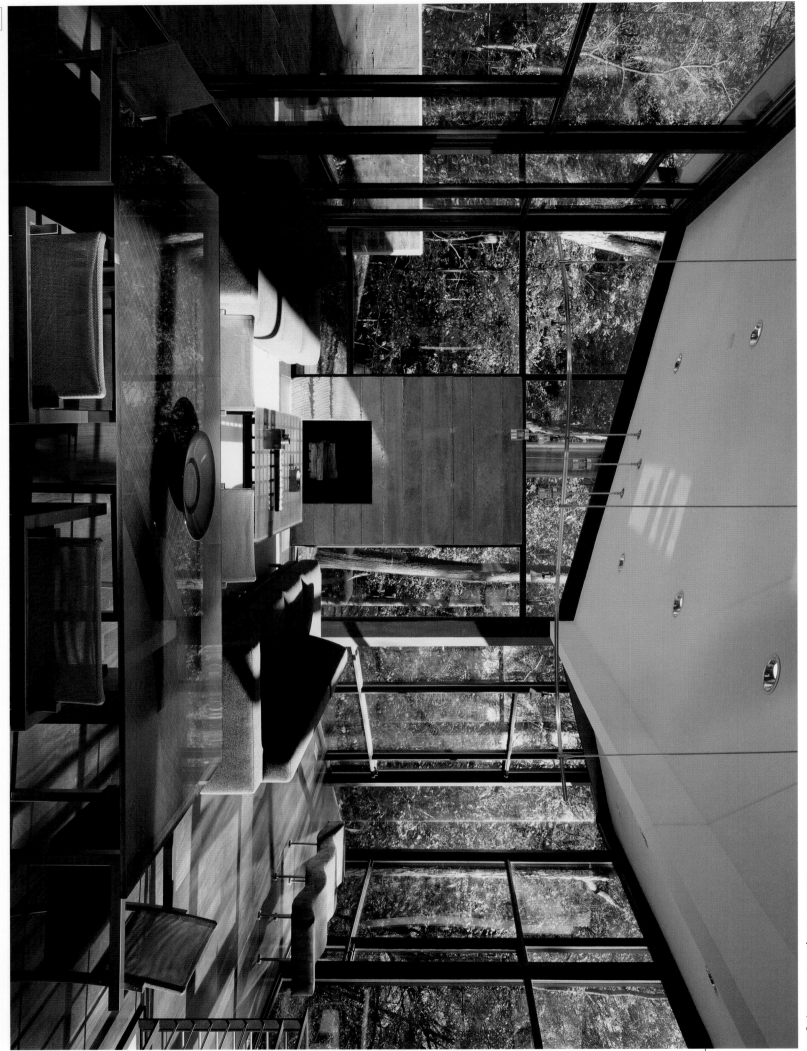

Robert M. Gurney, FAIA, Architect, page 89

4

A restudio, Inc. and Hailey Design, LLC, page 81

Photograph by Carol Bates/Bates Photography, Inc.

INTRODUCTION

As I started this book, there were several things I found to be unique about the greater Washington, D.C., area. First is just how close Maryland and Virginia are to the capital. You can drive, walk or peddle for less than a mile in any direction—usually crossing a bridge—and you may be in another state, but you still feel part of this close-knit community, so rich in diversity, culture and history.

Second is the varied landscapes from the edges of the Potomac River to the valleys of Maryland and the farms of Virginia, and equally varied examples of residential design. In its nearly 250-year history, the greater D.C. area has experienced a notable range of periods and styles, including the rowhouses of Georgetown, ornate Victorians of Capitol Hill, stately Neoclassical homes of Lafayette Square, Arts-and-Crafts bungalows of Chevy Chase, D.C., and a surprising array of contemporary houses that all seem to complement each other.

Third is the number of outstanding architects and architectural firms that reside in and around D.C. International icons of architecture, such as Hugh Newell Jacobsen, whose approach will stand the test of time because he has managed to encapsulate the history of architecture within the walls of modernism, are working alongside up-and-coming contemporary design firms such as Scout Motor Company and Studio27 Architecture. Traditional architects like David Neumann and Outerbridge Horsey demonstrate attention to detail in creating houses that have all the modern conveniences hidden amidst period charm. City living has its own style, evidenced by the high-rises of Philip Esocoff on Embassy Row, complete with incredible use of outdoor space, rooftop pools and courtyards for all to enjoy.

Described in *Dream Homes Greater Washington, D.C.* is what I find so intriguing about this place where people from all over the world come to live, work and play. It is a true melting pot of cultures expressed though the creative eyes of the architects. Some people do not need much, others want to recreate the past, while still others pursue the future of design.

I have met many great architects and made some great friends on this project. As you will see on the pages that follow, they all are very talented, and each can truly stand on his or her own with good merit.

Sincerely,

Kathryn Newell

Kathryn Newell
Senior Associate Publisher

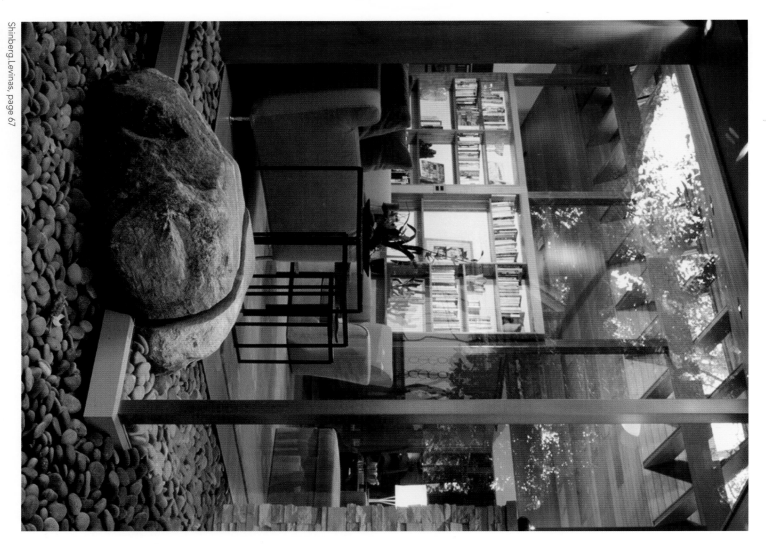

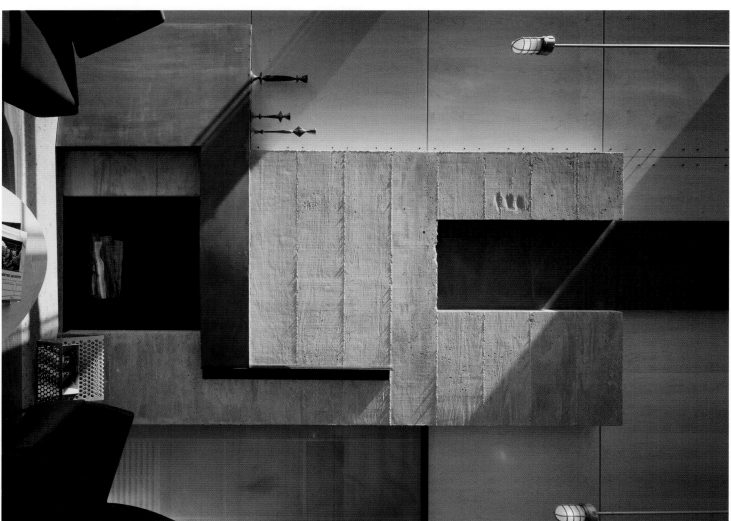

CONTENTS

A PERSPECTIVE

Undeniably, Washington, D.C., was designed to impress. From its elaborate architecture, monumental statuary and dynamic urban plan to its symbolic and physical position of prominence as the nation's capital, Washington, D.C., is rich in architecture new and old and enlivened by a diverse population.

Founded in July of 1790, the District of Columbia was carved from land in Maryland and Virginia. Its original urban plan did not evolve from a prosperous trading route or a center of commerce. It was created, instead, to display pride in a new democratic nation. In 1791, French architect and engineer Major Pierre Charles L'Enfant developed the plan of radiating roadways named for states in the union. The plan offers avenues culminating in expansive views towards monuments and significant buildings, always enforcing the greatness of the city. As the city grew, its architecture evolved from the democracy-evoking neoclassical aesthetics of ancient Greece and Rome to the picturesque Gothic, Italianate and Victorian styles of the 1800s. The 20th century brought a contemporary design vocabulary to the city. Today, the blend is a veritable architectural history of America.

That same composition of eras and styles is reflected in this book. *Dream Homes Greater Washington, D.C.* features a mix of contemporary designs, historic restorations and timeless traditional architecture, demonstrating the skill and vision of the greater D.C. region's top architects. As the nation's capital, the eighth-largest metropolitan area in the United States, and home to more than 180 international embassies,

9

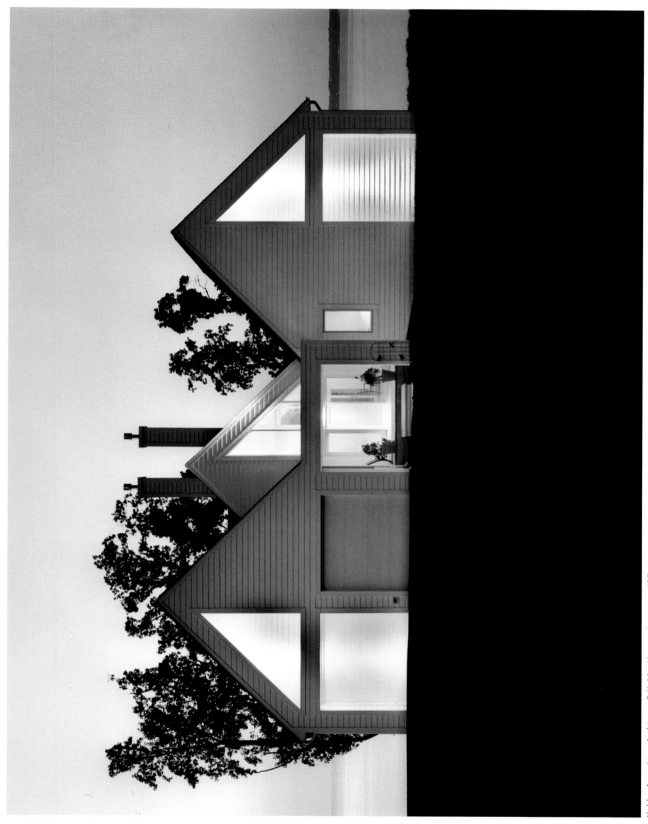

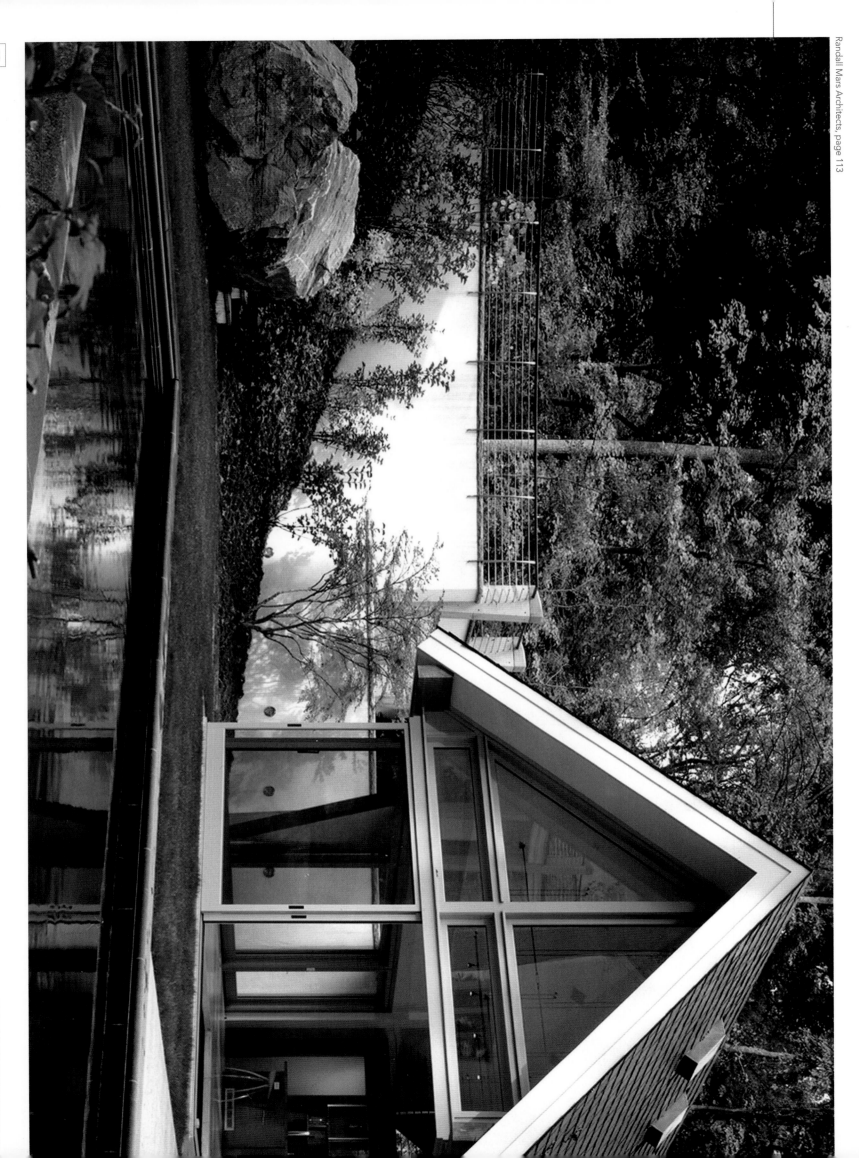

Washington, D.C., is vibrant and diverse with people from all cultures and backgrounds. The opportunities and locales for architectural creativity extend beyond the city's 68.3-square-mile limits and into neighboring Maryland and Virginia as well. More than 6 million people call the greater Washington, D.C., region home.

French philosopher Gaston Bachelard wrote in his book, *The Poetics of Space*, that "the house shelters daydreaming, the house protects the dreamer, the house allows one to dream in peace." He wrote of the intangibles related to one's home, and that a house is so much more than mere shelter; it has significant emotional connections that resonate deep within people. *Dream Homes Greater Washington, D.C.* features a stunning collection of houses that were carefully crafted for the emotional and physical requirements of their owners.

The beautiful photographs and captivating stories in this book can be used as starting points for your own dreams—whether for having a home designed and built with a fantastic future life in mind, or for modifying your existing house with efforts large or small. In any case, by reading this book, you will be encouraged by the power of good design and the people who make it their practice.

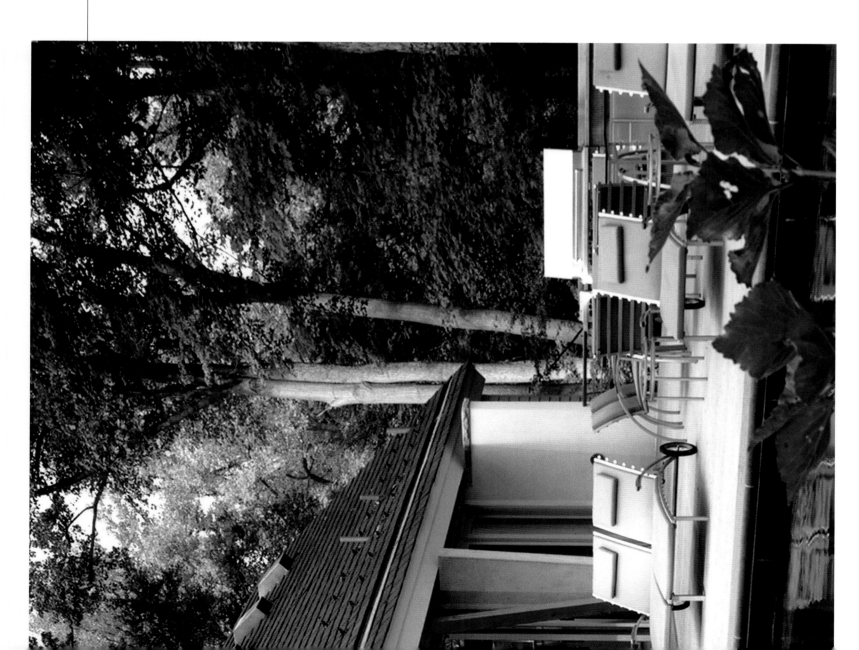

Dream Homes Greater Washington, D.C. highlights an impressive group of architects with varied levels of experience, a diverse range of aesthetics and a fascinating array of project examples, not to mention a host of awards and accolades. Yet all share a similar goal—using design to enhance the lives of their clients in a profound and positive way.

As you read about these professionals' unique approaches and philosophies, and learn about their influences, you will notice quite a bit of variety. You will also notice some common themes: a respect for, and responsibility to, the environment; a commitment to quality in materials and craftsmanship; and a passion for capturing the essence of each client's personality and lifestyle. Sometimes laugh-out-loud funny and at other times quite touching, the stories are personal, endearing and sure to inspire.

Meditch Murphey Architects, page 27

Gardner Mohr Architects LLC, page 23

MARYLAND

Shinberg.Levinas, page 67

ABOVE: A custom conservatory and stucco mouldings enhance an elegant stair hall in a historic renovation in Vienna, Virginia.
Photograph by Bob Narod, Photographer LLC

FACING PAGE: Extensive additions to a historic home in Vienna, Virginia, incorporate a careful mix of materials and forms to maintain the integrity of the original structure.
Photograph by Bob Narod, Photographer LLC

RICHARD FOSTER

Richard Foster Architects, LLP

Architect Richard Foster brings expertise in both design and construction to his role as managing partner at Richard Foster Architects. His namesake firm in Kensington, Maryland, is known for collaboration as well as creativity. A diverse portfolio of traditional residential designs is influenced by Foster's frequent travel and love of authentic detailing. Whether country farmhouse, Arts-and-Crafts bungalow or Federal townhouse, Foster's residential designs convey a sense of timelessness and appropriateness for the site. Each includes strategic sight lines and carefully framed views, clear organization of spaces with a sense of procession and elements of the unexpected for added visual interest. Most importantly, each house reflects the personality and aesthetic preferences of its owner. "At the end of the day, I want clients to feel that it is their house, and that they played a role in creating it," says Foster.

Foster has had a lifelong passion for design. Although he initially entered college to study engineering, after taking an Introduction to Architecture course, he quickly changed majors and schools to pursue a career in architecture. He holds a Bachelor of Science in architecture degree from the Catholic University of America and has been licensed to practice since 1984. He rose from apprentice to partner at

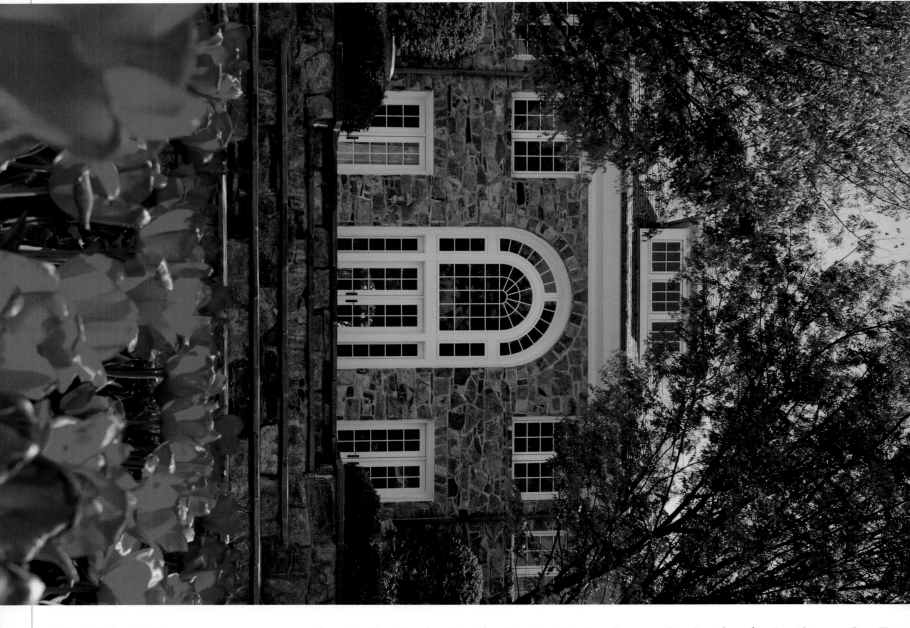

his first post-college design job, and then segued his project management and extensive historic district work into a new venture.

Serving as vice president of a residential development and construction firm for seven years, Foster was responsible for the design of numerous custom residences, as well as condominiums and mixed-use projects, including Washington's first "silver tower" located in the West End neighborhood. The variety of his architectural work was complemented by a range of construction challenges, such as infill buildings and construction in the historic Georgetown, Capitol Hill and Dupont Circle districts.

Foster's understanding of both architecture and construction management extends to his present practice, where he specializes in custom residential work. Founded in 1996, Richard Foster Architects, LLP, is a small firm known for its hands-on approach. Foster explains that designing a new house is a time-intensive challenge for the clients, with many decisions to be made. "I am able to walk clients through the process—from design to construction—making them aware of realistic budgets and timeframes," he says. During the design process, the firm uses 3-D computer graphics and models to give clients a picture of what their finished house will look like. While Foster knows that changes are often inevitable, the accurate information he conveys to clients at the start of a project ensures a smooth process with few surprises. He is personally involved in each project, assisted by a staff of two associate architects, one draftsperson and an office manager.

LEFT: Formal landscaping and stone steps lead to the entertaining terrace of a new home in McLean, Virginia.
Photograph by Bob Narod, Photographer LLC

FACING PAGE TOP: Authentic eves and dormers enhance the welcoming scale of a "new" stone farm house in McLean, Virginia.
Photograph by Bob Narod, Photographer LLC

FACING PAGE BOTTOM: The curved stair and wood paneling add richness to the entry hall.
Photograph by Bob Narod, Photographer LLC

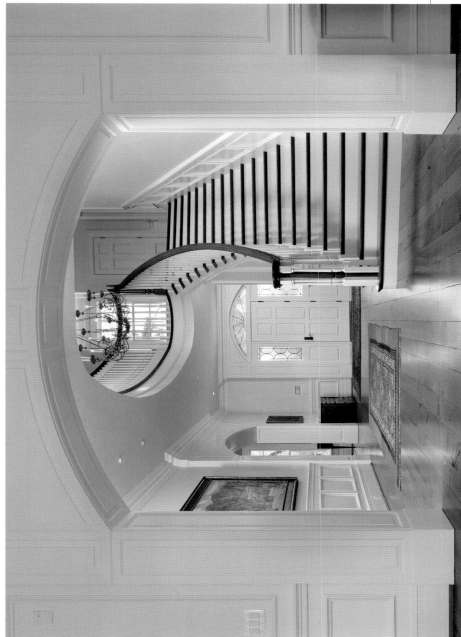

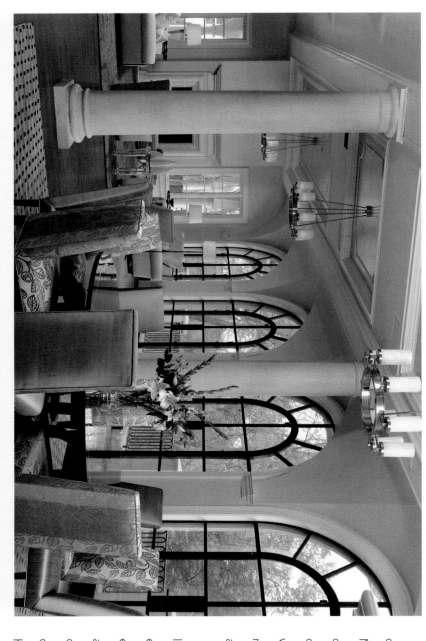

The boutique design firm has established a reputation for high-quality traditional architecture, ranging from Cotswold Cottages to Tuscan-, Mediterranean- and French-style houses. Foster appreciates the warmth, scale and charm of traditional aesthetics but incorporates modern features to meet present-day needs. The successful combination of Old World styling and craftsmanship with contemporary amenities has earned the firm recognition on HGTV and in magazines, including *Washington Spaces*, *The Washingtonian*, *Home and Design* and *Maryland and Washington Homes*.

Current projects are demonstrative of the firm's skill in varied styles and locations. A new custom stone house in McLean, Virginia, will look like it has evolved in phases over time. A historic house renovation in Georgetown includes extensive historic district coordination. A new ski chalet in Deer Valley, Utah, and vacation homes in North Carolina and New Hampshire are opportunities for creativity within a vernacular far from the D.C. metropolitan area. "I enjoy the challenge of every project," says Foster. "I take a lot of time to pick up the cues of historic architecture and the unique attributes of the surrounding area to create a residence that feels at home on its site and becomes a home for the family who will live there."

ABOVE: Stucco walls, limestone detailing and clay-tile roofing define this Mediterranean-style home. It is approached via a landscaped entry court framed by loggias.
Photograph by Bob Narod, Photographer LLC

FACING PAGE TOP: Silver-leaf groin vaults and steel windows define the great hall of a new home overlooking the Potomac River.
Photograph by Bob Narod, Photographer LLC

FACING PAGE BOTTOM: A maple-paneled gymnasium as seen from the "Sky Suite." Adjacent areas include a theater, billiards room, wine cellar and bar.
Photograph by Bob Narod, Photographer LLC

Richard Foster Architects, LLP

Richard Foster
10605 Concord Street, Suite 304
Kensington, MD 20895
301.942.9201

ABOVE: Optimal orientation, careful consideration of sun angles for daylight design and attention to detail make this front porch a delightful place throughout the day.
Photograph by Amy E. Gardner

FACING PAGE: The owners' passion for outdoor living inspired this transformation of their backyard into a subtropical retreat.
Photograph by Alan Karchmer

AMY E. GARDNER
CHERYL MOHR

Gardner Mohr Architects LLC

Twenty years ago, on the first day of their first jobs, architects Amy Gardner and Cheryl Mohr began an enduring friendship. Following successes with other firms, the friends established Gardner Mohr Architects in 2003. Each partner's professional experience in large-scale projects informs her work with rigor and attention to detail. Devoted predominantly to residential architecture, their practice offers award-winning and nationally recognized design skills at a highly personalized level. While the work is clearly devoted to a concern for space, light, order and craft, it is, most importantly, guided by Gardner and Mohr's commitment to environmental stewardship through responsible, inventive design and professional leadership.

The firm strives to create architecture that is "integrated, holistic and innovative," says Gardner, describing a process and philosophy that are intrinsically linked. Both LEED® Accredited Professionals, the partners carefully consider the environmental impact of their work. Their design process includes engaging a network of experts who offer professional advice about materials, systems and building technologies. They use this collective knowledge to design in an imaginative yet responsible way: balancing constructability with simplicity, and sustainability with durability. Deliberate siting in consideration of the sun; efficient systems; responsibly produced materials; and well-crafted details are employed to conserve energy, improve air

quality and offer the most long-term integrity and beauty. "We think of each building as a system accountable to a greater good, as well as to the needs of the client," says Mohr.

Not restricted by style or trends, the partners create homes that are modern yet timeless. Clients gain not only an artfully and responsibly designed house, but also one that is customized to their needs and lifestyles. Gardner and Mohr believe their clients are central to the design process and keep them continuously involved. This sense of collaboration extends to the firm's design staff.

"As architects, we are positioned to be leaders in environmental responsibility," says Gardner, who has reinforced this belief, teaching at the University of Maryland since 1989. In 2007, she served as lead faculty advisor for the Department of Energy's Solar Decathlon international challenge to advance solar technology. Mohr is an active volunteer, lending her architectural expertise through community service to boards and building committees at local schools. Their work has been featured in *The Washington Post*, *ArchitectureDC*, *Home & Design*, *Remodeling*, *Builder* and on HGTV's "Small Space Big Style."

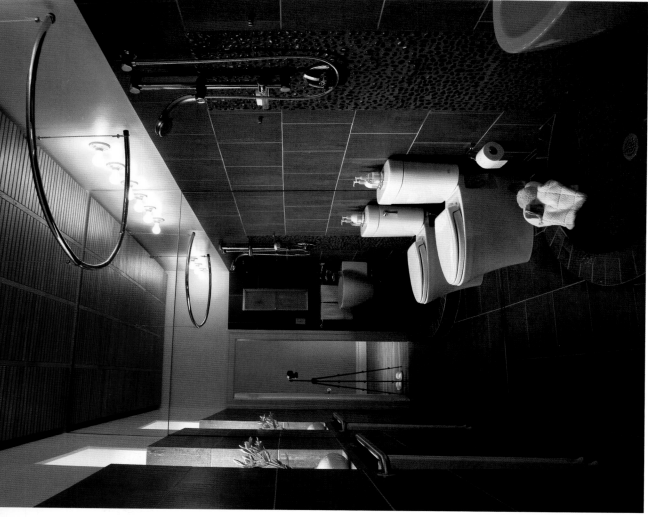

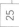

ABOVE LEFT: The material palette, including reclaimed oak throughout and the shoji-like doors, enhances the living room's connection to the garden.
Photograph by Amy E. Gardner

ABOVE RIGHT: White fixtures, black tile, natural wood and a mirror provide serenity by way of simplicity in this tiny bathroom.
Photograph by Cheryl Mohr

FACING PAGE LEFT: Rooms on the west side of this house connect to a terraced landscape via verandas, screened porches and balconies.
Photograph by Amy E. Gardner

FACING PAGE RIGHT: Deep overhangs and a west-facing sun screen offer cool comfort and privacy for plein-air living and dining.
Photograph by Alan Karchmer

Gardner Mohr Architects LLC

Amy E. Gardner, AIA, LEED® AP
Cheryl Mohr, AIA, LEED® AP
3626 Raymond Street
Chevy Chase, MD 20815
301.654.9145
www.gardnermohr.com

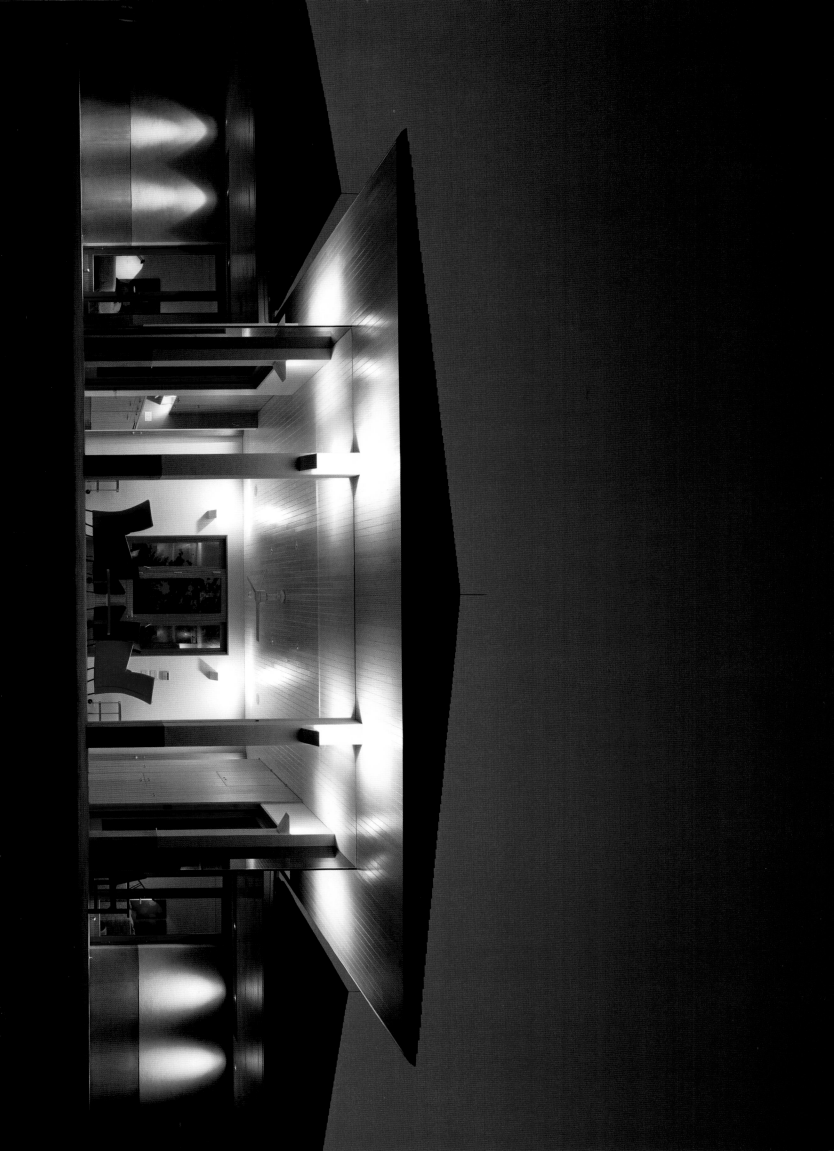

ABOVE: A glass door provides a view down the spine of this house. The right-hand, western side hunkers down in response to winter winds and heavy snow. The left-hand, eastern side opens up to the view.
Photograph by Maxwell MacKenzie

FACING PAGE: Thrust in a valley surrounded by rolling hills, the living room becomes a kind of proscenium stage for living.
Photograph by Maxwell MacKenzie

MARCIE MEDITCH
JOHN DENNIS MURPHEY

Meditch Murphey Architects

Marcie Meditch and John Dennis Murphey are architects with more than 20 years of experience apiece, including hands-on construction work and tenure under some of the region's modernist masters. Their passion for well-crafted, well-conceived architecture, emphasizing environmental sensitivity, encouraged them to begin Meditch Murphey Architects in 2000. Their firm of six architects has created award-winning, highly regarded designs for residential and commercial projects along the East Coast. Designs reflect clean lines, natural materials and a keen understanding of how buildings go together. "Our designs are quiet, not showy," Meditch explains. Their comfortable and inviting residences strike a balance between functionality and the personality of every client.

Simplicity is the key word Meditch and Murphey use when describing their firm's work, which is often influenced by Frank Lloyd Wright and other modern masters. One of their favorite examples of great architecture is Mies van der Rohe's "Barcelona" Pavilion for the city's exposition in 1929. The iconic glass box characterizes many of the ideas Meditch Murphey Architects promotes: a minimalist aesthetic, a connection between the indoors and the outdoors and an elegance that arises through thoughtful detailing and beautiful

craftsmanship. Common sense project management, respect for budgets and a hands-on approach to client relations ensure that Meditch Murphey designs progress through construction with similar ease.

The firm's design process is a "visual conversation" with clients, going back and forth sharing ideas, developing concepts and, most importantly, listening. "Think about a picnic," Murphey describes; the shelter is unobtrusive, the function works nicely, the views are important, but "the people make the picnic." Architecture needs the depth and complexity that comes from the input of each client. "If you design a house based on the ideas and aspirations that are important to the client, you get a house with personality," he adds.

Exploring new ideas is one of the firm's strengths. "We tell clients not to resort to what they have already seen," explains Meditch, who adds that the firm does the same, approaching each design without preconceived notions. Innovative concepts, such as a "Kitchen on Wheels" with movable components, are reflective of their approach. Environmentally conscious elements are considered at the start of each project, and the firm has a LEED® Accredited Professional on staff. The architects might maximize efficiency by grouping room functions to create open, multi-use spaces, or might include a Green roof for environmental benefits. "The house may not look like your neighbor's house, but it will suit the way you live," she explains, indicating that clients enjoy the process. "They feel comfortable because care is always taken to address their desires."

TOP LEFT: To the south, the living room provides views and access to the slate-tiled patio.
Photograph by Maxwell MacKenzie

BOTTOM LEFT: The eastern view from the living room seems boundless, exquisitely framed by the expansive wall of windows.
Photograph by Maxwell MacKenzie

FACING PAGE: A stone base completely surrounds the bottom of the home, protecting it from the weather, much like a pair of mud boots.
Photograph by Maxwell MacKenzie

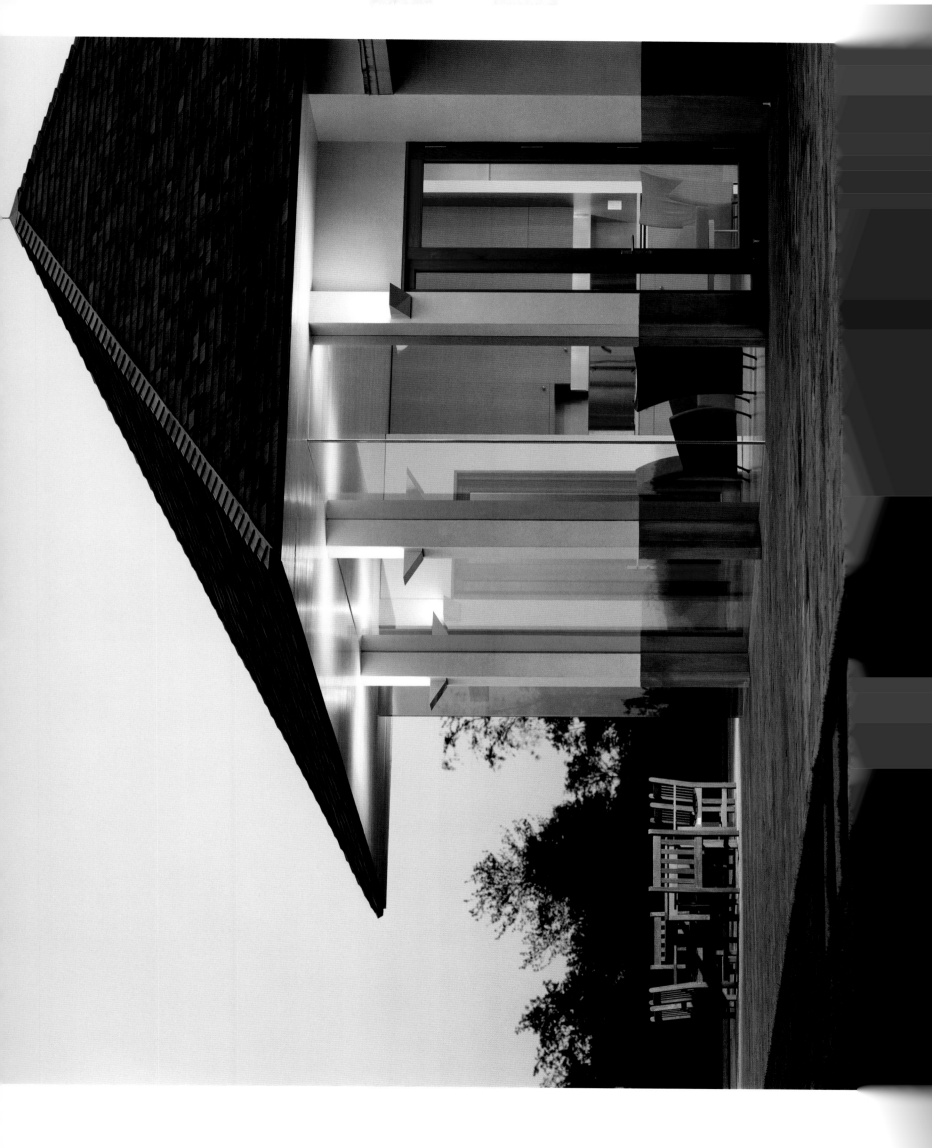

Meditch and Murphey have always enjoyed building. Meditch worked in construction for several years before pursuing architecture. Murphey first operated a woodworking and furniture-making shop. The married partners met in graduate school at the University of Minnesota, where each earned a Master of Architecture degree. The program included study in China, and both credit this experience with shaping their views of craftsmanship, detailing and scale. Murphey recalls seeing the closely arranged courtyard houses in Beijing, which proved to him that it is possible to design densely and elegantly at the same time, something the firm strives for in its own urban work.

Meditch Murphey Architects enjoys exploring concepts in sustainability, efficiency and community planning. The office culture is lively and creative, with staff often competing in design competitions to tackle new building types. They recently took first prize in the Suitland Manor National Design Competition for "Mixed Greens"—a development of Green-roofed residential and commercial buildings arranged around village greens. Another competition entry, for the MCPS Portable Classroom Design Challenge, earned a second-place commendation. The firm has earned design awards from the Northern Virginia, Virginia Society, Maryland, Potomac Valley and D.C. Chapters of the American Institute of Architects and a Custom Home Project of the Year.

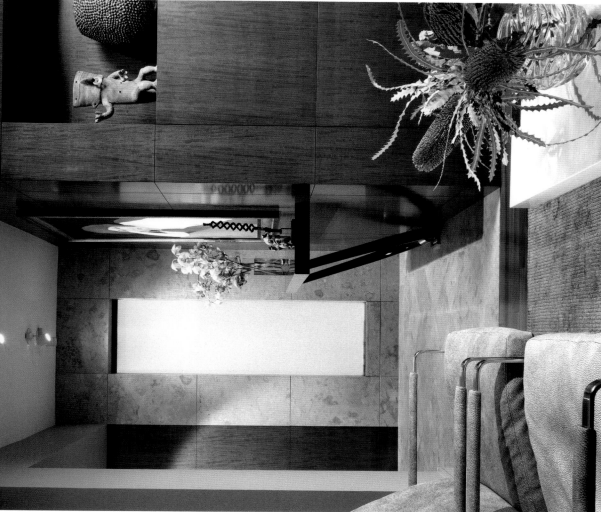

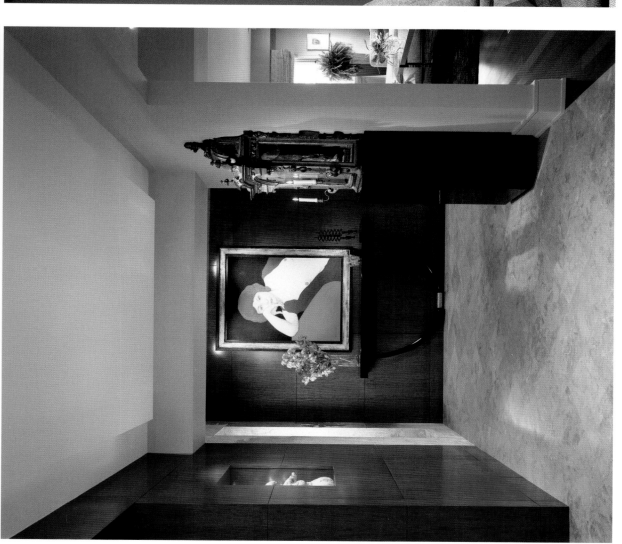

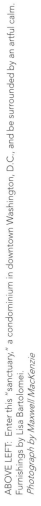

Meditch Murphey Architects
Marcie Meditch, AIA
John Dennis Murphey, AIA
6900 Wisconsin Avenue, Suite 500
Chevy Chase, MD 20815
301.657.9400
www.meditchmurphey.com

ABOVE LEFT: Enter this "sanctuary," a condominium in downtown Washington, D.C., and be surrounded by an artful calm. Furnishings by Lisa Bartolomei.
Photograph by Maxwell MacKenzie

ABOVE RIGHT: Viewed from the living room, a waterwall splashes sound throughout the two-bedroom apartment. Furnishings by Lisa Bartolomei.
Photograph by Maxwell MacKenzie

FACING PAGE: Simple lines and carefully selected finishes lend themselves to a Zen experience in this master bath. Furnishings by Lisa Bartolomei.
Photograph by Maxwell MacKenzie

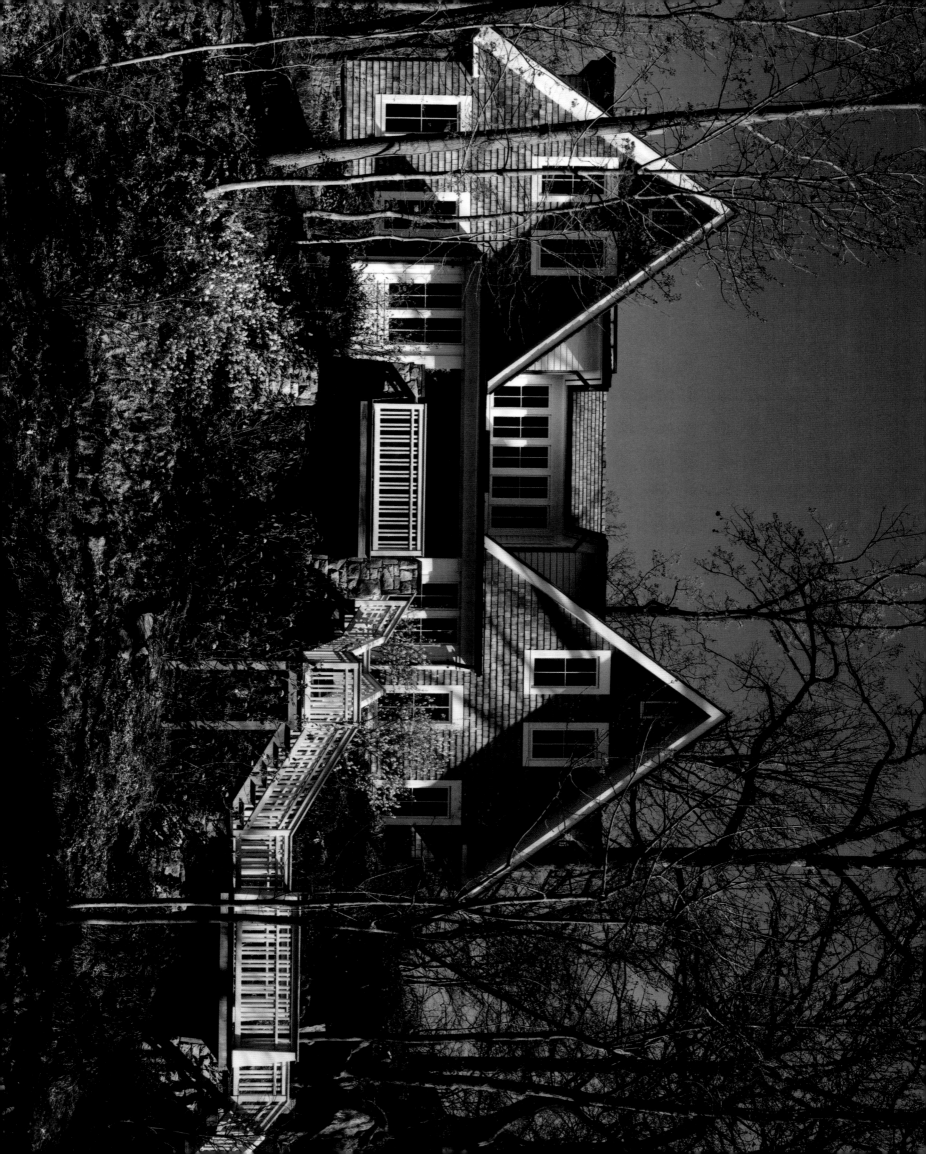

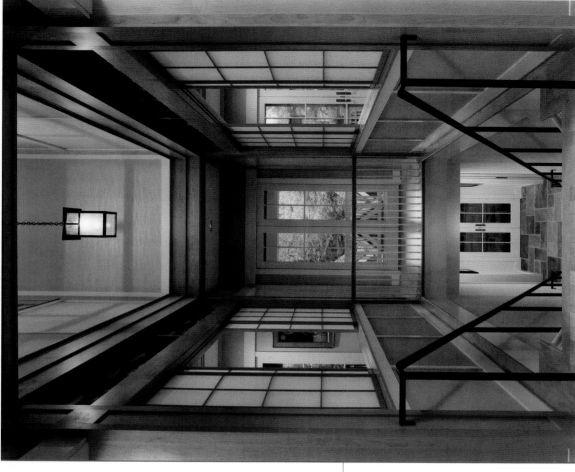

ABOVE: The stair hall of the Rock Creek Park residence.
Photograph by Maxwell MacKenzie

FACING PAGE: A new residence near Rock Creek Park in Washington, D.C.
Photograph by Maxwell MacKenzie

STEPHEN MUSE

Muse Architects

The award-winning work of Muse Architects is grounded in consideration of the bigger picture. "A building can only be judged as successful if it improves the larger context," explains senior principal Stephen Muse, FAIA. Of all project issues, the site is the one to remain constant, and it is the starting point for each of the firm's designs. With a high level of personal involvement and an equal measure of care for their work and clients, Muse and his team generate timeless architecture with a natural quality that looks as if it has always been there.

Muse recounts the story of being asked to speak to a community group about architecture within a historic context. The group was divided into two factions, each adamantly opposed to the other's viewpoint. The first group believed all new construction should be designed to replicate the town's existing architecture. The second group felt that new construction should present a decidedly modern image to contrast with the older architecture. Muse was asked to choose a side in the argument. However, his answer surprised the group and illustrates his belief in "design values" rather than a design philosophy.

"Every project we design, no matter the scale, begins with a study of the larger whole," Muse explains. "We look to extend what is best about the existing context while mitigating its problems." In other words, his practice takes the strongest characteristics from a site, neighborhood or existing building and merges those strengths with solutions to what may be problematic in that same site, neighborhood or existing architecture. In speaking to the community group, and in his own practice, Muse advocates "distinction as a result of problem-solving, as opposed to distinction for the sake of distinction."

The firm's residential designs involve the clients as an integral part of the process. "We wouldn't know how to design without knowing who will live there," Muse explains. One hundred percent of the designs are custom, meaning residences are crafted for individual families, never for speculative builders. Muse says that his design process involves investigating many options, with the

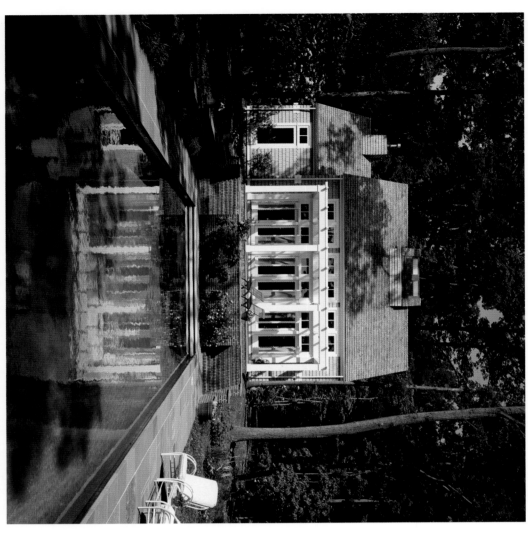

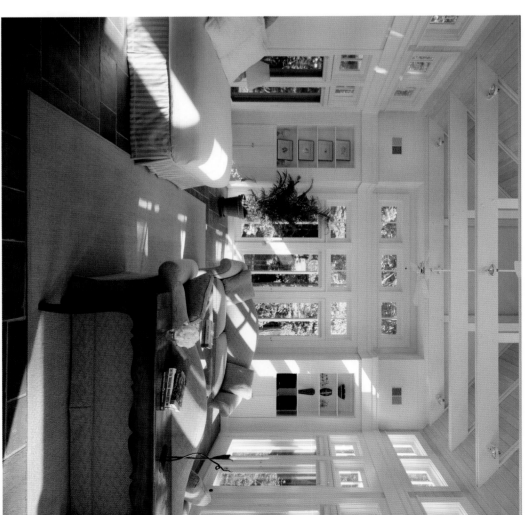

ABOVE LEFT: A new pool house on the South River in Edgewater, Maryland.
Photograph by Alan Karchmer

ABOVE RIGHT: The interior of the Edgewater pool house.
Photograph by Alan Karchmer

FACING PAGE: A new residence on the Tred Avon River in historic Oxford, Maryland.
Photograph by Robert Lautman

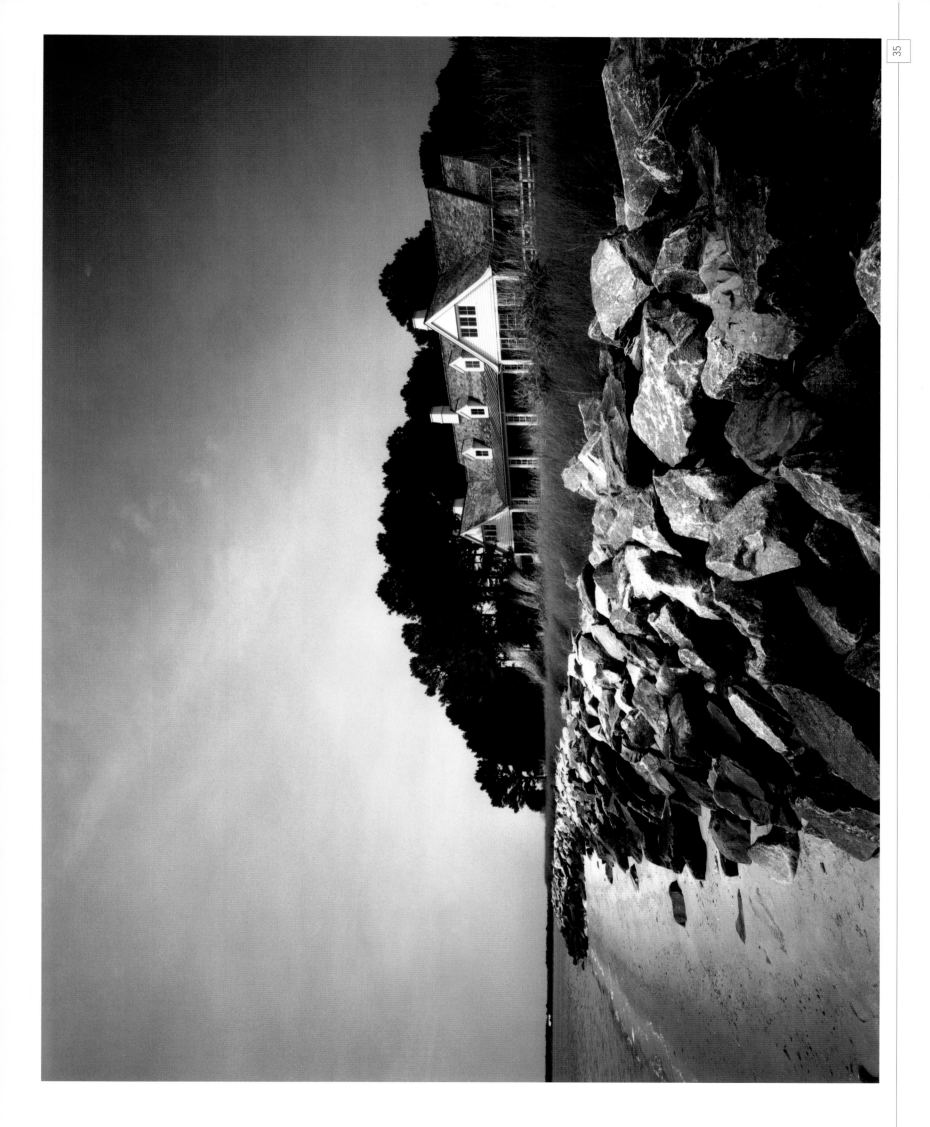

strongest ideas remaining on the table. While he admits to a big ego about the quality of his work, Muse is humble about where the ideas originate; he welcomes the input of clients, contractors and his staff, whose contributions strengthen every design.

Muse has grown his firm carefully over 24 years of practice. Seventeen of the firm's 19 staff members are architects. Many of the employees were Muse's former students, including William Kirwan, AIA. Kirwan joined Muse Architects upon graduation from the University of Maryland in 1987. After 15 years of employment, he became a principal of the firm. While each project's design vision originates with Muse and Kirwan, the staff contributes to, and improves upon, that vision. This collaborative studio environment is small enough to maintain personal involvement on every project, yet large enough to permit the firm to take on large-scale projects with complicated schedules. Most importantly, the size permits a continuous high level of care evident through all phases of design and client service.

Maintaining that level of care is very important to Muse Architects. The firm is known for highly detailed drawings and spending a great deal of time on-site. "We want to do work that is good and lasting," Muse explains, adding that he holds, as a benchmark, his children's observations of his architecture. "I want my kids to appreciate what I've done."

TOP RIGHT: An addition to a 1920s' Tudor residence in the Spring Valley neighborhood of Washington, D.C.
Photograph by Maxwell MacKenzie

BOTTOM RIGHT: The new family room in the Spring Valley residence.
Photograph by Maxwell MacKenzie

FACING PAGE: A new weekend residence in Delaplane, Virginia.
Photograph by Robert Lautman

Stephen Muse earned a Bachelor of Architecture with high honors from the University of Maryland and a Master of Architecture in urban design from Cornell University. He remained at Cornell as a Graduate Fellow, teaching and studying under Colin Rowe. A D.C. native, Muse was trying to decide whether to continue teaching or enter practice, when he returned home to visit family. "The cherry blossoms were blooming, and I realized what a beautiful city Washington is," he recalls. Muse relocated to the area and taught for several years at the University of Maryland before beginning his practice in 1983. Although dedicated to full-time practice, he has been a guest critic at the Harvard Graduate School of Design and recently donated a studio to the University of Maryland. His academic and professional work earned him the school's 2005 Alum of the Year award for "involvement in bridging education and the profession."

While most of the firm's portfolio is residential, it does engage in other design projects "with a residential hand." The same personal approach, intricate level of detailing and human scale are found in commercial, institutional and urban design work. The same emphasis on contextual design is also clear. For example, an addition to and renovation of the Leland Community Center in Chevy Chase, Maryland, balances the large scale of the county building within its residential neighborhood. Other work has included projects for schools and universities, religious facilities and commercial buildings.

LEFT: A spacious gallery connects the existing residence to the new dining and living rooms in this Cleveland Park addition.
Photograph by Robert Lautman

FACING PAGE: An addition to a 1920s' residence in the Cleveland Park Historic District of Washington, D.C.
Photograph by Robert Lautman

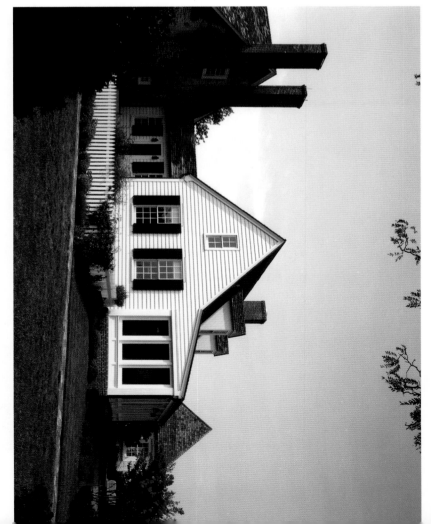

The designs of Muse Architects have been featured in more than 150 books and magazines, including *Architectural Record, Architectural Digest, Residential / Architect, House Beautiful* and *The American House: Design for Living.* The firm has earned more than 100 architectural awards, including three National Chapter AIA Design Awards, 14 AIA D.C. Chapter Design awards, 11 AIA D.C. Chapter Residential Design awards, and two National Trust for Historic Preservation awards. In 1996, Stephen Muse was elevated to fellowship in the American Institute of Architects for "notable design contributions to the profession of architecture."

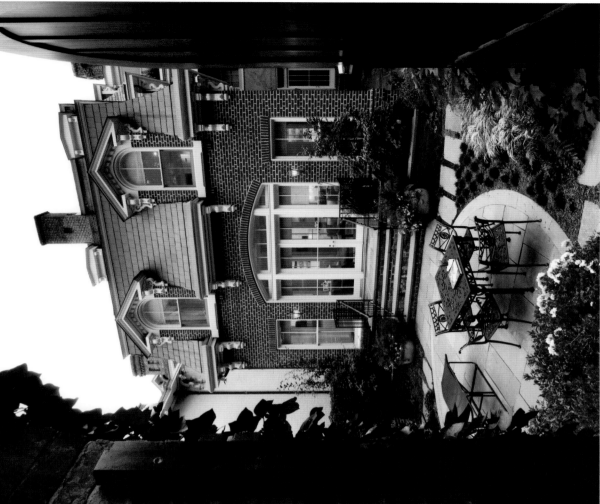

ABOVE LEFT: The new sunroom in the Georgetown addition.
Photograph by Robert Lautman

ABOVE RIGHT: An addition to a 19th-century residence in the Georgetown Historic District of Washington, D.C.
Photograph by Robert Lautman

FACING PAGE LEFT: The new kitchen/family room in the St. Mary's Manor addition.
Photograph by Robert Lautman

FACING PAGE RIGHT: An addition to an early 18th-century residence on the St. Mary's River in Drayden, Maryland.
Photograph by Robert Lautman

Muse Architects
Stephen Muse, FAIA
7401 Wisconsin Avenue, Suite 500
Bethesda, MD 20814
301.718.8118
www.musearchitects.com

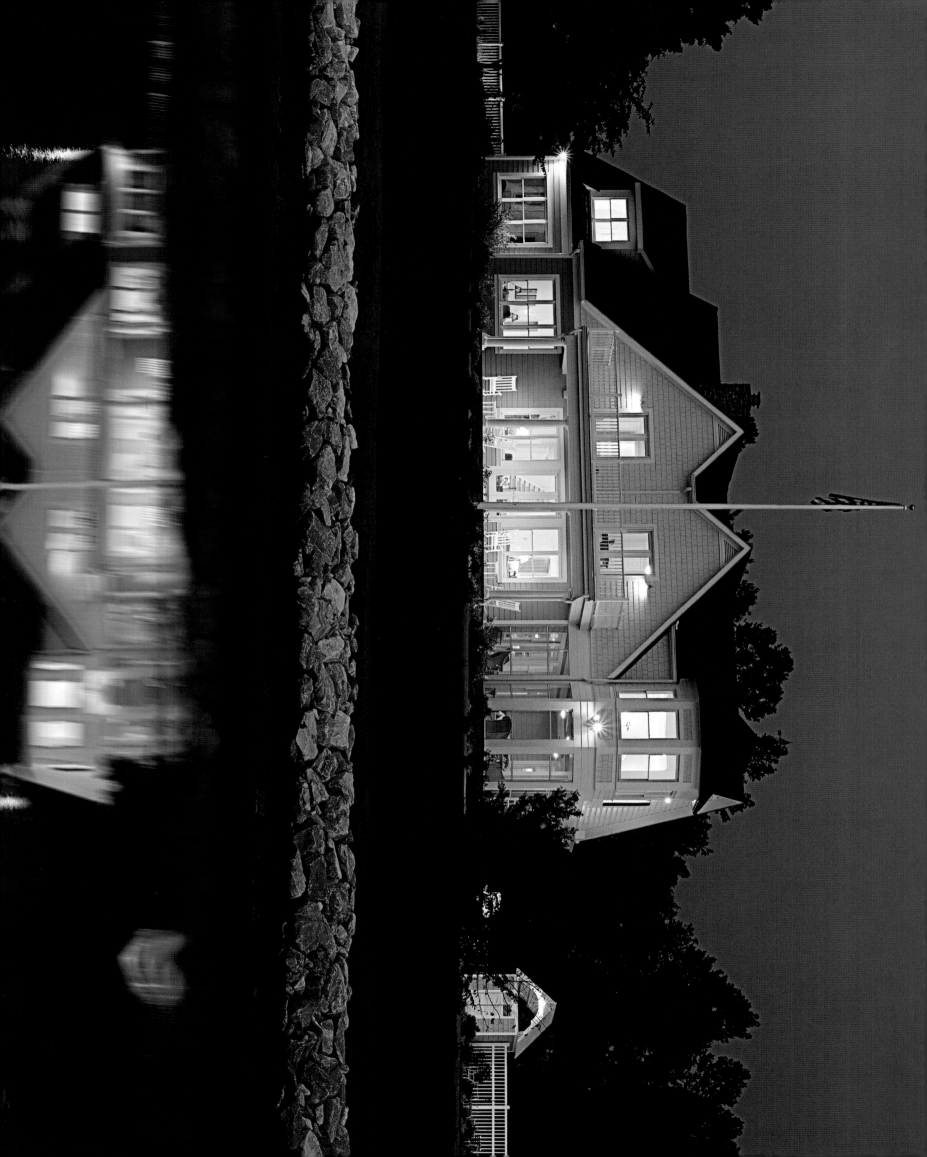

ABOVE: Accented in natural wood, this porch provides abundant natural lighting while offering panoramic views of the lake and pier.
Photograph by Kenneth Wyner

FACING PAGE: An eclectic mix of architectural forms brings a cottage-like charm to this lakefront home in Leonardtown, Maryland.
Photograph by Kenneth Wyner

GEORGE T. MYERS
MARK D. HUGHES

GTM Architects, Inc.

George Myers has always been an independent-minded guy. Confident in his balance of architectural creativity—he holds Bachelor and Master of Architecture degrees from the University of Maryland—and pragmatic understanding of construction, he established his own architectural firm just three short years after college. His entrepreneurial spirit paid off, and Bethesda, Maryland-based GTM Architects has grown to include 60 staff members and seven partners. "Everyone is an important part of the team," Myers believes, adding that the varied professional experiences and abilities run deep, infusing GTM's work with innovation and integrity. Myers explains that since 1989, "We have grown and diversified over the years while holding one thing constant: our commitment to excellence in both service and design."

Guided by a philosophy that emphasizes client relations, values design and is dedicated to enhancing the environment, GTM Architects is passionate and committed to its work. Every project includes a clearly articulated vision shared by architect and client. Project goals are established and met,

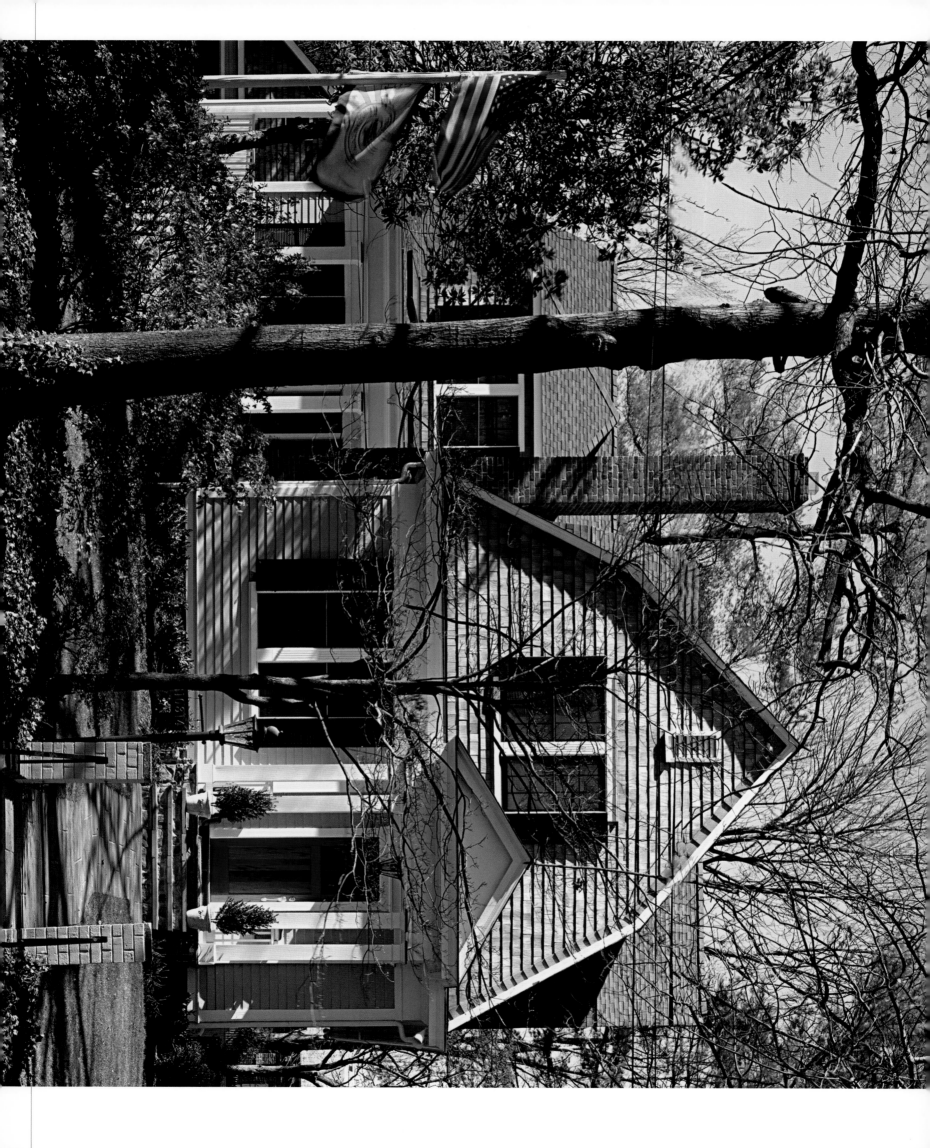

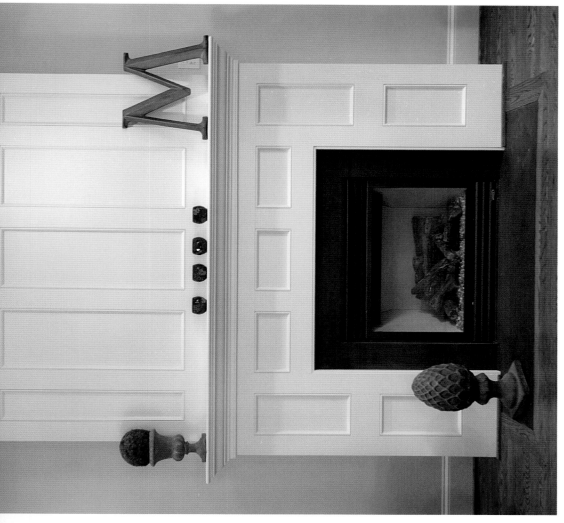

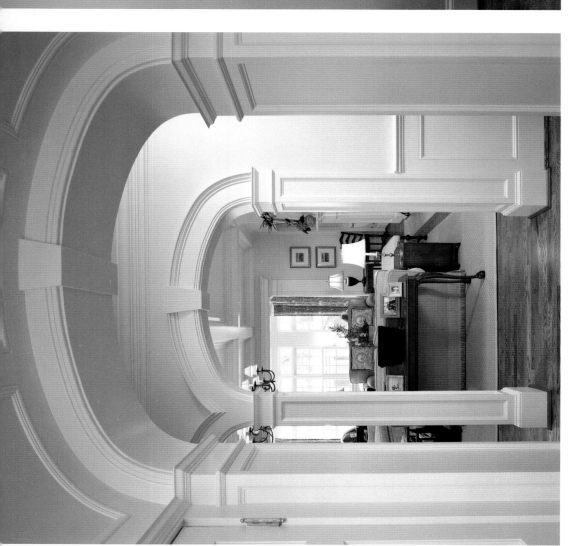

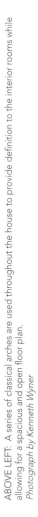

from aesthetics to budget and schedule. Integrity of designs is matched by integrity in practice, as GTM is adamant about teamwork within the office and with the builders and craftspeople with whom they work. "Every project presents an opportunity to explore new solutions. The unique qualities of each project challenge us to reinvent successful formulas to react to design issues in a fresh way," reads the firm's design statement.

About 30 percent of GTM's work is single-family housing, with a fair amount of multi-family projects as well. Myers and partner Mark Hughes handle most of the firm's residential designs. Hughes holds Bachelor and Master of Architecture degrees from the University of Maryland and is registered in Maryland and Virginia. Since joining GTM in 1990, he has also been responsible for a variety of commercial, retail and interior projects.

ABOVE LEFT: A series of classical arches are used throughout the house to provide definition to the interior rooms while allowing for a spacious and open floor plan.
Photograph by Kenneth Wyner

ABOVE RIGHT: Custom-built paneling brings a traditional feel to this fireplace in a home located in Bethesda, Maryland.
Photograph by Kenneth Wyner

FACING PAGE: By repeating the existing turn-of-the-century Dutch colonial gables, this home in Kensington, Maryland, was able to triple its existing size while preserving its historic character.
Photograph by Kenneth Wyner

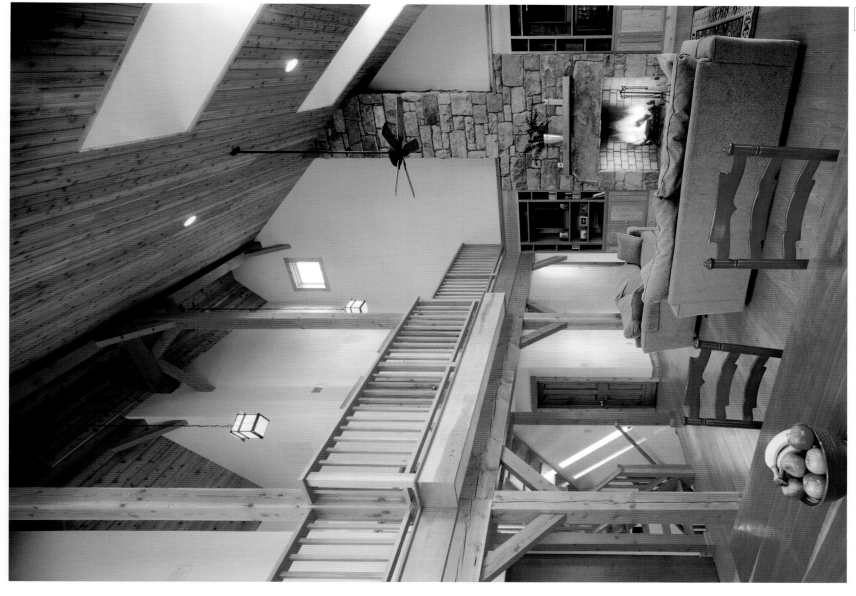

Hughes explains that residential projects begin by listening to clients describe their needs and preferences. "We take our cues from the homeowners," he says. Many of GTM's clients seek the old-style charm of more traditional architecture in combination with present-day amenities. GTM—which is known for its historic experience—is very proficient at blending trimwork, cabinetry and built-in details from years past with the open floor plans and modern conveniences of today. Whether working in an older home or recreating one in a traditional style, such as Shingle or Federal, GTM Architects takes an educated approach, with historic accuracy held in high regard. Throughout the process, the clients play an active role, working with architects and builders to modify the design so that it fulfills their wishes. "We pride ourselves on being responsive and good listeners. A good house is a collaboration," adds Myers.

GTM has a wide range of residential work, from new construction to small additions. A recent project involved the design of a tiny cottage in the backyard of a larger house. At just 500 square feet, it was still filled with the exceptional detailing and craftsmanship for which the firm is known, and says Myers, "it was just as fun."

In addition to Myers and Hughes, GTM principals include Richard Conrath, Barbara Slater Magistro, David Konapelsky, Melissa Cohen and Diane Taitt. Richard Conrath, with GTM since 1991, is responsible for a range of educational, commercial, retail, restaurant and healthcare projects. He earned a Bachelor of Architecture from the University of Houston and a Master of Landscape Architecture from Harvard University. Barbara Slater Magistro is in charge of both the interior design studio and GTM business development. She has a Bachelor of Fine Arts in interior design from Virginia Commonwealth University. Since joining GTM in 1998, David Konapelsky has also worked on a variety of project types. He holds Bachelor and Master of Architecture degrees from The Catholic University of America. Melissa Cohen, who leads the firm's historic preservation efforts, joined the firm in 2001. She holds Master of Architecture and Master of Science in historic preservation degrees from Columbia University and

RIGHT: The great room takes advantage of mountain views in this Shenandoah retreat. Natural interior framing and detail elements blend with the landscape, including the fireplace made with local quarry stone.
Photograph by Kenneth Wyner

FACING PAGE: This traditional entry hall features historic trim, bead-board wainscoting, warm oak millwork and a stained glass window.
Photograph by Kenneth Wyner

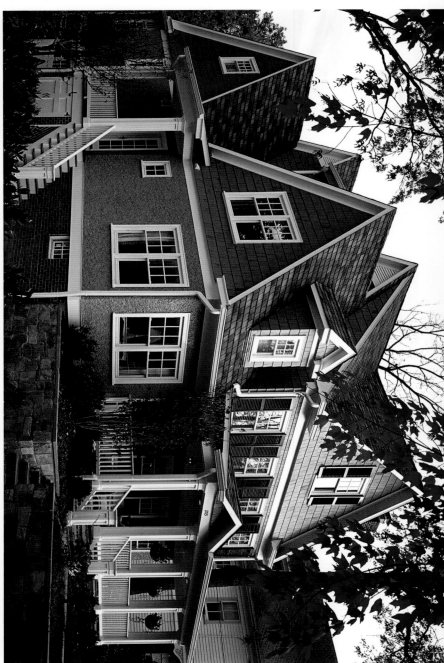

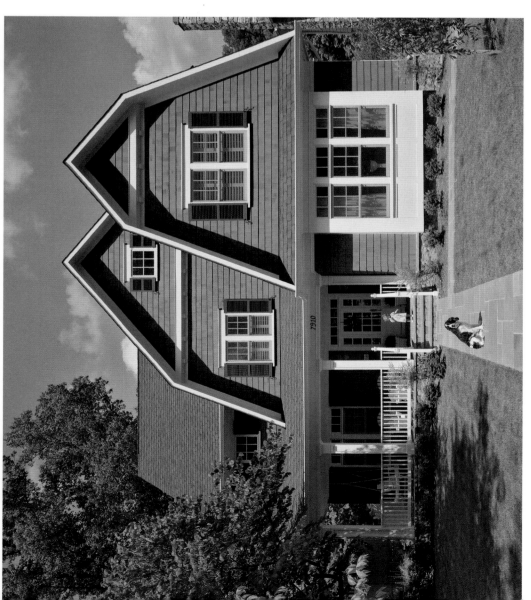

is a member of the National Trust for Historic Preservation. With GTM since 2002, Diane Taitt works on commercial interiors projects, bringing a decade of design experience. She is also a teacher and active in a range of community service initiatives.

Myers is proud of his partners' and staff members' varied backgrounds and sense of individuality. It has enriched the GTM portfolio with a diverse range of project types. The close client relations and careful detailing that characterize the firm's residential work are evident on all other projects, leading the firm to a variety of awards and media coverage.

GTM's extensive list of awards reflects both design and construction excellence. For residential projects, recognition includes three *Custom Builder* Gold Awards of Excellence and a Silver Award of Excellence in 2007 alone. Other awards include the 2006 BALA "Best in

ABOVE LEFT: The gambrel roof and exterior veneer of cedar shakes and stone combine to create a unique home while maintaining the feel of this traditional Bethesda neighborhood.
Photograph by Kenneth Wyner

ABOVE RIGHT: These Spring Valley residents turned misfortune—having a 100-foot-tall oak tree fall through their living room—into an opportunity to transform a seldom-used sitting room into this elegant living space.
Photograph by Kenneth Wyner

FACING PAGE TOP: This thoughtful transformation doubled the size of the house, yet maintained the architectural features and proportions of its traditional neighbors.
Photograph by Kenneth Wyner

FACING PAGE BOTTOM: The kitchen's open floor plan serves as a central space for family activity. The large island provides a generous workspace, as well as additional seating.
Photograph by Kenneth Wyner

American Living" award for a one-of-a-kind spec home, three design awards from *Remodeling* magazine, an AIA Citation for Architectural Excellence from the Potomac Valley Chapter and several awards from the National Association of the Remodeling Industry (NARI).

Projects designed by the firm have been featured in *The Washingtonian, Better Homes and Gardens, Custom*

Home, Washington Home & Garden, Chesapeake Home, The Washington Times, ArchitectureDC, Remodeling, Environmental Design & Construction, Traditional Home, Builder/Architect, Kitchen and Bath Designs and many others.

In addition to professional practice, many members of the staff at GTM are involved in philanthropic and community service efforts, participating in the Washington

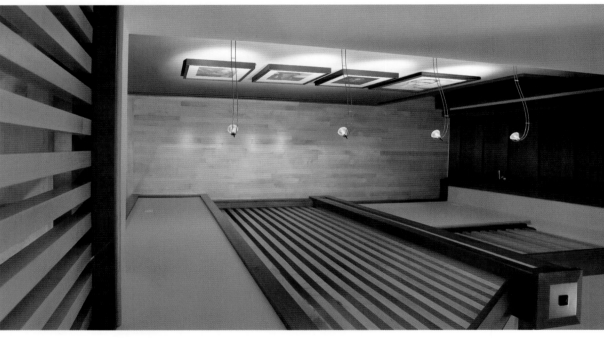

Architectural Foundation, Monumental Space Design Project, Marshall Heights Commercial District Improvement Study, D.C. Jewish Historic Society and Visitor Center at Meridian Hill Park. As a firm, GTM partners with the Bethesda/Chevy Chase High School to introduce interested students to architecture, and annually provides an academic scholarship to a University of Maryland student.

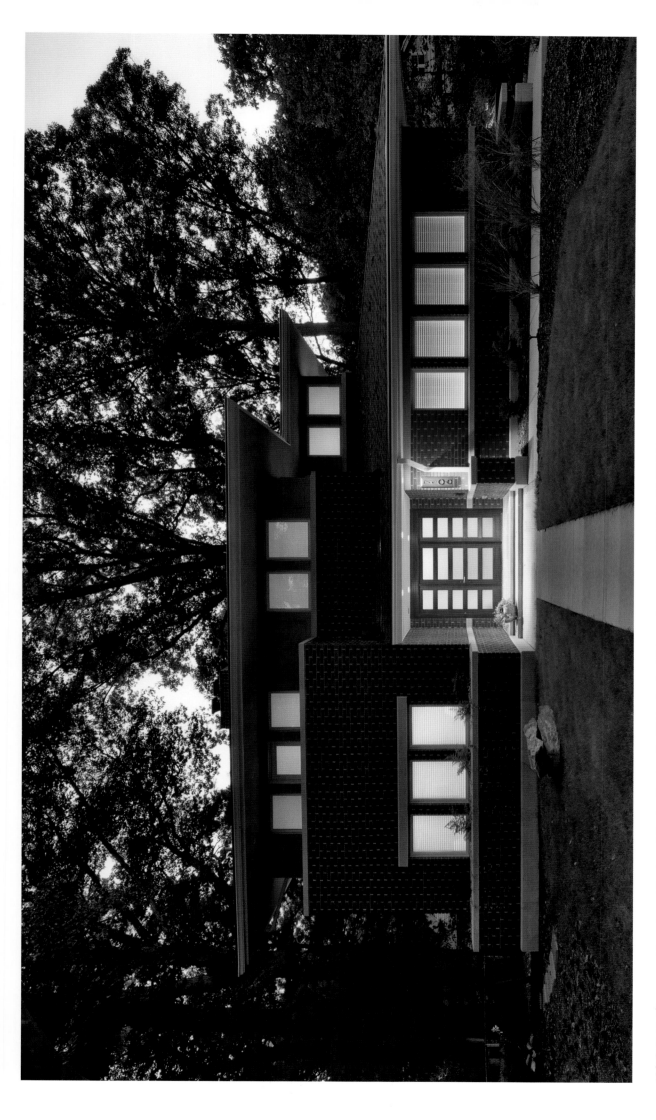

ABOVE: To provide an appropriate modern solution to a neighborhood burdened by "McMansions" and their towering building heights, this Prairie-style-inspired home focuses on the horizontal.
Photograph by Kenneth Wyner

FACING PAGE LEFT: The massive natural stone fireplace doubles as a display area, providing a niche to showcase the homeowner's personal artwork.
Photograph by Kenneth Wyner

FACING PAGE CENTER: A unified sense of rhythm is created in this hallway through diverse elements of lighting, balustrades and framed artwork.
Photograph by Kenneth Wyner

FACING PAGE RIGHT: The natural elements of the exterior are carried throughout the interior of the home, as evident in the stone wall and rich wood furniture in this dining room.
Photograph by Kenneth Wyner

GTM Architects, Inc.
George T. Myers, AIA
Mark D. Hughes, AIA
7735 Old Georgetown Road, Suite 700
Bethesda, MD 20814
240.333.2000
www.gtmarchitects.com

ROBERT REINHARDT

Reinhardt Architects

Architecture, it has been said, is a social art. Bob Reinhardt, AIA, abides by this philosophy by including his clients in his design process to generate homes that are warm, comfortable and well-suited to each individual or family's lifestyle. "Bob was able to translate my emotions into thoughtful, rational concepts," said one client. Reinhardt works in a range of styles, often transforming houses with complete renovations or seamless additions. "I don't have a signature style," he says. What the houses in his varied portfolio have in common is a sensitive architectural response to his clients' preferences, wishes and dreams, as well as their functional needs and construction budgets.

"I see myself as a guide through the entire process," explains Reinhardt, who adds that design doesn't stop until a project is built. His ability to solve design challenges and to incorporate ideas that clients never expected may be attributed to his education. Reinhardt earned an undergraduate degree in sociology before earning Bachelor and Master of Architecture degrees from Catholic University. He enjoys bringing out the best in his clients—and also in himself.

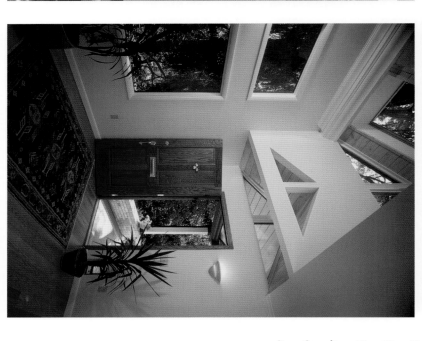

A typical design project begins with a brainstorming session, during which Reinhardt, with sketchpad in hand, will illustrate the ideas that his clients describe. He explains that this active process is very productive, but admits that the first time he approached a project in this manner it was due to lack of preparation. "I was expected to meet with new clients, but I didn't have the floor plans they requested," he remembers. "So we sat together and drew the plans. It was such a useful process that now I always do it." Reinhardt is as honest and direct in recounting this story as he is in his practice, making him a favorite with clients and contractors alike.

Beginning with his graduate school thesis, Reinhardt has actively incorporated energy efficiency and Green design principles into his work. From simple inclusions, such as extra insulation for energy efficiency, to more elaborate elements, such as photovoltaic panels for solar electricity, Reinhardt always keeps the environment in mind. "As best we can, we take advantage of the site," he explains, stating that passive solar efficiency is always considered.

Projects by Reinhardt Architects have earned awards from the National Association of the Remodeling Industry, National Trust for Historic Preservation and the American Institute of Architects, Potomac Valley Chapter. In addition to maintaining his practice, Bob Reinhardt is a member of the AIA, the National Trust for Historic Preservation and has served as a town councilman in Garrett Park, Maryland, where he works and lives with his wife and two black Labrador retrievers.

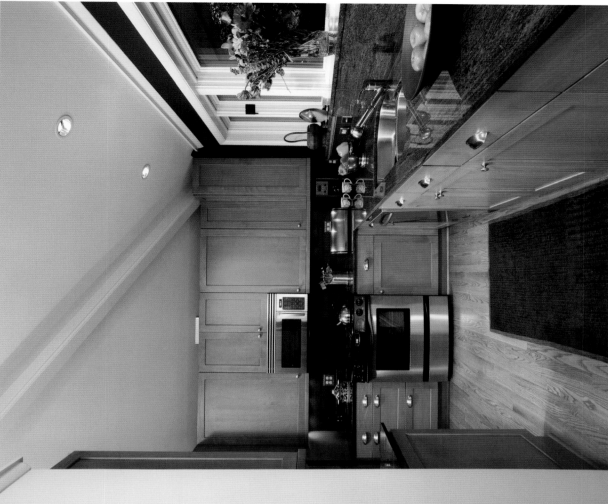

Reinhardt Architects

Robert Reinhardt, AIA
PO Box 129
Garrett Park, MD 20896
301.949.7554
www.reinhardt-architect.com

ABOVE LEFT: Adding a second floor transformed this 1940s' Cape Cod while maintaining its scale in the context of its Garrett Park, Maryland, neighbors.
Photograph by Les Henig Photography

ABOVE RIGHT: A new kitchen in a 1950s' ranch house features a raised ceiling.
Photograph by Greg Hadley Photography

FACING PAGE TOP: An expanded sunroom blends with the existing Potomac, Maryland, home.
Photograph by Les Henig Photography

FACING PAGE BOTTOM LEFT: With glass on three sides and into the gable, the beaded-wood ceiling covers a super-insulated roof over a radiant-heated floor.
Photograph by Les Henig Photography

FACING PAGE BOTTOM RIGHT: A sky-lit foyer presents a warm welcome.
Photograph by Les Henig Photography

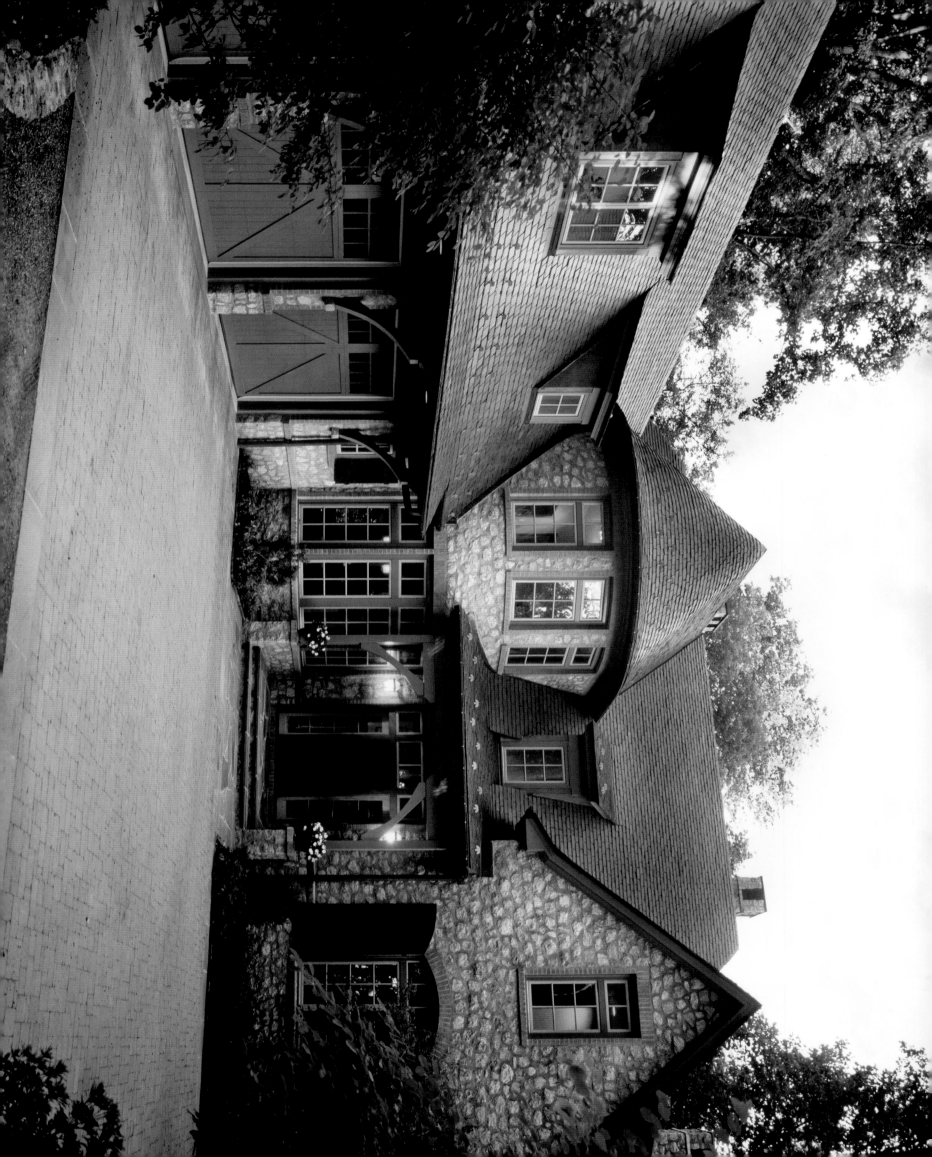

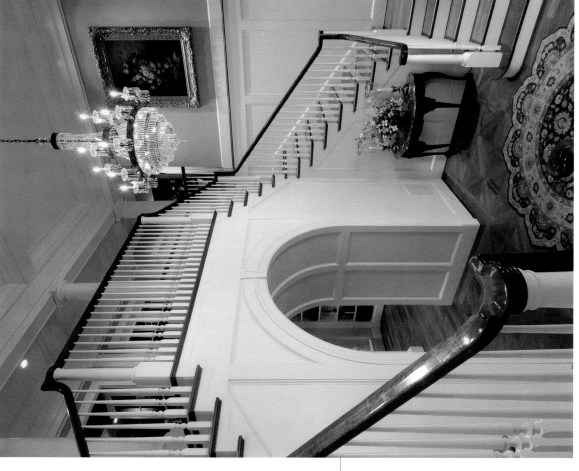

ABOVE: Stairs spill from the gallery, creating a gracious portal into the living room and beyond.
Photograph by Eric Taylor

FACING PAGE: The bracketed garage provides a welcoming entry court within a natural surrounding.
Photograph by Timothy Bell

JAMES F. RILL
ANNE Y. DECKER

Rill & Decker Architects, PC

Imagine being able to see your new house before it is built, to understand how rooms connect and how details will appear. While many architects use blueprints and renderings to give clients an idea of their future house, Rill & Decker Architects is different. "We get right to a visual connection with our clients," explains partner James Rill. The firm employs state-of-the-art software to literally build houses in the computer. Clients can look at photo-quality, three-dimensional images and see the design concept brought to life. They can appreciate imagery that would be confusing or complex when seen on paper. The architects, too, benefit from this process. They are able to work through building details in advance, minimizing surprises and unexpected delays during construction. The computer graphics have changed the way the firm practices, improving design, client relations and the bottom line. It is at the crux of what partner Anne Decker describes as their "personalized, flexible approach."

The Rill & Decker approach begins with close client involvement. The architects host intensive initial meetings to learn about each client's lifestyle and preferences, and to discuss ideas. Sketches, models and photographs of other projects are tools used to illustrate design concepts. "The most important thing is to

meet our clients' needs, not our own," Rill asserts. The firm aims to create architecture that will make an individual or family happy. "We want not only beautiful design, but design that gets built," he adds, stressing the importance of meeting both aesthetic and budget goals.

Decker refers to the firm's work as "traditional architecture with a twist." A foundation in traditional house styles, proportions and details is used as a starting point. "We use historic precedents as a base, but don't limit ourselves," she explains. The firm is well known for many styles of architecture, including Shingle Style, Craftsman, English Country and formal European houses. Their strength lies in merging these traditional styles with amenities and space planning compatible with today's lifestyles. The slight modern edge makes Rill & Decker houses feel comfortable rather than old fashioned.

Context is as important to a Rill & Decker design as client program and aesthetic preference. The firm's designs are sensitive to context—not only the immediate site conditions, but also vistas of neighboring landscape and property—sense of scale and proportion as well as the effects of sunlight. "Opening a home to the outside, pulling light indoors and creating a natural flow" contributes to what Decker describes as an "inside-outside" house, something for which the firm strives. They spend time designing outdoor spaces, such as courtyards that relate to both interior rooms and the landscape. "Some of the most beautiful 'rooms' in a house can be outdoor spaces," she adds. By integrating architecture with the landscape, the boundaries between the two are blurred.

TOP LEFT: The arched openings of the outdoor dining pavilion frame views of the surrounding pasture.
Photograph by Gordon Beall

BOTTOM LEFT: An open dining trellis accommodates large-scale outdoor entertaining.
Photograph by Gordon Beall

FACING PAGE: A romantic staircase flows from the master bedroom porch to the garden, as well as to the arched opening leading to the library below.
Photograph by Gordon Beall

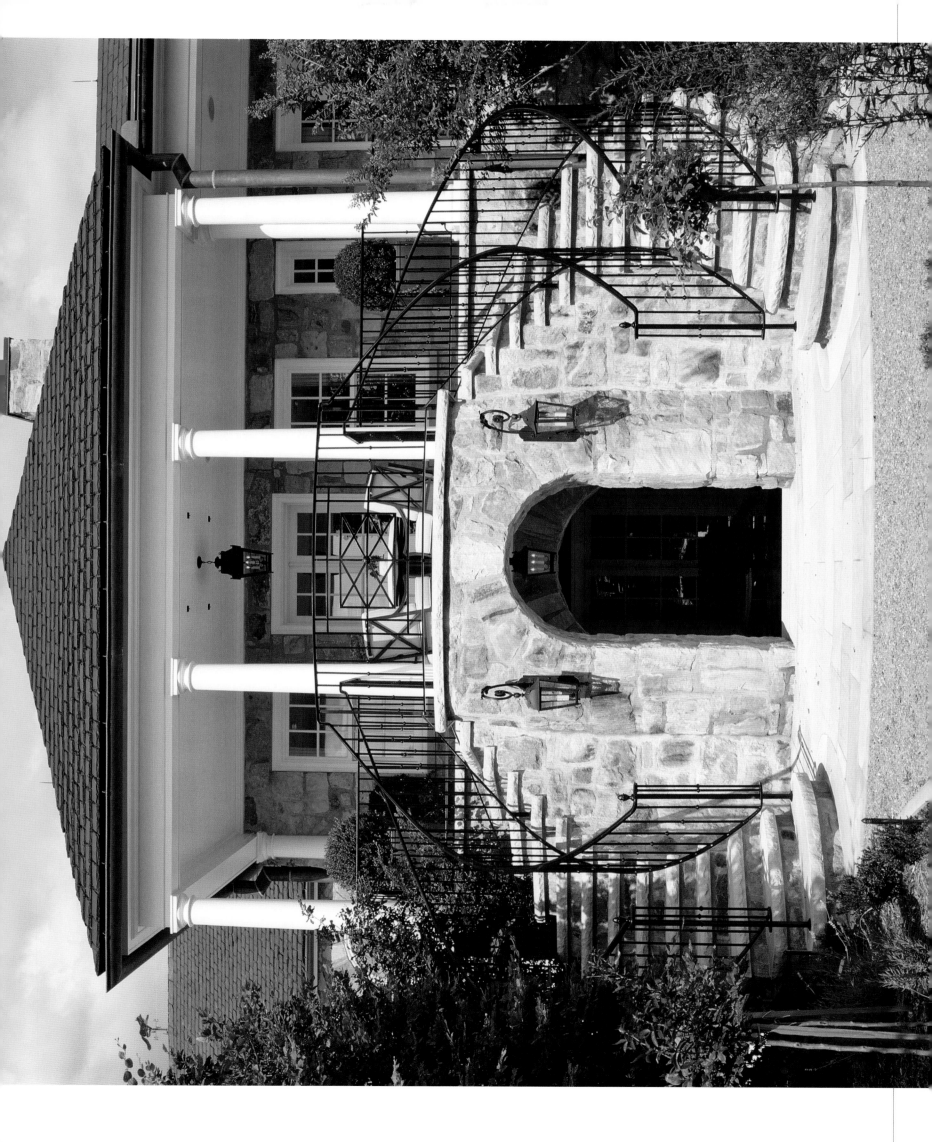

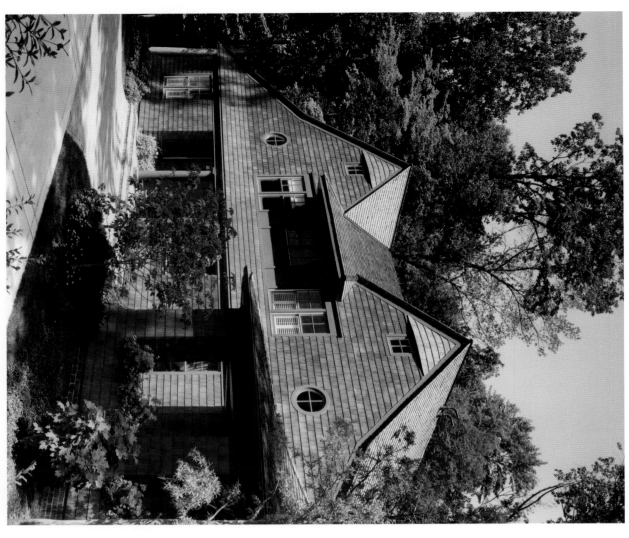

"Every person, site and project is different," says Rill. He believes the firm's personalized approach puts everyone at ease. He and Decker have more than 40 years of combined professional experience and have practiced together since 1995. While they share primary design responsibilities at the firm, they are quick to downplay their own roles. "Our work is very much a team effort," Decker describes. Their team includes one associate, six designers and two administrative staff members who contribute to the success of each project. "We try to encourage everyone to participate, ask questions and continue to learn," Rill adds. Within the studio environment, emphasis is placed on having fun with the process.

ABOVE LEFT: Natural exterior materials nestle the house in its wooded environment.
Photograph by Anice Hoachlander/HDPhoto

ABOVE RIGHT: High clerestory windows provide natural light, which reflects through the house.
Photograph by Anice Hoachlander/HDPhoto

FACING PAGE LEFT: Metal roofs, board-and-batten siding and field-stone walls provide a farmhouse feel on a historic horse farm.
Photograph by Ron Blunt

FACING PAGE RIGHT: The family room's soaring interior "barn" space, replete with chicken-wire rails, makes a reference to the farm.
Photograph by Anice Hoachlander/HDPhoto

Rill & Decker Architects' contextual, collaborative approach has led to award-winning projects and frequent editorial coverage. The firm has earned commendation with more than 75 awards and articles. This recognition for new construction, remodeling and additions shows the firm's proficiency across a range of project types. Awards have been given by the D.C. Chapter of the AIA (Residential Architecture), *Remodeling* magazine, Frederick (Maryland) County Builders' Association, Montgomery County Builder, Maryland National Capital Building Industry Association, *Chesapeake Home*, *The Washingtonian* magazine, *Southern Living* magazine, *Residential Architect* magazine and *Professional Builder* magazine. The work of Rill & Decker Architects has been covered in several books, as well as *Architectural Digest*, *New Old House*, *Southern Living*, *Custom Home*, *DC Spaces*, *Waterfront Home & Design* and *The Washington Post*.

LEFT: The pool-house bath uses natural materials to enhance connections with the landscape and provide low maintenance.
Photograph by Lydia Cutter.

FACING PAGE: The pool-house pavilion creates an outdoor living room, complete with fireplace, grill and wet bar.
Photograph by Lydia Cutter.

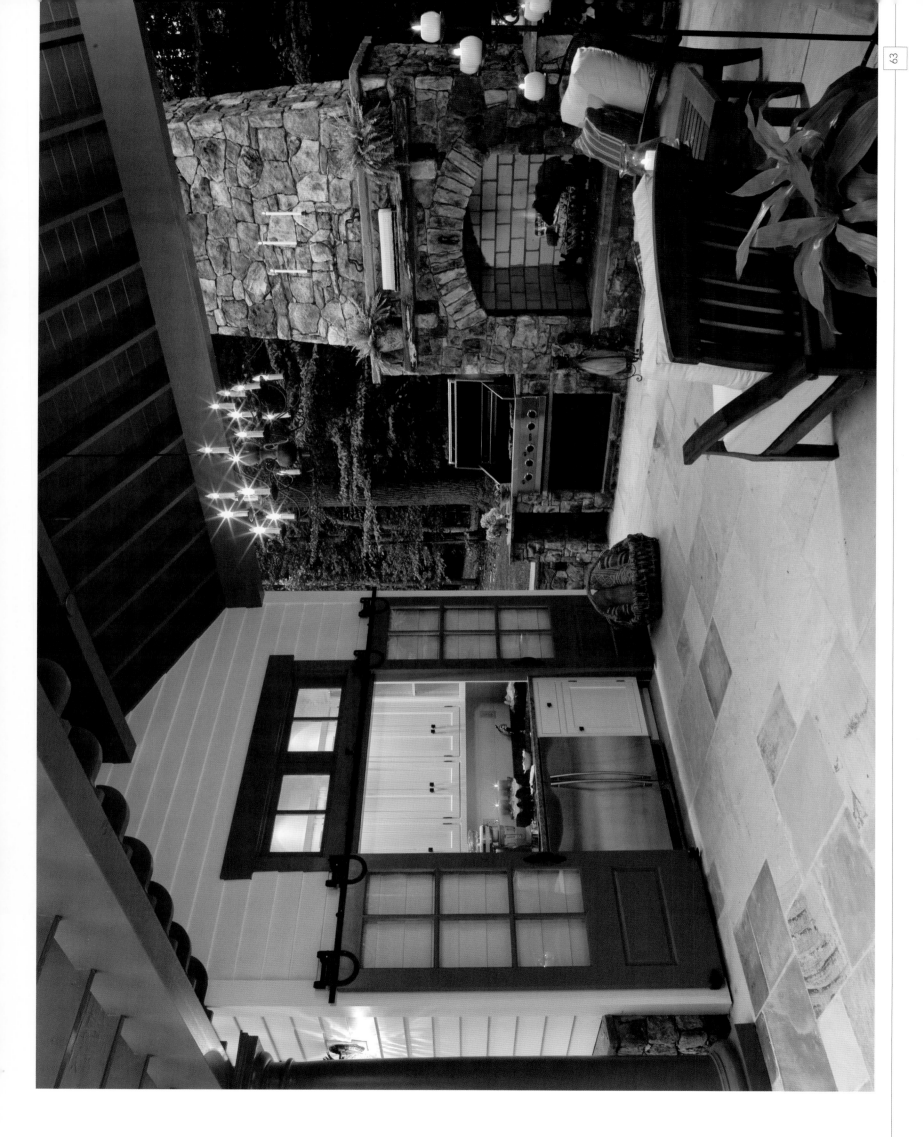

ABOVE: A deep-paneled family room wall harks back to old masonry walls.
Photograph by Gordon Beall

FACING PAGE: The new side entry serves as a link between the historic house and the addition.
Photograph by Gordon Beall

Rill & Decker Architects, PC

James F. Rill, AIA
Anne Y. Decker, AIA
5019 Wilson Lane, Suite 200
Bethesda, MD 20814
301.652.2484
www.rilldecker.com

MILTON SHINBERG
SALO LEVINAS

Shinberg.Levinas

S hinberg.Levinas, an award-winning and innovative design studio, approaches each project with a global vision. Principals Salo Levinas and Milton Shinberg, associate principal Antonio Vintro and a team of eight architects use their global perspective two ways: as an integrated way of thinking about each project—from the big picture to the smallest detail—and as a means of influence and inspiration from their international educations and work experiences. The combined "global" vision enriches a range of project types, from private homes to schools, religious buildings and commercial spaces.

Shinberg.Levinas approaches architecture with a focus it calls "humanistic." Architect, client, contractors and consultants are important teammates in the design process, and communication is open and continuous. "We listen to our clients, develop a concept and then work with contractors and consultants in an integrated fashion to maintain the original vision," explains Levinas.

By completing projects at a variety of scales and budgets—from small residential additions to large institutional buildings—the architects of Shinberg.Levinas remain realistic and grounded. "We don't lose sight of what is most important," explains Levinas, who says that regardless of budget size, the firm achieves quality with economy. In much of the firm's work, design elements—color, shape, light and unusual materials

ABOVE: A side view of the front entrance to the Levinas residence.
Photograph by Shinberg.Levinas

FACING PAGE: Front entrance to the Levinas residence. Ipe wall and a floating limestone slab are supported by rough-cut, contrasting stepping stones.
Photograph by Shinberg.Levinas

—are used to provide spaces that are visually striking and functionally elegant, while also being cost-effective.

For Shinberg.Levinas, the most important part of modern architecture is finding new solutions to old problems. Varying perspectives and appreciation for materials and technology used around the world offer diversity to keep ideas fluid. "The different staff members' cultures, educational backgrounds and experiences enrich the office," explains Vintro, who points out that the three principals represent North America (Shinberg), South America (Levinas) and Europe (Vintro). The *atelier*-style studio is strengthened by dynamic and collaborative relationships. Everyone contributes to the success of each project.

Salo Levinas was educated in Argentina and spent his early career working in Buenos Aires. He also was the architectural section editor of *La Razon*, the city's daily newspaper, interviewing and

gaining the insights of other architects from around the globe. In 1982, Levinas began his own practice in Connecticut. He subsequently moved to Washington, D.C., and founded a real estate development company before joining with Milton Shinberg to form Shinberg.Levinas in 1995. He maintains an active involvement in the D.C. community, as a visiting professor at the Corcoran School of Art, and with the Latin community, offering pro bono design services and consultation.

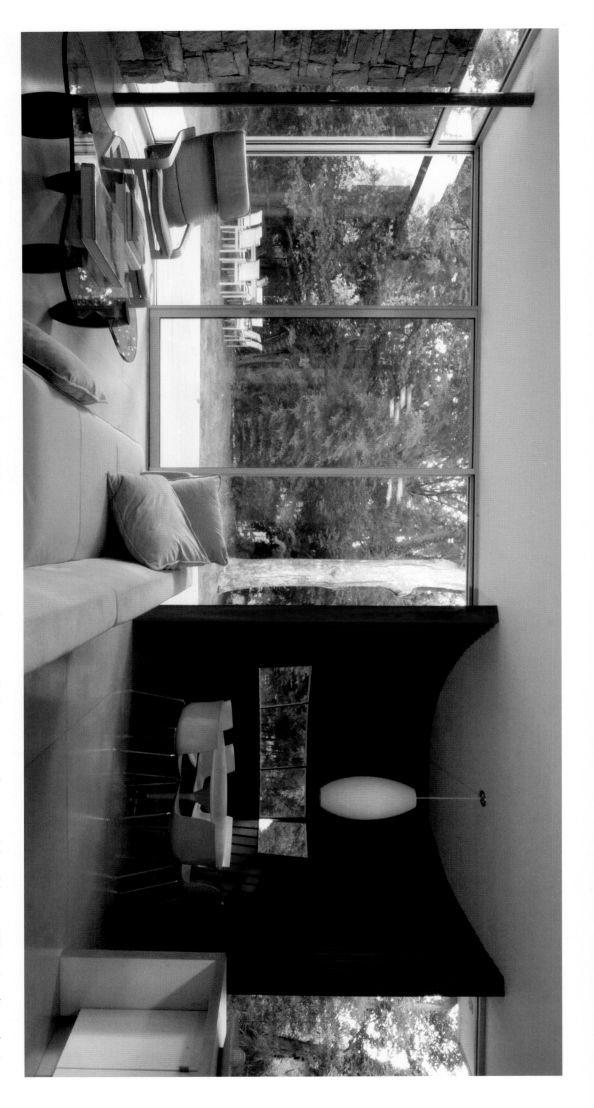

ABOVE: A view of the Levinas residence's great room and breakfast nook. The nook is embraced by the Ipe wall.
Photograph by Shinberg.Levinas

FACING PAGE: A rear view of the Levinas residence, which shows the glass-enclosed great room and master bedroom above.
Photograph by Shinberg.Levinas

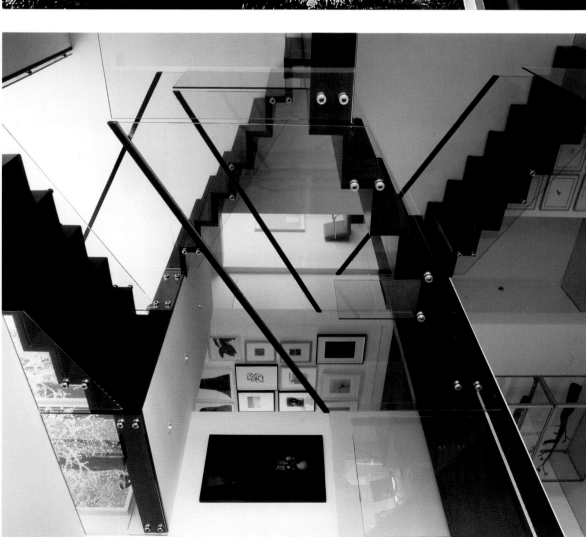

Milton Shinberg holds an architectural degree from Carnegie-Mellon University and has practiced since the mid-1970s. He was a partner in two successful firms before founding Shinberg. Levinas. For the past 30 years, Shinberg has maintained adjunct faculty status at the Catholic University of America, influencing a generation of young architects with both a theoretical and pragmatic approach. Shinberg also serves as a pro bono design consultant for several non-profit groups. His projects, renderings and articles on design have been widely published, and he has presented the firm's work at national conferences.

Antonio Vintro is a Spanish architect, trained in the United States. He earned an undergraduate degree from Rice University and a Master of Architecture degree from Yale University.

After graduation, he practiced in Barcelona before returning to the United States and joining Shinberg.Levinas. He was named associate principal of the firm in 2006. Vintro's is just one of many backgrounds that infuse the firm's work with international perspective.

ABOVE LEFT: Georgetown Square's dramatic main stairway crafted of steel, wood and glass.
Photograph by Wouter Van Der Tol

ABOVE RIGHT: Georgetown Square's 15-foot-by-21-foot open living room provides views of the swimming pool beyond.
Photograph by Eric Laignel

FACING PAGE: Georgetown Square's sculpture gallery; the steps to the left lead up to the open dining room.
Photograph by Eric Laignel

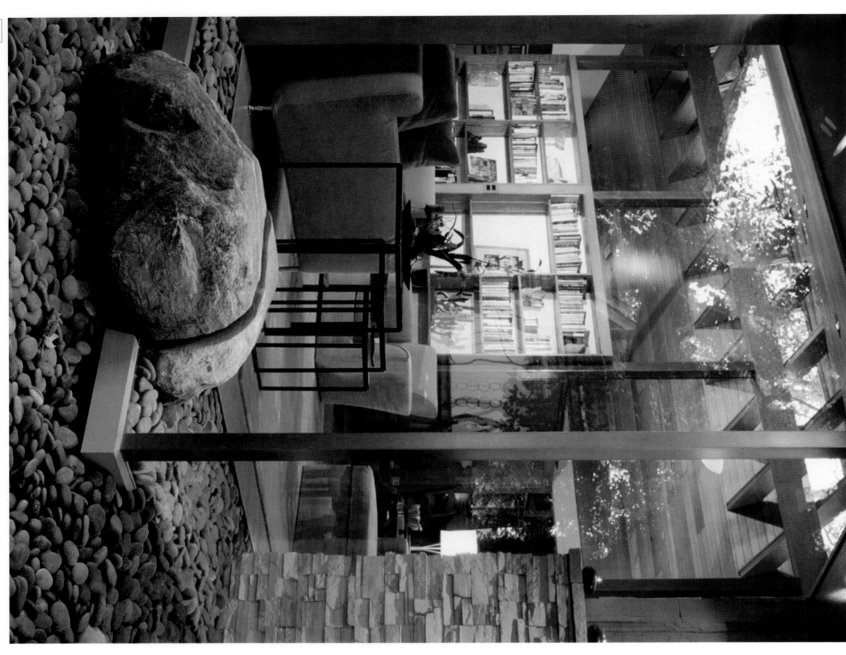

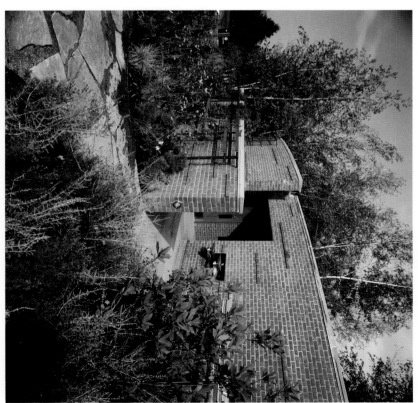

Since its founding more than a decade ago, Shinberg.Levinas has earned international and national recognition. It has also received national and regional awards from the American Institute of Architects. The firm's work has been published in *The Washington Post, The New York Times, Interior Design, Home & Design, Le Figaro* and in international books about design.

The strength of Shinberg.Levinas' projects lies in its balance between practicality and a thoughtful and inspiring design philosophy. The firm has completed projects across the United States and in Argentina. "The key is good design," says Levinas. "We want to serve every client best, reflecting their needs and aspirations with architecture that will be efficient and timeless."

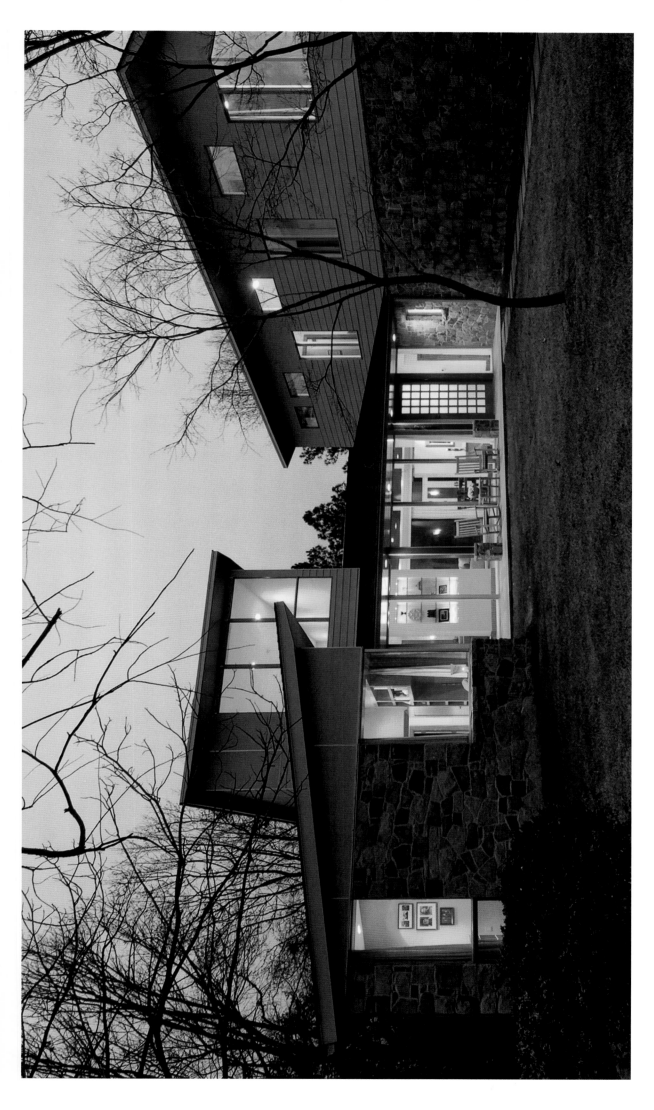

ABOVE: An exterior view of the front entry and terrace of the Hamburger residence during twilight reinforces the impact windows make both inside and outside.
Photograph by Bob Narod

FACING PAGE LEFT: An exterior detailed view of a glass corner of the Goldstein residence.
Photograph by Timothy Bell

FACING PAGE TOP RIGHT: The entrance to the comfort station located at the Chicago Botanical Garden is warm with natural materials.
Photograph by Shinberg.Levinas

Shinberg.Levinas
Milton Shinberg
Salo Levinas
4733 Bethesda Avenue, Suite 550
Bethesda, MD 20814
301.652.8550
www.shinberglevinas.com

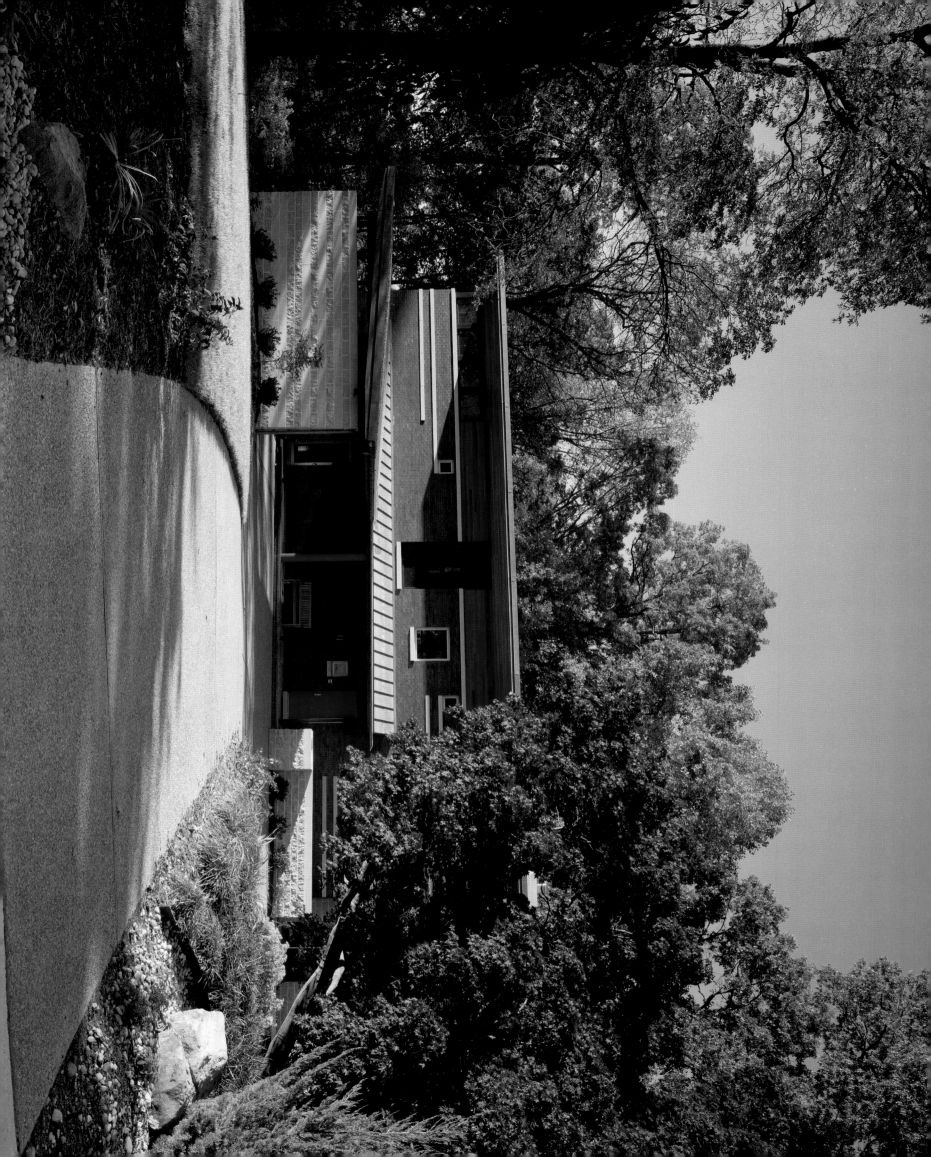

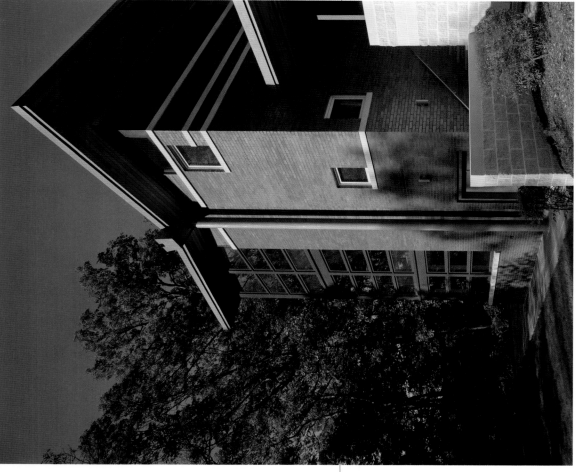

ABOVE: This new Tulip Hill residence's glazed rear façade opens to views of the Potomac River. The butterfly roof collects rainwater to irrigate the site.
Photograph by Anice Hoachlander/HDPhoto

FACING PAGE: This new Tulip Hill residence respects the horizontal character of its 1950s' neighborhood.
Photograph by Anice Hoachlander/HDPhoto

GREGORY WIEDEMANN

Wiedemann Architects LLC

"Each of us has memories of homes, either ones that we have lived in or ones that we have visited, that shape our sense of home," explains architect Gregory Wiedemann. His firm, Wiedemann Architects, has developed a reputation for finely crafted, highly detailed houses that capture each client's perception of what home should be. "We, as architects, design homes that make references to those memories, while inspiring memories for generations to come."

Listening is the firm's universal starting point; Wiedemann sees it as his first duty as an architect.

While the firm is well-known for seamless additions to older houses, its wide variety of work includes new contemporary, transitional and traditional houses, as well as commercial and civic buildings. Regardless of architectural style, each Wiedemann Architects project is characterized by authenticity and appropriateness of materials, proportions and details, and an integrated relationship with its site. "We strive to create a sense of fit that will represent the spirit of this time, while reflecting these timeless principles of design."

Born and raised in Washington, D.C., Wiedemann has been principal of his own firm since 1984. Following a successful partnership, he became sole proprietor of Wiedemann Architects in 1994. Wiedemann holds a Bachelor of Arts in mathematics and urban planning and a Bachelor of Science in civil engineering

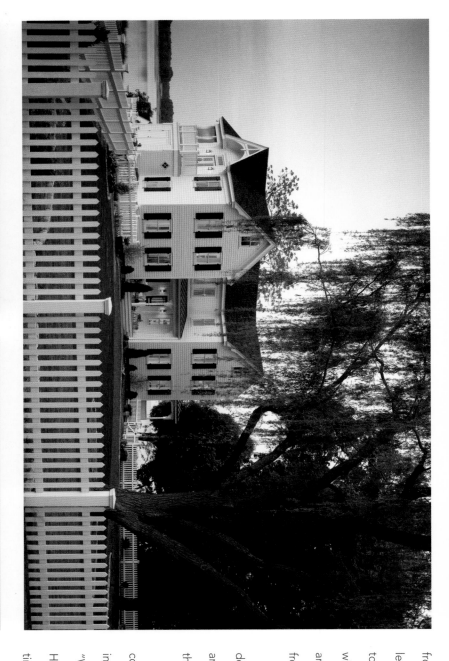

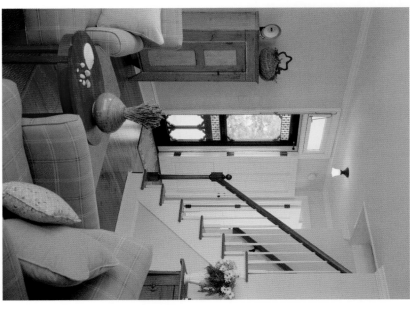

from Tufts University. His combined interests in art, math, planning and design led him to pursue architecture. He earned a Master of Architecture degree as the top-ranked student in his class at Harvard University's Graduate School of Design, where he was a Graham Foundation Scholar, Frederick Sheldon Traveling Fellow and the recipient of the AIA Medal. He was honored with an Architectural Award from the National Society of Arts & Letters.

In 30 years of practice, Wiedemann has remained committed to design education. He has served on the faculties of Johns Hopkins University and the University of Maryland, earning a national AIA Education Honor Award at the latter.

Wiedemann credits his teaching experience with influencing the firm's collaborative studio environment. All eight staff members hold graduate degrees in architecture and have between seven and 20 years of professional experience. "We are proud of every project that we have taken on," Wiedemann explains. He and his team are passionate about their range of work and ability to achieve timeless and appropriate solutions for each client and site.

The work of Wiedemann's firm has been recognized with more than 70 design awards. In 2006, the firm earned an Honor Award for Architectural Excellence from the Potomac Valley Chapter of the AIA, Remodeling Design Award, Custom Builder Luxury Home Gold Award, *Southern Living* Best Addition and Montgomery County (MD) Award for Historic Preservation. Projects have appeared in more than 100 articles in both national and regional publications.

Wiedemann Architects LLC

Gregory Wiedemann, AIA

5272 River Road, Suite 610

Bethesda, MD 20816

301.652.4022

www.wiedemannarchitects.com

ABOVE: This new residence in Merry-Go-Round Farm takes its form from the natural hillside. The entry courtyard includes a bridge over a small pond with a waterfall, which provides a welcoming approach.
Photograph by Anice Hoachlander/HDPhoto

FACING PAGE TOP: An addition to an Eastern Shore farmhouse seamlessly doubles the size of the modest original house.
Photograph by Anice Hoachlander/HDPhoto

FACING PAGE BOTTOM LEFT: A new gabled balcony off the master bedroom, adjacent to a new screened sleeping porch, affords views of the garden and setting sun.
Photograph by Anice Hoachlander/HDPhoto

FACING PAGE BOTTOM RIGHT: The interior of this Eastern Shore farmhouse maintains its authentic charm with antique heart pine flooring and a restored original staircase.
Photograph by Anice Hoachlander/HDPhoto

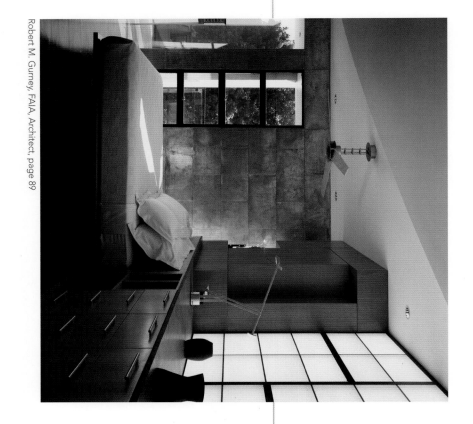

Robert M. Gurney, FAIA, Architect, page 89

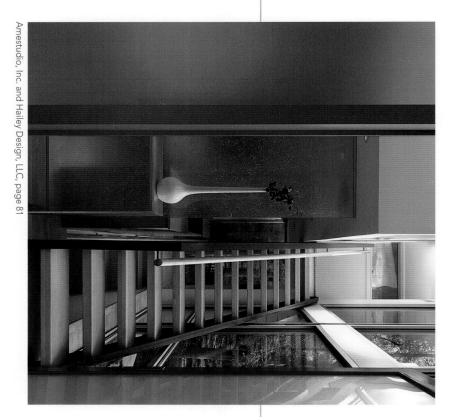

Amestudio, Inc. and Hailey Design, LLC, page 81

Kohler Associates Architects, page 105

NORTHERN VIRGINIA

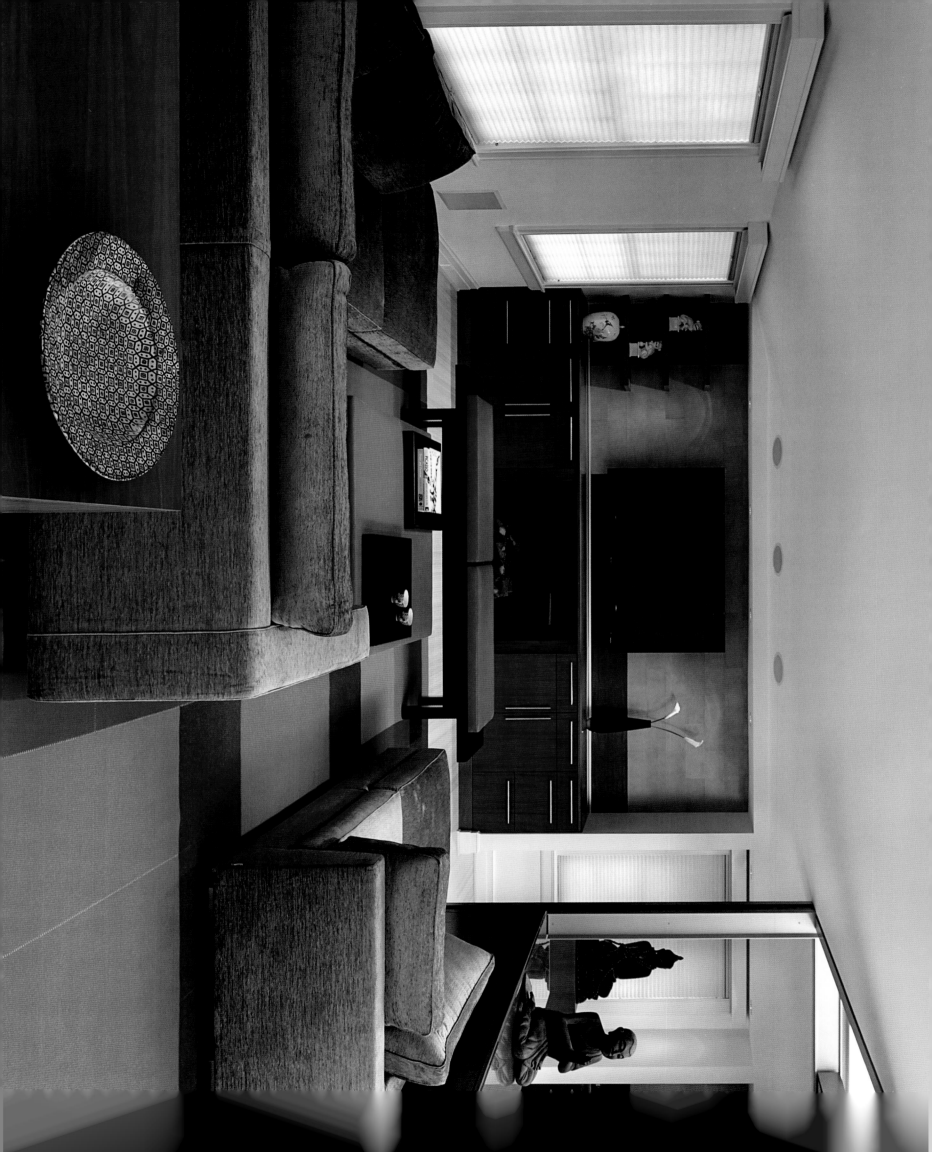

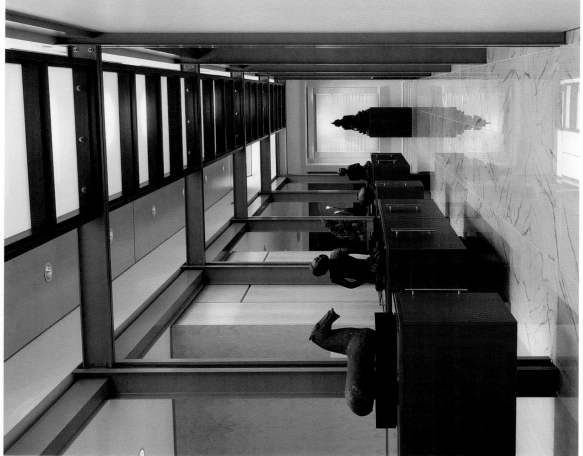

ABOVE: Winchester Construction of Annapolis renovated the penthouse of this 1914 John Russell Pope residence. Custom Metals of Virginia provided the aluminum framework through which filtered light illuminates sculptures in the central gallery.
Photograph by Paul Burk Photography

FACING PAGE: A variety of textures and materials animates the media lounge. The neutral tones of the sofa, leather wall tiles and bamboo flooring are punctuated by the vivid reds of the custom felt rug, coffee table and bench.
Photograph by Paul Burk Photography

BENJAMIN AMES
CATHERINE HAILEY

Amestudio, Inc.
Hailey Design, LLC

"Modern design does not have to be cold or austere," explains Benjamin Ames. The principal of Amestudio promotes a rigorous and innovative approach to design. He responds to climate, context, comfort and client lifestyle to generate residences that "challenge conventional notions of domesticity" through a project's program and materiality. Working with interior designer Catherine Hailey of Hailey Design, Ames creates animated spaces with an unusual mixture of residential, commercial and sustainable materials. Their shared interpretation of modern is anything but austere; instead, the award-winning houses the two firms have designed together feature ordered spaces, rich materials and comfortable elegance. "We are committed to creating work based on the fundamentals of modern design, yet with flexibility and openness to meet the needs and personalities of our clients," Hailey explains.

Established in 2000, Amestudio is dedicated to beautifully functional, innovative design. Ames earned a Bachelor of Science in architecture from Georgia Tech University and a Master of Architecture from the University of Maryland. Several years spent studying and working in Rome and Paris shaped his view of modernist housing. The son of a furniture maker, Ames grew up near Colonial Williamsburg. The element of craftsmanship is apparent in his custom designs fabricated by cabinet, glass and metal artisans. In practice,

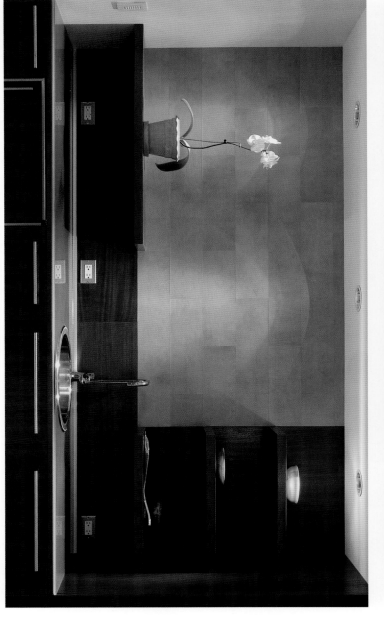

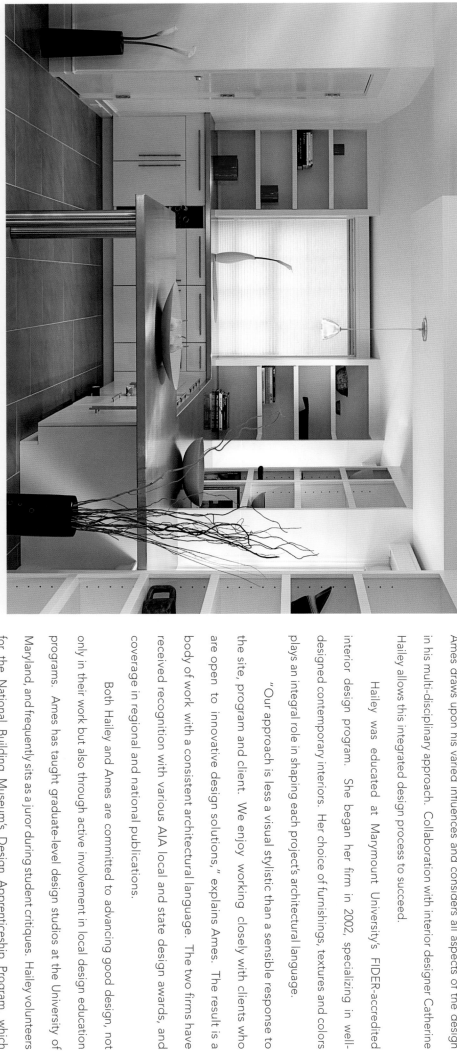

Ames draws upon his varied influences and considers all aspects of the design in his multi-disciplinary approach. Collaboration with interior designer Catherine Hailey allows this integrated design process to succeed.

Hailey was educated at Marymount University's FIDER-accredited interior design program. She began her firm in 2002, specializing in well-designed contemporary interiors. Her choice of furnishings, textures and colors plays an integral role in shaping each project's architectural language.

"Our approach is less a visual stylistic than a sensible response to the site, program and client. We enjoy working closely with clients who are open to innovative design solutions," explains Ames. The result is a body of work with a consistent architectural language. The two firms have received recognition with various AIA local and state design awards, and coverage in regional and national publications.

Both Hailey and Ames are committed to advancing good design, not only in their work but also through active involvement in local design education programs. Ames has taught graduate-level design studios at the University of Maryland, and frequently sits as a juror during student critiques. Hailey volunteers for the National Building Museum's Design Apprenticeship Program, which teaches children about design and construction. They appreciate the opportunity to bring innovative contemporary design to the greater Washington, D.C., region. Within the area's conservative context, Amestudio and Hailey Design distinguish themselves with creative and integrated design solutions that create excitement, elegance and comfort.

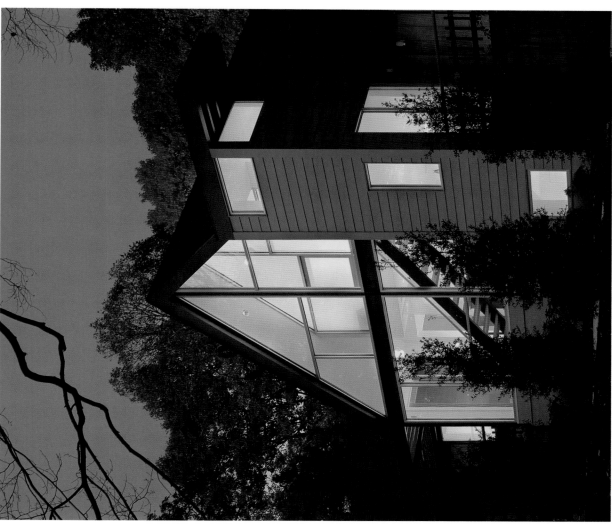

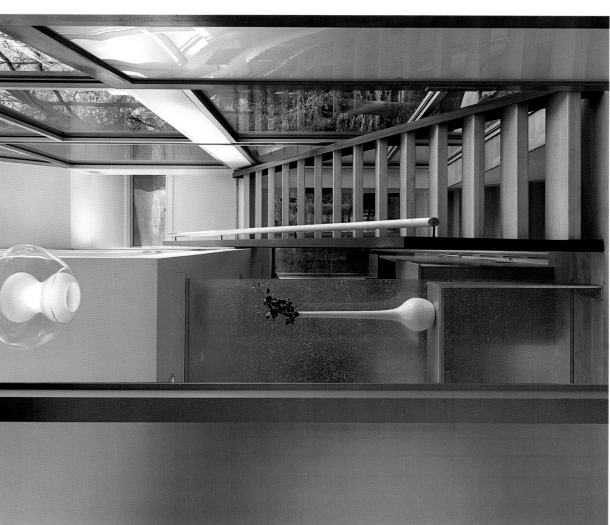

ABOVE LEFT: At the entry, light filters through layers of specialty glass by Dulles Glass. A steel stair with open maple steps provides additional transparency and views.
Photograph by Paul Burk Photography

ABOVE RIGHT: The Snyder residence of Alexandria, Virginia, uses a glass façade to invite guests to evening events. The master bath is tucked behind an internal frosted-glass façade.
Photograph by Paul Burk Photography

FACING PAGE TOP: The art studio maximizes work space with stainless steel counters by Custom Metals of Virginia. White cabinets and grey tile provide a monochromatic space for colorful artwork.
Photograph by Paul Burk Photography

FACING PAGE BOTTOM: In the kitchenette, a frosted glass counter contrasts the warm leather wall tiles as mahogany cabinetry provides shelving and conceals the appliances.
Photograph by Paul Burk Photography

Amestudio, Inc.
Benjamin Ames, Associate AIA
205 South Patrick Street
Alexandria, VA 22314
703.549.2948
www.amestudio.com

Hailey Design, LLC
Catherine Hailey, Affiliate ASID
1710 Commonwealth Avenue, B-3
Alexandria, VA 22301
571.274.9592
www.catherinehaileydesign.com

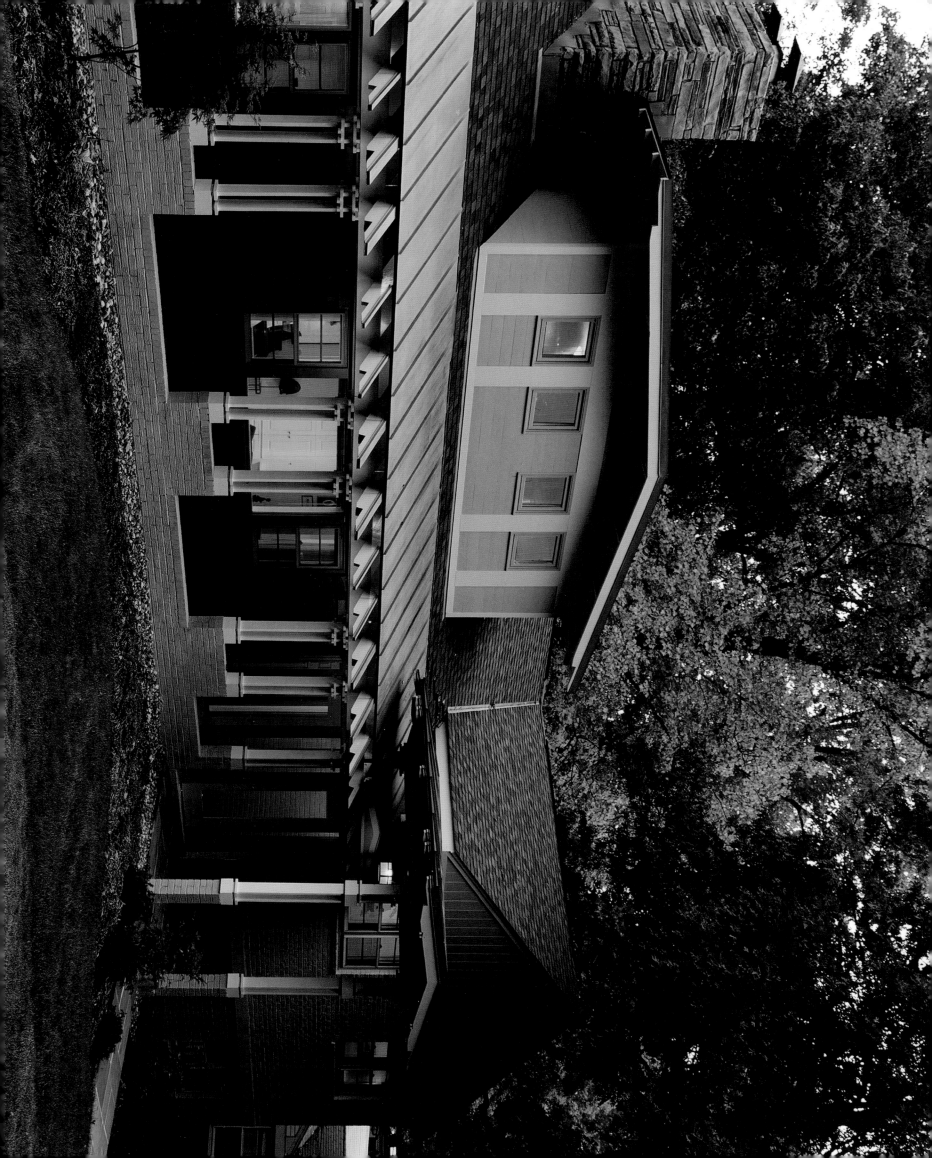

ROGER BASS

Bass Architects Chartered
Abingdon Development Corporation

Architect Roger Bass knows that the most important part of achieving one's dream house is whether or not it can be built—at a budget that is realistic for the client. He is uniquely familiar with the processes of both design and construction, and is in a position not only to design his clients' dream homes, but also to build them. As a partner in Bass Architects Chartered and its sister construction company, Abingdon Development Corporation, Bass and his partners ensure client satisfaction from concept to completion, working closely with them to achieve results that meet aesthetic, functional and financial goals.

After earning a Bachelor of Arts from the University of Rochester and a Master of Architecture from the Harvard University Graduate School of Design, Bass spent his early career working on large-scale projects along the East Coast. He was involved with the design of the Space Shuttle Launch Facilities at Cape Canaveral, Florida, and planning for the Northeast Corridor Improvement Program. In 1986, he founded his private practice in D.C., relocating Bass Architects to McLean, Virginia, in 1994. Together with partner Maire A.M. Bourque, AIA, and their staff, Bass has completed successful residential, commercial and institutional projects, including several award-winning residential and religious facilities.

ABOVE: Bass Architects thoroughly researched the history, architecture and mystique of the ofuro in order to design an authentic bath for this unique home.
Photograph by Ken Wyner

FACING PAGE: This stunning new entrance portico and vestibule welcomes family and friends while incorporating the existing fieldstone walls.
Photograph by Alan Karchmer

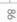

After bidding projects to a range of general contractors—and seeing their sub-par levels of quality and service—Bass considered the idea of starting a construction firm. In 1998, he founded Abingdon Development Corporation with partner Chuck Cromack, a longtime friend and contractor who he admired for his level of craftsmanship and commitment to every project. The Class-A-licensed contracting company now builds most of Bass Architects' residential projects. The partnership ensures clients have a single point of contact throughout the design and construction process. Bass says it gives him an added level of control while providing clients with an accurate idea of construction costs and timelines. "We can realistically describe the process of design through construction because we do it all."

The Bass Architects design approach is simple. "We see ourselves as providing a service, and we keep our clients involved," explains Bass. A dialogue between architects and clients is encouraged. Preconceived notions are abandoned in order to create architecture that is appropriate for the specific program and context of every project. Projects ranging from new construction to additions and renovations have been completed in the greater D.C. region and as far away as Cape Cod and Atlanta.

The work of Bass Architects and Abingdon Development has been featured in magazines such as *Before and After, New Dominion, Ministry & Liturgy* and the book *Houses of God.* In addition to his responsibilities at both firms, Bass teaches design and drawing at Marymount University.

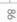
86

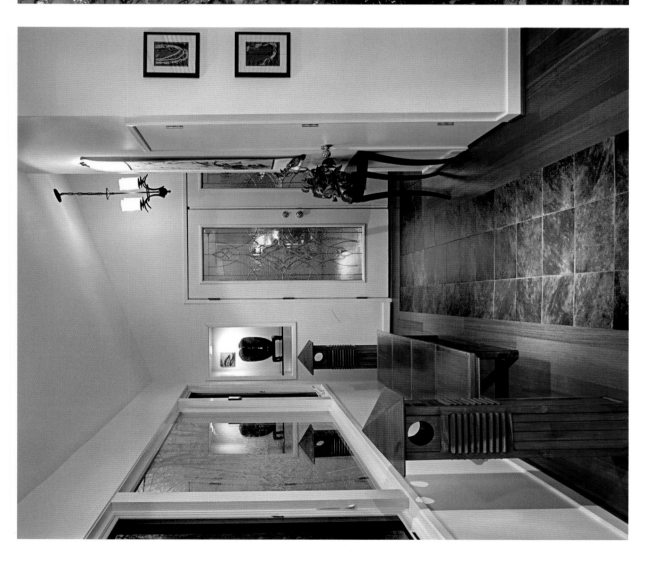

Bass Architects Chartered
Abingdon Development Corporation
Roger Bass, AIA
1477 Chain Bridge Road
McLean, VA 22101
703.506.1390
f: 703.506.2109
www.bassarchitects.com
www.abingdon1998.com

ABOVE LEFT: Light, airy and welcoming, the entryway reflects both the homeowner's roots in Hawaii and the simplicity of Eastern architecture and design.
Photograph by Ken Wyner

ABOVE RIGHT: The expanse of glass, added lighting and bold front walk give the house curb appeal and make it more welcoming.
Photograph by Alan Karchmer

FACING PAGE TOP: Sunlight floods the family room thanks to floor-to-ceiling windows that seamlessly unite the indoor and outdoor spaces.
Photograph by Sheri Warneck

FACING PAGE BOTTOM: This interior was divided into small rooms, leaving it dark and claustrophobic. Walls were removed to add light and space to the existing kitchen.
Photograph by Ken Wyner

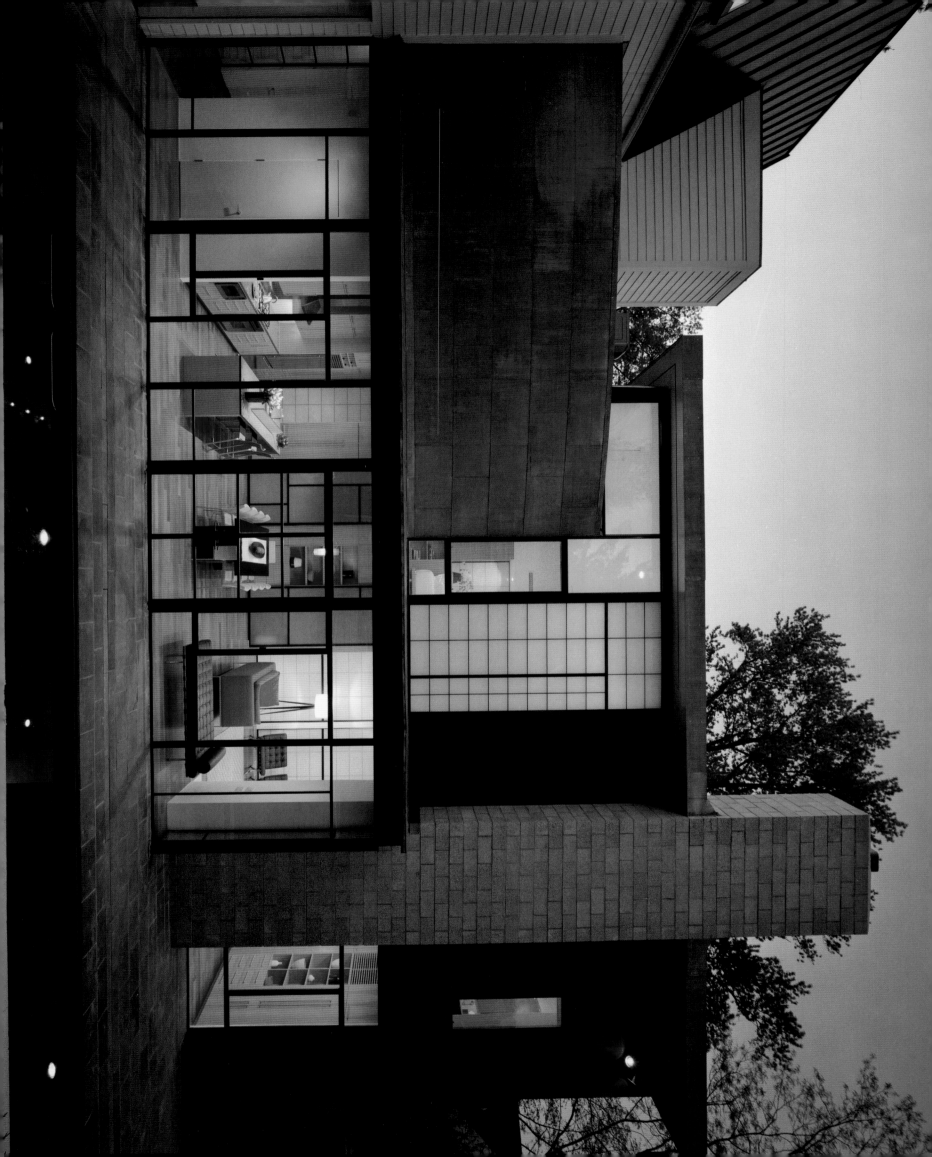

ABOVE: Blue Ridge farmhouse addition, Washington, Virginia.
Photograph by Paul Warchol

FACING PAGE: Kessler residence, Chevy Chase, Maryland.
Photograph by Maxwell MacKenzie

ROBERT M. GURNEY

Robert M. Gurney, FAIA, Architect

In stark contrast to the vinyl-clad developer houses dominating today's residential landscape, the work of Robert M. Gurney, FAIA, displays authenticity within the clean lines and pure geometry of a modern aesthetic. Known for being meticulously detailed and beautifully crafted, the architecture is a synthesis of each client's programmatic requirements, site constraints and budget. "Our office believes that architecture must break from unnatural and unhealthy imitation," Gurney explains. He eschews synthetic materials such as plastic, styrene and foam, believing this artificiality "greatly compromises our sensual gratification and ecological awareness." His firm instead advocates natural materials and efficient space planning, while emphasizing a connection to the environment with ample light, views and ventilation.

Gurney's design process is interactive. Each design begins with an in-depth discussion of the client's program and a thorough evaluation of the project site. He does not want to see clients' clippings or photographs of other projects; instead he learns about their likes and dislikes through listening. By working closely with clients, the architect is able to understand their spatial needs and lifestyles. Gurney is not averse to sitting for hours around a client's kitchen table, discussing design or taking the time to appreciate each client's daily routine so that he can enhance or adjust the scheme to meet his or her goals. The personal

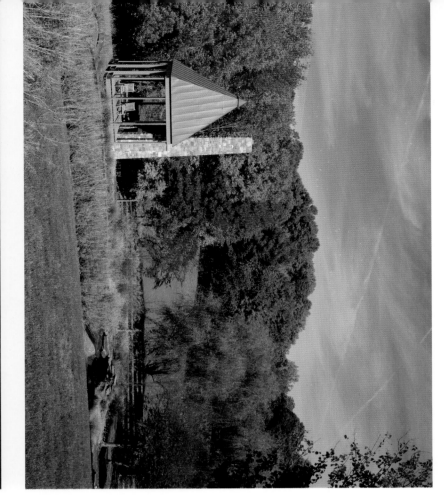

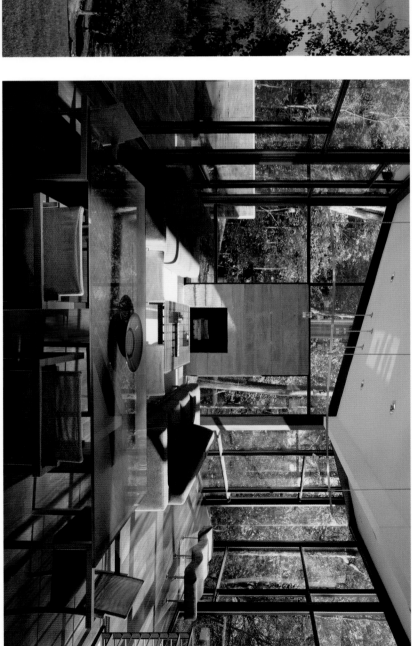

project requirements are merged with a response to the environment, whether rural or urban, to be sure content and context align. The design is refined until both Gurney and his clients are satisfied. "I'll never show anything I don't love," Gurney says. But he adds, "At the end of the day, we all have to love it."

Known for spending a considerable amount of time on project sites, Gurney and his staff remain committed to their designs throughout construction. Always sensitive to how its buildings are put together, the firm builds models and constructs full-size replicas of key building elements to ensure their level of detailing is accurate. The staff works closely with its team of metal, stone, and glass craftspeople and carpenters to ensure their designs are executed as precisely as conceived.

Gurney's award-winning "Pavilion at Water's Edge" in Great Falls, Virginia, is an elegant example of the firm's philosophy. Regardless of scale or budget, every project is exceptionally detailed and carefully balances site and programmatic requirements. The garden pavilion is a simple form in the landscape, open

ABOVE: Hargrave residence, Glen Echo, Maryland.
ABOVE LEFT: Pavilion at Water's Edge, Great Falls, Virginia.
LEFT: Occoquan River House, Occoquan, Virginia.
FACING PAGE: Corvasce | Goldstein residence, Washington, D.C.
Photography by Anice Hoachlander/HDPhoto

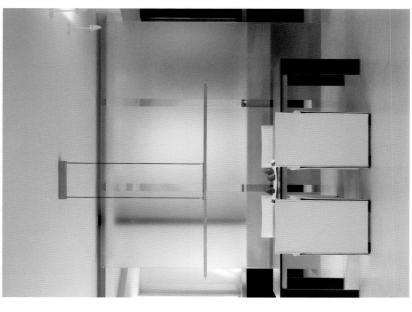

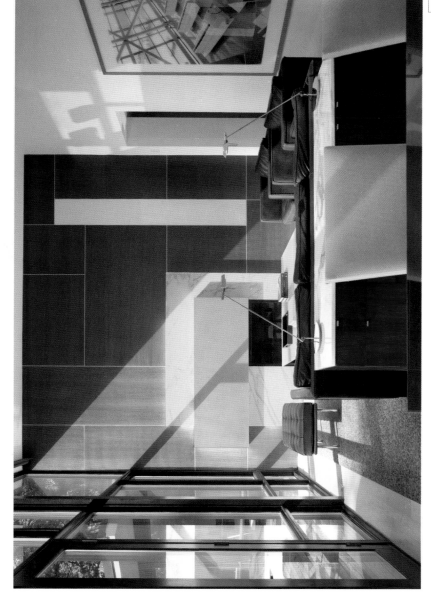

to experience views of a nearby pond and a five-acre rural site. A massive stone fireplace anchors the building to the ground and creates an interior focal point. Within a small footprint, the building allows for inward gathering or outward contemplation. Its fine craftsmanship and design were acknowledged with a 2006 Washington, D.C., AIA Residential Award and *Custom Home* magazine's Grand Award.

The office of Robert M. Gurney has earned more than 100 local, national and regional design awards, including an AIA National Honor Award, three AIA National Housing Awards and residential design awards from the Washington, Baltimore, Virginia Society and Northern Virginia Chapters of the AIA. The firm's work has been published extensively in several books, magazines and newspapers. *Architectural Record, ArchitectureDC, Residential Architect, Inform* and the *Chicago Tribune* are just a sampling of the prestigious publications that have covered Gurney projects in recent years. In 2006, the firm was the top vote-getter in *The Washingtonian* magazine's list of top architects and remodelers as selected by its peers.

Begun in 1990, the office of Robert M. Gurney includes a staff of five architects who share a passion for design. Gurney's leadership style is hands-on, and the firm's small dynamic permits everyone's involvement on all projects. They have designed houses along the East Coast from Falmouth, Maryland, to North Carolina, with the majority of work centralized in the greater Washington, D.C., region, including Maryland and Northern Virginia. Each residence is completely custom and site-specific, resulting in a portfolio of dramatically different works that respect their historical, topographical and regional contexts within a contemporary vocabulary.

TOP LEFT: Ontario apartment, Washington, D.C.
Photograph by Maxwell MacKenzie

TOP RIGHT: Ontario apartment, Washington, D.C.
Photograph by Maxwell MacKenzie

BOTTOM RIGHT: Corvacse I Goldstein residence, Washington, D.C.
Photograph by Anice Hoachlander/HDPhoto

FACING PAGE: Hargrave Residence, Glen Echo, Maryland.
Photograph by Anice Hoachlander/HDPhoto

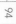

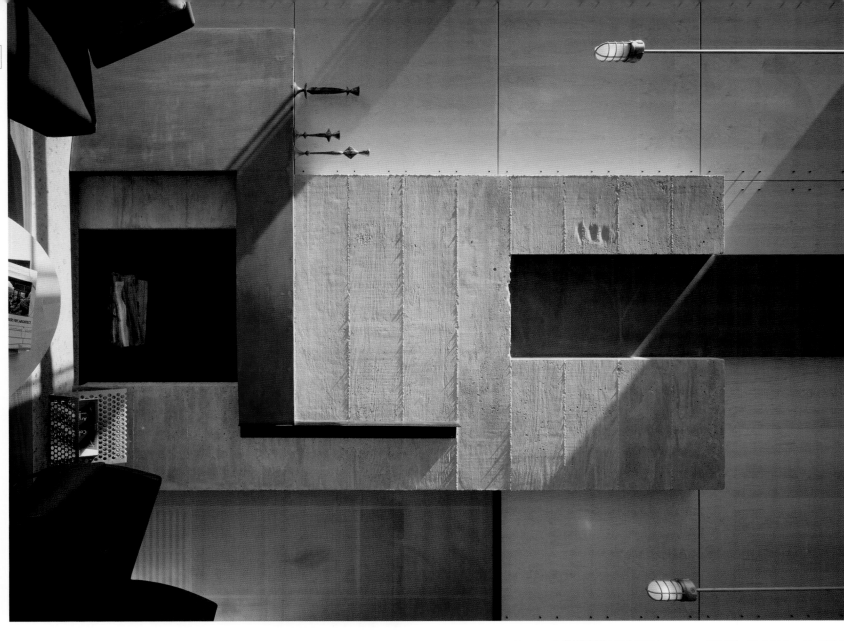

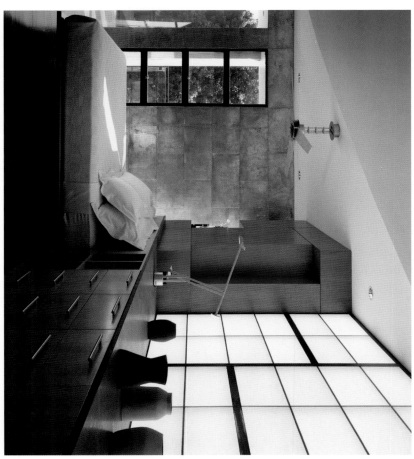

Many of Gurney's projects include the interior design expertise of his wife, Therese Baron Gurney, ASID. She shares her husband's sense of rigor and order, and works within a similar modern design language. "She makes my projects better," Gurney explains. Her seamless integration of interior design and furnishings within his architecture creates cohesive and unified compositions.

As the figurehead of such a well-respected and honored firm, Robert Gurney is modest about his personal background. He earned Bachelor of Science in Architecture and Master of Architecture degrees from Catholic University. He has served as a member of the AIA Northern Virginia Chapter Board of Directors, Design Committee, Schools Connection Committee and the Virginia Society State Design Committee. Gurney is a founding member of the Congress of Residential Architects and is a current member of the VSAIA Honors Committee. He regularly sits as a guest critic on student design juries at Virginia Tech and Catholic University, and frequently hosts student interns. In recognition of his contributions to the profession, Gurney was elevated to Fellowship in the American Institute of Architects in 2002.

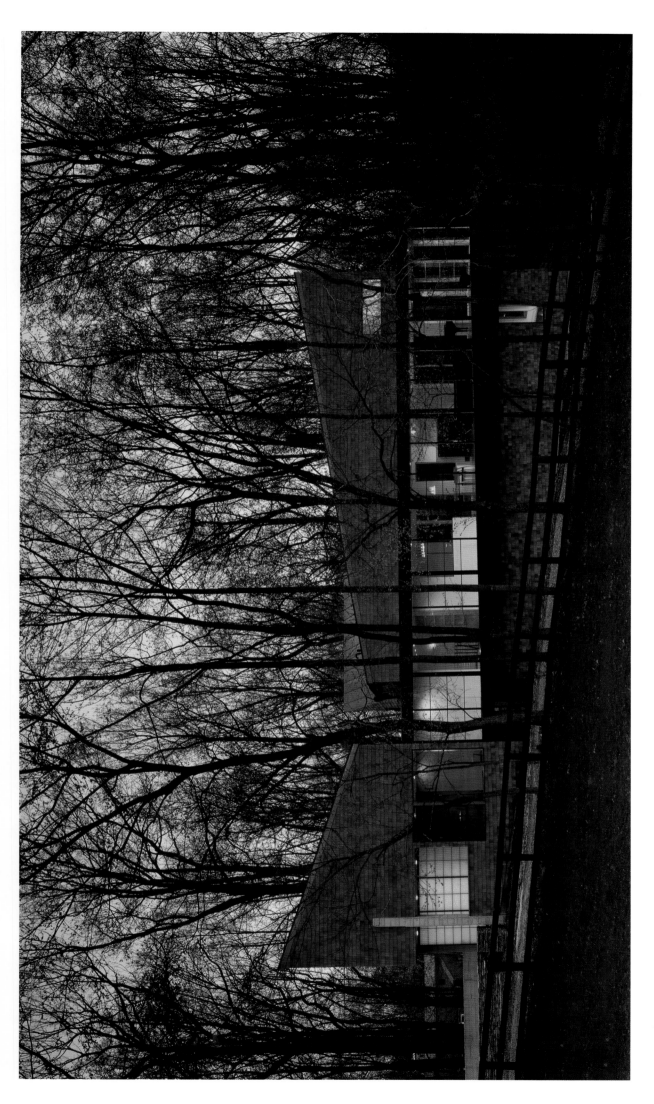

ABOVE: Packard | Komoriya residence, Potomac, Maryland.
Photograph by Anice Hoachlander/HDPhoto

FACING PAGE LEFT: Calvert Street residence, Washington, D.C.
Photograph by Paul Warchol

FACING PAGE RIGHT: Calvert Street residence, Washington, D.C.
Photograph by Paul Warchol

Robert M. Gurney, FAIA, Architect

Robert M. Gurney, FAIA
113 South Patrick Street
Alexandria, VA 22314
703.739.3843
www.robertgurneyarchitect.com

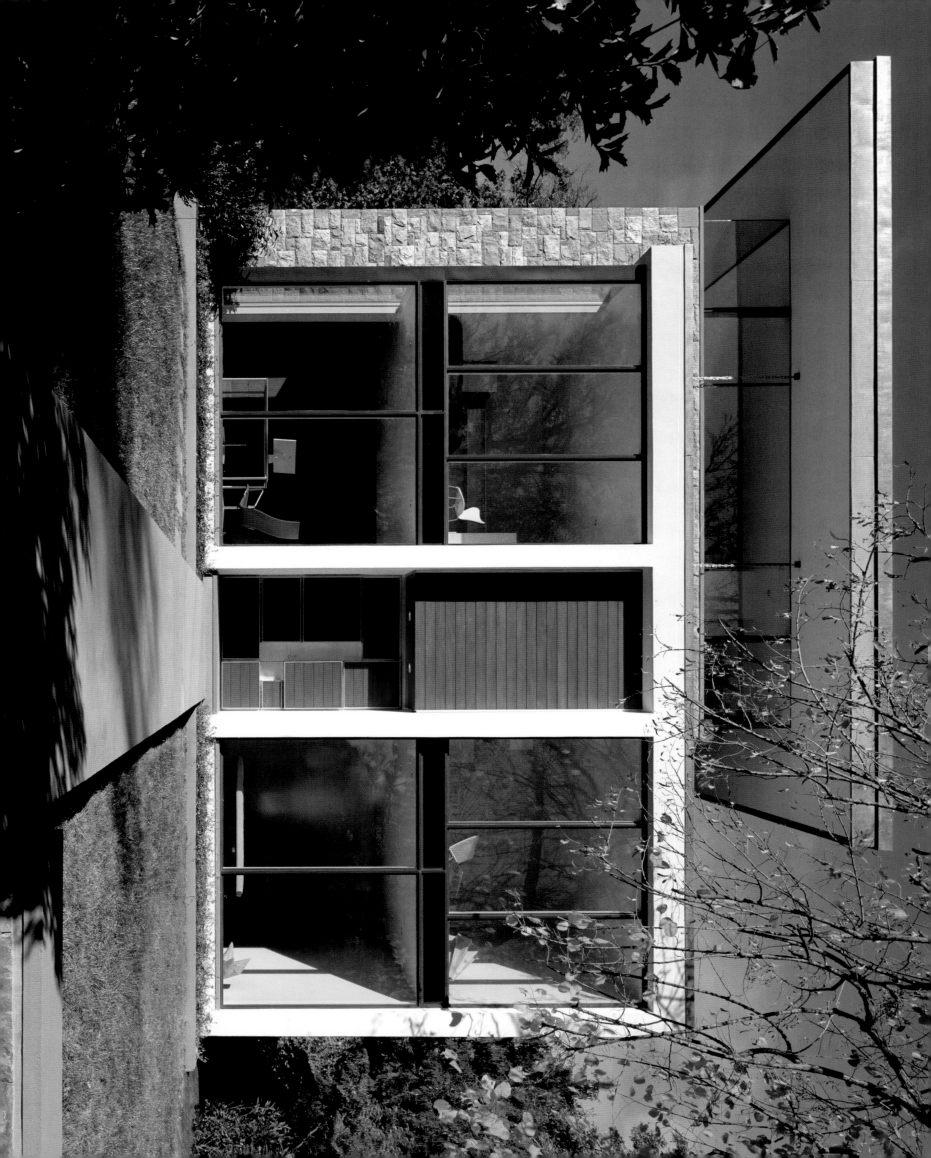

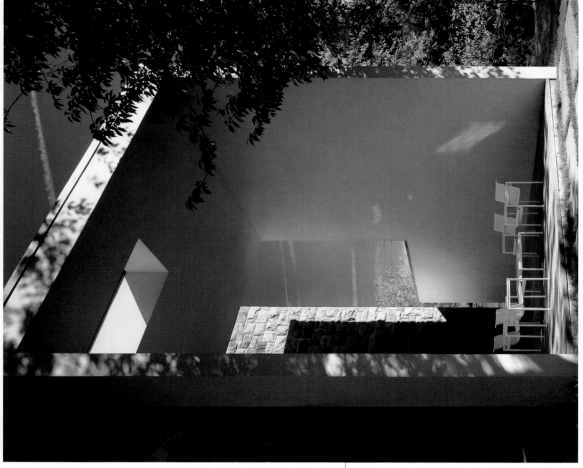

ABOVE: Calem Rubin residence, back exterior.

FACING PAGE: Calem Rubin residence, front elevation.
Photography by Paul Warchol Photography

DAVID JAMESON

David Jameson Architect, Inc.

In only 10 years, David Jameson has built his practice into one of the leading architectural design firms in the greater Washington, D.C., region. Clients seek out Jameson for his award-winning modernist design vision. The breadth of his work illustrates his response to the unique requirements of each project.

Each project begins with an investigation of the environmental context. A clear connection to the land is executed through architectural elements and materials carefully chosen to reinforce that relationship. Authenticity and sustainability are critical to Jameson, who has effortlessly integrated Green design principles into his projects. He often selects natural materials such as metal and stone for durability and life span. Additionally, he explains that environmental consciousness extends beyond finish materials. "We think about where products are made and the distance and energy consumption required in transporting those materials to the site." For him, sustainability is about examining the larger picture and making projects environmentally responsible on a long-term basis.

Jameson's work is grounded in artistic principles that give his architecture a sculptural feel. Light and shadow are key elements, and he employs devices such as brise soleils and light monitors to filter natural light—and the daily and seasonal changes it offers—deep within interior spaces. Jameson's favorite building

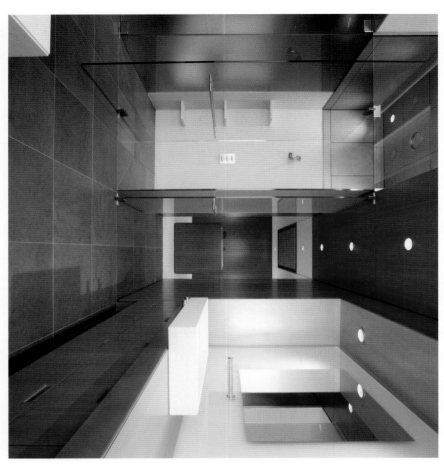

is the Pantheon in Rome, which he calls "a visceral experience of light and shadow."

Modern architecture's masters also provide inspiration for Jameson. He particularly admires Le Corbusier and Louis Kahn, and their influence is reflected in his work. His Eastern Market Rowhouse on Capitol Hill features a lantern-like glass and steel volume. The design for the Glenbrook residence features weighted forms juxtaposed with the weightlessness of glass. Jameson also admires the philosophy and writing of Viennese architect Adolph Loos, and the absence of ornament in Jameson's award-winning BTR house echoes Loos' philosophy. In each of Jameson's designs, there is a conceptual elegance that allows his architecture to balance the complexities of program, tectonics

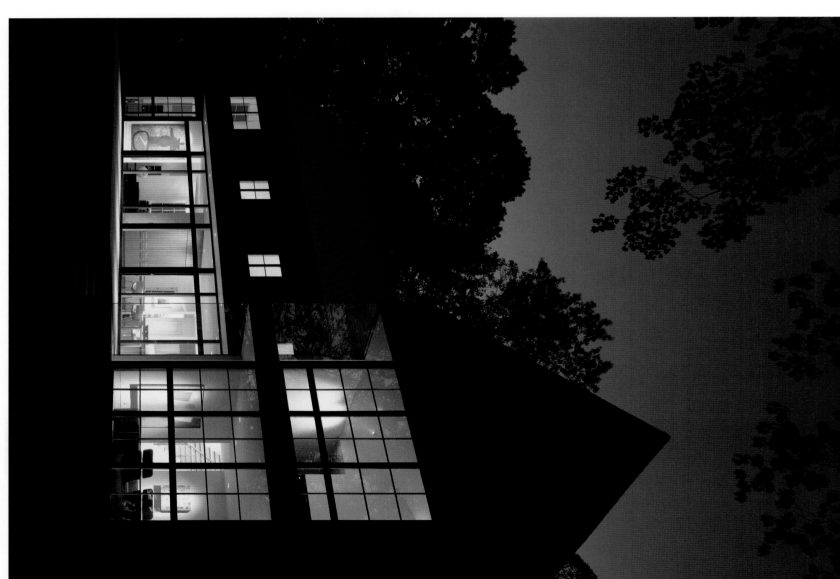

ABOVE: Simon Kuney residence, interior view.
Photograph by Paul Warchol Photography

RIGHT: Burning Tree residence, back exterior.
Photograph by Anice Hoachlander/HDPhoto

FACING PAGE: Spout Run residence, back elevation.
Photograph by Paul Warchol Photography

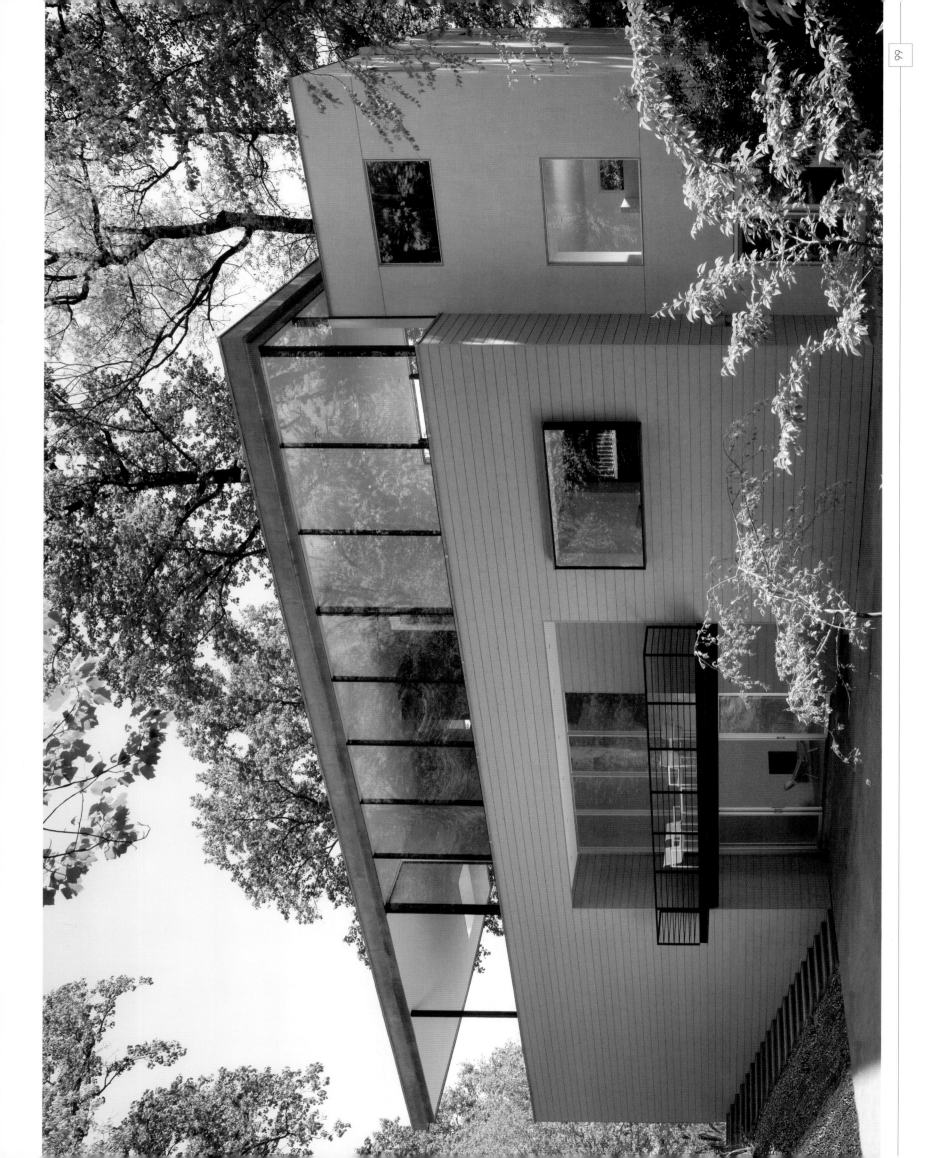

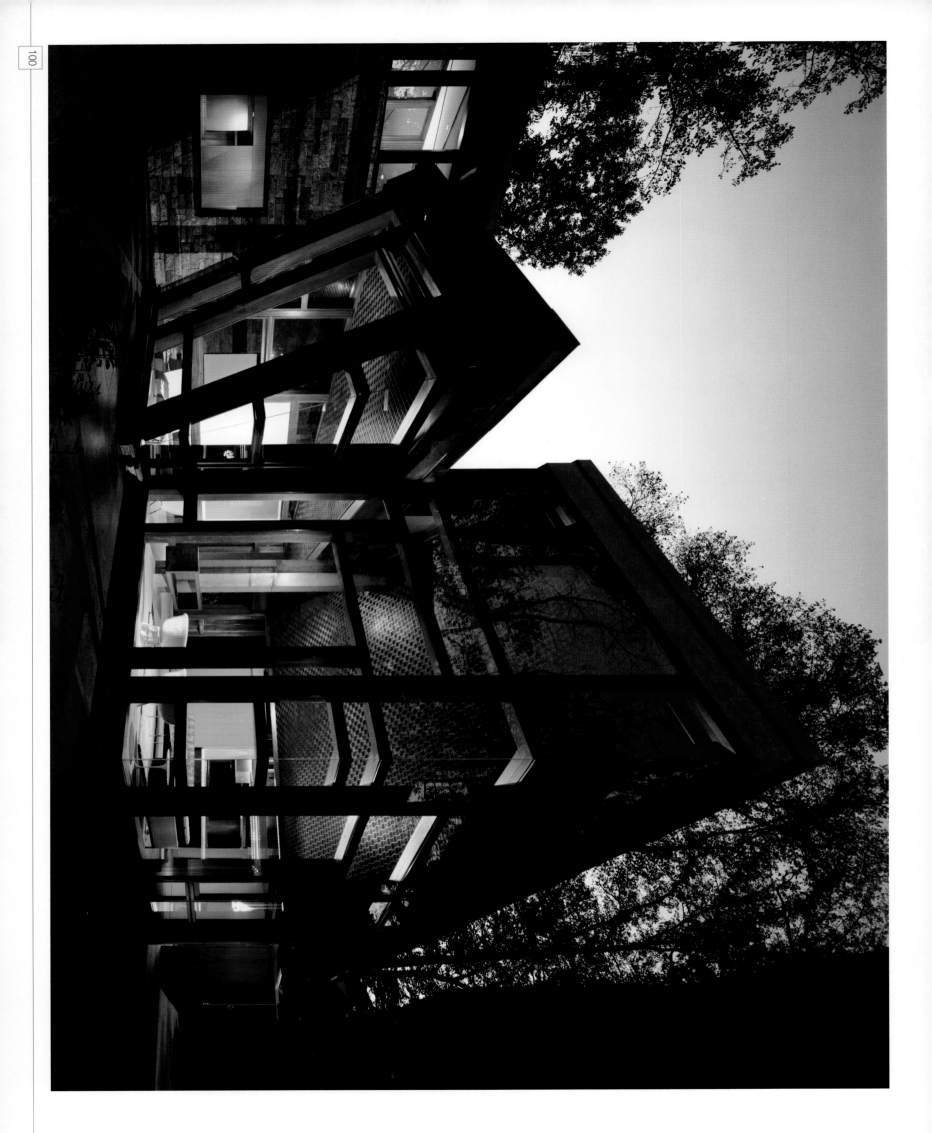

and materiality while maintaining clarity of form and function. Using minimalist forms and authentic materials, Jameson's designs are habitable pieces of art.

Jameson prefers to think of architecture as an art, rather than a business. He describes his work habits as rigorous and dedicates long hours to combining beauty with function. Meticulous attention to detail is one of his hallmarks, no matter the scale of the project, whether a 150-square-foot tea house or a 15,000-square-foot residence. "I approach every project with the same level of care, and I am relentless in my work. Design isn't an occupation; it's a passion," he says.

Jameson's work has been published in more than 100 national and international design publications, including *Architectural Record, House Beautiful, Metropolitan Home* and *Residential Architect* in the United States, and magazines in Italy, Ireland, Hong Kong, New Zealand and Russia. He has been covered regionally in *The Washingtonian* and *Baltimoire* magazines, *The Baltimore Sun, The Alexandria Gazette* and *The Washington Post.* More than 70 design awards attest to Jameson's creativity and commitment to design excellence. In 2006, he received the prestigious American Architecture Award from the Chicago Athenaeum Museum of Architecture and Design.

TOP RIGHT: Glenbrook residence, front elevation.

BOTTOM RIGHT: Glenbrook residence, interior view.

FACING PAGE: Glenbrook residence, exterior view.
Photography by Paul Warchol Photography

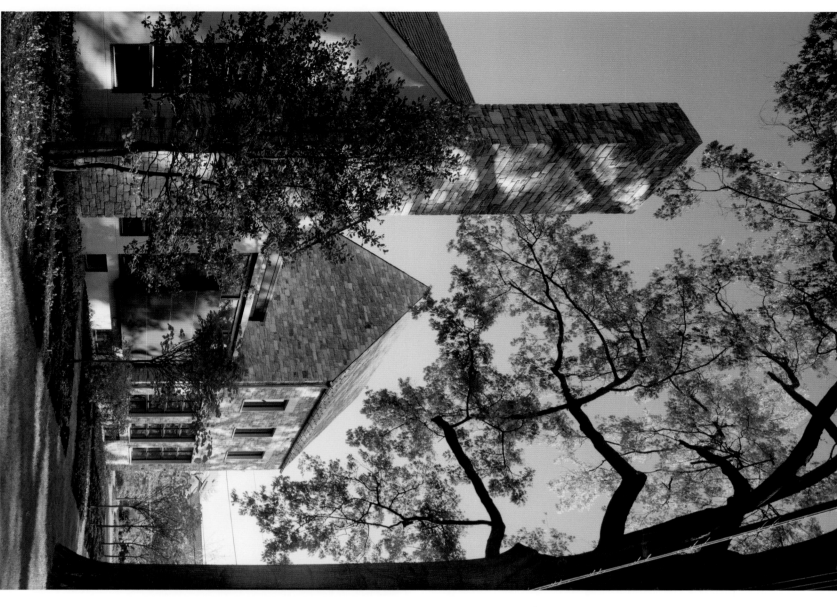

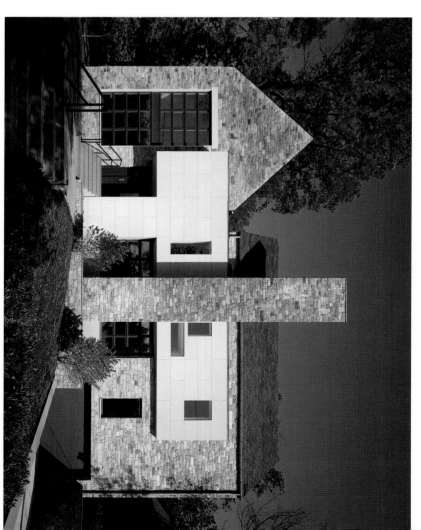

Becoming an architect was Jameson's childhood dream, and architecture has always been a driving force in his life. He received a Bachelor of Architecture degree from Virginia Tech and became licensed 12 years ago. Virginia Tech honored him with the 2004 Outstanding Alumnus Award. He founded David Jameson Architect in 1997 and today has five employees. His wife oversees the business side of the practice, allowing Jameson to concentrate on design and project management. He is active in the American Institute of Architects, serving as a Board member for the Northern Virginia Chapter. In 2004, the AIA bestowed its coveted national Young Architect's Award on Jameson, and in 2007, he was elevated to the AIA's College of Fellows, both in recognition of his design contributions to the profession.

ABOVE: Edgemoor residence, front elevation.
Photograph by Michael Moran Photography

LEFT: Edgemoor residence, exterior view.
Photograph by Michael Moran Photography

FACING PAGE LEFT: Eastern Market rowhouse, exterior elevation.
Photograph by Anice Hoachlander/HDPhoto

FACING PAGE RIGHT: BTR, exterior view.
Photograph by Paul Warchol Photography

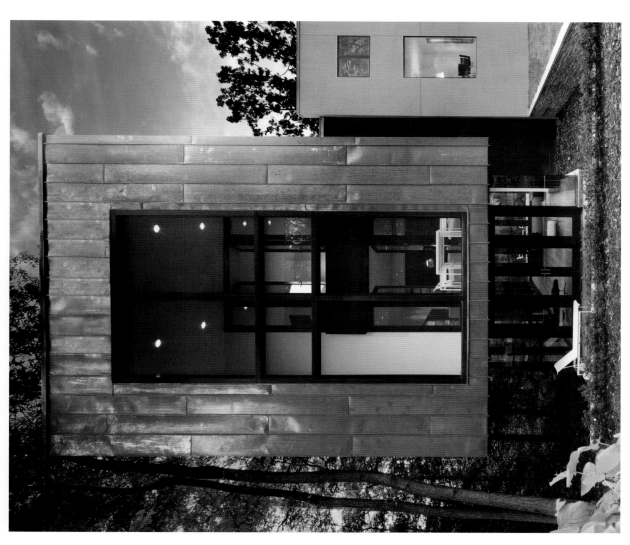

David Jameson Architect, Inc.
David Jameson, FAIA
113 South Patrick Street
Alexandria, VA 22314
703.739.3840
www.DavidJamesonArchitect.com

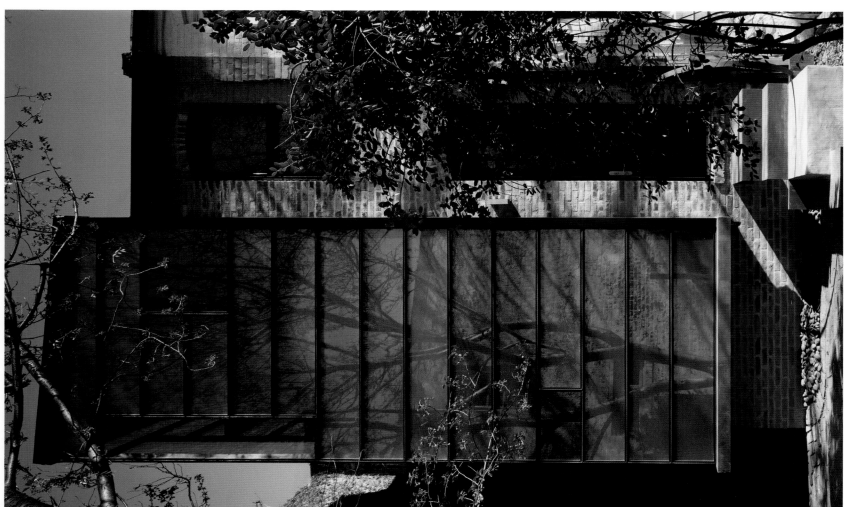

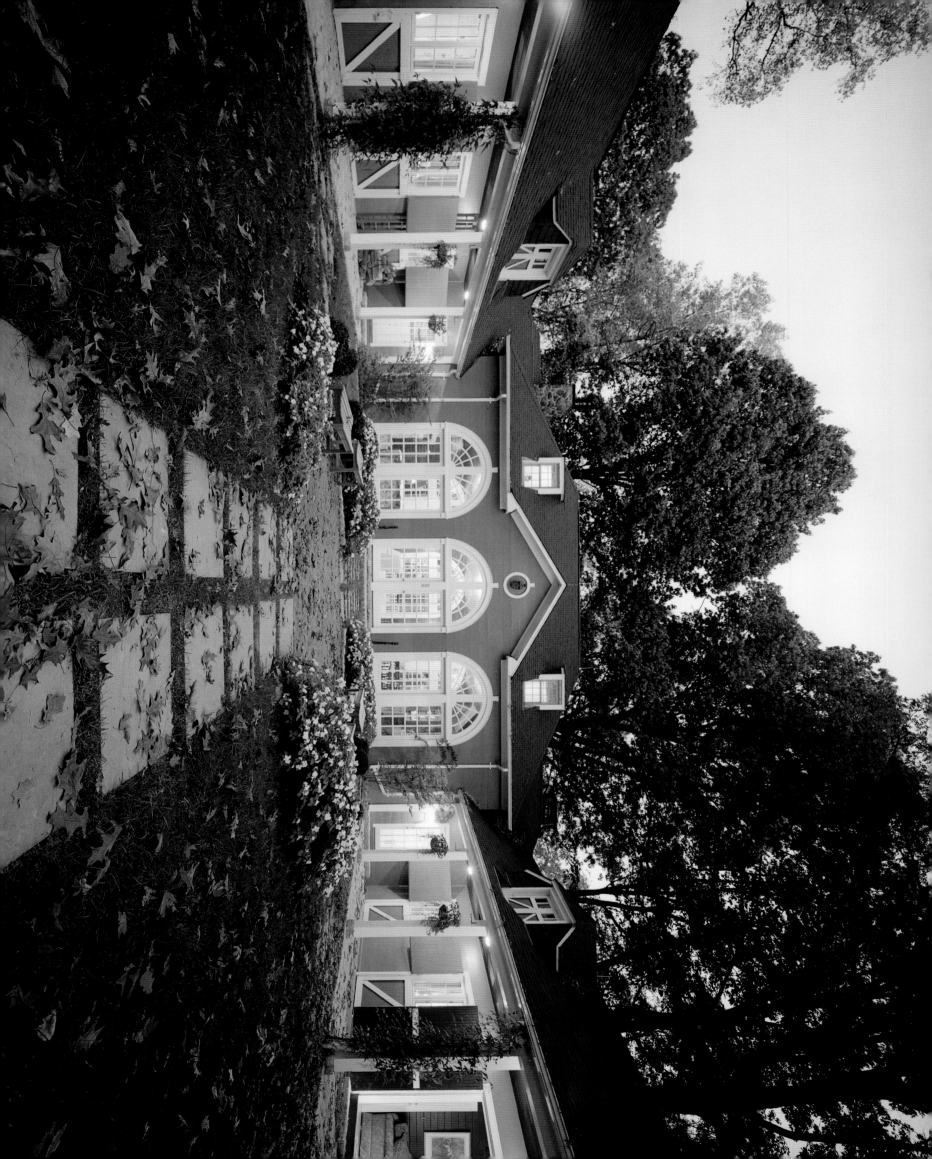

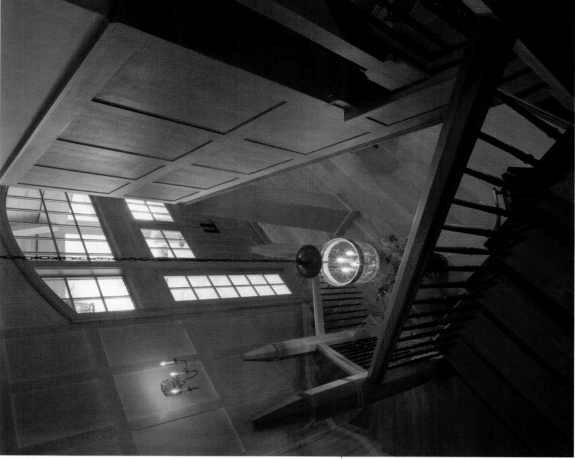

ABOVE: This custom estate foyer was constructed entirely of quarter-sawn white oak finished in lime, custom newel posts and wrought iron pickets.
Photograph by James Ritchie

FACING PAGE: This historic carriage house was converted into the renowned Goodstone Inn. The original stalls were transformed into guest rooms. The original stable doors were left intact and retrofitted with custom casement windows.
Photograph by James Ritchie

MARK KOHLER
WILLIAM FLETCHER
THOMAS FLACH

Kohler Associates Architects
Kohler Homes, Inc.

With a 40-plus-year legacy of design excellence and quality craftsmanship, Kohler Associates Architects and its sister construction company, Kohler Homes have proven how an integrated design and construction process and a commitment to community service and the environment go hand in hand. "We are architects and builders who share in our clients' passion for well-crafted architecture as a way to enhance quality of life," explains Mark Kohler. As the president of both firms, he works, along with vice presidents Bill Fletcher and Tom Flach, to continue the work of his father, Karl Kohler, who began the company in 1963.

The Kohler name has become synonymous with its seamless design-build approach. A commitment to quality, integrity and client service ensures clients become "clients for life."

Kohler Associates designs houses across a range of styles and locations. "We love the opportunity to design for unique sites, from Skyline Drive with views of the mountains to waterfront homes along the Potomac River, Chesapeake Bay and Delaware beaches," says Flach. "We try to work within the context of the existing neighborhoods," adds Kohler. From Craftsman-style bungalows to minimalist contemporary houses, the aesthetics may change but the commitment to appropriate detailing remains consistent.

As designs are developed, the construction phase of a project begins. Kohler Homes—a Class-A-licensed contractor—builds most projects designed by Kohler Associates. "We believe that well-crafted architecture is achieved through the collaborative efforts of a team, including the client, the architect and the builder," explains Kohler. Accurate construction pricing is generated from day one, while a single point of contact keeps communication open. Clients gain peace of mind knowing their designs will be executed to perfection.

Permeating every design is the Kohler dedication to Green architecture. "Kohler Homes makes it a top priority to actively promote sustainable building methods and architectural designs with both employees and clients," says Kohler. From tree preservation, responsible demolition methods, use of environmentally

ABOVE: This estate home was designed to look like a turn-of-the-century lodge by using stone, stucco, steep slate roofs, custom ironwork and quarter-sawn oak throughout. This beautiful rear elevation overlooks terraces, multiple pools and waterfalls.
Photograph by James Ritchie

ABOVE LEFT: With its red board and batten siding, standing seam metal roofs and simple structures, this retreat home was designed to blend with its Shenandoah Valley setting.
Photograph by James Ritchie

LEFT: This home's dramatic new rear elevation, including an addition of a new master bedroom and expanded kitchen/living area, flawlessly integrates the new with the old.
Photograph by James Ritchie

FACING PAGE: This new elegant stone addition blends seamlessly with its historic counterpart while overlooking a beautiful negative-edge pool.
Photograph by James Ritchie

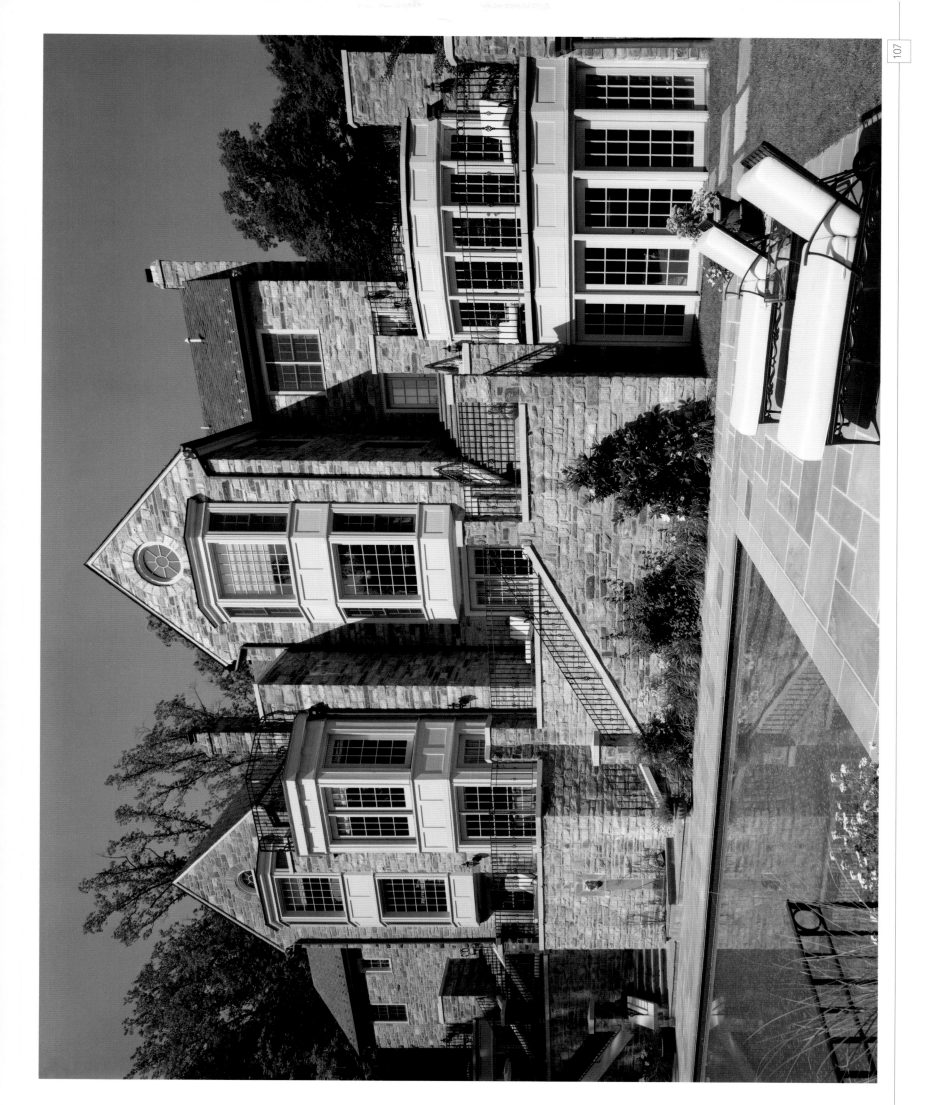

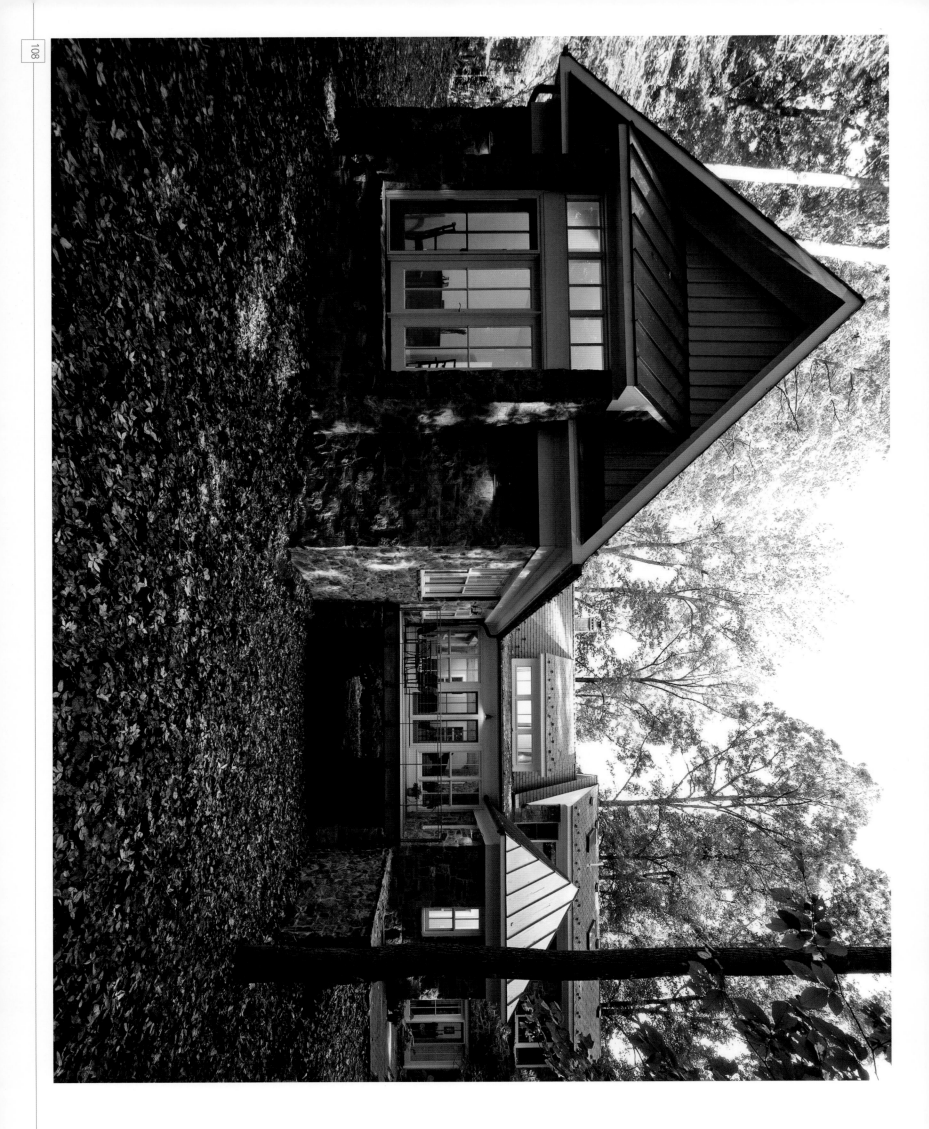

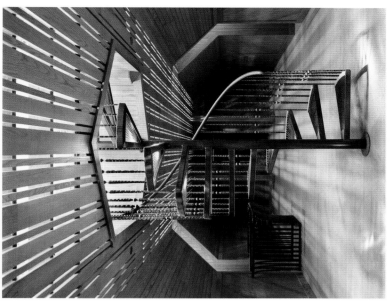

friendly building materials and incorporation of alternative mechanical systems and superior insulation, to Green office practices such as recycling and energy-efficiency, Kohler practices what it preaches. "We are constantly evaluating new products and processes to educate ourselves and our clients," Kohler describes.

In addition to its environmental commitment, the Kohler firms are leaders in community service. Kohler Homes annually participates in the Rebuilding Together nationwide effort to revitalize houses for low-income homeowners. The firm is also an active financial and volunteer contributor to Habitat for Humanity, the Fannie Mae Foundation Help the Homeless Program and a host of other local and national charities.

Strong firm leadership supports the Kohler reputation. Mark Kohler holds a Bachelor of Architecture degree from Virginia Tech and has practiced since 1984. He has served on the board of directors for the Metro D.C. chapter of the NARI and co-chaired its CotY Awards Committee. Fletcher holds the same degree from Virginia Tech and has practiced for 30 years. Tom Flach earned undergraduate degrees in economics and psychology from Vanderbilt University before obtaining a Master of Architecture from Virginia Tech in 1992. He has 15 years of professional experience.

Kohler Associates and Kohler Homes have been published more than 50 times, in *Home & Design*, *Qualified Remodeler*, *The Washingtonian*, *Southern*

TOP LEFT: Stone from the existing carriage house exterior wall was exposed and complemented with the home's recycled white oak beams to give the home's interior a warm and rustic appearance.
Photograph by Greg Hadley

TOP RIGHT: The slatted wood ceiling of this second-story barn loft permits both light and ventilation. The spiral stair allows access from the stable's second-floor loft to the top of the cupola, providing a vantage point of the entire estate.
Photograph by James Ritchie

BOTTOM RIGHT: This elegant stable, constructed of stone, red oak and Vermont slate, was designed with the latest technology, including an electronic water-monitoring system, sprinkler systems, built-in computer monitors and a complete lutron system operated by LUI screens.
Photograph by James Ritchie

FACING PAGE: This striking addition spans an existing swale as a sustainable solution to preserve the natural drainage of the site.
Photograph by Greg Hadley

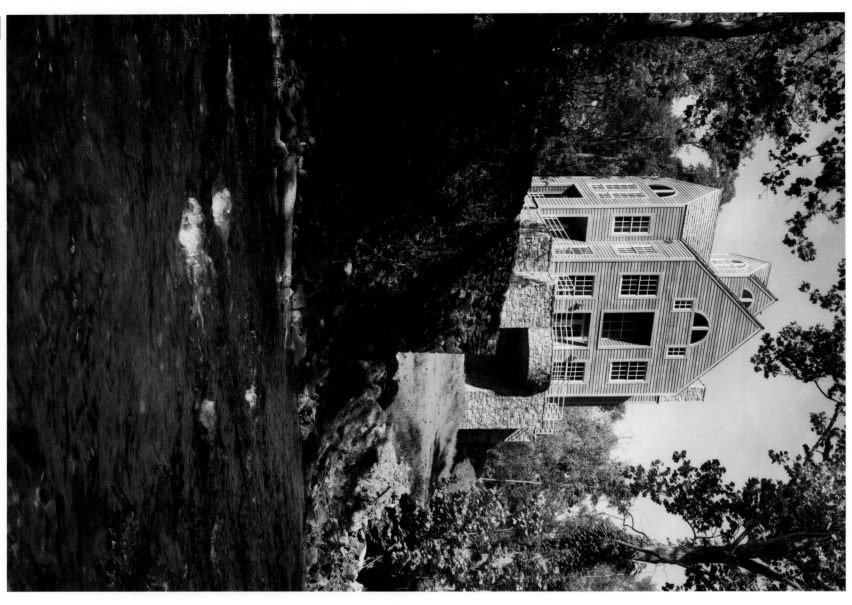

Accents, Chesapeake Home, Spaces, Southern Living, Builder, Country Living, The Washington Post, LA Times Magazine and others. The firms have also earned more than 55 design awards, including ranking as one of the region's top 30 remodelers by The Washingtonian. In 2005, a Kohler project earned the Fairfax County, Virginia, Tree Preservation Award for its work to preserve and protect trees during construction; Kohler Homes remains the only residential construction firm to ever receive this honor.

With a shared respect for collaboration, environmental responsibility and community service, Kohler Associates and Kohler Homes prove that quality and value can be combined as seamlessly as design and construction.

ABOVE: Renovation and additions transformed this 1980s' contemporary into a memorable and beautiful cottage in the woods.
Photograph by Greg Hadley

FACING PAGE LEFT: This mill house overlooking the Shenandoah River recalls the original mill that once stood in its place with its stone, horizontal cedar siding and cedar shake roof.
Photograph by James Ritchie

FACING PAGE RIGHT: The mill house interior is visually anchored by a central stair rising three stories to a cupola. The floor of the cupola consists of steel grating, enabling light to filter through the house, as well as allowing ventilation, thus passively cooling the home.
Photograph by James Ritchie

Kohler Associates Architects
Kohler Homes, Inc.
Mark Kohler, AIA
William Fletcher
Thomas Flach, AIA
5206-B Rolling Road
Burke, VA 22015
703.764.1200
www.kohlerhomes.com

ABOVE: Boulders surround the pool space of this Little Falls home; the main house pavilions look out to the Potomac River and beyond.
Photograph by Anice Hoachlander/HDPhoto

FACING PAGE: This Little Falls pool house boasts large glass doors, which retract to connect the spa to the pool and landscape.
Photograph by Anice Hoachlander/HDPhoto

RANDALL MARS

Randall Mars Architects

Modern master Mies Van der Rohe's famous aphorism "less is more" has made its way into popular culture. However, it remains the root of many architects' design philosophies, among them McLean, Virginia-based Randall Mars. He is fond of rephrasing, "less is more (more or less)," when describing how his firm reduces designs to their essentials, clearly expressing function through familiar—not necessarily abstract—forms. Mars shares Mies' penchant for rational architecture with light, open and airy qualities, yet is capable of incorporating it into homes with traditional characteristics. "Often, our designs are understated," Mars describes. "Modern architecture does not have to be a bold statement to be beautiful."

Mars has practiced for 29 years, the last 18 of which have been with his own four-person firm, Randall Mars Architects. He earned master's and bachelor's degrees from the University of Florida and has served on the boards of directors of the state and local chapters of the American Institute of Architects. He is currently one of three vice presidents of the Northern Virginia chapter of the AIA. He also teaches a course on interior design at Marymount University and has participated on his synagogue's building committee.

Mars' combination of practice, teaching and leadership gives him an interesting perspective. He is passionate about architecture and enjoys sharing it with others. "To work in a profession which results in such a substantial physical product experienced by so many people is very special," he describes. He maintains close relationships with clients, keeping them highly involved throughout the design process. "We are sensitive to the way our clients use their homes and create very livable responses to their programs." He believes it is not necessary to begin with an extraordinary concept to achieve extraordinary results. And his clients appreciate this level of patience and detail, exemplified by a client who called Mars to acknowledge he was "still discovering design elements every day."

Randall Mars Architects has won AIA Design Awards at the state and local level, and national awards from *Residential Architect* and *Builder* magazines. Mars' most gratifying achievement was when the firm's entry—one of more than 2,400 from across the country—earned semi-finalist status in the 2004 Pentagon Memorial Competition. His work has been praised for its spatial and environmental connections—within homes and to their landscapes—and for compositions that carefully balance economies of scale and budget with elegant aesthetics. Projects have been covered in *Builder, Custom Home, House Beautiful, Home & Design, Southern Living* and *Home* magazines. When he describes his own work, Mars says, "It doesn't shout." Instead, through its modest modernity, it leaves a much more lasting impression.

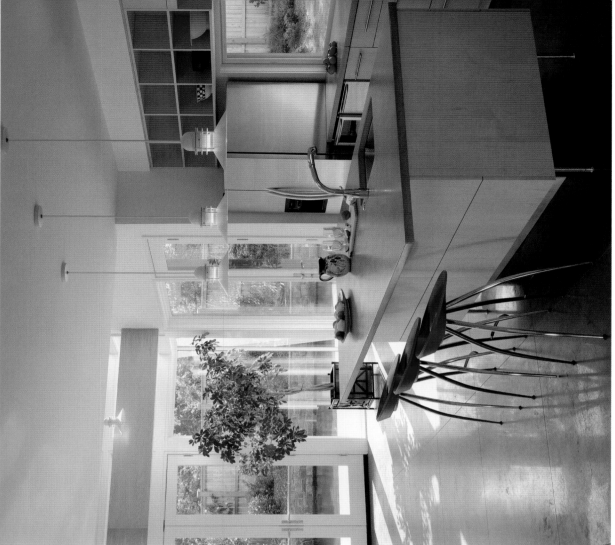

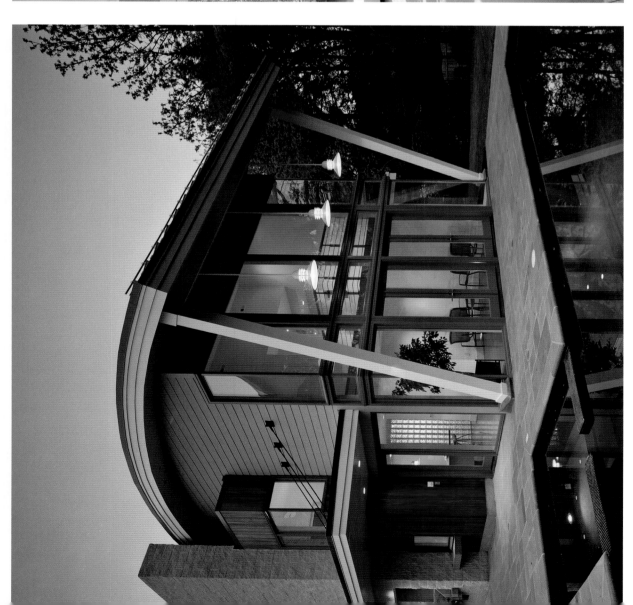

ABOVE LEFT: A vaulted metal roof provides shade and cover for the pool and guest house.
Photograph by Anice Hoachlander/HDPhoto

ABOVE RIGHT: The kitchen of this pool and guest house was designed for entertaining and has wonderful views of the pool and waterfall beyond.
Photograph by Anice Hoachlander/HDPhoto

FACING PAGE LEFT: Passing under a stately weeping oak tree, solid concrete block walls flank the glass window wall at the entry of this Vienna residence.
Photograph by Randall Mars

FACING PAGE RIGHT: Located in Vienna, the home's living room shares the great vaulted living space with the kitchen, which is beyond the partial-height wall. The fireplace surround, hearth and mantel are custom-cast concrete.
Photograph by Anice Hoachlander/HDPhoto

Randall Mars Architects
Randall Mars, AIA
6708 Old McLean Village Drive
McLean, VA 22101
703.749.0431
www.randallmarsarchitects.com

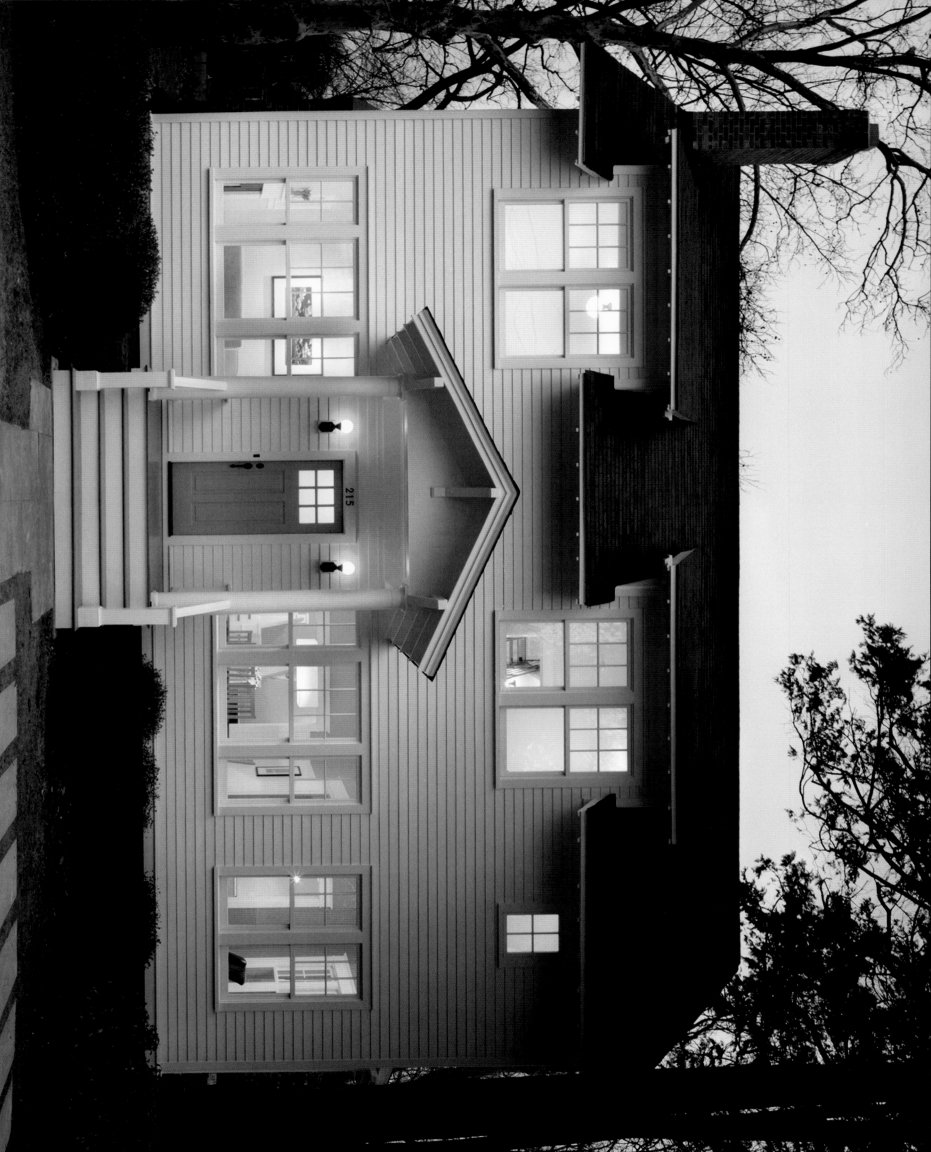

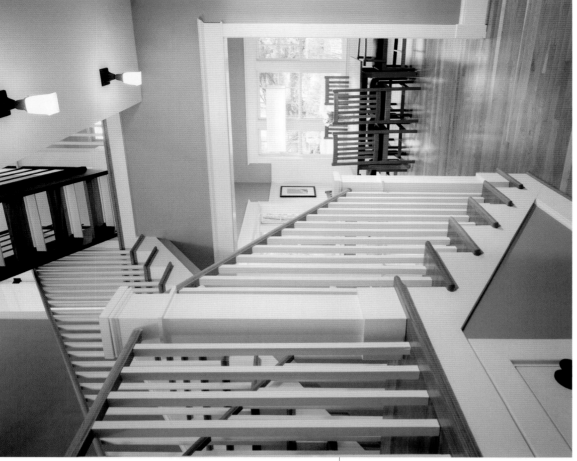

ABOVE: Falls Church addition-renovation; new central stair hall with steel-and-wood stair to third-floor study, showing the juxtaposition of traditional and modern detailing.
Photograph by Anice Hoachlander/HDPhoto

FACING PAGE: Falls Church addition-renovation, front elevation; new seamless second-floor addition on existing renovated 1920s' cottage.
Photograph by Anice Hoachlander/HDPhoto

CHARLES M. MOORE

Moore Architects, PC

People often tell architect Charles Moore that they can recognize his firm's work. They are not noticing a signature style or aesthetic similarity; instead, people are drawn to Moore's well-detailed houses that balance outstanding design with practical functionality. Accented by color and organized for contemporary lifestyles, the homes designed by Moore Architects respect their context and the lifestyles of their occupants, making the designs equally as appropriate the day they are completed as they are 10 years later.

The firm designs new houses, additions and renovations, balancing the residential work with a small number of commercial and institutional projects. Moore explains that most of his residential clients are regular people who want their houses to fit the fabric of a traditional neighborhood. Yet, they also want the open, light-filled spaces characteristic of contemporary design. "We're not interested in reproducing old houses," Moore says, adding that houses of all ages need to be respected. Striking a balance, most of the firm's residential designs have a traditional exterior appearance with more modern interiors.

Clearly organized and interrelated spaces are hallmarks of Moore's work. "A great house should be easy to understand," he explains. Designs tend to incorporate many windows, to connect the indoors and

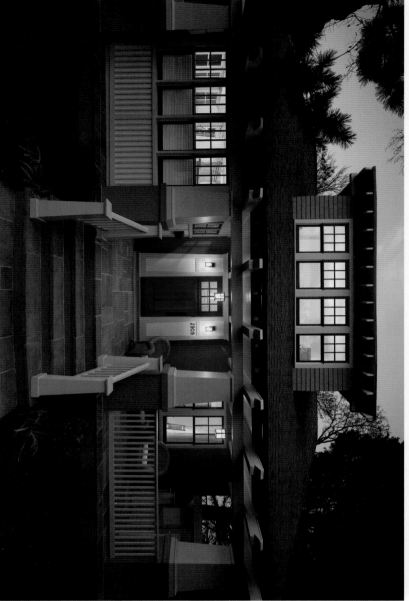

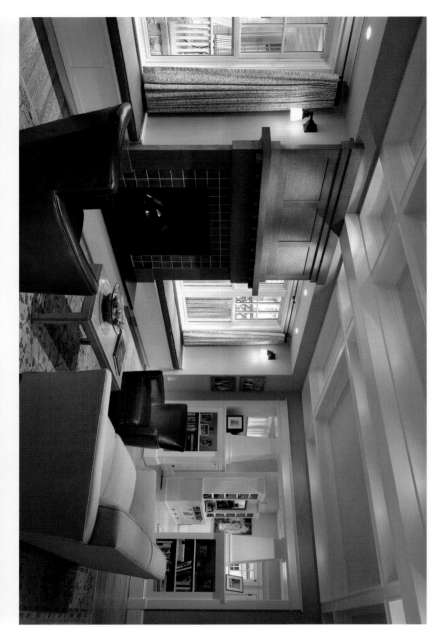

outdoors, offer changing views and maximize natural light. A recent bungalow renovation included 65 new windows, enhancing the home's character and brightening its traditional format.

While Moore sets the design direction for projects, he is quick to acknowledge the team effort of his six-person staff: Associate Jill Gilliland, RA; Sarah Farrell; Charles Warren, RA; Shamual Choudury; Chris Tucker and Susan Conway. The firm successfully manages up to 30 projects at any given time and has done work all across the country. "We like the excitement and dynamic of running different projects at once," Moore explains, crediting his staff. "They make it possible."

Moore Architects' work has earned awards from AIA Chapters in D.C. and Virginia, as well as from the Washington Architectural Foundation, Arlington County Historical Affairs and Landmark Review Board and *Southern Living* magazine. In 2006, Moore's renovation and expansion of the Historic Willow Oak Residence earned the AIA D.C. Award of Excellence for Historic Resources, and the firm was included on *The Washingtonian* magazine's list of top architects and remodelers as chosen by its peers. Projects have been featured in a full complement of national publications, including *Architectural Digest, Remodeling, Cottage Living* and *Fine Homebuilding.*

Charles Moore earned a Bachelor of Architecture degree from Virginia Tech and has maintained his own practice since 1989. He has been involved in his Falls Church, Virginia, community for 10 years as chair of its Historic Architectural Review Board and participates in numerous task forces relating to his town's design and preservation.

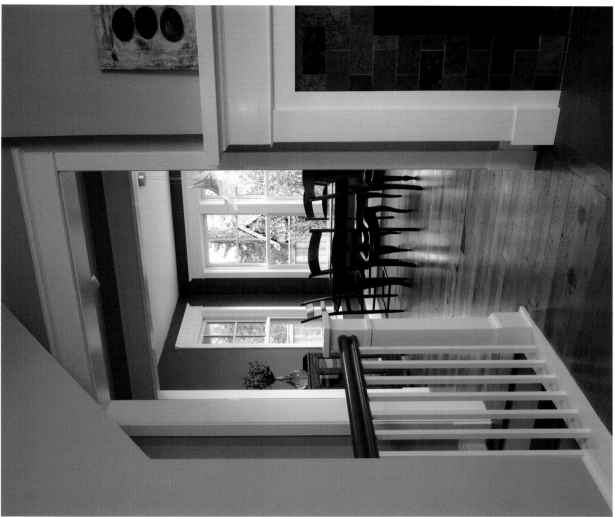

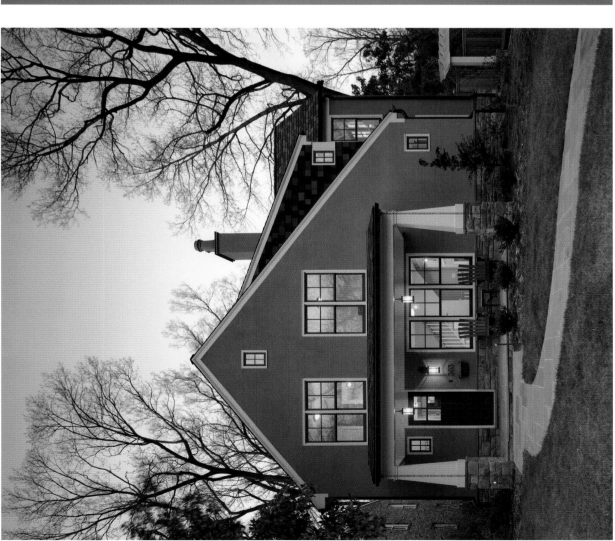

ABOVE LEFT: Virginia Avenue renovation, front elevation; a new front porch, stone base and dormers recast the odd salt-box as a charmingly elegant residence.
Photograph by Anice Hoachlander/HDPhoto

ABOVE RIGHT: Virginia Avenue renovation, interior; the layering of framed views guides the visitor through the residence.
Photograph by Anice Hoachlander/HDPhoto

FACING PAGE TOP: Cleveland Park addition-renovation; the living room's color, light and texture collaborate to create a special interior space.
Photograph by Prakash Patel

FACING PAGE BOTTOM: Cleveland Park addition-renovation, exterior; a celebration of the Craftsman icon: the front porch.
Photograph by Prakash Patel

Moore Architects, PC
Charles M. Moore, AIA
603 King Street, Third Floor
Alexandria, VA 22314
703.837.0080
www.moorearch.com

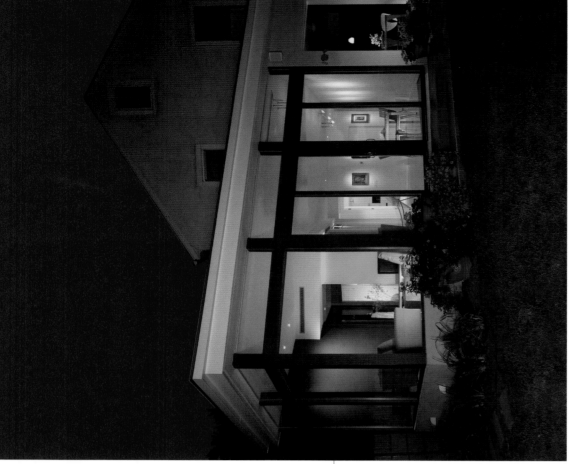

SUSAN WOODWARD NOTKINS

Susan Woodward Notkins Architects, PC
Goldfarb Notkins + more Architects, PLLC

"We love to work with light, lots of light from all kinds of sources. Light is the generator, a mediator of mood and a dynamic activator of place," says Susan Woodward Notkins, AIA. Her studio practice, Susan Woodward Notkins Architects, believes light is an important element in making houses feel timeless, comfortable and interesting. The studio does lighting design in-house to enhance and complement both the architecture and the lifestyle of each client. They use color to make spaces stand out or recede, and love to experiment with the surfaces between indoors and out. This connection to the outdoors permeates the firm's residential work, enlivening houses with natural light and outdoor vistas. "Every design decision has a reason, even if it is the joy of a whimsical move," Notkins explains, adding that the collaboration of her colleagues and clients leads to the best solutions of all.

"A choreography of the familiar and the surprising" is how influential teacher, author and architect Charles Moore liked to define architecture. Notkins had the opportunity to study under Moore, an architect known for his humanistic approach and belief that architecture should engage all of the senses. When Notkins founded her own practice in 1974, these beliefs shaped her design philosophy and approach.

Today, Notkins continues to operate her namesake firm, while partnering in its sister company, Goldfarb Notkins + more Architects. The two firms share one design studio, collaborating on projects with each other and their clients. "We are always thinking, not only about how places and spaces will work and be useful, but equally important, how they will feel," Notkins says, adding that how architecture "feels" is as important as how architecture "looks." Her goal is to make architecture that is soft-edged, clean-lined, full of delight, well-organized and very livable. Parts of the firm's fundamental principles of good, responsible design have always been sustainability, passive solar design and energy efficiency.

Critical to Notkins' process is an ongoing dialogue with clients. At the start of a residential design project, clients are asked to generate three lists: basic needs, reasonable aspirations and a wish list of dream amenities. They are encouraged to use as many adjectives as possible when describing their ideal home, from big and open, bright and light, to warm, intimate spaces. Armed with this list of priorities, Notkins and her team act as translators, creating a design that will support the lifestyle each

ABOVE LEFT: Opening the roof ridge with a 43-foot-long skylight enlivens this 1970s' contemporary with dynamic light patterns. The contrasting original exposed structure brings unique focus.
Photograph by Katherine G. Stifel

ABOVE CENTER: A new door between kitchen and dining floats as a gliding metal plane designed to reflect changing exterior and interior light as a functional sculpture.
Photograph by Katherine G. Stifel

ABOVE RIGHT: The curved ceiling soffit provides light, implies circulation and, backed by red cabinetry, makes a place for the buffet in this open apartment plan.
Photograph by Katherine G. Stifel

FACING PAGE: Angled deliberately for privacy from neighbors, this façade was opened to marvelous ravine views while enclosing calm shelter with opaque shades at night.
Photograph by Anice Hoachlander/HDPhoto

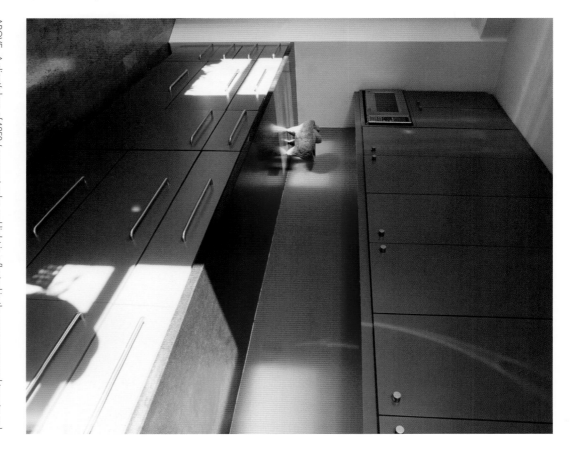

ABOVE: A client's love of 1950s' resonant color and light is reflected in the grass-green and tomato-red kitchen with black granite countertops and cork floor.
Photograph by Katherine G. Strifel

LEFT: Tall and narrow, a portico echoes trees in surrounding woods. Vertical slots, capturing views and changing light invite curiosity and signal entry.
Photograph by Katherine G. Strifel

FACING PAGE LEFT: A low-ceiling barn, 19-feet-square, was discovered inside a house while renovating. The original barn siding is revealed when surrounding shed ceilings are raised for light and height.
Photograph by Franklin & Ester Schmidt, F + E Schmidt Photography

FACING PAGE RIGHT: Stuccoed in the red color of the papaya from the client's country, Colombia, South America, a transformed fireplace is integrated with cabinetry and green slate materials repeated throughout the project.
Photograph by Anice Hoachlander/HDPhoto

124

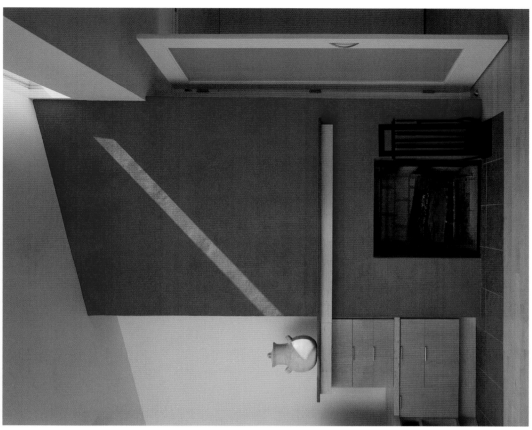

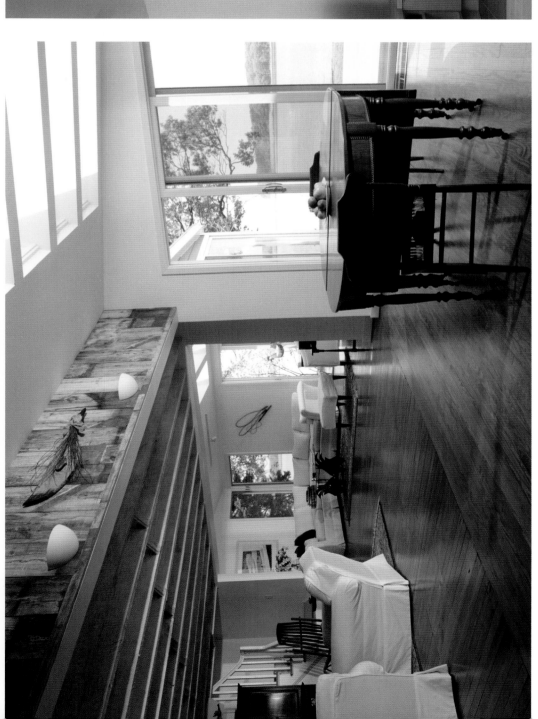

client is seeking. "We want to give them the house they dreamed about but didn't know they could have," she says, adding that the studio always works to provide more than the clients could imagine. The studio takes great pride in the fact that, with few exceptions, all of its hundreds of projects have been built as designed.

Commercial and institutional design is guided by the same principles that define the two firms' residential architecture. "We think about all projects the way we think about houses," Notkins explains, adding that after all, most adults spend more time in their offices and most children spend more hours in schools than at home. Why not design these spaces with the same comforts in mind? Noteworthy non-residential projects have included the Montessori School of Northern Virginia and office interiors for the *Chicago Sun-Times* in the National Press Building in Washington, D.C.

Notkins earned a Bachelor of Arts in politics before studying architecture, and she is an advocate of public service. In addition to serving as a member of the Fairfax County Architectural Review Board since the early 1980s,

she has served as a pro bono architect on community land use issues and as chairperson of the County's Telecommunications Task Force Design Committee. In this role, she has evaluated the impact of telecom towers and sought creative ways to blend them into the neighborhood context, including lobbying Congress and developing a model to be used nationwide. "I believe it's critical that architects get out of their offices and share their unique training and insights in the public arena," she adds. She is also involved professionally in the National Trust for Historic Preservation, Preservation Alliance, American Institute of Architects and has served in the Potomac Conservancy Land Trust Board, the Washington Area Architectural Group and National AIA Women in Architecture Committee.

Notkins' colleagues include Cheryl Guerin Copeland, AIA; Katherine G. Stifel, AIA, LEED® AP; and Elijah V. Gross, Associate AIA. Her partner in GN+m is Joanne Goldfarb, AIA.

Susan Woodward Notkins Architects and Goldfarb, Notkins + more Architects have earned Award of Excellence, Merit Award and Exceptional Design Award commendations from the American Institute of Architects chapters in Northern Virginia and Washington, D.C., and from Fairfax County. Projects have been featured in numerous publications such as *Inform*, *The Washington Post*, *The Washingtonian* and *Better Homes and Gardens*.

TOP LEFT: To strengthen connection to the landscape, walls open to ever-changing tidal marsh views with delicate glass and cable rails to look through, not at.
Photograph by Cheryl G. Copeland

BOTTOM LEFT: Dark, marsh-green paint tones make the wall seemingly disappear, enhancing the sense of living outside while remaining inside.
Photograph by Cheryl G. Copeland

FACING PAGE LEFT: The canopied entry, a processional passage through the landscape, provides cadence and strong movement, while masking the house's front wall from streets on this corner property.
Photograph by Eric A. Taylor Photographer

FACING PAGE RIGHT: A simple glass box, angled to thrust out to the river, alternately illuminated and shaded, provides a quiet retreat inside yet outside.
Photograph by Eric A. Taylor Photographer

Susan Woodward Notkins Architects, PC
Goldfarb Notkins + more Architects, PLLC
Susan Woodward Notkins, AIA
Joanne Goldfarb, AIA
1179 Crest Lane
McLean, VA 22101
703.243.1247
www.swn-architects.com

ABOVE: The entry pergola leads to a wood door, set in a stone wall. The glass entry hall beyond connects the living and bedroom wings and reveals the pasture beyond.
Photograph by Ron Blunt

FACING PAGE: The two wings of this modern farmhouse form a courtyard, defined by a terrace and an elevated lawn.
Photograph by Ron Blunt

ELIZABETH READER
CHARLES SWARTZ

Reader & Swartz Architects, PC

Elizabeth (Beth) Reader and Charles (Chuck) Swartz are principals of Reader & Swartz Architects. They equate their body of residential, commercial and institutional work to an extended family—appearances may differ, but shared relationships and traits exist within the whole. Deeply rooted in the conviction of "making where we live better," the firm designs projects that reflect an appreciation of context, a willingness to collaborate and a subtle sense of creative playfulness. "Architecture should have a spark," Swartz believes. The firm aims to incorporate this glimpse of personality, or soul, into every project.

Reader & Swartz is located in the Shenandoah Valley of Virginia, about 70 miles outside of Washington, D.C. Housed in Winchester's City Meat Building, the staff is surrounded by photos of the butchers who once occupied the space. The open studio was consciously designed as one room to encourage collaboration. Projects are a combined effort by eight architects, each bringing individual strengths and imagination. Swartz jokingly refers to the staff as a club, emphasizing that having fun with the design process—and each other—is part of a regular day.

In his essay "The Soul of It," Swartz compares the hard-to-define, intangible ideas of beauty and soul with the reasons why people feel comfortable in certain houses. "I think people really want their objects

and architecture to have soul," he explains. To generate architecture that embodies this level of personal satisfaction, "We start out with the site and the client," describes Reader. A thorough study of the site's geography and history informs vernacular forms and building orientation. The firm then asks a lot of questions—about everything from spatial needs to material preferences to the client's choice in music—in order to develop a solution that makes sense for the person and place. "We have a tendency to take really simple buildings we grew up with and rethink them," explains Reader. Re-imagining the recognizable forms of barns and farmhouses, often as a series of structures in the landscape, creates dramatic spaces that link indoors with outdoors.

The firm's portfolio ranges from log cabins to steel-and-glass contemporaries. "If you keep an open mind, clients take you places you didn't think you could go," says Swartz. He and Reader

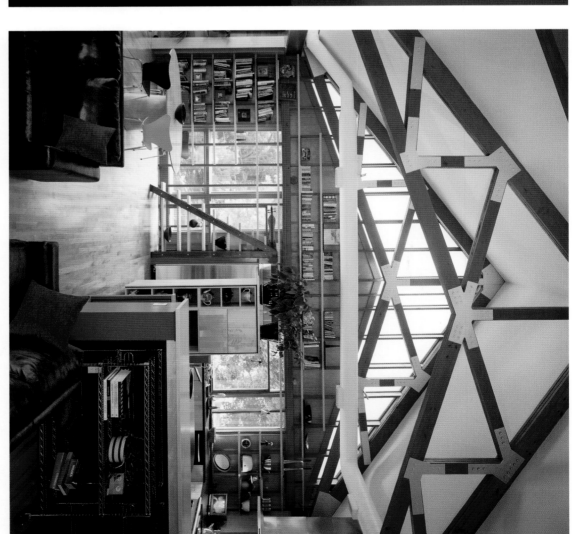

ABOVE LEFT: This renovation and addition to a 1960s' tract house involved flipping the bedroom and living levels, so that the upper-level living space has the higher ceilings and the best views.
Photograph by Anice Hoachlander/HDPhoto

ABOVE RIGHT: The upper level is a light-filled loft space, with an open floor plan and a library built into the framing of the original walls.
Photograph by Anice Hoachlander/HDPhoto

FACING PAGE: The inverted shed roof addition of glass, steel and wood opens to views of the Blue Ridge Mountains.
Photograph by Anice Hoachlander/HDPhoto

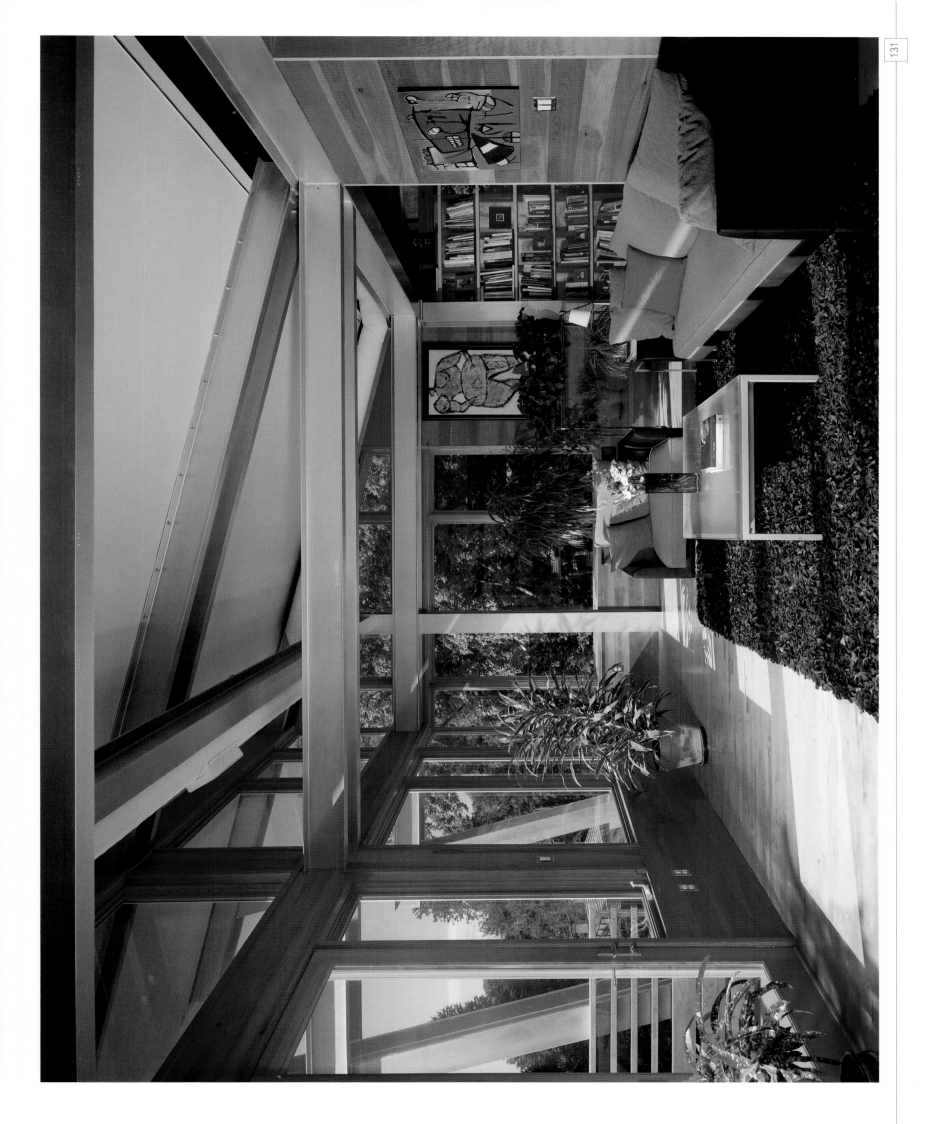

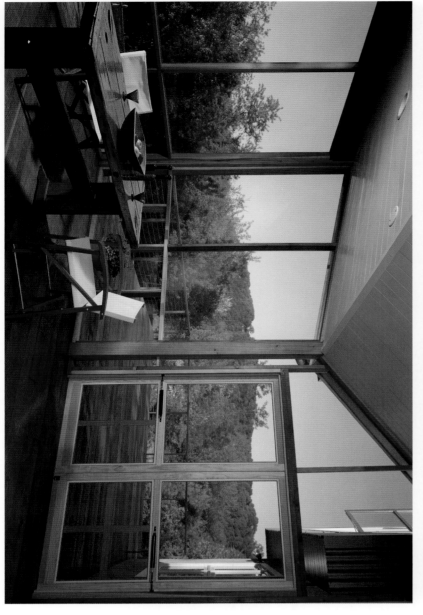

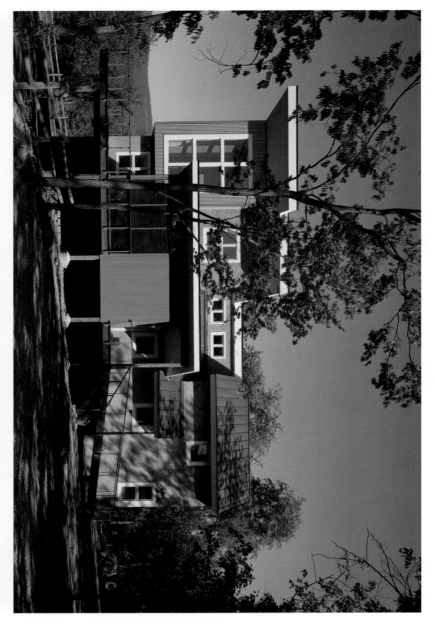

acknowledge the open and active participation of their clients throughout all phases of a project. The firm is known for showing clients its concepts early, often before floor plans are fully developed, to illustrate broad ideas and encourage acceptance. "We want our clients to understand our designs, to keep everyone on the same page," adds Swartz. Once plans and elevations have been established, the architects insist a builder join the team to provide construction insight and also to gain the same appreciation for the project's goals and owners' needs.

"Basically, we try to do good work," says Swartz. In keeping with its philosophy, the firm devotes a considerable amount of time and effort to projects for nonprofit and community groups. Designing for a children's environmental museum, an American Red Cross chapter building or Habitat for Humanity gives Reader & Swartz perspective. The firm understands the importance of maximizing what clients receive for their dollar, regardless of project budget.

Reader and Swartz both earned Bachelor of Architecture degrees from Virginia Polytechnic Institute & State University and have practiced since 1986. Swartz is a LEED® Accredited Professional. Their firm's work has been covered in books and magazines, including *Inform*, *The Washingtonian*, *Residential Architect*, *Southern Living*, *Home*, *Town & Country* and *Custom Home*. In 2003, Reader & Swartz Architects was included in "21:4:21," an exhibit of 21 Washington, D.C., region emerging architects for the 21st century.

By imagining every project as a chance to do something new and interesting, and doing so with a sense of humor and a penchant for practicality, Reader & Swartz creates architecture that has both soul and originality.

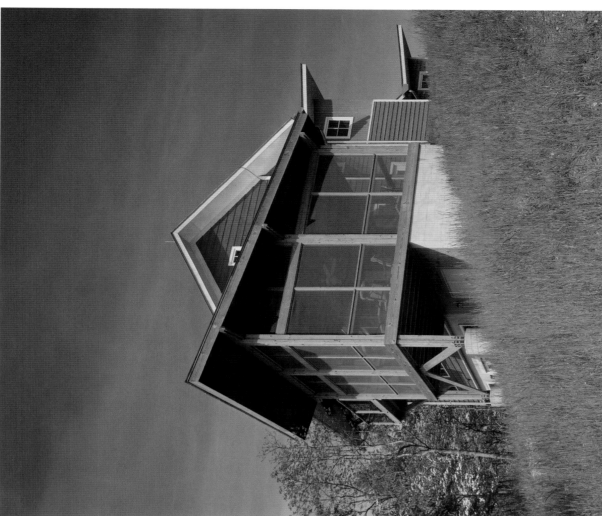

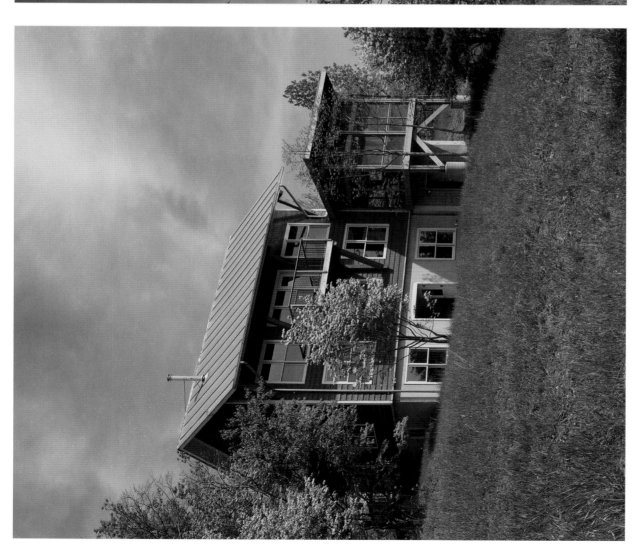

ABOVE LEFT: This passive-solar, timber-frame house was constructed from recycled cribbing timbers from the Saint Lawrence Seaway.
Photograph by Anice Hoachlander/HDPhoto

ABOVE RIGHT: The screened porch projects over the steep site, and serves as a large outdoor living room.
Photograph by Anice Hoachlander/HDPhoto

FACING PAGE TOP: A small weekend house, built in the 1970s, was transformed into a year-round, three-level house with views of the Skyline Drive.
Photograph by Anice Hoachlander/HDPhoto

FACING PAGE BOTTOM: Large windows, and this butterfly-roofed screened porch, connect the house to its river and mountain views.
Photograph by Anice Hoachlander/HDPhoto

Reader & Swartz Architects, PC

Elizabeth Reader, AIA
Charles Swartz, AIA, LEED® AP
213 North Cameron Street
Winchester, VA 22601
540.665.0212
www.readerswartz.com

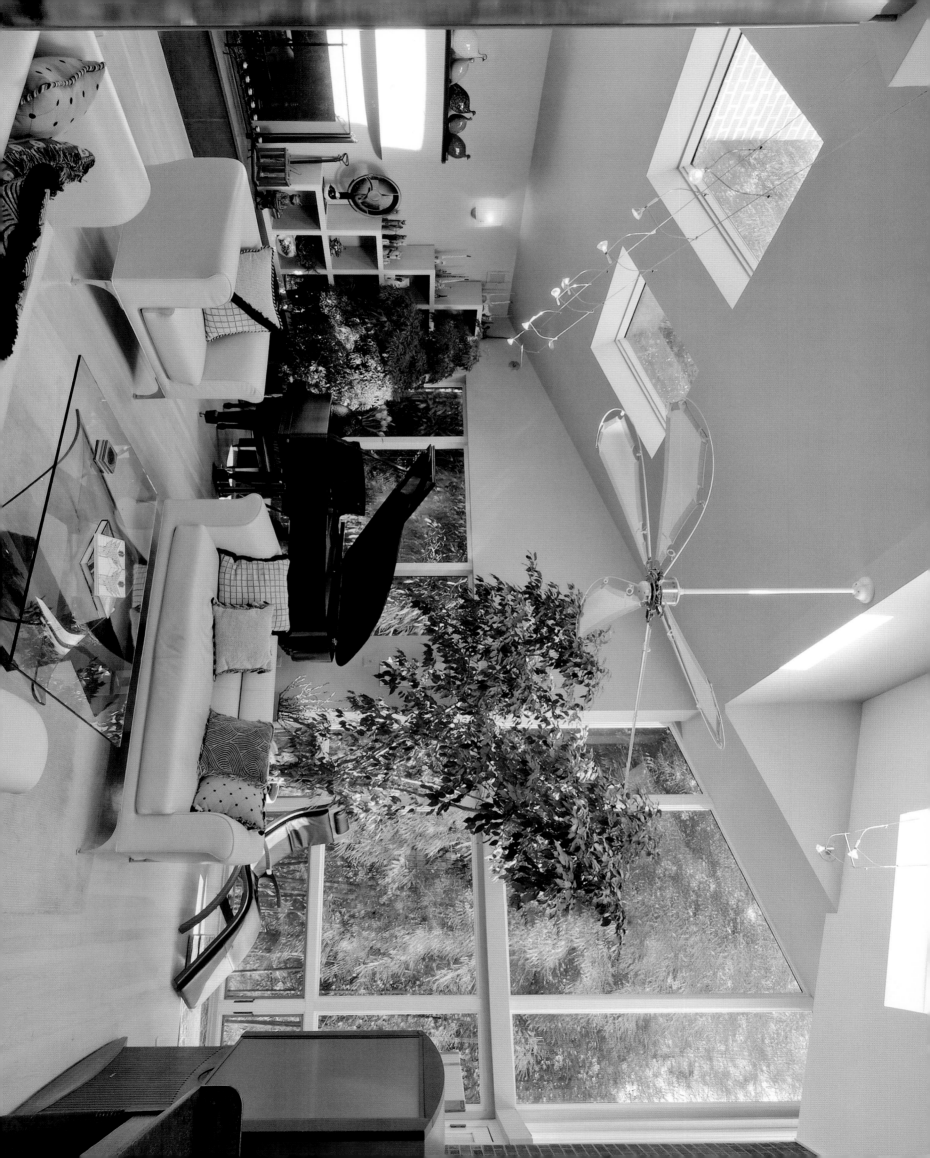

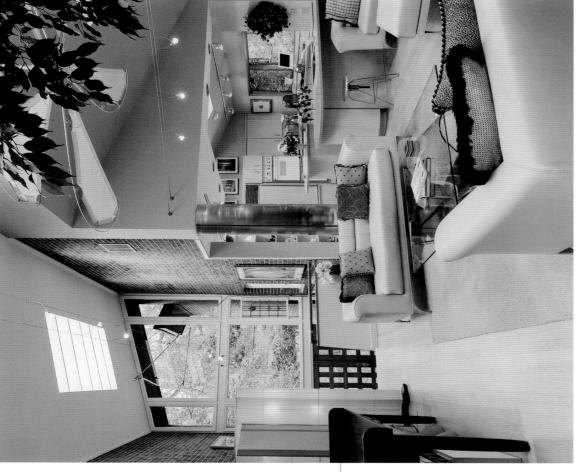

ABOVE: A view toward the kitchen and entry foyer from the living room.
Photograph by Bill Reeves Photography

FACING PAGE: Soaring roofs, expansive glass and an open floor plan replace low ceilings, confined rooms and small windows in this rehabilitated 1970s' split-foyer contemporary.
Photograph by Bill Reeves Photography

DAVID W. RICKS

DW Ricks Architects + Associates, PC

As an undergrad, David Ricks attended a lecture by the renowned architect and theorist Paolo Soleri. Mesmerized by Soleri's revolutionary architectural images—blending architecture, sociology and ecology to create cultural improvement—Ricks immediately declared architecture as his major. Now an architect with 27 years of experience, Ricks uses context and history as guides to shape architecture that makes conscious improvements in the lives of his clients. "I keep an open mind and never come to the table with a predisposition of the design solution," he explains.

Ricks begins by studying the project's natural and man-made setting, or context. "Contextualism is a process to arrive at a design of which many styles can and do play a role," he describes; his portfolio reflects a range of work from very contemporary to more traditional. Ricks and his firm also use historic precedence as a guide, referring to their extensive architectural library as a source of information and inspiration. Their projects stress the importance of linking building plans and façades together to create a successful overall design. "Our façades often provide hints of the interior floor plans, and vice versa, creating a clear rhythm and connection between interior and exterior," Ricks explains. Collaborative client relationships throughout

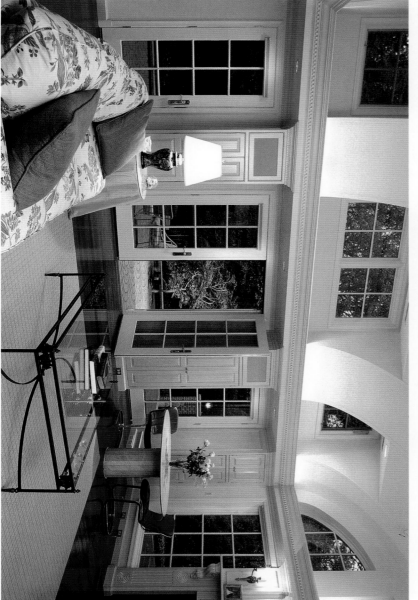

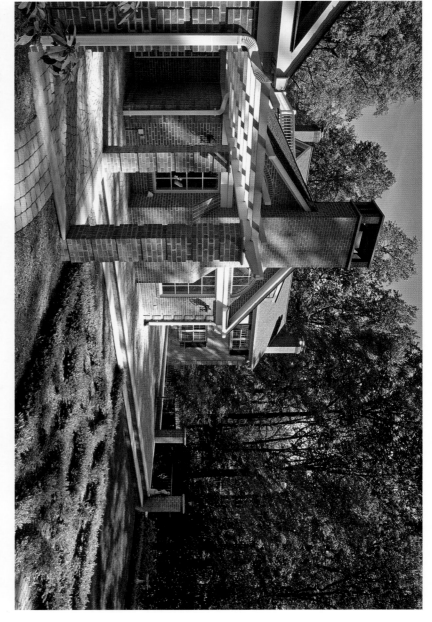

design give the architecture its personality, capturing solutions most appropriate to the individual families who will live inside each house.

DW Ricks Architects + Associates was established in 1988. In addition to Ricks, four staff architects contribute to the vitality of every design: Vincent Gonzaga, Theresa Wyatt, Christian Dvorak and Nancy Yuen. Ricks' son, Andrew, is considering following in his father's footsteps; he lends his design skills to the firm's website while pursuing his education.

DW Ricks is known for being an easy firm with which to work. Ricks is open and approachable, wanting every client to enjoy the design process as much as he does. Though he has won a host of AIA and local design awards, Ricks explains, "They are not nearly as rewarding as a satisfied client who will champion the importance of architecture because of the profound increased quality of life our designs bring them."

Ricks received a Bachelor of Architecture degree from the University of Maryland, where he serves as an occasional student design critic. He was appointed to and served for nine years on the Arlington County Historic Affairs Landmarks Review Board (HALRB) and continues active civic involvement with Arlington's urban design and development initiatives. The work of DW Ricks Architects has been published in *The Washington Post, Remodeling, Custom Home, Better Homes and Gardens* and on the HGTV shows "Before and After" and "Curb Appeal."

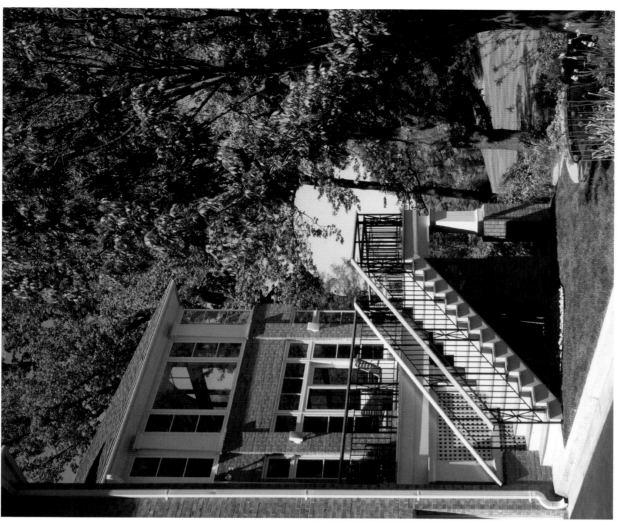

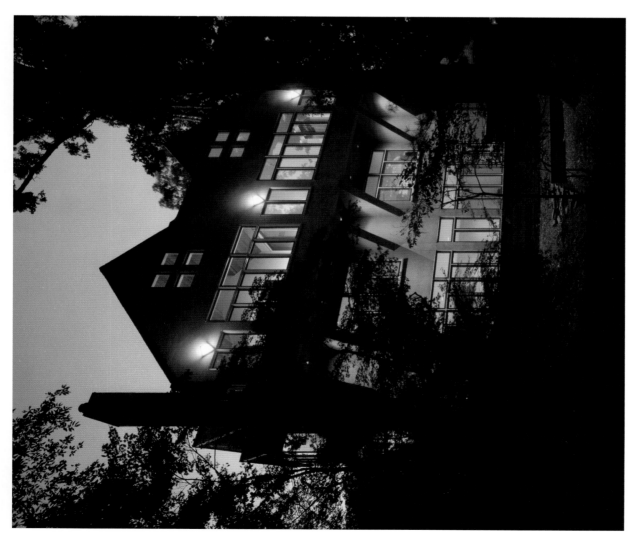

DW Ricks Architects + Associates, PC

David W. Ricks, AIA

2009 North 14th Street, Suite 703

Arlington, VA 22201

703.525.0156

www.dwricksarchitects.com

ABOVE LEFT: This new contemporary house is both modern and contextual, designed with distinctly different front and rear façades. The front is respectful to its traditional neighbors both in material and massing, while this rear façade is less restrained, responding to the interior spaces, primary views and solar orientation.
Photograph by Bill Reeves Photography

ABOVE RIGHT: This two-story rear addition integrates both traditional details and contemporary design. Corner windows emphasize the park setting and panoramic views. A vaulted ceiling and rear arched window are visible through the upper master bedroom windows.
Photograph by Bill Reeves Photography

FACING PAGE TOP: Side view of the great room (former garage) and terrace addition onto an existing brick Colonial.
Photograph by Helmuth Humphrey

FACING PAGE BOTTOM: This south-facing great room addition was recaptured and converted from an existing two-car garage. A new semi-detached garage was designed and relocated.
Photograph by Helmuth Humphrey

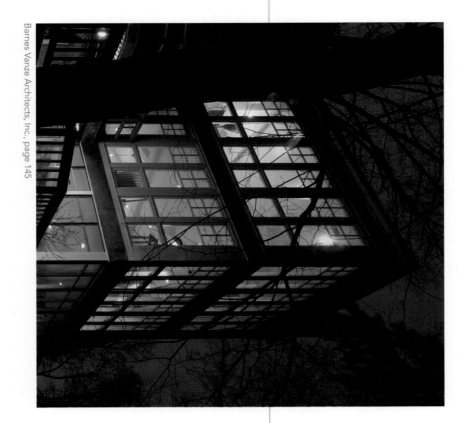

Barnes Vanze Architects, Inc., page 145

ColePrévost, Inc., page 157

Cunningham I Quill Architects PLLC, page 163

WASHINGTON, D.C.

ABOVE: Dramatically lit, this stair entrance rises to the loft.
Photograph by Gregory Emelio Rubbo

FACING PAGE: Designed as the dominant element of this living room, the series of three windows invites the outdoors in.
Photograph by Boris Feldblyn

RAUZIA RUHANA ALLY
GREGORY EMELIO RUBBO

Scout Motor Company

Images of childhood leave an indelible impression on most people. Yet few have exposure to such diverse landscapes and experiences as the principals of Scout Motor Company. Rauzia Ruhana Ally, grew up in tropical Guyana, playing along the canals and in her father's rice mill. Gregory Emelio Rubbo was raised in rural Pennsylvania around a patchwork quilt of fields and farms, steel mills and the railroad. Both environments were stimulating, fostering a sense of invention and creativity. The emotional process of exploration and innovation continues to thrive in the two architects as they lead their design studio.

The firm name was derived from the same honest, straightforward approach that the principals use to design architecture: by extracting the essential form and meaning from otherwise complex information. "Our name has everything to do with the spirit of what we do and who we are," explains Ally. A scout is an inquisitive seeker, reliant upon his or her powers of observation and innovation. A motor is a machine, its aesthetic appearance derived solely from its function. In the modernist tradition of creating "machines for living," Scout Motor Company begins its design process without preconceived notions. Instead, the architects spend a great deal of time learning about their clients' lives. Each residence is highly personalized,

characterized by exceptional craftsmanship and detailing, often with custom-fabricated pieces or elements built by the designers themselves.

Family relationships and friendships are an influential part of Ally and Rubbo's work and practice. The married partners get to know their clients on such a level that intimate friendships develop. "We are a product of where we come from," Ally says. The same is true for every client, and houses are designed to capture each individual's style of entertaining, living and relaxing. "Our designs are commanded from our discovery of who the client was, who he is and who he will be," adds Rubbo. Childhood photos on the company website display the importance of the principals' own families; the *Customatic* refrigerator in the background of one of Rubbo's shots hints at the design solutions they aim to provide.

Ally and Rubbo both attended Catholic University of America, earning Master of Architecture and Bachelor of Architecture degrees, respectively. Ally also holds an undergraduate degree in fine arts from the University of Maryland and teaches as an adjunct professor at Catholic University of America.

Scout Motor Company and its work have been featured in *AIA D.C.* and *The Washingtonian* magazines and on the HGTV show, "What You Get For The Money." The firm also participated in the 21:4:21 Exhibit of emerging architects for the 21st century. Recognized for its high-tech yet touched-by-the-hand designs and aesthetic elegance, the architecture of Scout Motor Company has earned awards from the D.C. and Virginia Chapters of the AIA, and *The Washingtonian*, *Remodeling* and *International Design* magazines.

ABOVE: A refreshing interpretation of the integral elements in a kitchen, this aluminum countertop is supported by a stainless steel sink with exhaust portals above and appliances on the cart below.
Photograph by Gregory Emelio Rubbo

FACING PAGE LEFT: This distinctive sink supports the countertop with cut-between counter and wall.
Photograph by Gregory Emelio Rubbo

FACING PAGE RIGHT: This dynamic aluminum cart perfectly houses kitchen appliances elegantly, allowing more of the kitchen's intended architecture to be enjoyed.
Photograph by Gregory Emelio Rubbo

Scout Motor Company
Rauzia Ruhana Ally, AIA, NCARB
Gregory Emelio Rubbo, Associate AIA
1432 Swann Street NW
Washington, D.C. 20009
202.797.2376
www.scomoco.com

ABOVE: Three-story porch, family room and master bedroom addition, Chevy Chase, Maryland. The addition—very different from the traditional center hall Colonial existing home—changes the character of the house and playfully opens it to the wonderful view at the rear.
Photograph by Anice Hoachlander/HDPhoto

FACING PAGE: Farmhouse addition and renovation, The Plains, Virginia. The addition of casual living spaces, bedrooms and wraparound porches sympathetically adds to the original country farmhouse.
Photograph by Anice Hoachlander/HDPhoto

ANTHONY S. BARNES
STEPHEN J. VANZE

Barnes Vanze Architects, Inc.

Partners Anthony Barnes and Stephen Vanze have worked side by side in a single office for more than 20 years, witnessing the growth of their firm from two to more than 25 employees. Barnes Vanze Architects, has grown in reputation, as well as size, earning commendation from *The Washingtonian* magazine as one of the city's "Top 15 Architects" several years in a row, and receiving awards from the American Institute of Architects, as well as from *Builder, Remodeling, Traditional Building, Custom Home* and *Southern Living* magazines. The wide appeal of Barnes Vanze's work stems from its combination of imaginative, livable architecture and high level of client service.

Barnes and Vanze met when they were both working for a D.C. firm doing large-scale commercial and institutional projects across the country. Each has an impressive bio of educational and professional credits. Anthony Barnes has a Master of Architecture degree from Yale University and an undergraduate architecture degree from the University of Witwatersrand in South Africa, where he was raised. He sits on the advisory board of the Friends of Georgetown Waterfront Park and has served as president and board member of the National Child Research Center. Stephen Vanze earned a Bachelor of Arts from Brown University and a Master of Architecture from the University of Virginia. He is an Old Georgetown Board Commissioner and has been

president of both the Washington Architectural Foundation and the D.C. chapter of the AIA. They are united in their down-to-earth and practical philosophy, guiding their firm by providing "flexible, informal and dynamic design solutions."

The partners describe their firm as collaborative. They each run separate projects, but offer design commentary to one another. Two senior associates, Timothy Clites and William Wheeler, handle project management along with a staff of project architects and intern architects. The studio environment helps refine and improve every design. "We have consciously sought out employees who are strong designers," explains Vanze. As a result, when clients hire the firm, they receive a unified vision and the same high-quality architecture, regardless of the individuals assigned to the project.

The variety of Barnes Vanze's work has ranged from private residences to clubs, restaurants and retail spaces in a combination of new and historic settings. "We're most interested in doing appropriate solutions," describes Vanze.

ABOVE LEFT: Coastal home renovation, Rehoboth, Maryland. A crawl space annex was transformed into a boat bearth-like bunk room, complete with bead board built-ins and strapped ceiling.
Photograph by Anice Hoachlander/HDPhoto

ABOVE RIGHT: Coastal home renovation, Rehoboth, Maryland. The new porch's lattice-framed oculus, fan, exterior drapes and maritime details create the perfect outdoor pool side room.
Photograph by Anice Hoachlander/HDPhoto

FACING PAGE: Renovation and addition to an 18th-century log cabin farmhouse, Great Falls, Virginia. The original log cabin had been added onto several times. In this latest renovation/addition, all of the existing house was meticulously renovated and this glassy porch-like kitchen/family room was created.
Photograph by Anice Hoachlander/HDPhoto

"Problem-solving is more important than pushing a design solution that a client doesn't really want", adds Barnes. The firm's broad stylistic range evidences their response to particular problems; designs will stand out or defer to neighbors as is best suited to the programmatic and contextual requirements. Barnes is proud of the firm's consistency: "We do our work at the highest standard no matter the style."

Green Design has become an important focus of the firm in recent years. Both partners are LEED® Accredited Professionals who emphasize education along with sustainability. They teach clients about the benefits of Green demolition, waste management and energy efficiency. The firm has embarked on a tree-planting program to combat carbon emissions. As part of their commitment to sustainable design, they buy every client a small tree to be planted on the project site. They also advocate spatial efficiency. "We help people evaluate their needs, to try to build less than they think they want and still be happy with the results," says Vanze. Building houses of quality that are also affordable is something of a challenge, but Barnes Vanze demonstrates that with economy of scale, it can be done.

The firm is presently working on projects along the East Coast, from Bangor, Maine, to Palm Beach, Florida, and in Utah and France. Both partners believe that "you get the kind of work that you do," and strive for projects that display good design while meeting client needs, promising to lead every client to the best design solution.

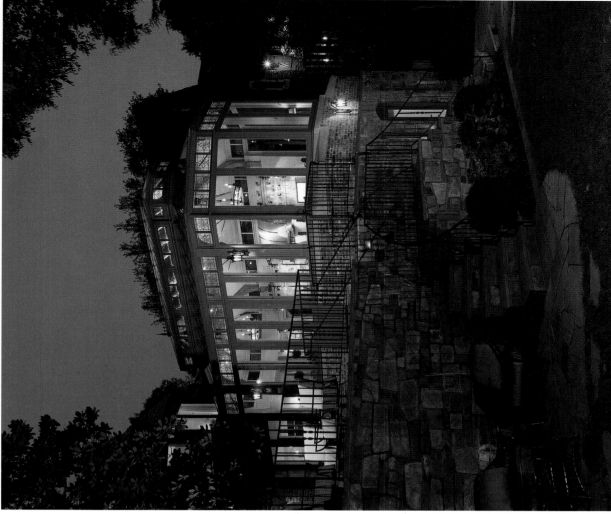

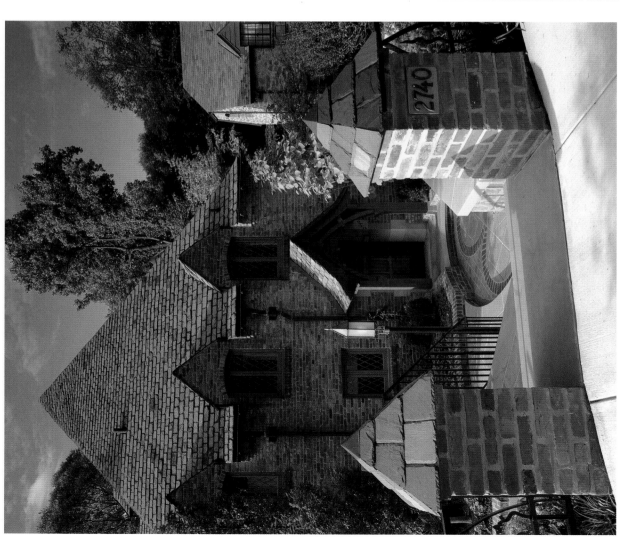
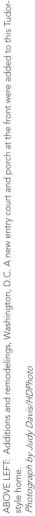

ABOVE LEFT: Additions and remodelings, Washington, D.C. A new entry court and porch at the front were added to this Tudor-style home.
Photograph by Judy Davis/HDPhoto

ABOVE RIGHT: Additions and remodelings, Washington, D.C. The rear of the same home shows the new summer kitchen, sitting as a pavilion looking over the terraced garden.
Photograph by Judy Davis/HDPhoto

FACING PAGE TOP: New home, Talbot County, Maryland. Inspired by Shingle-style coastal design of the early 20th century, this Eastern Shore second home takes advantage of the views and breezes under a simple roof form.
Photograph by Anice Hoachlander/HDPhoto

FACING PAGE BOTTOM: New home, Talbot County, Maryland. A view from the porch overlooking the water.
Photograph by Anice Hoachlander/HDPhoto

Barnes Vanze Architects, Inc.
Anthony S. Barnes, AIA, LEED® AP
Stephen J. Vanze, AIA, LEED® AP
1000 Potomac Street NW, Suite L-2
Washington, D.C. 20007
202.337.7255
www.barnesvanze.com

MARGARET E. CLARKE

Clarke Architecture, PLLC

Architect Margaret E. Clarke enjoys working in the Washington, D.C., area because of its tremendous diversity of architectural styles. From civic buildings to private residences, the capitol region's architecture represents all eras and aesthetics of our nation's design history. For Clarke, the variety of houses presents an opportunity for creatively merging the residential designs of the past with the lifestyle needs of the present. Her practice, Clarke Architecture, is built upon residential renovations and seamless additions that pay careful attention to context, scale and connectivity—inside homes and within neighborhoods.

Starting from the outside in, Clarke endeavors to make her projects "good neighbors." She investigates neighborhood context to ensure new construction or renovation work is complementary to the existing scale and architectural detailing of a project's environs. When designing a two-story house within an area of single-story homes, she might include a front porch to continue a low roof line and minimize the appearance of height.

By establishing layered views and clear circulation patterns, Clarke creates connectivity and relationships between interior spaces. She uses high-quality interior details—built-in cabinetry, columns and low walls—to divide rooms while retaining connections and reinforcing the feeling of openness. Clarke often

ABOVE: This knee wall detail with column and glass-fronted cabinet separates the kitchen from the dining room and hallway in the Kensington project. The interior columns are reminiscent of those on the exterior of the home.
Photograph by Anice Hoachlander/HDPhoto

FACING PAGE: Front elevation of a renovated 1950s' rambler in Kensington, Maryland. Renovations on the exterior include raising the roof pitches on both gable ends and adding a front porch and barrel vault at the entryway to unify the two gable ends. The columns establish a rhythm and an organizing vocabulary. Because the family room (at the right of the image) replaced the existing garage, a new three-car garage and master suite—which peaks over the top of the right roof pitch—was added. The newly landscaped property was the final touch to the project.
Photograph by Anice Hoachlander/HDPhoto

creates links to a home's landscape to create the perception of additional space. Punctuating a room with glass brings in natural light and views to make the space appear bigger.

Clarke is known for her ability to listen carefully to her clients. Her design process always begins with an investigation of problems to be corrected and goals to be met. "I'm sensitive to the fact that the home belongs to someone else," Clarke explains, adding that her job "is to take clients' goals, large and small, and translate them into beautiful spaces that bring joy." Her work strikes a balance between aesthetic quality and quality of life. Natural materials—she is especially fond of soapstone and maple—lend a warmth and richness to her interiors while offering durability for everyday life.

Clarke's most rewarding projects are those in which the client is willing to rethink the entire house. She emphasizes that houses are not static, but can be reworked. Often, reconfiguring

ABOVE LEFT: Interior view of the new dining room and kitchen of a renovated and expanded brick ranch home in Washington, D.C. The goal was to bring light into the heart of the home. Using cherry columns, beams and French doors with transoms, the dining room was defined and delineated from the kitchen while bringing warmth into the space. The cherry cabinets and windows found in the kitchen unify it with the dining room, while a curved soapstone counter at the island and curved track lighting serve as a counterpoint to the more rectilinear lines of the columns, beams and doors.
Photograph by Anice Hoachlander/HDPhoto

ABOVE RIGHT: A view of the living room upon walking into the residence in Kensington, Maryland. Columns and beams define the living room from the new hallway. The new French doors at the rear of the living room bring light into the space and connect with the new rear porches. The new tray ceiling with recessed lighting enhances the feeling of height in the space.
Photograph by Anice Hoachlander/HDPhoto

FACING PAGE: Interior view of a kitchen and dining room/family room addition in Bethesda, Maryland. Built-in bookshelves and a window seat in warm maple were incorporated to make the dining room cozy and inviting.
Photograph by Anice Hoachlander/HDPhoto

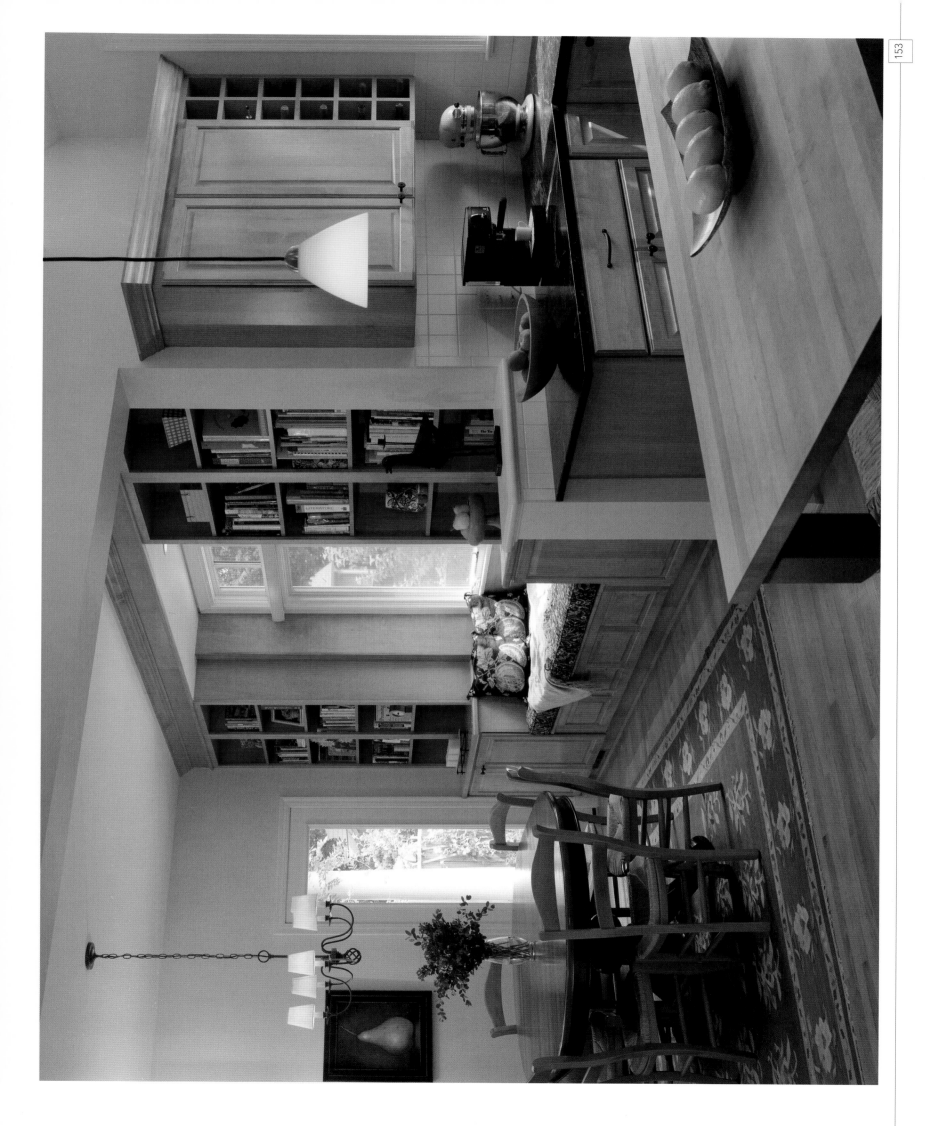

interior spaces will make an exciting difference in how spaces connect and how families interact —and may eliminate the need to build an addition at all. Clarke provides the example of a project where reorganizing circulation created a more livable and comfortable home. The house was situated on a street that evolved from quiet to busy. As the road became busier, the family no longer used the front entrance. Clarke reoriented the house to establish a main entry from a side street, and reworked the interior spaces to correlate to the new orientation. "I try to take what is confusing or left over from another era and make it work for today," she explains.

Clarke earned a Bachelor of Arts from Mount Holyoke College, where she studied art history. A concentration in Italian Renaissance art encouraged her appreciation for the classical architectural principles of balance, proportion and symmetry. She went on to earn a Master of Architecture degree from the University of Maryland. A member of the American Institute of Architects, Clarke has been a licensed architect for the past 15 years, seven of which have been as sole proprietor of her namesake firm. She has served as a judge for *Remodeling* magazine's design competition and has authored articles for trade publications, including *The Journal of Light Construction* and *Remodeling*. She was recognized by *Washingtonian* magazine as an "up-and-coming" architect. Her practice includes work in Washington, D.C.; northern Virginia; Maryland; Connecticut and Massachusetts.

RIGHT: Exterior view of a 1920s' rowhouse in the historic Kalorama neighborhood of Washington, D.C. The renovations included new landscaping, lighting and a repainted exterior.
Photograph by Anice Hoachlander/HDPhoto

FACING PAGE: Interior view of the Kalorama rowhouse upon entering the front door. The interior was completely reworked and re-proportioned to bring in natural light and add elegance to the home. Carefully crafted details include a new hallway with closet and curved niches to the dining room, a new arched exterior door from the breakfast room to the backyard, and new arches and wainscoting in the dining room.
Photograph by Anice Hoachlander/HDPhoto

Clarke Architecture, PLLC
Margaret E. Clarke, AIA
1791 Crestwood Drive NW
Washington, D.C. 20011
202.722.6552

ABOVE: People do not realize that the rubber-upholstered door is really a door—it is very sexy.
Photograph by Angie Seckinger

FACING PAGE: The outdoor living space of this Potomac, Maryland, residence spectacularly integrates the indoors with the outdoors.
Photograph by Timothy Bell

ROBERT COLE
SOPHIE PRÉVOST

ColePrévost, Inc.

In the 1940s and 1950s, husband-and-wife designers Charles and Ray Eames embodied the spirit of the mid-century modernist movement, designing everything from iconic furniture and architecture to toys and graphics. The two understood that good design—regardless of scale—can improve the quality of people's lives. Their design philosophy was based on having "serious fun" with the process. The studio practice of designers Robert Cole and Sophie Prévost parallel the Eames' in many ways. ColePrévost looks for opportunities to display its design skills across a wide range of disciplines, from architecture and interiors to furniture and garden design. "We are interested in innovation, in learning and in exploration—without labels and without preconceptions," explains Cole. As a hybrid design firm, ColePrévost advocates well-thought-out design that shapes experiences and heightens the sense and pleasure of living.

"Our designs are meant to be felt," Cole and Prévost explain. They describe a multi-sensory experience that equally influences physical and emotional feelings. "A home should never look like a stage set," describes Prévost. "We see our design as a backdrop for living." They aim to create moods, places to live, but not static tableaux. Light, textures, colors and a sense of wit are essential to their work. "Design should never take itself too seriously," she adds. By combining the unique attributes of each client's lifestyle,

site and program, and continuously asking questions, ColePrévost creates very personal spaces. The firm's design voice, or "style," is consistently ordered, elegant and functional—while always unique. The firm's ability to design down to the smallest detail ensures that unexpected and innovative are always balanced with conventional and practical.

Taking cues from European design trends, Asian influences and architectural history, the work of ColePrévost retains a freshness and spontaneity. Both partners favor spatial overlaps of activities, rather than segregated rooms for specific uses. Materiality and detailing are emphasized. A waxed leather floor or a steel wall might be used to create a visual effect, but also to offer a scent, texture or sound to enhance the pleasure of living. Their houses are meant to be fluid, to improve with age while accommodating the changing lives within. Essentially, theirs is an architecture of

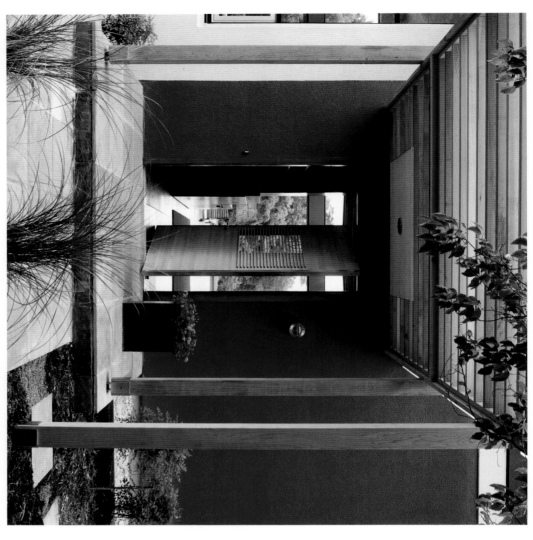

ABOVE LEFT: The pivot at the base allows you to open this massive, solid maple door leaf with a soft nudge, thereby producing a dramatic effect.
Photograph by Celia Pearson

ABOVE RIGHT: This sophisticated, high-style apartment is endearingly referred to as the "New Yorker's" apartment.
Photograph by Timothy Bell

FACING PAGE: Avoiding a standard laboratory for cooking, the kitchen was kept fresh, light and interesting with an herb garden and swing for the 2006 Washington Design Center Designer Show House.
Photograph by Lydia Cutter

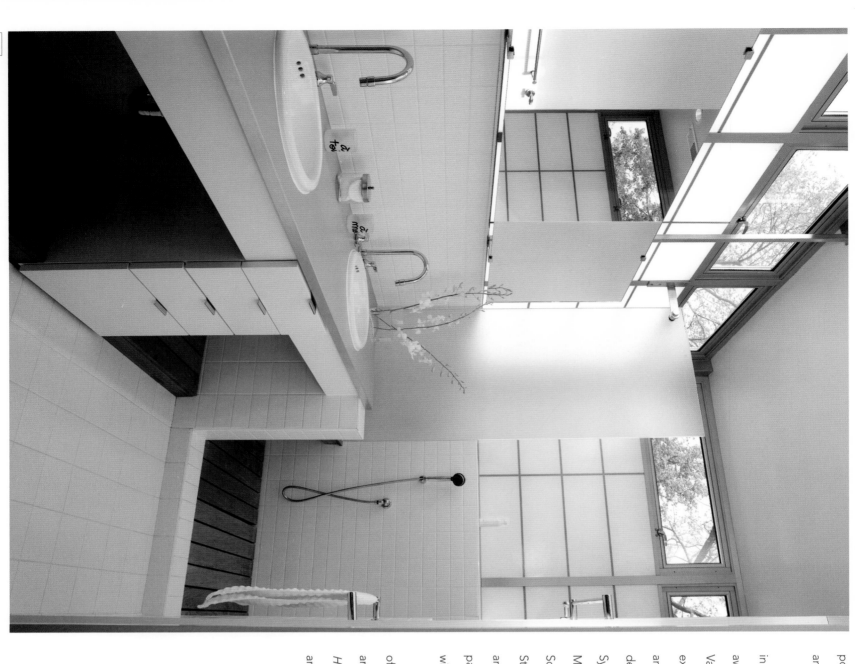

portraiture—capturing the persona of the clients and responding to their needs and site conditions in built form.

Principals Cole and Prévost founded their firm in 1996. Prior to joining in practice, the married parents of two children earned individual reputations as award-winning and highly published designers. Robert Cole was educated at Vassar College and the Architectural Association of London. His professional experience includes practice in the United States and abroad in London, England, and Düsseldorf, Germany. He spent 17 years teaching architectural and furniture design and theory at the Architectural Association of London, The University of Sydney, the University of Michigan, Cranbook Academy of the Arts, Carnegie Mellon University and the Catholic University of America. Originally from Monaco, Sophie Prévost studied paint restoration in Paris before moving to the United States. She earned a Bachelor of Arts in interior design from Mount Vernon College and a Master of Architecture degree from Catholic University. Both agree their partnership offers an innate level of trust; they enjoy sharing the design process with one another and with their clients.

The work of ColePrévost has earned awards from the American Institute of Architects, International Interior Design Association, as well as *Remodeling* and *The Washingtonian* magazines. Projects have been featured in *Metropolitan Home*, *Inform*, *The Washington Post*, *Residential Architect*, *Interiors*, *Spa Finder* and in several books.

ABOVE LEFT: Redesigned into a sleek, updated space, this was originally a 1960s' bungalow.
Photograph by Timothy Bell

ABOVE RIGHT: Here, the slate floors provide the continuous extension of the inside out.
Photograph by Timothy Bell

FACING PAGE: This bathroom was designed to give the feeling of being among the trees; with the fiberglass panel system, privacy is achieved while letting nature in.
Photograph by Angie Seckinger

ColePrévost, Inc.

Robert Cole, RIBA
Sophie Prévost, ASID
1635 Connecticut Avenue, NW
Washington, D.C. 20009
202.234.1090
www.coleprevost.net

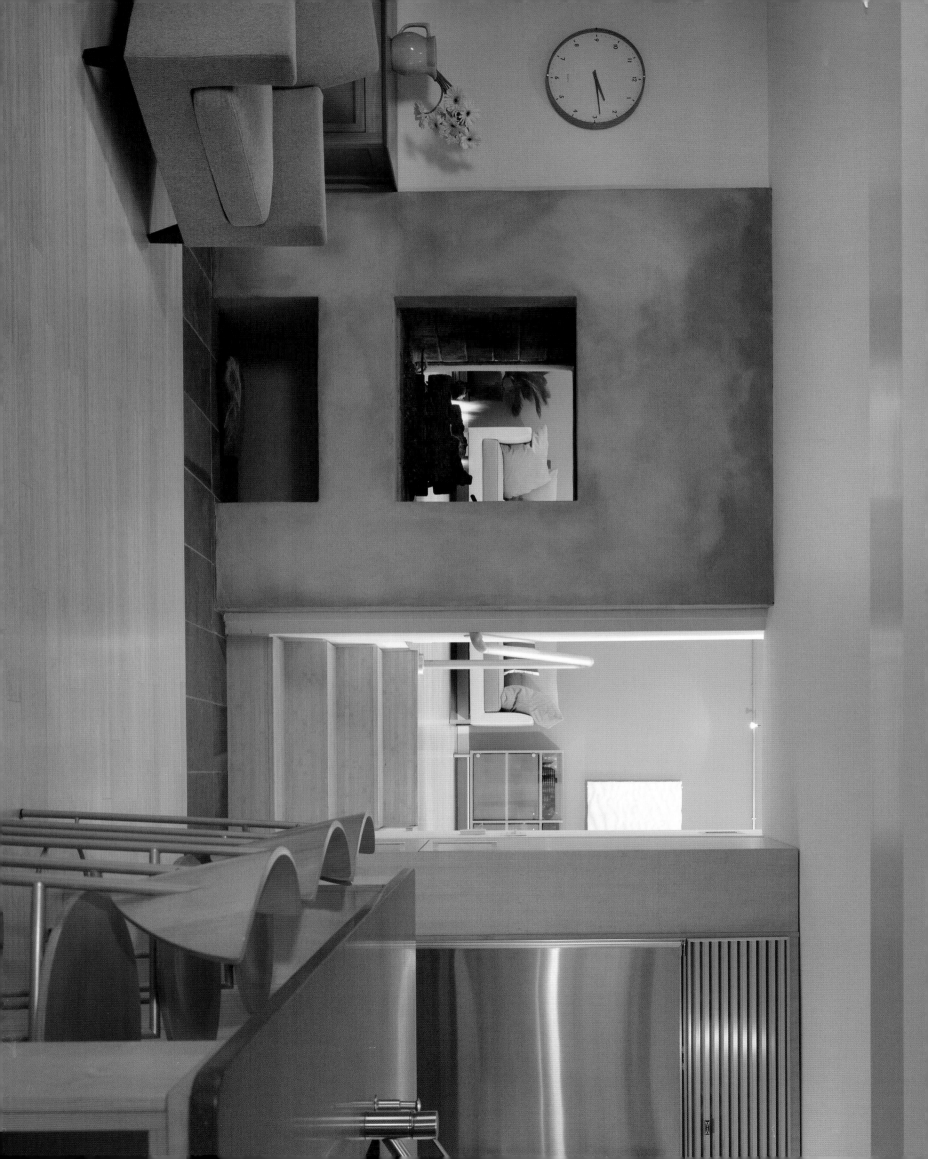

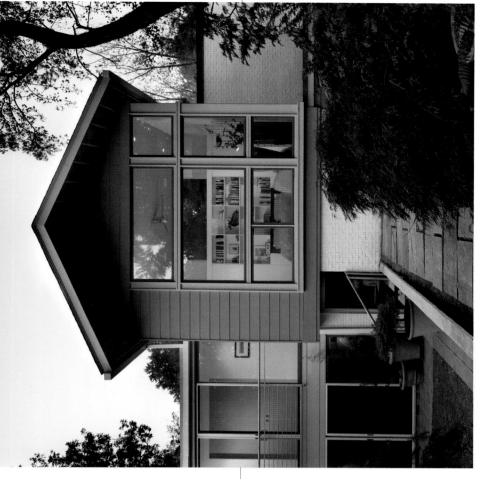

ABOVE: This addition to a 1960s' split-level home in Bethesda, Maryland, illustrates a sensitive resolution to site constraints and client space needs. The master suite, which echoes the mid-century lines of the original façade, punctuates the end of the addition, embracing the garden and creating an intimate courtyard.
Photograph by Anice Hoachlander/HDPhoto

FACING PAGE: Previously a dark and cramped space in the existing house, the renovated interior enjoys generous light from the front, fluid circulation and expansive views to the lush rear garden.
Photograph by Anice Hoachlander/HDPhoto

RALPH CUNNINGHAM
LEE QUILL

Cunningham | Quill Architects PLLC

Cunningham | Quill Architects is a firm not easily categorized. Equally adept at designing in contemporary or traditional aesthetics, for single-family residences or mixed-use developments, and within any size or context, the firm remains resolutely unspecialized. Its defining mark is a dedication to design excellence through rigorous attention to details, involved client relationships and sensitivity to every spatial experience.

Founding principal Ralph Cunningham explains, "We understand what is important to our client and what is important to the site. Those are the values that remain consistent on all of our projects."

For its custom residential work, Cunningham | Quill is committed to helping individuals realize and refine their vision of home. "Although we work in many different styles and architectural vocabularies," principal Christopher Morrison explains, "There is always the same clarity of planning and design." The firm enters into each project without preconceived notions, working to ensure each home's aesthetics and functionality are cohesive and clearly articulated through the nuances of appropriate proportion, scale, detailing and craftsmanship.

Ralph Cunningham and Lee Quill established Cunningham | Quill Architects in 1996. Cunningham holds a Master of Architecture degree from Columbia University and an undergraduate degree in architecture

from Washington University in St. Louis. In 20 years of professional experience, he has maintained active involvement in academia, serving as a visiting critic at Catholic, Howard, Ohio State and Columbia Universities. A resident and native of Washington, D.C., Cunningham is immediate past president of the board of directors of the Georgetown Day School. Lee Quill holds a Bachelor of Architecture degree from Virginia Polytechnic Institute and State University. An Alexandria, Virginia, resident, he is involved in community planning and urban design initiatives, and recently served as chairman of the Alexandria Urban Design Advisory Committee. Since 1996, he has been a member of the Metropolitan Washington Council of Governments—Metropolitan Development Policy Committee, and is involved with several Urban Land Institute technical advisory planning panels.

Cunningham and Quill are joined by principals Scott Matties and Christopher Morrison. Matties earned a Master of Architecture and a Bachelor of Science in architecture from the University

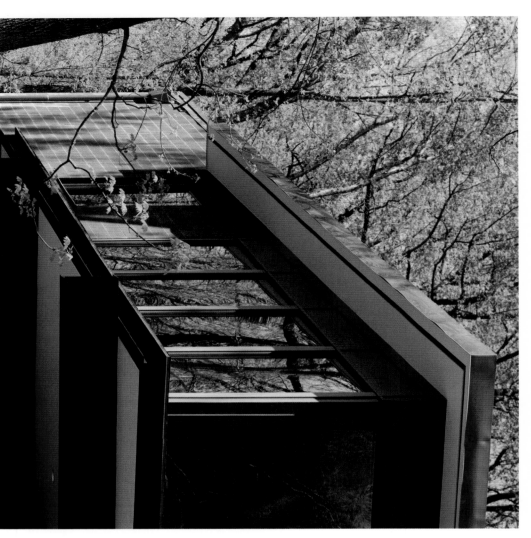

ABOVE LEFT: This award-winning residence for a professional photographer is distinguished by a dramatic cantilever over its steeply sloping site.
Photograph by Maxwell Mackenzie

ABOVE RIGHT: The kitchen, dining, entertaining and living areas occupy the primary volume of this live/work residence, accommodating the client's needs for flexible space that integrates the outdoors.
Photograph by Maxwell Mackenzie

FACING PAGE: The glass living room, suspended between two solid pieces, commands a view of the street, the woods and the entire surrounding neighborhood.
Photograph by Maxwell Mackenzie

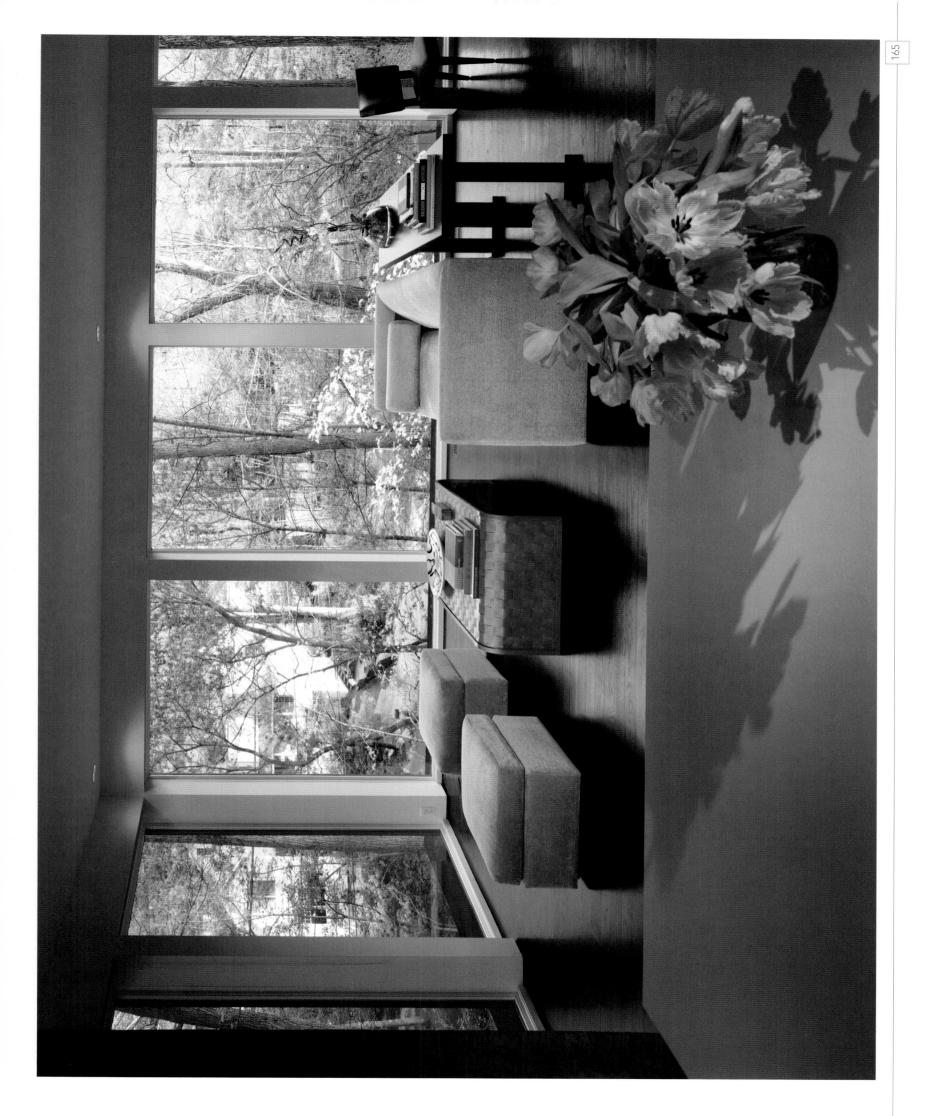

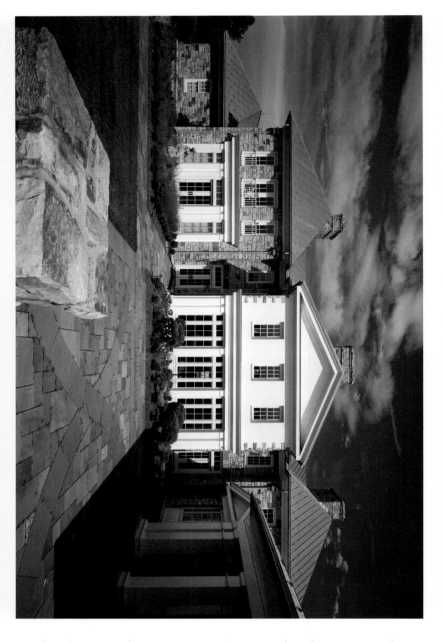

of Michigan. His education emphasized community and town planning, areas in which he continues interest and involvement. He has led numerous community meetings and presentations to advance an understanding of architecture and planning. He joined the firm in 1998. Morrison earned a Master of Architecture from the University of Maryland and a Bachelor of Arts in chemistry and physics from St. Louis University. An award-winning architect with the practice since 2000, Morrison is committed to both the community process of architecture and the development of young architects through mentorship and as a visiting critic at local universities.

Together with associates David Bagnoli, AIA; Maria Casarella, AIA; Devon Perkins, AIA, and Adam McGraw, AIA, the principals oversee a staff of 30. The collaborative nature of the office encourages knowledge and idea sharing. In weekly meetings, the entire staff reviews each project so that any individual can offer input. Everyone appreciates and enjoys the challenges presented by such a variety of work. Clients also enjoy the wide range of influences and ideas presented by the firm's designers. Characterized as "intellectually curious," clients are often eager to participate in the process of shaping their environment. The staff welcomes and advocates their participation.

Cunningham | Quill has received more than 20 design commendations for its work, including awards from the Washington, D.C., chapter of the AIA and from *The Washingtonian, Remodeling, Residential Architect* and *Custom Home* magazines. In 2006, the firm was awarded the AIA D.C. Catalyst Award for historic preservation and adaptive reuse of the Mather Building, and the Award of Merit for Historic Resources for the Caton's Walk development, both in Washington, D.C. Projects have been published in *House Beautiful, Southern Accents, Southern Living, Washington Spaces* and *The Washington Post*, and have appeared in the Sarah Susanka book *House to Home* and the Taunton Press book *Additions*.

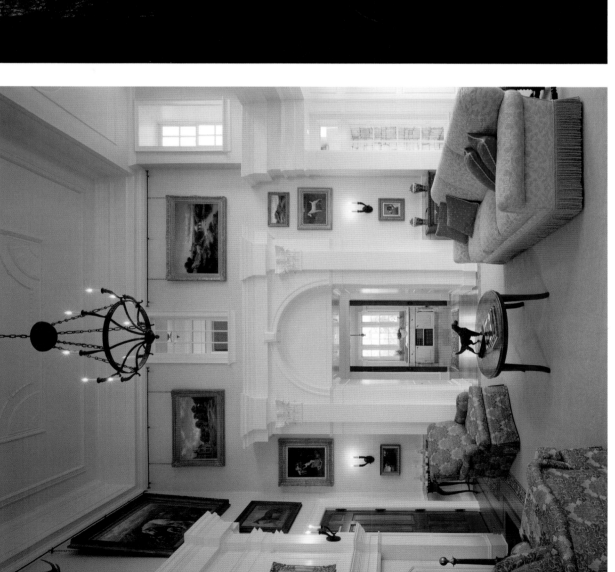

ABOVE LEFT: The great room, the primary entertaining space, is traditionally detailed and proportioned.
Photograph by Maxwell Mackenzie

ABOVE RIGHT: The summer house combines the simplicity of agricultural architecture with a commanding classical temple front. Used as a private structure for cooking and relaxation, it consists of one large room with 12-foot windows overlooking the pond.
Photograph by Maxwell Mackenzie

FACING PAGE TOP: Sensitive site orientation, preservation of scale and formal axial relationships drove the design process for this residence. The Manor House is a contemporary derivation of an English manor house, integrating carefully articulated details and proportions with the owner's program.
Photograph by Maxwell Mackenzie

FACING PAGE BOTTOM: Nestled in the rolling hills and forest of the Hunt Country, this award-winning estate integrates the local architectural vernacular of the Virginia Hunt Country with the contemporary needs of the owner in a manor house, stable, guest house and waterside folly (summer house). The estate encompasses 100 acres, conserving 80 acres as a preserve.
Photograph by Maxwell Mackenzie

Cunningham | Quill Architects PLLC

Ralph Cunningham, AIA
Lee Quill, AIA
Scott Matties, AIA
Christopher Morrison, AIA
1054 31st Street NW, Suite 315
Washington, D.C. 20007
202.337.0090
www.cunninghamquill.com

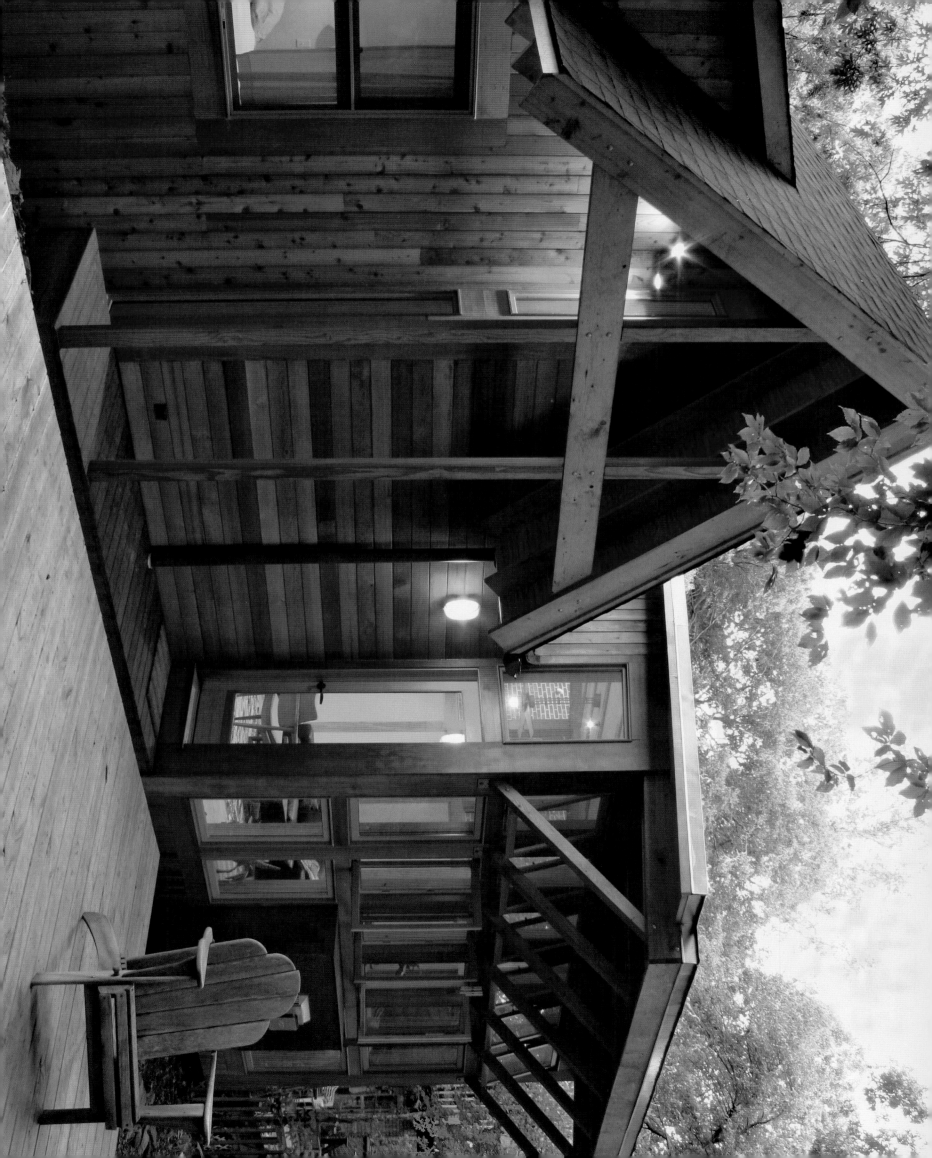

KENDALL DORMAN
Wiebenson & Dorman Architects PC

Kendall Dorman of Wiebenson & Dorman Architects speaks a contemporary language of architecture, not only through the clean, modern forms of his designs, but in his commitment to addressing the present-day needs of his clients and the environment. The way he describes his practice is simple: "We instill what we believe is good design . . . in order to create dynamic, enjoyable, comfortable and responsible architecture."

In much the same way as the mid-century modernists wanted to make design accessible to the masses, Dorman and his firm care first and foremost about their clients' needs. "We want our projects to get built," he explains, adding that this means careful attention is paid to site conditions, local codes, the times in which we live and, of course, budget. To Dorman, the emphasis is on creating open and light-filled spaces to fit each family's lifestyle. He is not opposed to using stock building materials or IKEA cabinetry. "It's a balance between aesthetics, efficiency, durability and reasonable price," he says. A responsibility to the environment is expressed through passive solar design techniques, efficient building systems and a sensitivity to each house's relationship to the land.

Dorman's pragmatic approach to architecture extends from residential projects to designs for nonprofit organizations, including Emmaus Services for the Aging, Bread for the City, Martha's Table and Saint Luke's Shelter. "It is a good way to contribute to the community through my work," he describes of these mostly pro bono efforts. He is also active in the community as a member of the Washington Area Bicyclists Association board of directors.

A native of Lincoln, Nebraska, Dorman earned a Bachelor of Science in architectural studies from the University of Nebraska and a Master of Architecture from Arizona State University. After working in Phoenix, Los Angeles and Chicago, he settled in Washington, D.C., and in 1994, joined the late John Wiebenson in practice. "Wieb was a great architect and a very patient mentor and friend," Dorman recalls. Wiebenson's collaborative relations with clients and his policy of presenting many options are two practices Dorman continues.

"It is rare that a project will only have one right answer," Dorman declares. By presenting clients with a range of choices, he encourages them to play an active part in the design process. For Dorman, good design is less about exotic finishes and deep philosophy than about providing practical solutions that are uplifting and gratifying to both him and his clients.

The work of Wiebenson & Dorman Architects has been featured in *The Washington Post, The Washingtonian, Metropolitan Home, House Beautiful Special Editions* and on HGTV. Awards include a Community Facilities Award for High Architectural Merit, Washingtonian Residential Design Award and a Met Home of the Year.

ABOVE LEFT: This Takoma Park, Maryland, residence features a variety of natural wood finishes—exterior cedar siding, interior pine trims and birch veneer doors and storage cabinets—connecting the interior with the exterior and the whole house with nature.
Photograph courtesy of Wiebenson & Dorman Architects PC

ABOVE RIGHT: The addition/renovation to this pseudo-colonial house utilizes modern forms and materials, improves the circulation, allows for abundant natural light and includes complete living facilitation on one level.
Photograph courtesy of Wiebenson & Dorman Architects PC

FACING PAGE TOP: A family, living on the East Coast, preserved ties to Middle America by investing in a small-town, main-street building for a second home—above what was originally a pharmacy. Designed for gatherings large and small, the layout incorporates a mezzanine and cabinets that provide ample storage and sleeping options. Tall transoms above glazed interior doors take advantage of high ceilings and natural light from round-top, double-hung windows. Intact and prominently displayed at the entry are the wheels, cogs and pulleys of the turn-of-the-century elevator.
Photograph courtesy of Wiebenson & Dorman Architects PC

FACING PAGE BOTTOM: Substantial additions, renovations and improvements to a mid-century modern house successfully balance the original design doctrine with the owner's 21st-century goals.
Photograph courtesy of Wiebenson & Dorman Architects PC

Wiebenson & Dorman Architects PC
Kendall Dorman

1711 Connecticut Avenue NW
Washington, D.C. 20009
202.234.4200
www.wdarchitects.us

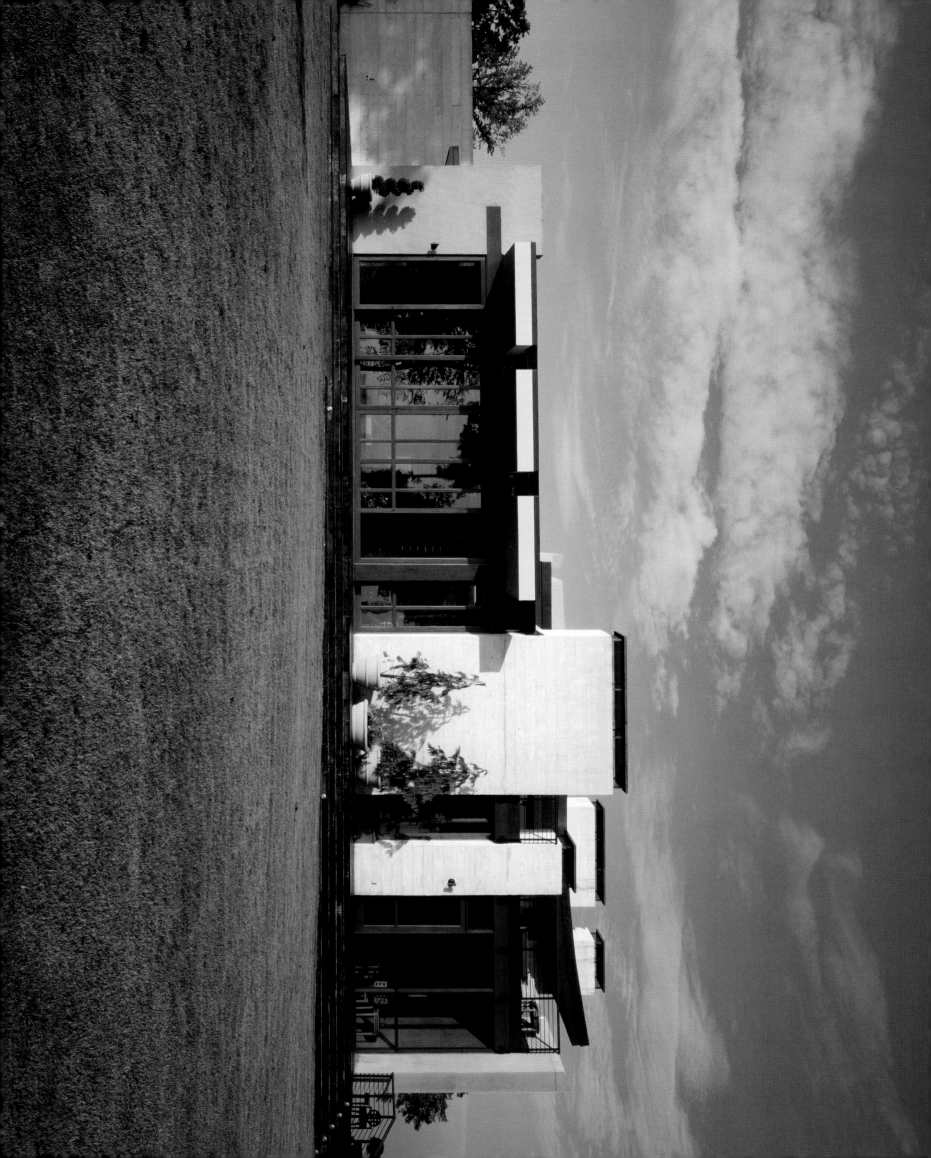

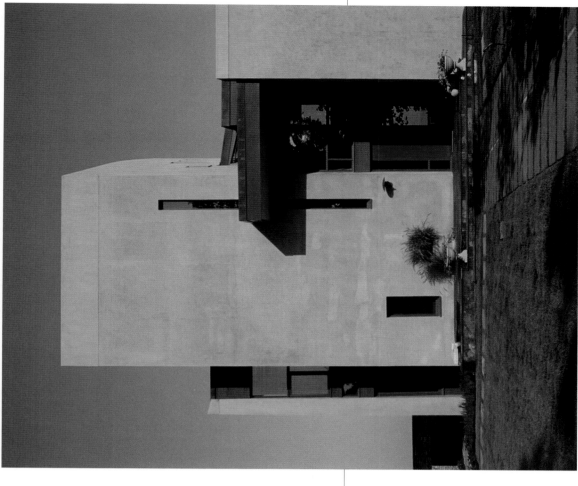

ABOVE: The approaching view of the entry along a slate path.
Photograph by Alan Dynerman, FAIA

FACING PAGE: An exterior view of the residence's sunroom and library.
Photograph by Robert Lautman

ALAN DYNERMAN

Dynerman Architects, PC

Architect Alan Dynerman, FAIA, is committed to the idea that the nobility of architecture is rooted in its utility: "Architecture is an applied art; its use is at the root of its beauty. Understanding this is essential to the transformative ideas of architecture—it allows the mundane to be understood as profound," he explains. He likens architecture to a symphony or a play: all are meant to be experienced in order to be fully appreciated.

Dynerman says of his work, "I don't know the answer before I begin." He is known for telling clients to let go of preconceived ideas of what a house should look like and instead asks, "How do you want to live in this house?" He focuses on how it should impact and enhance their way of life.

His diverse portfolio of contemporary and traditional projects has evolved out of exploration and investigation. He engages his clients, determines their lifestyles and preferences and develops the best solution for them within the greater context of their lifestyle and site. "The idea that a building and its design work with the site is the first thing we think about," he adds. Architecture that engages the landscape, recognizes its part in the natural and man-made environment and understands its place in the hierarchy is the balance Dynerman strives to achieve.

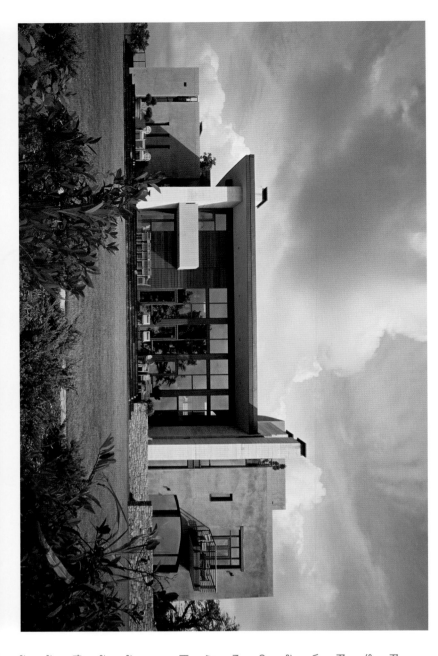

Dynerman Architects was established following several successful partnerships. Now, working as a sole practitioner with a small number of supporting designers, Dynerman completes both residential and commercial projects. "We are a small firm, but our reach has been broad," he describes of work done in Kuala Lumpur, Malaysia; Huntsville, Alabama; and in D.C., Maryland and Virginia. Projects have earned a National AIA Honor Award, several D.C. chapter AIA Awards and commendations by other professional organizations and magazines. His work was recently featured in *Inspired House* magazine's *Great Homes* publication, and his firm was mentioned in *The Washingtonian* magazine's listing of top D.C. architects, as selected by their peers.

Dynerman earned an undergraduate degree from Columbia University and trained under architectural icon Bruce Goff before pursuing graduate studies at the University of Virginia School of Architecture. A licensed practicing architect for more than two decades, Dynerman also teaches at the University of Maryland and sits on the advisory board of the UVA School of Architecture. He was named a Fellow of the American Institute of Architects in recognition of both his design skills and professional leadership.

Dynerman's most enjoyable projects are those where he and the clients mutually seek answers. Credited with being a good listener, he brings the design discussion to a "language of understanding." The results are houses that clearly embrace their specific place and function with beauty and grace.

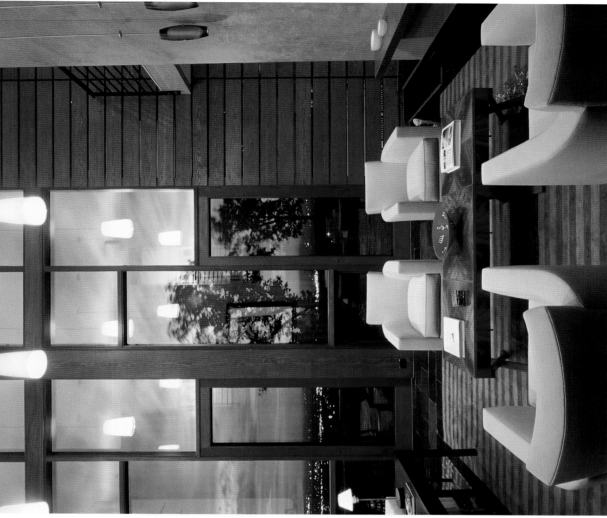

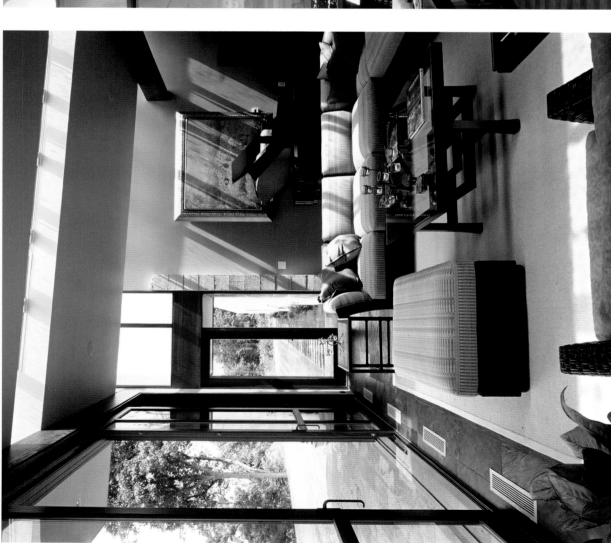

ABOVE LEFT: This sunroom exemplifies its name with expansive glass that invites in the sunlight.
Photograph by Robert Lautman

ABOVE RIGHT: Here, again, large windows prove to be an integral design element in this living room. Not only are the views intended to be a part of the room's ambience, the tone changes with the time of day as seen here at evening fall.
Photograph by Robert Lautman

FACING PAGE TOP: This west elevation and terrace demonstrate the importance of clean lines in context with the site.
Photograph by Alan Dynerman, FAIA

FACING PAGE BOTTOM: This cozy, contemporary master bedroom features a fireplace as its focal point.
Photograph by Robert Lautman

Dynerman Architects, PC
Alan Dynerman, FAIA
1025 33rd Street NW
Washington, D.C. 20007
202.337.1290
www.dwarchitects.com

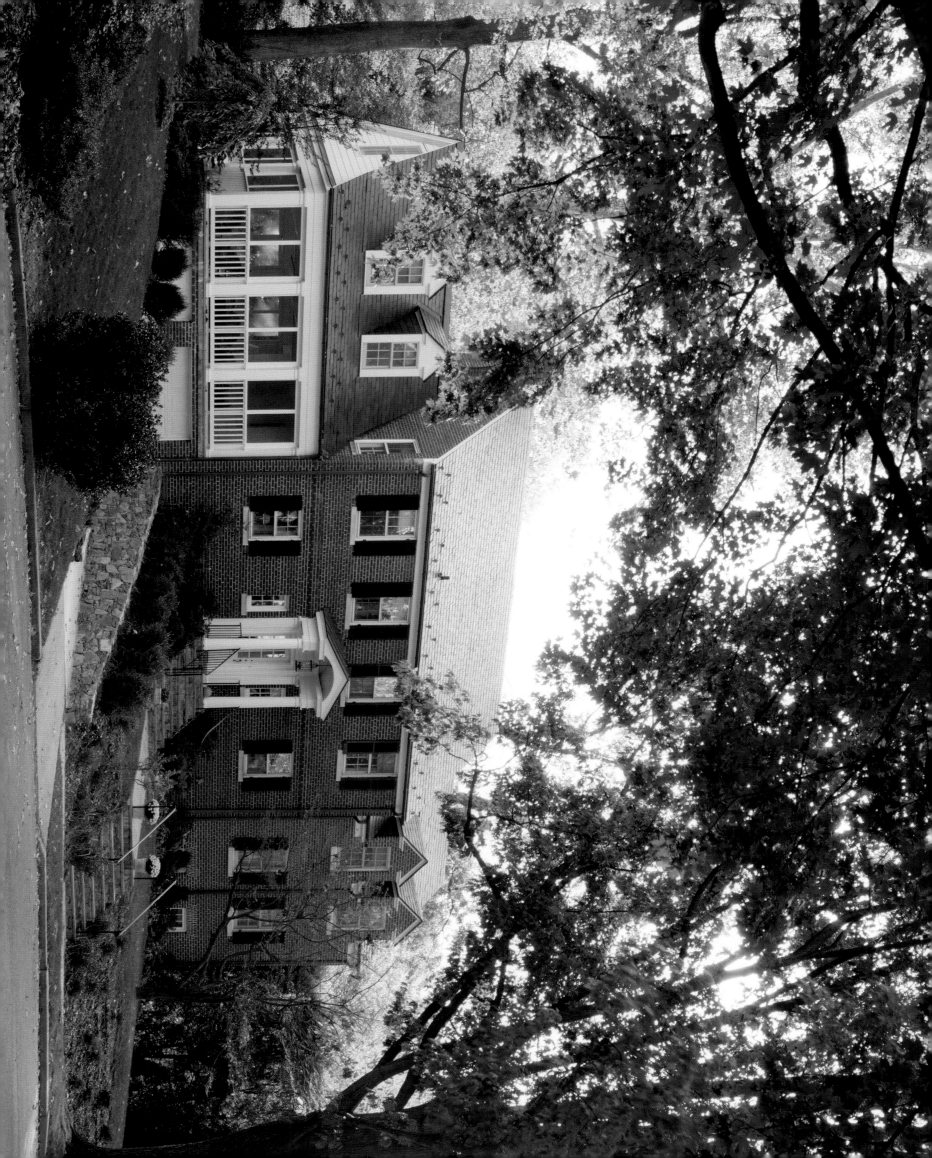

ABOVE: A view of the family room from the rear garden.
Photograph by Catherine Tighe

FACING PAGE: The front façade of a home in northwest Washington. The front porch and wings to the right and left were added in 2000. Contractor: Costello Custom Builders.
Photograph by Catherine Tighe

CLIFF ELMORE

Cliff Elmore Architects, PLLC

Some people know their career destiny as children, building elaborate block towers and aspiring to architecture. Others follow a more circuitous path. For Cliff Elmore, his first job after college—and its influential employer—would shape his future career path. Armed with a Bachelor of Arts degree in English from Vanderbilt University and a love of fine arts and music, Elmore took an administrative position with award-winning modernist architect Hugh Newell Jacobsen. From the sidelines of design, Elmore learned to appreciate how buildings are put together, and the importance of detail-oriented and ordered work. At Jacobsen's encouragement, Elmore left the firm to pursue graduate studies in architecture.

Elmore earned a Master of Architecture degree from Yale University and went on to work for some of the leading architects of the time, including Paul Rudolph and Richard Meier in New York and Allan Greenberg in Washington, D.C. "This has given me experience working at the highest levels of the profession, and has allowed me to see what is possible, what the best architects can do and what they do to achieve the best possible work," Elmore explains.

For him, doing the best work means approaching projects with a high level of detail. He feels it is important to strive to achieve a holistic approach to the practice of architecture, so that there is no distinction between large design decisions, small details and the more mundane, practical issues of construction. From initial considerations of client goals, site and current house conditions, Elmore develops a design concept that he then refines. "Often, one clearly preferable design solution stands out early on," he says. He emphasizes that architecture is always about self-editing and knowing when to simplify.

Much of Elmore's early work has consisted of additions to existing houses. For additions, he stresses that the new structure blends seamlessly with what already exists, and not appear to be clearly added. "It's the same approach as for a new house, where you wouldn't make one side different than another," he explains. His additions always work within the context and vocabulary of the existing home so as to be viewed as part of

a cohesive whole. Elmore's interior architecture reinforces this belief; he loves to design furniture, built-ins and cabinetry to ensure the same level of detail transcends form to functional elements.

While most of Elmore's residential design has been traditional in appearance, tenets of modern architecture always find a way into his work. In every project, as much as possible, Elmore incorporates energy efficiency, abundant natural light and space planning to encourage connectivity within interiors and to a home's exterior environment. "Any well-designed house should have these features," he advocates.

Taking a particular interest in accessible housing, for both handicapped and elderly residents, Elmore sits on the board of an organization that promotes ADA

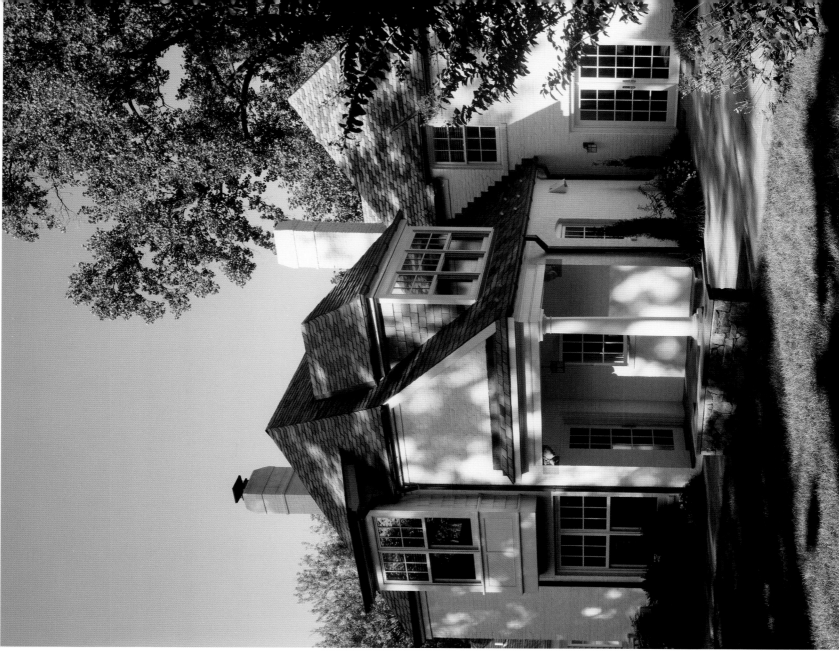

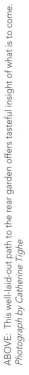

ABOVE: This well-laid-out path to the rear garden offers tasteful insight of what is to come.
Photograph by Catherine Tighe

RIGHT: A Spring Valley, Washington, D.C., residence as viewed from the rear garden.
General Contractor: Costello Custom Builders. Millwork by Juniper Cabinet and Millwork.
Photograph by Catherine Tighe

FACING PAGE LEFT: This vantage point offers a view of the relationship between the kitchen and breakfast room beyond.
Photograph by Catherine Tighe

FACING PAGE RIGHT: A view from the breakfast room to the rear hall and library beyond.
Photograph by Catherine Tighe

(Americans with Disabilities Act) accessibility, raising funds to modify houses for people who cannot afford to do so. He respects the idea of aging-in-place, and is committed to helping make houses comfortable for all people. His subtle incorporation of wheelchair ramps, roll-in showers and lowered counters in one house proves that accessibility can be integrated with elegance and style.

Elmore founded Cliff Elmore Architects in 2000 and has earned recognition as one of Washington's up-and-coming design firms with inclusion on *The Washingtonian* magazine's 2006 list of top architects and remodelers as selected by their peers. In addition to designs for residential projects, Elmore has completed a small number of commercial and institutional projects, including renovation and historic preservation

ABOVE: The façade of a house in Spring Valley as viewed from the rear garden. General Contractor: Frontier Construction Company. Millwork by Juniper Cabinet and Millwork. Interior Design by Stacey Sadie.
Photograph by Catherine Tighe

LEFT: Expansive windows provide a beautiful view from inside the home to the terrace and garden.
Photograph by Catherine Tighe

FACING PAGE TOP: A clean-lined, bright kitchen provides access and a view to the family room beyond. Concealed pocketing shutters can be used to close off the kitchen from the family room..
Photograph by Catherine Tighe

FACING PAGE BOTTOM: Carefully planned built-ins and trim details in the family room include a fireplace, a recess to accomodate a television and a desk concealed with pocketing doors.
Photograph by Catherine Tighe

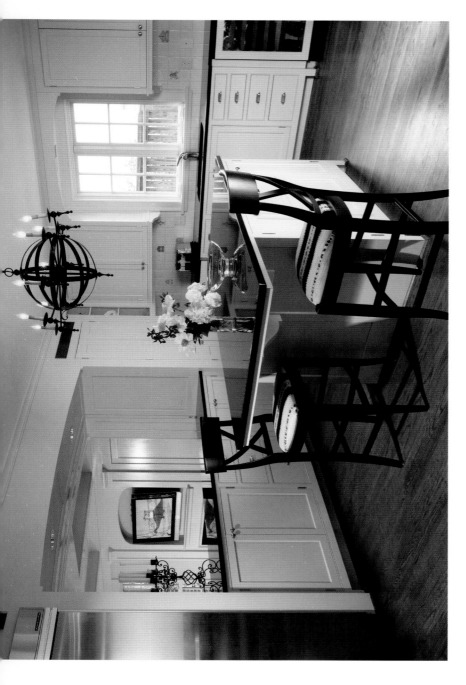

work. Nevertheless, he remains modest about himself and his work. He credits his family—wife Anne and son Church—with the support and encouragement necessary to run his practice. Not the type to promote his singular design vision, Elmore instead believes, "With sufficient effort, architecture can attain inevitability, where a structure seems so natural and to make so much sense that the hand of the architect becomes invisible."

ABOVE: A cheery galley kitchen takes advantage of the available space and view.
Photograph by Catherine Tighe

RIGHT: From a different vantage point, again, one can appreciate the use of elegantly arched entrances delineating the dining room from the living room beyond.
Photograph by Catherine Tighe

FACING PAGE: Arched openings and complementary millwork details frame the view from the living room of a Washington, D.C., apartment. General Contractor: Bedrock Builders. Millwork by Bedrock Builders and James Marshall Woodworking. Interior Design by Lavinia Lemon Interiors.
Photograph by Catherine Tighe

ABOVE LEFT: The view of the rear façade from the garden shows the expansive kitchen and master bedroom windows.
Photograph by Catherine Tighe

ABOVE RIGHT: The formal entry hall of a house in the Kalorama area of Washington, D.C., incorporates a dramatic staircase and an arched hallway entrance. General Contractor: Accent General Contracting Inc. Millwork by James Marshall Woodworking. Interior Design by Lavinia Lemon Interiors.
Photograph by Catherine Tighe

FACING PAGE TOP: A view of the front parlor. Columns help to differentiate the parlor from the adjoining front hall while maintaining open flow and sight-lines.
Photograph by Catherine Tighe

FACING PAGE BOTTOM: French doors and floor-to-ceiling windows establish a strong connection between the kitchen and garden.
Photograph by Catherine Tighe

Cliff Elmore Architects, PLLC

Cliff Elmore, RA
4900 Massachusetts Avenue NW, Suite 115
Washington, D.C. 20016
202.237.8955

PHILIP ABRAM ESOCOFF

Esocoff & Associates | Architects

There is quite a bit of variety in people's perceptions of a "dream home"—from cozy cottages to sprawling mansions. Architect Philip A. Esocoff, FAIA, will tell you his dream home is the one he has shared with his wife and son for the past three decades. His modest residence encompasses three units in the D.C. historic register-listed Woodward Condominium Building on Connecticut Avenue. Opened in 1910, the Spanish Colonial building and its elaborate Baroque entrance embody a timeless elegance and grace. Esocoff and his wife were married beneath its red-tiled roof pavilion. With captivating views of the Washington skyline, impeccable interior detailing and a place in the city's architecture and urban design history, The Woodward is a wonderfully personal private home that maintains a strong connection to its context and place in time.

Esocoff and his namesake firm, Esocoff & Associates | Architects, aspire to create the same landmarks for living with their luxury high-rise residential projects. Called "savvy, exuberant, witty, and wonderful" by *Washington Post* architecture critic Benjamin Forgey, Esocoff's work strikes a balance between expressive design and meeting the goals of both developers and families.

"We see building in Washington not as a series of restrictions—height, historic districts and preservation—but as a series of opportunities," says Esocoff. His firm puts both thought and creativity into its

designs from exterior façades to individual residences. Designs must meet with approvals from zoning commissions, community groups and historic review boards. However, none of the firm's work would be possible without support for design excellence from clients such as Post Properties, Faison Associates and RCP Development. Esocoff & Associates' 30 architects spend a great deal of time considering what it means to build responsibly in the Washington context, architecturally, urbanistically, historically and culturally. Their

ABOVE: Pergolas with ornamental stars provide intimate spaces for small gatherings. Exhaust fans for the dwellings below are contained visually and acoustically within the chimney masses.
Photograph by Maxwell MacKenzie

LEFT: Floor-to-ceiling glazed bay projections with balconies above capture dramatic views up Massachusetts Avenue.
Photograph by Maxwell MacKenzie

FACING PAGE LEFT: Rendered in granite and limestone, the corner bow of Post Massachusetts Avenue combines the fenestration for the club room and dwelling above into a fitting urban-scaled façade feature.
Photograph by Maxwell MacKenzie

FACING PAGE RIGHT: A gracious club room with limestone fireplace offers a quiet oasis from the busy downtown intersection just outside.
Photograph by Maxwell MacKenzie

intellectual rigor and focused approach have earned 25 multi-family residential commissions with more than 5,000 individual residences in the last seven years alone.

Esocoff buildings located at 400, 1010 and 1499 Massachusetts Avenue NW, as well as the nearby Whitman at 910 M Street NW, have become neighborhood landmarks, recognized for their design, planning and response to historic preservation. The firm addresses Washington's challenging site constraints—narrow lots, height restrictions, nearby buildings—with creative massing, careful material selection and refined exterior detailing. For example, on its 400 Massachusetts Avenue project, an embellished screen wall bridges different height requirements on two sides of the building to create an architectural flourish at a key urban nexus. Warm masonry colors reduce glare from Washington's often bright-white skies. Window glass is recessed—a small but critical additional dimension into the exterior wall than is common—to increase the plasticity of the façade and suggest a more traditional depth of masonry construction. "It's a visually satisfying, deceptive yet true expression of contemporary architectural sensibilities and building technologies," Esocoff explains. The firm works closely with its masons and construction teams to ensure that elaborate brickwork bonding patterns and carefully tooled mortar joints are faithfully executed. "We look carefully at the very smallest details in a way that is not typical for large residential buildings," he adds.

It may come as a surprise that Esocoff & Associates designs each individual residence in its buildings. There are no stock floor plans; every building and unit is unique. What may be an even greater surprise is that Phil Esocoff has a personal hand in every one. After having lived in a condominium for most of his life, Esocoff can appreciate the lifestyle's subtleties. "I think about every ritual of life, from a casual Sunday morning with a bagel and newspaper to an intimate dinner party, so that they are all gracious experiences," he explains. He and the firm analyze everything from storage ("Everyone needs someplace for their rolling luggage") to sight lines ("You don't want to see the bathroom from the

LEFT: Designed for Faison & Associates, the H Street façade of 400 Massachusetts Avenue NW becomes an ornamental screen wall, framing views of Union Station for a private terrace at its prow.
Photograph by Maxwell MacKenzie

FACING PAGE: The undulating façade along Massachusetts Avenue is a rich tapestry of materials, colors and forms in a well-orchestrated composition. While it emphatically marks this key intersection in the L'Enfant plan, it also joins cooperatively with surrounding buildings to properly define the surrounding streets.
Photograph by Maxwell MacKenzie

dining room table"). Even the noise level of the HVAC system is carefully considered; the firm often specifies water-source heat pumps that are both quiet and energy efficient, and always locates mechanical systems away from primary living spaces. Esocoff is quick to add that he judges a building's beauty by functionality, durability, as well as, aesthetics—abiding by the Vitruvian principles of commodity, firmness and delight.

Community spaces within each building are as well thought-out as the individual homes. Stemming from Esocoff's personal connection to his own building's rooftop, roof gardens are frequently incorporated. Walking paths and gathering areas are complemented by gardens outfitted with pools, grills and catering kitchens complete with trash chutes. Recently, several projects have included fully landscaped sustainable Green roofs that harvest rain water, which is reused for irrigation. Both environmentally beneficial and fostering a sense of community, the roof garden comes to be seen and used by residents as a communal backyard.

Esocoff enjoys any opportunity to show how his firm's multi-family projects can have architectural merit and be a meaningful part of the urban fabric. His work has earned numerous awards for design and construction craftsmanship, and has been featured in prestigious architectural journals, including *Architectural Record, Abitare and Architecture,* as well as local newspapers *The Washington Post* and *The Washington Times*. "I would like to think we have raised the level of architectural discourse through our work and public presentations," he says.

A Fellow of the American Institute of Architects, Esocoff has practiced for 33 years. He holds undergraduate and Master of Architecture degrees from the University of Pennsylvania and a diploma in polyhedral and geodesic structures from the Architectural Association Graduate School in London. In 1975, he followed then-girlfriend, now wife, renowned architect Amy Weinstein, FAIA, from Philadelphia to Washington, D.C. He spent 16 years with an area firm, 10 as a principal, before founding his own firm in 1995. Esocoff fosters within his firm a collaborative, studio environment. Its staff is divided into small teams for each project, with contributions welcomed and expected from everyone.

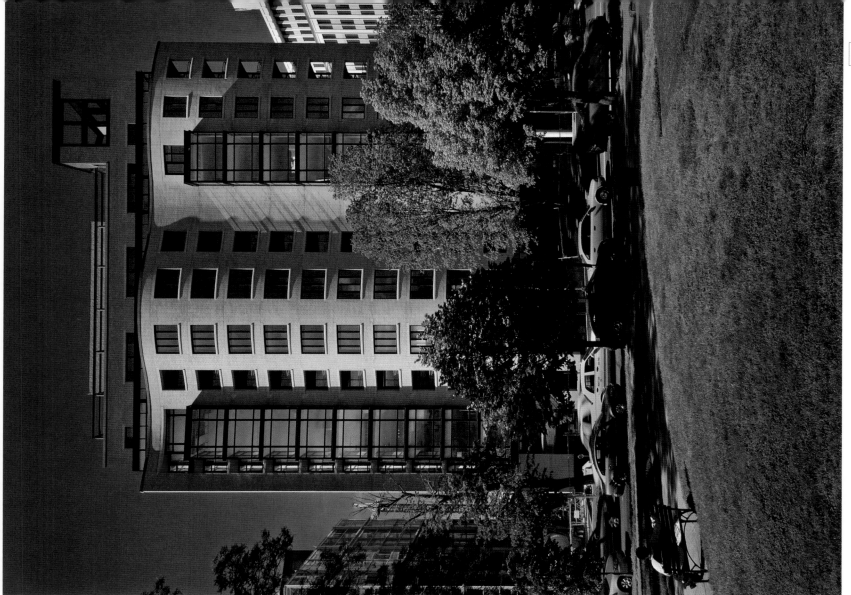

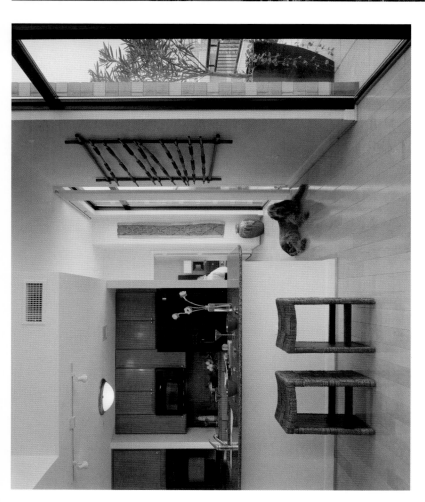

Esocoff and his family understand what it means to live in a wonderful building that connects to the city at large. He remembers being struck initially by The Woodward's architecture and shares the sentimental remembrances that come from being married and raising a family in one place. "I hope the buildings my firm designs will allow other families to share this kind of experience," he says. Despite all the awards and media accolades, Esocoff admits he is waiting on one final stamp of approval. "I'm waiting for someone who wants to get married atop one of my buildings."

ABOVE: Penthouse units at the two top floors of buildings along Massachusetts Avenue take advantage of a zoning required 1:1 setback. Their generous terraces feature sweeping views that include the Washington Monument, National Cathedral and Capitol building.
Photograph by Maxwell MacKenzie

RIGHT: The sinuous façade of 1010 Massachusetts Avenue NW, designed for RCP Development and Faison, is punctuated by projecting glass bays. Elsewhere, inset balconies frame views of the sculpture in Gompers Park.
Photograph by Maxwell MacKenzie

FACING PAGE LEFT: Unique stone floor "carpets" were fabricated using computer cutting technology. Aniline-dyed wood paneling creates a compelling interior entry experience.
Photograph by Maxwell MacKenzie

FACING PAGE RIGHT: A color reversal and quieter coloration welcomes residents at the elevator lobby.
Photograph by Maxwell MacKenzie

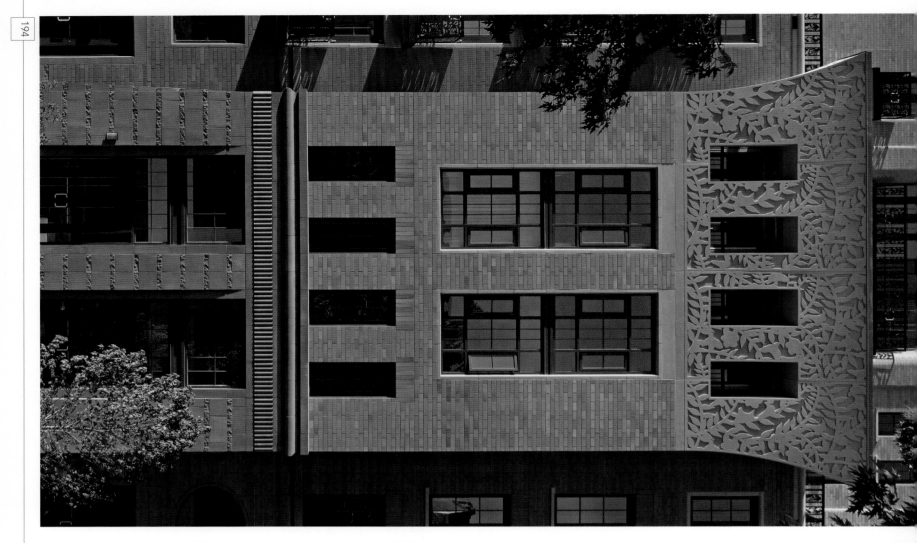

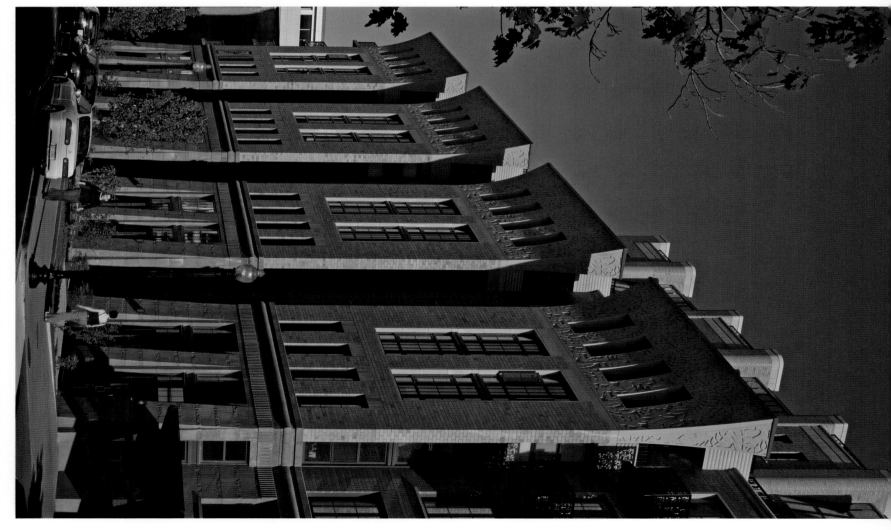

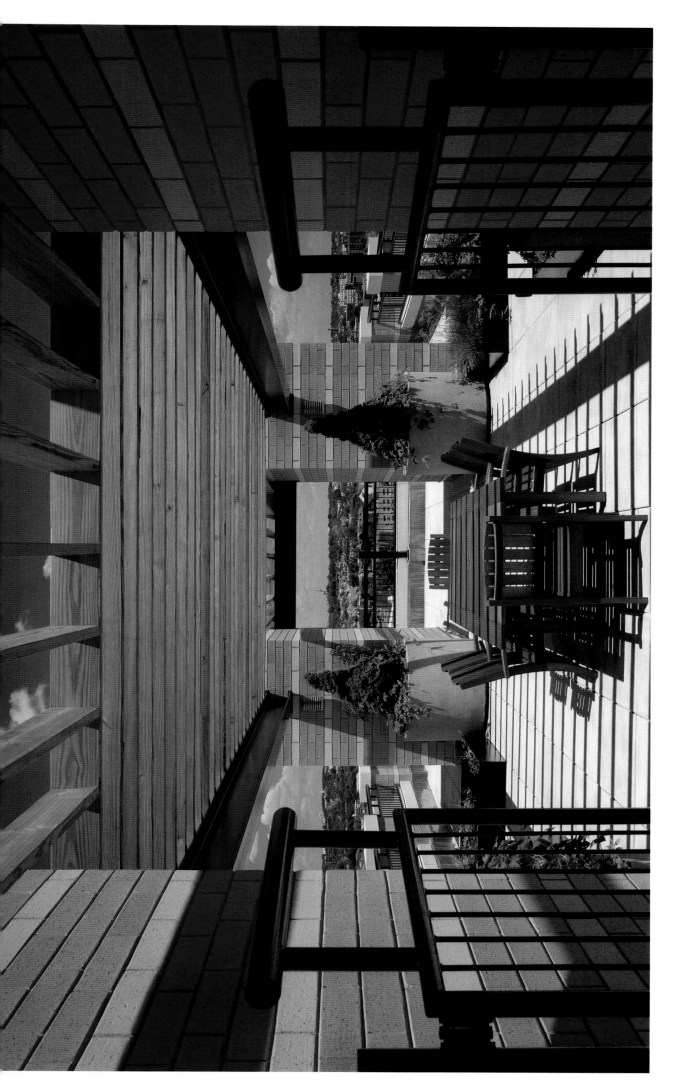

ABOVE: A rooftop pavilion along Massachusetts Avenue is a popular venue for parties—and perhaps weddings—at 400 Massachusetts Avenue NW.
Photograph by Maxwell MacKenzie

FACING PAGE LEFT: The rhythm of the bay projections along the street is echoed in the setback towers above the seventh floor. Although this project is within a historic district, the 40-foot zoning-required setback that separates the upper and lower levels of the building was generated by concern for an especially historic and exuberantly detailed group of townhouses across the street.
Photograph by Maxwell MacKenzie

FACING PAGE RIGHT: The battered base and flared cornice of The Whitman, designed for Faison, encompass richly detailed cast stone. Custom floral bas relief patterns respond to the surrounding high Victorian architectural context.
Photograph by Maxwell MacKenzie

Esocoff & Associates | Architects
Philip Abram Esocoff, FAIA
1150 Seventeenth Street NW, Suite 800
Washington, D.C. 20036
202.682.1600
www.esocoff.com

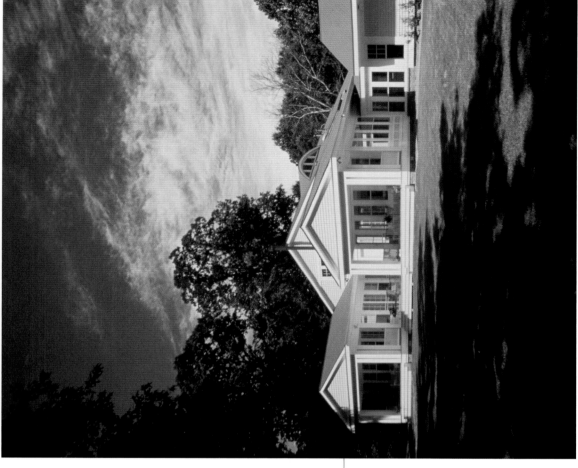

ABOVE: In Memphis, Tennessee, the Neoclassical plantation house melds with the bungalow to create a contemporary hybrid.
Photograph by Alan Karchmer

FACING PAGE: With simple, clean-lined columns, the veranda maintains the historical integrity and charm of the traditional South.
Photograph by Alan Karchmer

JERRY HARPOLE

Harpole Architects, PC

Jerry Harpole knew he wanted to become an architect from the tender age of three, when he played with wooden blocks made by his grandfather. Harpole evolved from building houses with blocks to designing them on paper. He earned a Bachelor of Science in architecture from Georgia Institute of Technology and a Master of Architecture with honors from Harvard University Graduate School of Design, and studied at the École des Beaux-Arts in Paris. "Architecture is the only career I ever considered," Harpole remarks. "I am lucky to do what I love every day."

Harpole encourages this same passion for architecture in each of his clients, by maintaining open relationships and continuous dialogue. "I bring clients along in the process," he describes, blurring the lines between their ideas and his own. For his high-profile and elite clientele, Harpole creates truly custom houses, never imposing his vision but instead capturing the shared vision that arises through the collaborative process. Each house is very specific to its occupants and neighborhood, resulting in a portfolio rich with variety.

ABOVE LEFT: South Beach in Key West. Two apartments combined to create a large loft space that unites the living room, dining room, kitchen and office surrounded by balconies overlooking Mallory Pier. The furniture style and placement give the feel of an ocean liner.
Photograph by Gordon Beall

ABOVE RIGHT: The limestone columns, with fossils embedded in the surface, create a colonnaded entry hall, while the honed marble flooring mellows the intense Florida sun.
Photograph by Gordon Beall

FACING PAGE: Designed by Jerry Harpole, the bookcases and the semicircular desk define the office area.
Photograph by Gordon Beall

Advocating strong, simple design concepts that carry through an entire project, Harpole believes a good idea can survive even in the face of budget cuts, client changes-of-mind or construction challenges. His architecture can best be called transitional, an aesthetic that blends the openness of contemporary design with the softness of more traditional styles. While it features some traditional detailing, the look is cleaner and more streamlined. "There is a livable edge to my work," he explains.

With more than 25 years of professional experience—and houses completed across the country and in Europe—Harpole is proud to have retained the now old-fashioned ability to draw by hand. "I'm faster than the computer," he says with a laugh. He is able to render images that bring designs to life for his clients. The artistic architect also paints, sculpts and designs furniture for many of his interior design projects.

Harpole Architects has been in practice since 1982, providing architecture, interior design and construction administration services. Harpole is assisted by a staff of six employees. Recognized for its attention to detail and its demand for quality and perfection, the firm was included on *The Washingtonian* magazine's 2006 listing of top architect and remodeler "names to know." Projects designed by the firm have been featured in *Architectural Digest, Home & Design, Robb Report, Metropolitan Home, Better Homes and Gardens Special Interest Publications, Renovation Style, The Washington Post, Palm Springs Life* and *San Diego Magazine*.

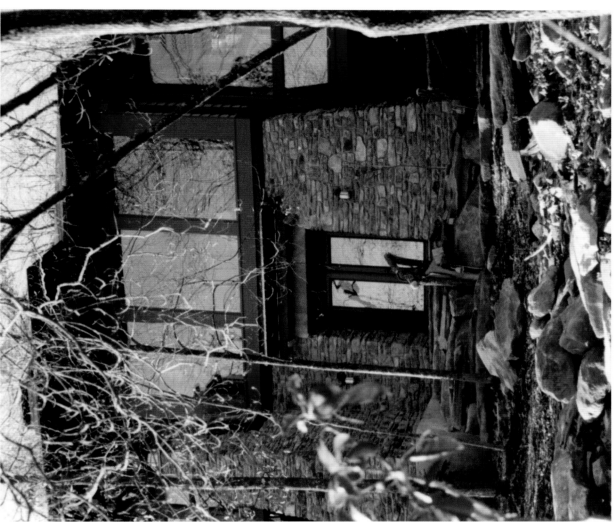

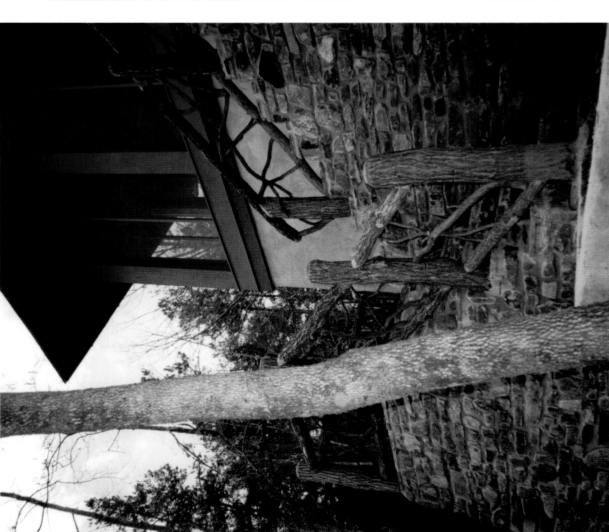

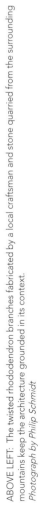

ABOVE LEFT: The twisted rhododendron branches fabricated by a local craftsman and stone quarried from the surrounding mountains keep the architecture grounded in its context.
Photograph by Philip Schmidt

ABOVE RIGHT: The stairway from the first-floor foyer to the second-floor living room is a bridge, which crosses a natural stream connecting the main house to the garage.
Photograph by Philip Schmidt

FACING PAGE: Natural materials abound in the living room. Tennessee orchard stone, verdigris copper, polished granite, pine logs, peeled sassafras railings and wood floors connect the interior design with the exterior architecture.
Photograph by Philip Schmidt

Harpole Architects, PC
Jerry Harpole, RA
1413 B Wisconsin Avenue NW
Washington, D.C. 20007
202.338.3838

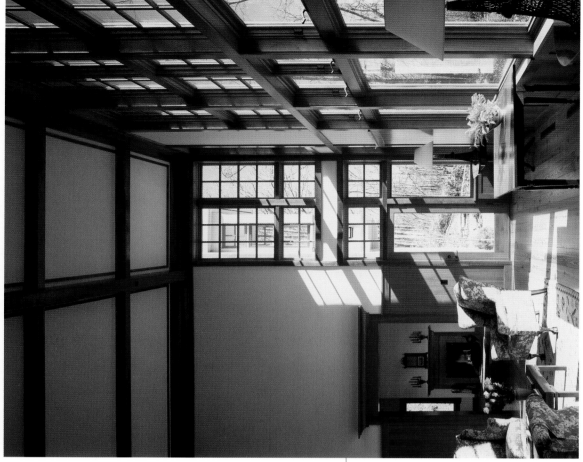

ABOVE: Killermont, Rappahannock County, Virginia. Natural sunlight floods this great hall with library and fireplace in the foreground. The handsome natural-finish cherry paneling frames the large, divided-light windows, merging with the trees beyond.
Photograph by Maxwel/MacKenzie

FACING PAGE: Shown at dusk, the west façade of this Killermont, Virginia, residence reveals salient design elements, including deep roof overhangs, stucco tower walls, paneled walls and a stone base.
Photograph by Maxwel/MacKenzie

OUTERBRIDGE HORSEY

Outerbridge Horsey Associates, PLLC

The Pritzker Prize-winning Mexican architect and landscape designer, Luis Barragan, was recognized for imbuing his modern designs with vibrancy, warmth and restrained elegance. His motto "to promote beauty in the service of graceful living" has been adopted by Washington, D.C., architect Outerbridge Horsey, AIA, LEED® AP, to sum up his own approach. His seven-person practice, Outerbridge Horsey Associates, balances modernism with the scale, proportion and order of more traditional aesthetics. The firm's stylistic versatility, restraint, meticulous attention to detail and integration of architecture with the landscape have contributed to its award-winning reputation since 1987.

The firm's brand of "traditionalism with invention" incorporates an understanding of architectural vernacular with a studied interpretation of the client's requirements for the present and future. "Our goal is to create something authentic that belongs to the client," Horsey explains. Guided by a lifestyle questionnaire and in-depth conversations, he and his associates learn how their clients live, how they think and what they admire. This understanding and collaboration inspires the designers to present initial possibilities, which allows further collaboration, and produces houses that are personalized and unique.

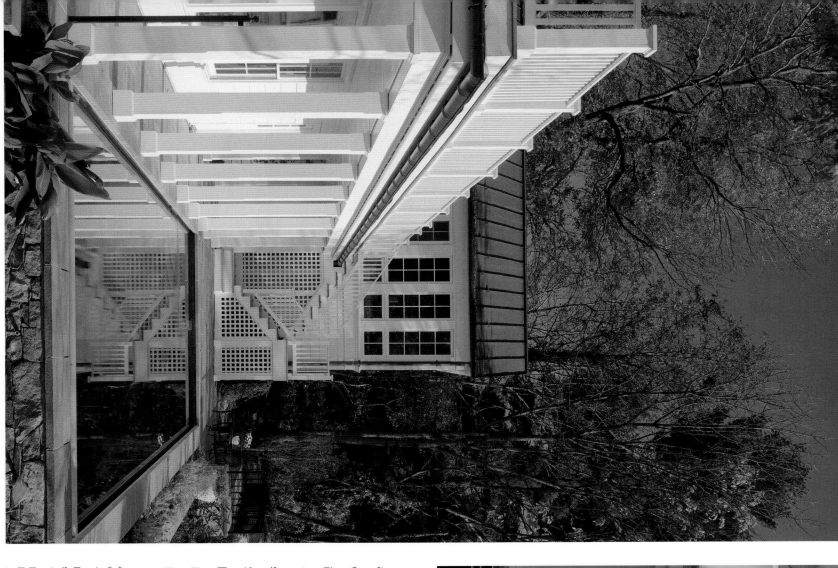

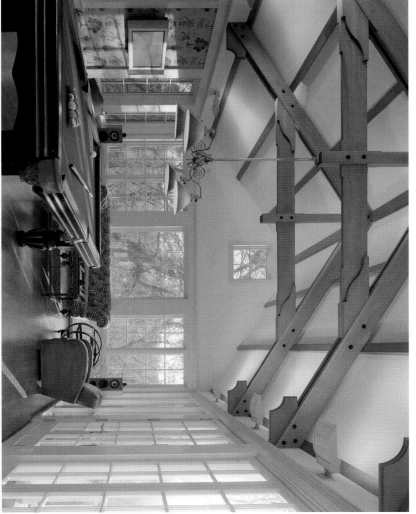

Their projects are characterized by an understanding of traditional building and infused with a sensibility of modern architecture. Forms are derived from, and closely linked to, the surroundings, whether urban context or rural environment. "I'm a modernist at heart, even though much of my work is traditional," Horsey confides. He believes that all of his work should appear to have been always "intended to be there." Designs incorporate abundant natural light through the use of clerestories, skylights and windows. Interior rooms are integrated with outdoor spaces to engage the landscape. Spaces are ordered in pleasant, inspired ways to encourage interaction and a comfortable flow between rooms. The greatest compliment paid to him, he says, was by renowned architect Hugh Newell Jacobsen, who, admiring the design of his pyramidal greenhouse addition, admitted, "I wish I had built this myself."

ABOVE: With a majestic view of the Potomac Palisades through its expansive windows beyond, this game room is complete with "I" finish trusses, a pool table and seating area. Builder: RSB Builders, Whitehaven, Washington, D.C.
Photograph by Maxwell MacKenzie

LEFT: On a steeply sloped site, the columned kitchen porch, exterior stair and swimming pool integrate the house with the surrounding landscape. Whitehaven, Washington, D.C.
Photograph by Maxwell MacKenzie

FACING PAGE: Anchoring the house on its steeply sloped site, the two towers frame the great hall overlooking the valley below. Killermont, Rappahannock County, Virginia.
Photograph by Maxwell MacKenzie

In each project, the firm ensures the use of the highest quality materials and detailing to provide the client with the finest finished product possible within the budget. Through the years, Horsey has developed strong bonds and admiration for the best contractors, skilled craftsmen and artisans in the area. He is active personally throughout construction, working closely with contractors on issues of construction, material selection and detailing to ensure that the finished product is as he and the clients envisioned. The firm takes particular pride in its custom design and integration of elements such as stairs, windows, doors, paneling, casework and kitchen cabinetry.

As a LEED® Accredited Professional, Horsey has been a longtime advocate of the importance of Green design to his clients. On the large scale, the firm has produced award-winning site plans—in collaboration with such noted landscape designers as Michael V. Bartlett of Bethesda, Maryland—that prove their understanding of the correct placement of architecture elements, gardens and vistas for the particular climes of the locale. In the firm's residential work, incorporating natural daylight for passive solar efficiency is one of the most important considerations in every design. "Much of what we do has always been Green," Horsey says. Geothermal energy sources and other efficient building systems are specified for long-term benefits. Issues of indoor air quality are met by selecting finishes—such as paints, carpets and cabinet materials—that limit or avoid harmful off-gassing. The firm often selects locally produced or locally available building materials that require less energy to transport to a project site. "Our contractors are sensitive to Green design, too; we all understand the importance of this approach," he explains.

Principal Outerbridge Horsey founded his firm in 1987. He is the principal designer, working closely with the design team which includes Natalia Veniard, Katie Phelps, Ari Goldstein, John Cazayoux and Charlotte Dam. Their combination of skills, and Horsey's established working relationships with like-minded structural and mechanical engineers, lighting designers and landscape designers, contributes to the design development, refinement and successful completion of every project.

The firm has designed residential projects ranging from new houses to renovations and additions in locations as varied as the Washington, D.C., metropolitan region; Maryland's Eastern Shore; the Blue Ridge Mountains of Virginia; Newport, Rhode Island; and Antigua, Guatemala. Current residential projects include new houses near St. Michaels on Maryland's Eastern Shore, on the Wicomico River in Southern Maryland, in Madison County, Virginia and in Nantucket. In addition to its residential work, Outerbridge Horsey Associates also designs for institutional clients. Recent projects have included the Georgetown University Alumni House and a complete renovation and expansion of the Zartman House administration building at Sidwell Friends School in Washington,

ABOVE: This master bathroom, located in the historic main house, boasts wood paneling and detailing designed to seamlessly integrate the historic interiors. Myrtle Grove, Talbot County, Maryland. Builder: John S. Labat.
Photograph by Charles Rumph

LEFT: Interior of pool/guest house with view from the living room, through the kitchen and entry to the study beyond. Myrtle Grove, Talbot County, Maryland. Builder: John S. Labat.
Photograph by Erik Kvalsik

FACING PAGE LEFT: Pool/guest house designed in the Eastern Shore manor house vernacular, sits comfortably under the great oak. Myrtle Grove, Talbot County, Maryland. Builder: John S. Labat.
Photograph by Charles Rumph

FACING PAGE RIGHT: A spectacular view of the historic main house and law office, pool/guest house, garage additions and the Miles River. Myrtle Grove, Talbot County, Maryland. Landscape design with Michael V. Bartlett.
Photograph by David Wallace

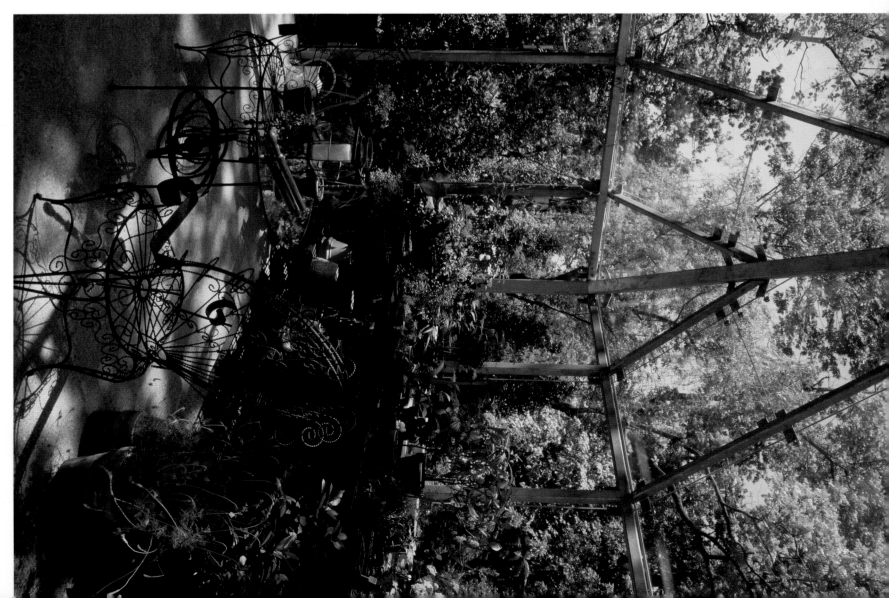

D.C. The firm has been recognized for design excellence with numerous awards from the Washington, D.C., and Northern Virginia chapters of the American Institute of Architects, and the AIA *D.C./Washingtonian* magazine "Residential Design Award."

A descendant of the early 19th-century Attorney General and United States Senator from Delaware of the same name, Outerbridge Horsey VII was born in Washington, D.C., and grew up abroad. His father's career in the Foreign Service moved him from Tokyo to Rome to Prague, concluding with four summers in Sicily. It was there that Horsey developed an interest in classical archaeology. He enrolled at the University of Pennsylvania and migrated to its Design of the Environment program, receiving a Bachelor of Arts. After taking a year off back home in Washington, which he spent building, gardening and attending the Corcoran School of Art, he returned to Penn to earn his Master of Architecture degree.

Horsey has long been committed to the Georgetown community in which he lives and works. He co-founded Trees for Georgetown in 1987, a volunteer group that plants, monitors and cares for street trees. From 1988 to 1992, he served as the first President of the Georgetown Ministry Center, a nonprofit ecumenical organization dedicated to assisting the homeless. He is a member of the Washington, D.C., Northern Virginia and Potomac Valley chapters of the AIA and the National Council of Architectural Registration Boards. He is married to Georgina Owen, a fine arts consultant, designer of women's accessories and a longtime associate of the D.C. Environmental Film Festival. They live in Georgetown with their two greyhounds.

TOP RIGHT: Whitehaven, Washington, D.C., residence. Builder: Ronald S. Barnes.
Photograph by Maxwell MacKenzie

BOTTOM RIGHT: This pool house complex includes pedimented bath and changing pavilions, which flank the center pergola creating a place apart and providing a garden focal point. Washington, D.C. Builder: Bowa Builders.
Photograph by Bob Narod

FACING PAGE LEFT: This greenhouse addition provides a place of tranquility and industry; an extension of the house, at one with the garden. Washington, D.C.
Photograph by Anne Gummerson

FACING PAGE RIGHT: The interior view of a greenhouse addition. Washington, D.C. Builder: John D. Richardson.
Photograph by Anne Gummerson

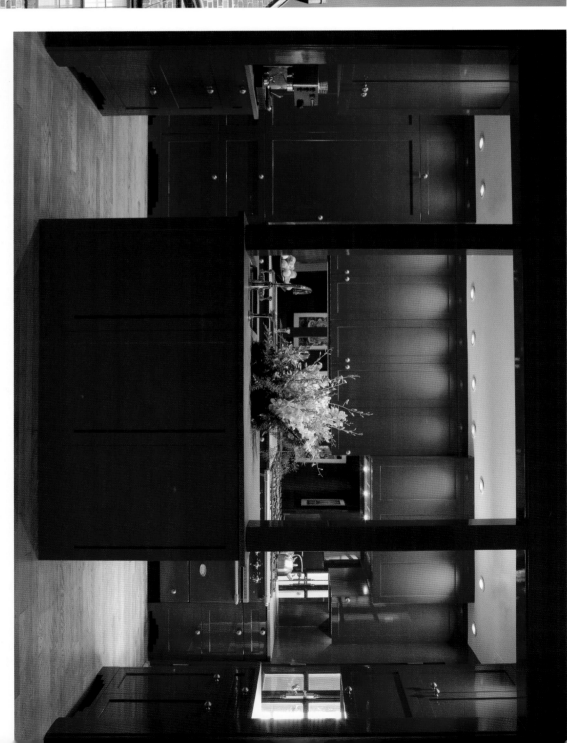

ABOVE: A lacquered, Bhutanese red kitchen provides an elegant extension of the dining room in this townhouse, Washington, D.C. Lighting with Scott M. Watson, IALD.
Photograph by Gordon Beall

LEFT: A steel-framed, wood-bay window extends the house into the garden, while a roof deck connects with the sky of this townhouse. Builder: Douglas Bale, Washington, D.C.
Photograph by Gordon Beall

FACING PAGE LEFT: This Naturalist's dayroom incorporates a collection of paintings, intaglio seals and bird sculptures. Original labyrinth floor design by the architect. Washington, D.C. Builder: David J. Brown.
Photograph by Anne Gummerson

FACING PAGE RIGHT: This dayroom—with domed clerestory flanked by skylights and mirrored recesses—includes the owner's astrological sign, painted by Howard R. Carr. Washington, D.C.
Photograph by Anne Gummerson

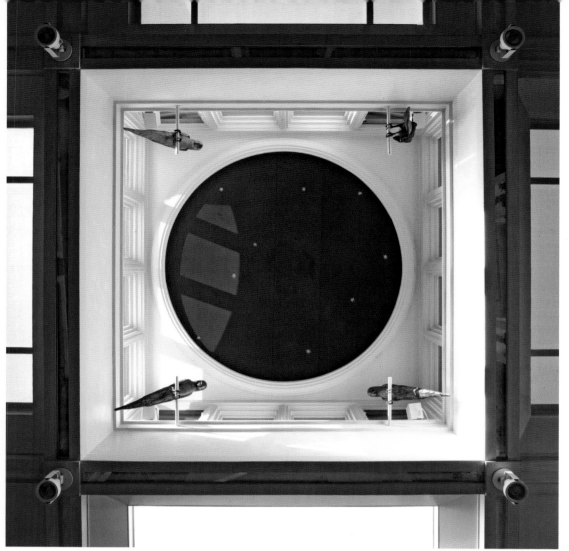

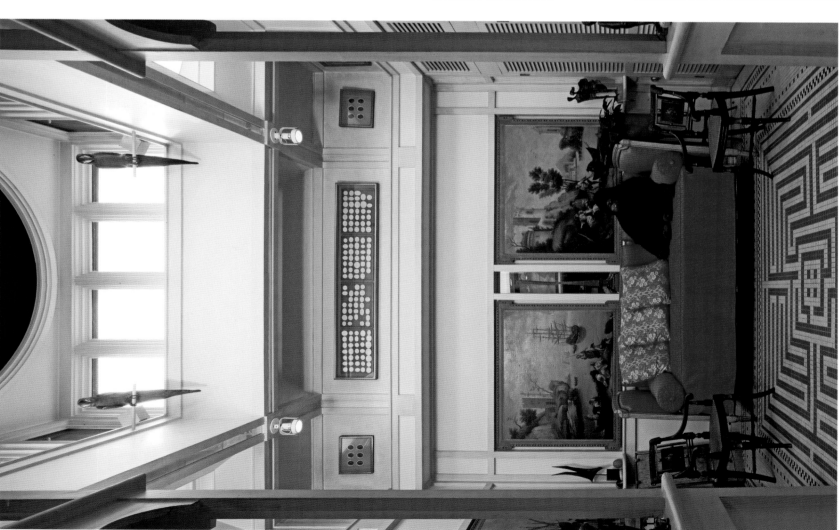

Outerbridge Horsey Associates, PLLC
Outerbridge Horsey, AIA, LEED® AP
1228 ½ 31st Street NW
Washington, D.C. 20007
202.337.7334
www.outerbridgehorsey.com

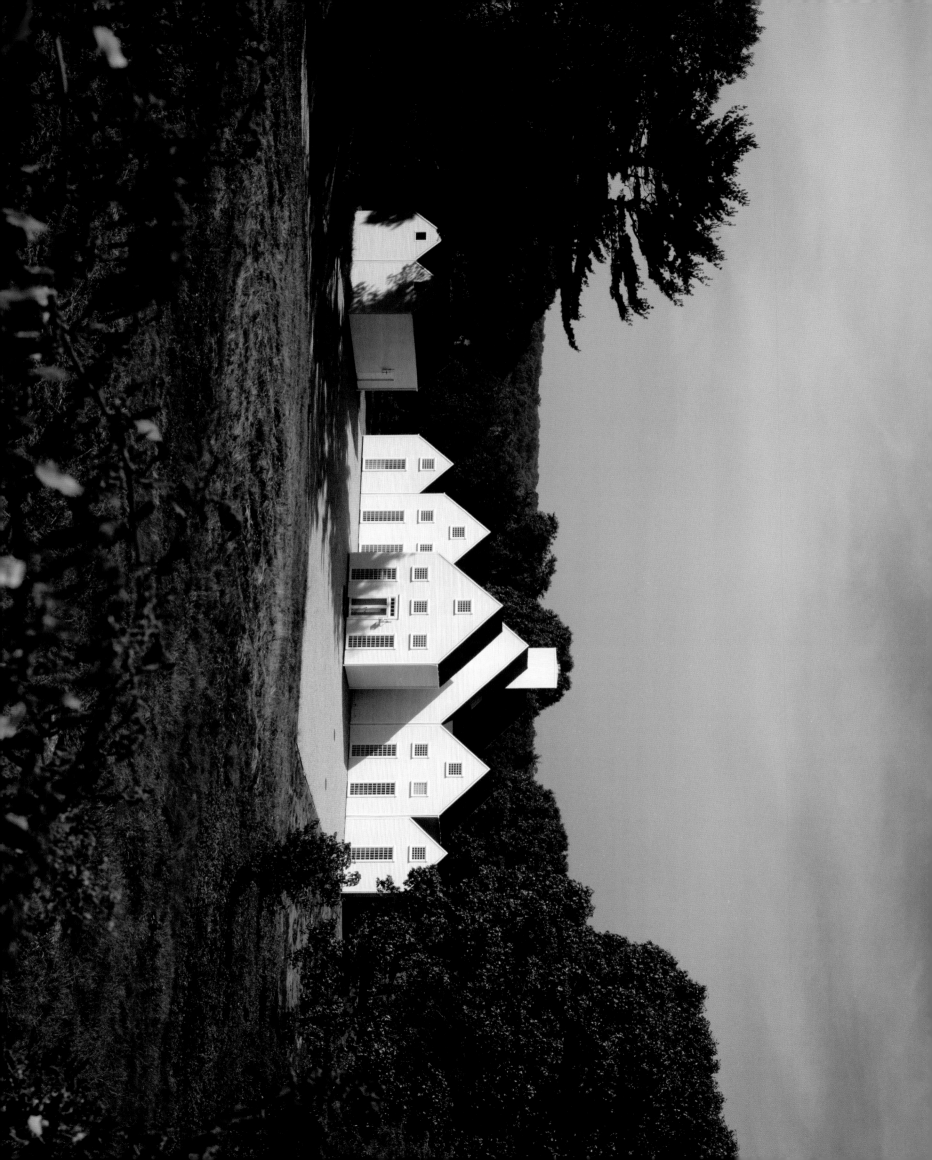

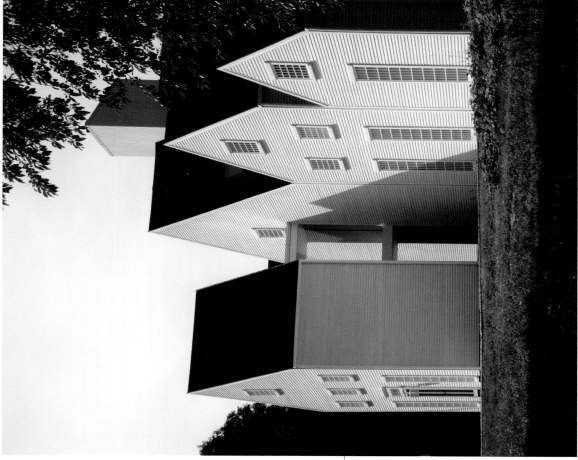

ABOVE: This engaging entry pavilion is a welcome front to the Palmedo house.
Photograph by Robert C. Lautman.

FACING PAGE: The stark whiteness of the Palmedo house against the lush, green trees cuts a very dramatic scene as viewed from the road. Saint James Long Island, New York.
Photograph by Robert C. Lautman.

HUGH NEWELL JACOBSEN

Hugh Newell Jacobsen, FAIA, Architect, PLLC

Many architects—in D.C. and elsewhere—credit Hugh Newell Jacobsen, FAIA, with encouraging them to pursue architecture as a career, influencing the way they practice or simply inspiring them to design in a similarly elegant, modern manner. Jacobsen has earned more than 120 design awards, including six American Institute of Architects Honor Awards; published three monographs; lectured worldwide; and completed projects in 28 states and 11 countries. Despite his impressive professional bio and reputation for design excellence, Jacobsen remains grounded. He is most proud of being married to his wife Robin for 54 years, and speaks with equal emotion when describing his latest grandchild or his latest residential project.

"Good houses should be about families, about children," he says. The significance of Jacobsen's architecture is as much about meeting each client's needs and complementing each site, as it is about any accolades that might result.

A Michigan native, Jacobsen left home to study painting, "much to my father's dismay," he recalls with a chuckle. He later transitioned to architecture. He holds undergraduate degrees from the University of Maryland, a London Architectural Association School of Architecture certificate, and a Master of Architecture degree from Yale. He began his career with an apprenticeship in the office of Philip

Johnson, where he learned to appreciate residential architecture. The time was mid-century, when modernism flourished and design opportunities were wide. Jacobsen opened his eponymous firm in 1958.

The influence of Louis Kahn, who taught Jacobsen at Yale and became a mentor and friend, is evident in his minimalist aesthetic, materiality and detailing. He recalls the torment of design studios, when Kahn would criticize everything from Jacobsen's architectural concept to his clothes and car. But it taught him a rigorous attention to details and consistency of concept. Jacobsen's use of natural light to infuse architecture with warmth and vitality is also influenced by his mentor. "The eloquence in the language of architecture is measured by how a building is put together," Jacobsen explains. "Detailing expresses the 'how' of buildings and—when done with great care and skill—reinforces the 'why.'"

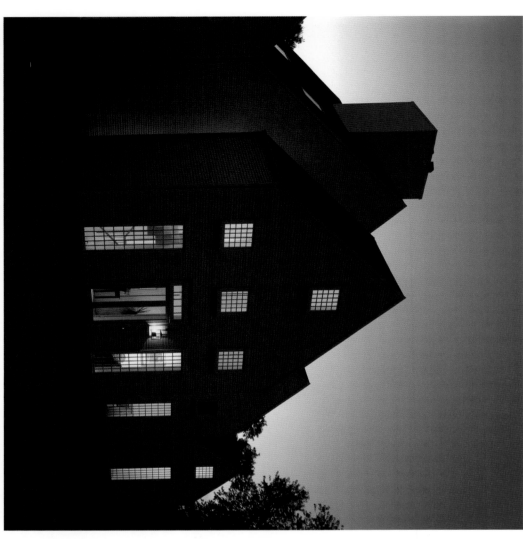

ABOVE LEFT: Another vantage point of the Palmedo house entry illuminated at night.
Photograph by Robert C. Lautman

ABOVE RIGHT: The Zamoiski residence pool house—which includes this outdoor living area—is beautifully reflected off the water at nightfall. Eastern shore, Maryland.
Photograph by Robert C. Lautman

FACING PAGE: The open kitchen/dining room pavilion of the Zamoiski house.
Photograph by Robert C. Lautman

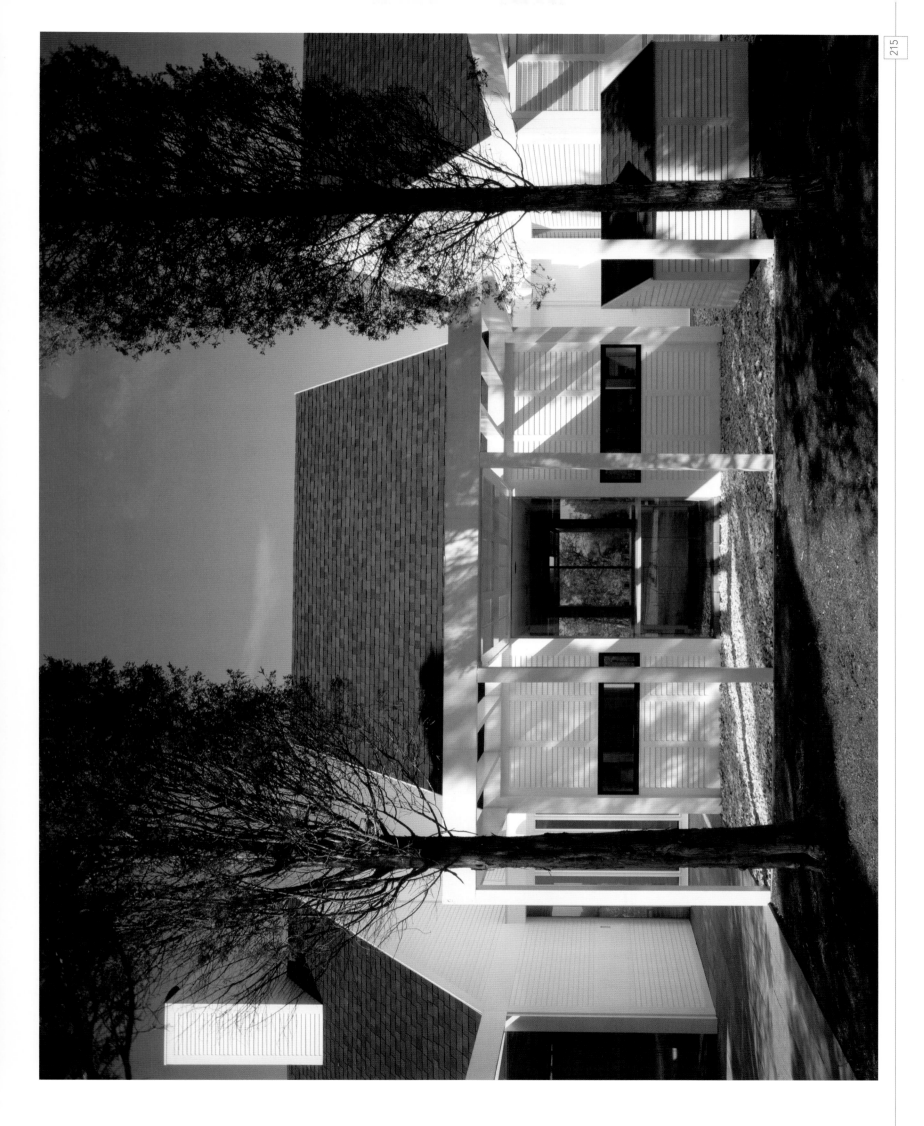

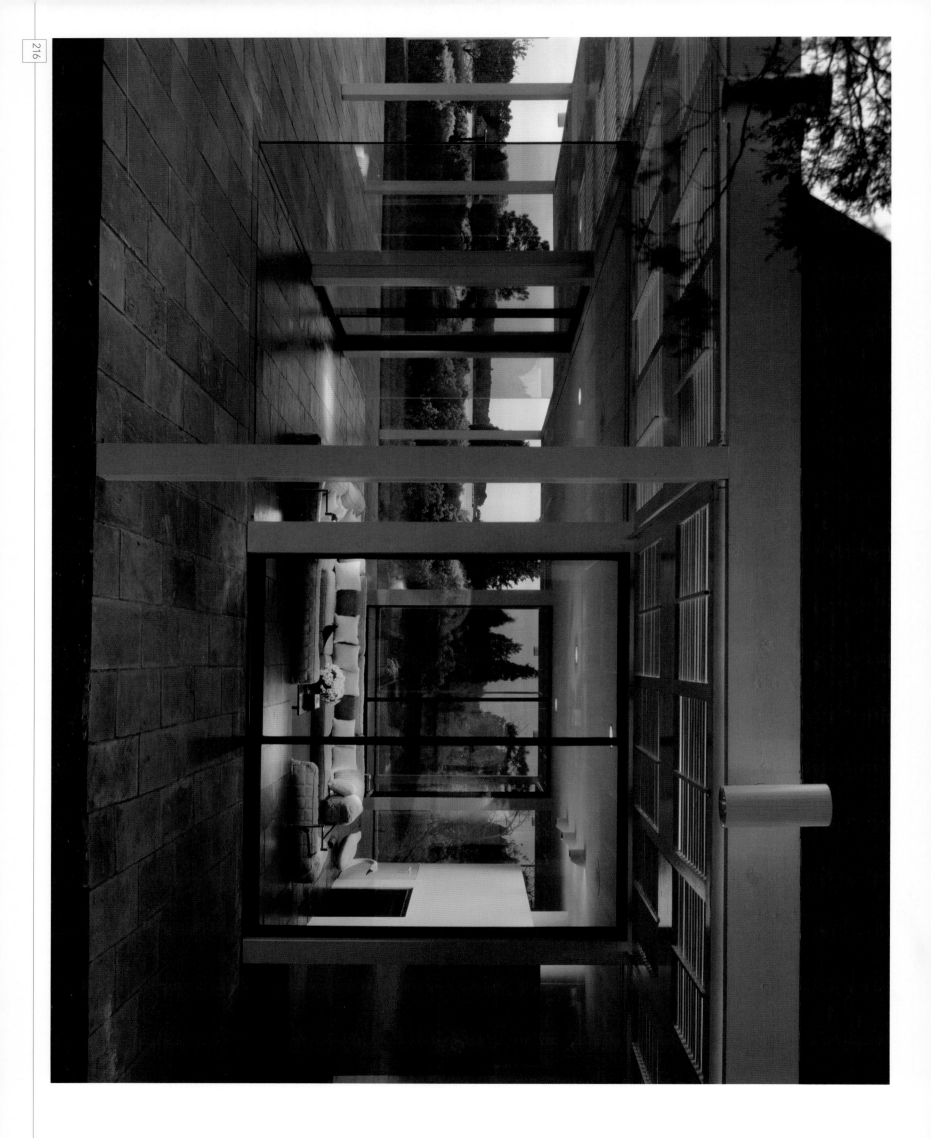

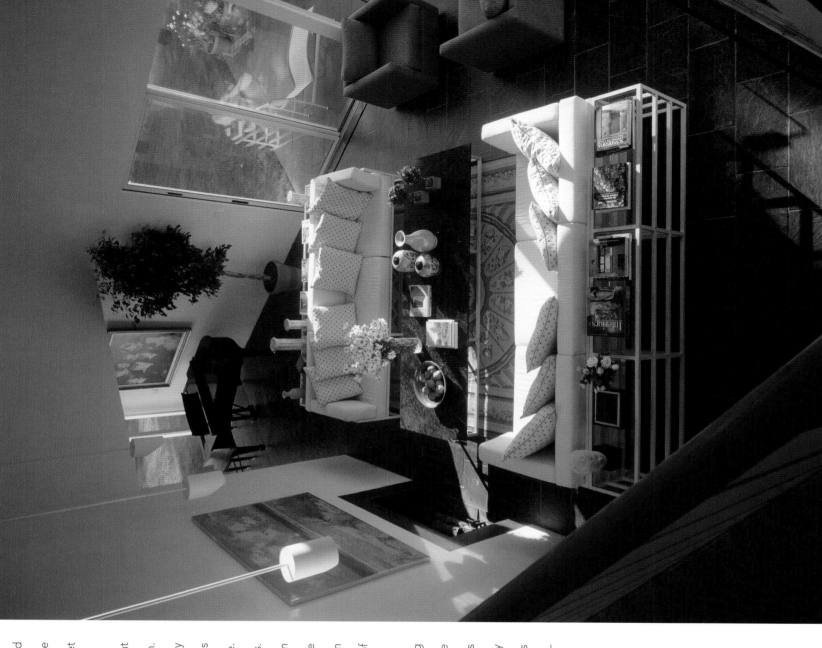

Jacobsen has designed cultural, institutional and commercial buildings. His ability to incorporate contemporary spaces within historic structures, and his knowledge of historic preservation, have earned commissions, including the U.S. Capitol Building addition and two Smithsonian Institution restorations. Yet residential architecture has always been his passion.

"A house should look like a house," Jacobsen asserts, describing that his houses typically take the classic "Monopoly house" gabled-room form. However, his modernist training and eye for simple elegance bring contemporary sophistication to this traditional model. Functionality and flexibility are always high priorities, and Jacobsen eschews the notion of open, multipurpose space. Instead, his architecture is often arranged as a series of function-specific pavilions. The interior spaces within each building, and the exterior spaces created between them, serve not only to enhance the architectural design, but to complement the landscape as well. When *LIFE* magazine selected him to design its 1998 "Dream House," the magazine remarked on Jacobsen's ability to "combine the best of modernism with traditional American style, visual excitement with livability."

Balancing the specific needs and requirements of his clients is something that Jacobsen takes quite seriously. At the start of a project, clients complete detailed program outlines, answering questions about how many pairs of shoes they own and how they like to entertain. Jacobsen's ability to incorporate flexibility and expansion potential makes his houses appreciated for aesthetics, as well as functionality. "If I can solve the problem of where to put skis and Christmas trees— the 'stuff' of life—I've done my job," he says.

RIGHT: A bird's-eye view of the living room pavilion of the Palmedo house. *Photograph by Robert C. Lautman*

FACING PAGE: This open living room with glass from all sides integrates the room with the outdoors. Zamoiski house. *Photograph by Robert C. Lautman*

Clearly, he has done his job well over the past four decades of practice. His buildings have been recognized with six AIA Honor Awards—the nation's highest honor for architecture. Twenty of Jacobsen's residential designs have earned "Record House" commendations from the professional journal *Architectural Record*. Jacobsen was honored by promotion to Fellow of the AIA in 1971. His range of other professional honors has included the Washington chapter AIA Centennial Award, the national Tau Sigma Delta Silver Medal for Distinction in Design and several honorary degrees. He has been included on *Architectural Digest*'s AD 100 list of the top architects and interior designers in the world. He also is an academician of the National Academy of Design.

"My life is far better than anything I dreamed of as a kid in Michigan," Jacobsen says. "I adore what I do; it doesn't feel like work." While he continues to actively design, Jacobsen has turned the firm's leadership over to his son, Simon. As CEO, the younger Jacobsen has transitioned the firm to sophisticated computer drafting and project management methods, and oversees the staff of 20. He regularly ribs his father, quipping, "You haven't lost it—yet." The great respect the two have for one another's design skills is obvious, and clearly the firm's legacy will not only maintain, but elevate, the quality and integrity of its architecture.

Hugh Newell Jacobsen, Works from 1993-2006 will be available in bookstores in 2007. It is the third monograph on the firm's work.

ABOVE: The library/music room of Palmedo house is flooded with natural light as a lovely backdrop.
Photograph by Robert C. Lautman

FACING PAGE: The view from the living room of the Palmedo house displays the linear relationship between the window shape and where the eye is directed.
Photograph by Robert C. Lautman

Hugh Newell Jacobsen, FAIA, Architect, PLLC
Hugh Newell Jacobsen, FAIA
2529 P Street NW
Washington, D.C. 20007
202.337.5200
www.hughjacobsen.com

ABOVE: Locust Hill; entry portico with clapboard wing and breezeway beyond.
Photograph by Robert C. Lautman

FACING PAGE: Locust Hill; a new stone house in Virginia inspired by local farmhouses.
Photograph by Robert C. Lautman

DAVID JONES

David Jones Architects

"Now and then one visits a house that simply seems to fit. Complementing its owners' lives and tastes, it occupies the land and the neighborhood comfortably, as if it had been there forever. Proportions, details, materials and quality of workmanship make every line and corner feel almost inevitable. Antiques and the latest appliances, dramatic artworks and relaxing gardens coexist within an easy continuum of past and present."

These opening words on its website aptly describe almost any house designed by David Jones Architects. Going beyond a comprehensive knowledge of historical house styles, Jones and his Washington, D.C., firm continue an American creative tradition of adapting a living past to modern American families and their communities.

It can be complicated work making older house styles suitable for life in the 21st century, so it is no surprise that David Jones has established quite a reputation for traditional residential designs that incorporate all the amenities of modern life. "We often find ourselves designing family homes for clients who plan to pass them on to the next generation—homes that will need to withstand the test of time,"

Jones explains. "Just as I live in a restored, 100-year-old house based on a style that was first popular more than 200 years ago, I expect the houses we design today to be just as flexible, and just as enduring."

Educated at Princeton and Cambridge Universities at a time when geometric modernism reigned, Jones acquired an approach that distills architecture to its clearest forms. Yet he also followed a passion for history, taking every architecture history course Princeton offered, which led him to become a designer of tradition-inspired houses. "I was taught to look for clarity in design," Jones explains, adding that this rigor can apply to a modern or traditional home.

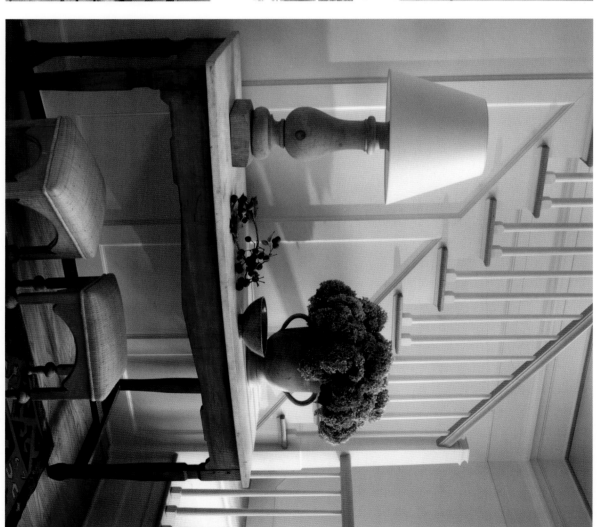

ABOVE LEFT: Residence in Potomac, Maryland; view of the central gallery opening into the family room.
Photograph by Walter Smalling Jr.

ABOVE RIGHT: Residence in Potomac, Maryland; stairway with simple handrail and painted paneling.
Photograph by Walter Smalling Jr.

FACING PAGE: Residence in Potomac, Maryland; new home with stone and shingle exterior.
Photograph by Walter Smalling Jr.

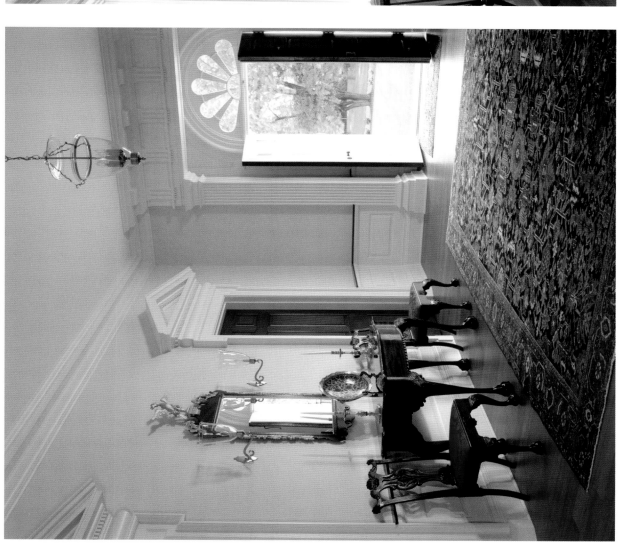

After serving in the Navy and the Peace Corps, Jones joined a leading Washington firm acclaimed for its designs ranging from single-family homes to large civic and institutional projects. He founded David Jones Architects in 1977. Based in a converted townhouse near Washington's Dupont Circle, the office focuses its creativity exclusively on custom residential work.

The firm's seven architects practice in a studio environment that fosters collaboration and a creative openness that signals an unstuffy approach to history. Jones believes that "historically grounded architecture can be both inventive and unique to its own time and place." The firm's size allows Jones and his colleagues to guide each project, and each owner, through the phases of

ABOVE LEFT: Georgian manor; front entry hall.
Photograph by Gordon Beall

ABOVE RIGHT: Georgian manor; kitchen and breakfast room.
Photograph by Gordon Beall

FACING PAGE: Georgian manor in Maryland; inspired by "Mt. Pleasant," a pre-revolutionary house in Philadelphia.
Photograph by Erik Kvalsvik

building a new house, from initial site selection and design through completion of construction. Along with new homes along the East Coast and throughout the Washington, D.C., region, the firm welcomes the opportunity to design an addition to an existing house of any style, and has done so in styles ranging from Tudor to French Norman to English Cottage. Regardless of appearance, every design offers consistent attention to detail and appropriateness of form to site, neighborhood context and the client's lifestyle.

Design of a new home often begins with a review of the firm's library. Clients are encouraged to browse through books and pictures of architecture through time, indicating likes and dislikes. "They educate me, and sometimes I educate them," says Jones, who often stresses that quality construction and authentic detailing are the most critical components of any design.

Indeed, at times the biggest challenge facing the firm is finding builders willing to make the extra commitment to crafting a home with such finely articulated design. Jones is adamant about proportion, materials selection and attention to detail, believing in consistency in both a home's architecture and its construction. The results have earned the firm numerous design awards, including the national Palladio Award for the best new traditional house in 2003 and again in 2006, as well as honors from the American Institute of Architects, the National Trust for Historic Preservation and the National Association of Home Builders. The firm's work regularly appears in such publications as Architectural Digest, House Beautiful, Period Homes, Southern Accents and Veranda.

While every home Jones designs exists very much in the present—and some are more streamlined, with open spaces and expanses of glass—the architecture always demonstrates an appreciation of the past. "We search for poetry, dignity, permanence, simplicity and sometimes drama," Jones says. He and his firm believe that houses rooted in thoughtful continuity with the past offer their occupants comfort and a reassuring "fit" in an otherwise hectic and changing world.

ABOVE: New residence in Forest Hills, Washington, D.C.
Photograph by Robert C. Lautman

FACING PAGE TOP: Pine-paneled family room in Chevy Chase, Maryland.
Photograph by Walter Smalling Jr.

FACING PAGE BOTTOM: Living room of a new residence in Kenwood, Maryland.
Photograph by Gordon Beall

David Jones Architects
David Jones, AIA
1739 Connecticut Avenue NW
Washington, D.C. 20009
202.332.1200
www.davidjonesarchitects.com

ABOVE: Summer home in Annapolis, Maryland, on the Severn River; this home features open living, dining and kitchen areas. Glass cabinets allow for continuous views of the mature trees. Interior Design by Brandy DeVries.
Photograph by Architect Donald Lococo

FACING PAGE: Summer home in Annapolis, Maryland, on the Severn River with a bridge entrance view.
Photograph by Architect Donald Lococo

DONALD LOCOCO

Donald Lococo Architects, LLC

"Make excellence in design first and foremost, and you will succeed as a designer; respond to a client's needs by careful listening, and you will succeed as an architect." These two principles guide the practice of Donald Lococo Architects, controlling each project's timing and budget, giving birth to each family's aspirations and vision and allowing principal Donald Lococo to create architecture of significance.

Guided by the motto "listening is an art," Lococo makes this his top priority. His design process starts with a dream list Lococo asks clients to make. From this point, a written program is created. Together with the client, Lococo reviews images from his vast collection, along with images from his clients. "From this type of visual Rorschach test, we move closer to a client's aesthetic sensibilities," he explains. Once the owner's aesthetic and programmatic preferences are understood, Lococo says the process is effortless. He has the pieces to anticipate what the client feels is important and beautiful. "I have a very vivid mind's eye," Lococo says; the dexterity with which he can translate ideas into architecture and express them is fun for both him and his clients, allowing all to move through the design process with confidence.

Lococo abandons the idea of a signature style, believing that the most appropriate way to leave a mark is by creating the perfect design for a home's inhabitants. "I create a negotiation between the house

and people in it," he describes. With projects located throughout the eastern United States, Lococo has had opportunities for houses in a variety of contexts and aesthetics. His commissions vary in scope from small renovations to entire estates; his interest is piqued by the design potential of the project rather than the scope.

His practice focuses on single-family residences, ranging from modest additions to some of D.C.'s most prestigious commissions, including a major renovation of Senator Hillary Rodham Clinton and former President Bill Clinton's Washington home. From a new residence on Martha's Vineyard, designed to look like its classically New England, Shingle-style neighbors, to a renovation of a 99-acre Middleburg, Virginia, estate that brought a traditional farmhouse into the 21st century, Lococo's work has varied influences and wide appeal. A glance at his portfolio shows the order and discipline of one well-versed in many architectural languages. His understanding and appreciation of historic and vernacular precedents allow him to either reproduce authentically or create contemporary work, as is most appropriate for a project's conditions.

ABOVE: Multiple uses are consolidated to this light-infused kitchen/mudroom space in the Martha's Vineyard residence.
Photograph by Architect Donald Lococo

LEFT: Exterior of residence in Martha's Vineyard, Massachusetts, viewed from the pool terrace.
Photograph by Architect Donald Lococo

FACING PAGE: This summer home in Annapolis, Maryland, underwent a significant renovation, including the addition of a new master suite with lower terrace and a reworked façade.
Photograph by John Dean

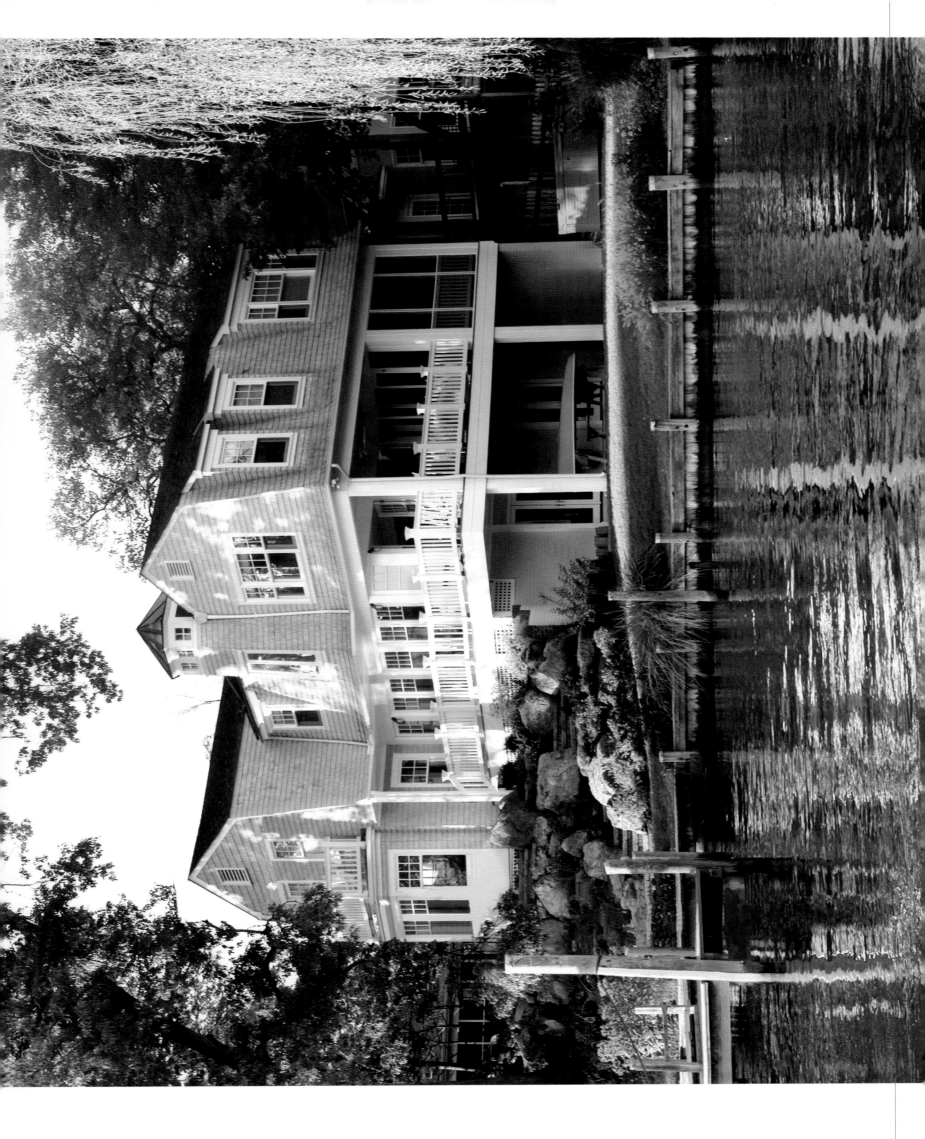

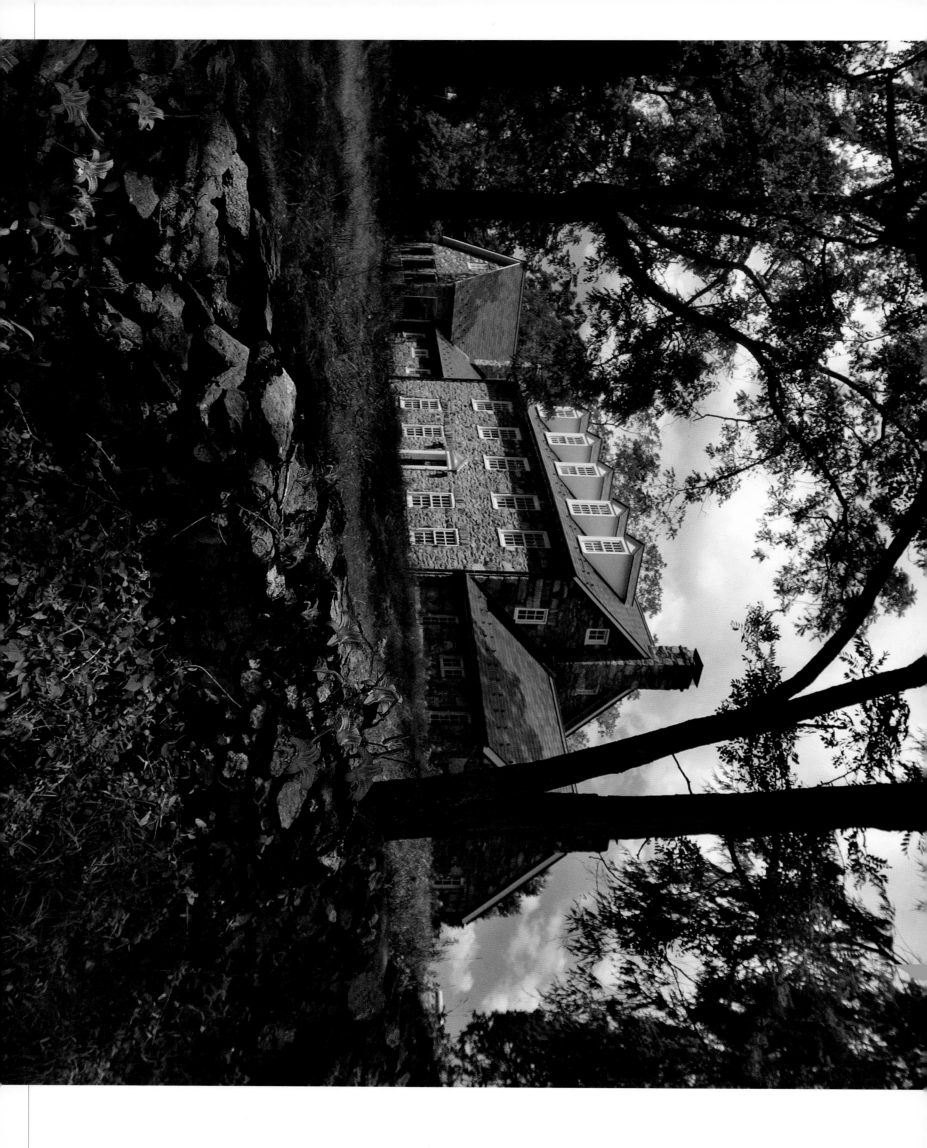

Although Lococo's projects range in size, he has kept his practice decidedly small to ensure involvement, direction and guidance for each part of a design. His hands-on approach through an entire project fosters continuity and confidence with clients.

Renovations are also of particular interest to Lococo and a forte of his practice. He has many examples of before-and-afters that he has done. His goal is to make the new seamless with the existing. "When clients unveil their renovation to guests, it is hard to explain what was original

ABOVE LEFT: The handrail of the newly added stair hall was fashioned from a walnut tree on the property of this Middleburg, Virginia, home. Panels at the landing conceal walk-in cedar closets. Interior Design by Rosemarie Howe.
Photograph by Maxwell MacKenzie

ABOVE RIGHT: A practical baby/pet gate vanishes into the wall.
Photograph by Celia Pearson

FACING PAGE: Before it was historically renovated, this residence was a "beautiful ruin" at Stonyhurst Estate in Middleburg, Virginia.
Photograph by Architect Donald Lococo

and what is new. I consider this a compliment," Lococo states. Most of his successful renovations start with an exasperated client in an architectural quagmire. His first thought when presented with this type of challenge is, "This is a great 'before' photo op!"

Lococo earned a Master of Architecture degree from the University of Michigan at Ann Arbor. Guided by Lococo's modernist education, the firm is presently broadening towards more contemporary work, while enjoying the traditional architectural challenges of D.C. and other historic cities. He explains, "Our recent success has brought us great interest by the community and the media, which has been rewarding given the long hours of work and dedication."

Peers and the public alike have taken notice. The firm won eight design awards in 2006 alone. An Annapolis, Maryland, residence, dubbed "The Tree House," earned design excellence awards from the Maryland and Northern Virginia chapters of the AIA, and was named *Southern Living* magazine's 2007 Home of the Year. The modestly sized home of elegant post-and-beam construction is organized upside-down, with bedrooms on the lower levels and living spaces on the upper floor to maximize views (see signature photo). Its deep bracketed roof overhangs extend the exposed structural trusses seen indoors.

The scope of the firm's other awards—including the Northern Virginia AIA Award for Excellence in Historic Architecture; *Washingtonian/AIA* Washington D.C. Chapter Award for Distinctive Residential Architecture; Builder's Choice National Grand Prizes for Best Whole House Makeover and Best Custom New Home (3,500 square feet or more); and the Vetter Windows National Champion Award—display the firm's proficiency in a range of project types. Magazines including *Architectural Digest, House Beautiful, Renovation Style, Custom Home* and *Waterfront Home & Design* have featured Lococo's designs.

In his youth, Lococo was on track to become a concert pianist. He still loves music and compares its organization and poetic qualities to architecture. Just as a Beethoven symphony can appeal to a child, an adult or a professional musician, a home should similarly resonate with people at all levels. Lococo aims for this quality in his own work. Now, Donald lives with his wife and two daughters in Bethesda, Maryland.

ABOVE: In this downtown Washington, D.C., brownstone, open dining and living areas abbreviated by columns take the place of what was originally an acupuncture office.
Photograph by Gordon Beall

FACING PAGE TOP: The back terrace of a renovated home in Chevy Chase, Maryland, boasts an outdoor/indoor room.
Photograph by Walter Smalling

FACING PAGE BOTTOM: The front exterior of this Chevy Chase, Maryland, home was renovated by replacing the split-level brick façade with a row of French doors nestled into true stuccoed walls.
Photograph by Walter Smalling

Donald Lococo Architects, LLC
Donald P. Lococo, AIA
3413 ½ M Street NW
Regency Row, Georgetown
Washington, D.C. 20007
202.337.4422
www.donaldlococoarchitects.com

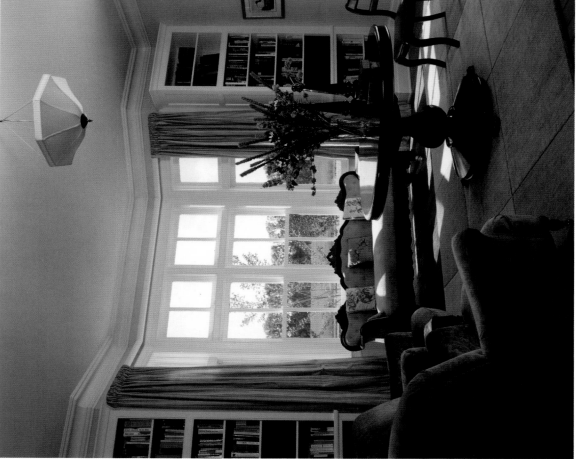

ABOVE: A large bay window was added to the existing study to take advantage of the sweeping landscape and river views.
Photograph by Walter Smalling

FACING PAGE: A major renovation and addition doubled the size of the original Victorian farmhouse, giving it new life as a year-round family retreat.
Photograph by Walter Smalling

DAVID E. NEUMANN

Neumann Lewis Buchanan Architects

Neumann Lewis Buchanan Architects is guided by the principle, "The past perfected, pure and simple." Using natural building materials, careful craftsmanship and traditional proportions and details, they create houses of enduring quality and grace. The firm's designs draw upon period precedents, with the architecture invigorated with planning and technology that is attuned to the way people live today. "Simplicity, grace and beauty are our design watchwords," explains founding principal David Neumann. "We design homes to become a treasured part of a family legacy."

In both urban and rural settings, the firm has designed projects ranging from large estate houses to small cottages, always with authentic and creative plays on classic themes. Almost half of the projects undertaken by Neumann Lewis Buchanan are renovations and additions. The architects explain that their clients are often looking for the emotional comforts and character of older homes, but need the modern accommodations typically lacking in old houses. "We don't look for a historic prototype to fit our client's modern program," Neumann explains. Instead, they find ways to incorporate larger kitchens, family rooms, en-suite bathrooms and ample closet space—things not characteristically found in an older house—making them fit seamlessly into the overall composition.

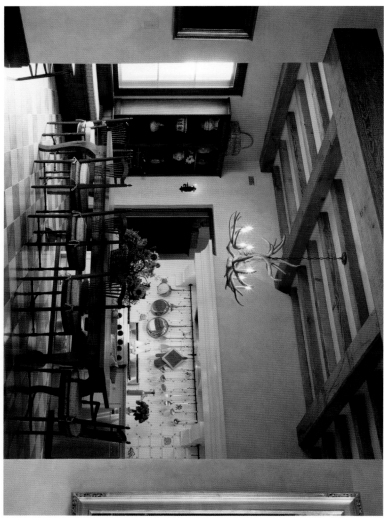

The majority of the firm's work is located throughout the mid-Atlantic, although current projects include homes in Denver, Colorado, and Nashville, Tennessee. The architects are attentive to each home's location and environs, explaining that context plays an important role in every design. "We want our buildings to be good neighbors," Neumann describes. Appropriate siting, scale and materials ensure that their designs fit whether the project is located on Maryland's Eastern Shore, in the Virginia piedmont or in urban Washington, D.C. While the work has been primarily residential, the firm will occasionally accept a project with a similar domestic scale, such as a Virginia winery currently in design development.

Neumann Lewis Buchanan's three partners consider their most successful projects those where no distinctive architect's mark is visible. One such project illustrates their commitment to timeless design. The architects were asked to create a new guest and pool house on the grounds of a 150-year-old farm. Using forms and a palette of materials complementary to the original buildings

ABOVE: As seen from the family room, a custom-made chestnut rectory table serves as the focus for this country kitchen.
Photograph by Ron Blunt

LEFT: The wrought iron pergola covered with a bamboo canopy and clematis vines shade a series of blue shuttered French doors.
Photograph by Ron Blunt

FACING PAGE: The fieldstone exterior is buttered with a lime mortar to lend an aged appearance to this new French farmhouse built in Virginia's piedmont.
Photograph by Ron Blunt

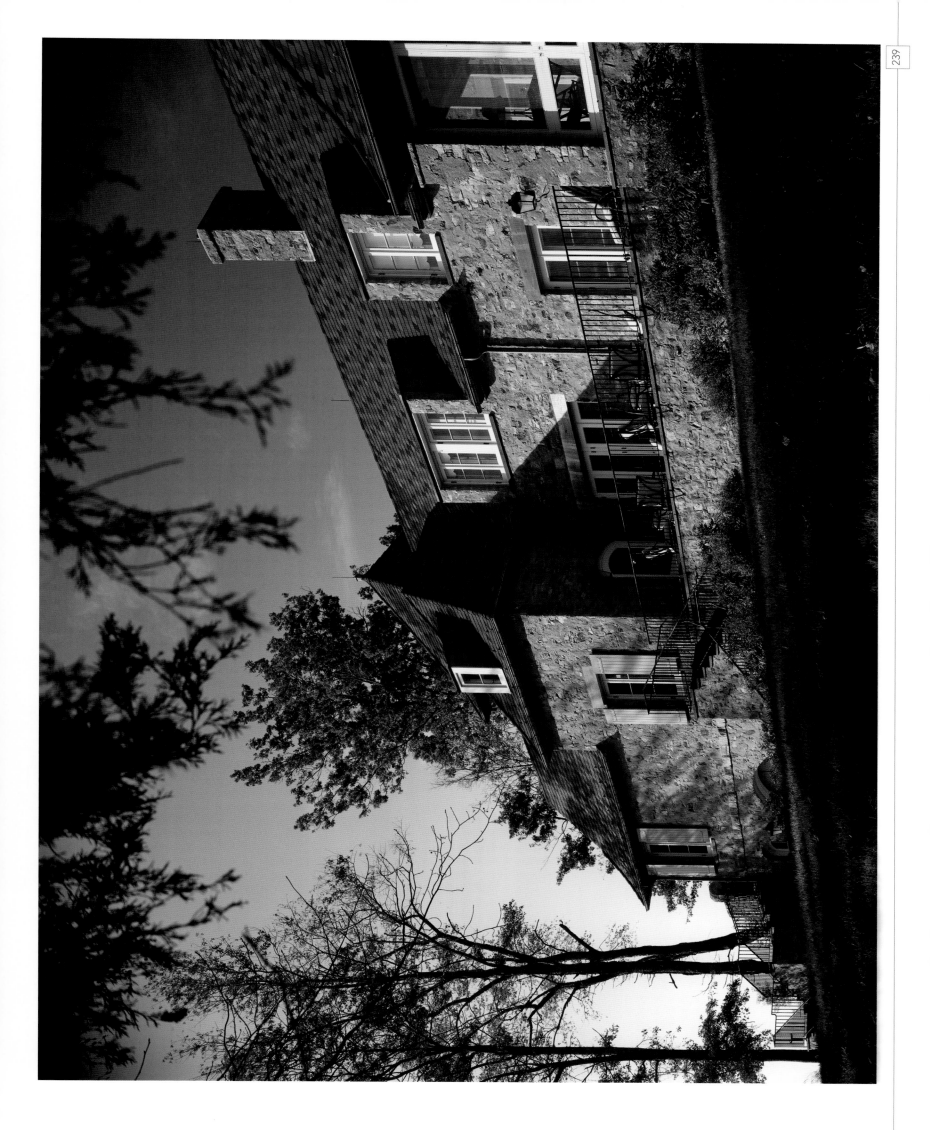

on the property, the architects were able to quietly enhance the historic setting. "When tradespeople on the job asked if it was a restoration, we knew we had achieved what we set out to do," Neumann recalls.

David Neumann founded the firm in Washington, D.C., in 1986 and established a second office in Middleburg, Virginia, in 1989. He earned a Bachelor of Architecture degree from Virginia Tech in 1977 and gained early professional experience on a wide range of cultural, institutional, commercial and residential projects. Neumann is a past president of the Washington, D.C., chapter of the American Institute of Architects. He serves on the board of directors of the Washington Architectural Foundation and the mid-Atlantic chapter of the Institute of Classical Architecture & Classical America.

Andy Lewis, AIA, joined the practice in 1986 while maintaining his own architectural illustration practice, Arcobaleno. An accomplished illustrator, Lewis' drawings have appeared in *The Washington Post, Time-Life Books, New Old House, The Washingtonian* and *Print.* He completed architectural studies and a one-year faculty honorarium at Virginia Tech. Lewis is a member of the American Society of Architectural Illustrators and the Piedmont Environmental Council.

Mark Buchanan, AIA, joined the firm in 1987 shortly after its inception. He holds a Bachelor of Science in architecture from the University of Texas at Arlington. His prior engineering studies at the University of Cincinnati, in tandem with his design skills, give him critical knowledge of both the art and science of architecture. A devoted classicist, Buchanan is a member of the Institute of Classical Architecture & Classical America and the National Trust for Historic Preservation.

The firm has remained small by preference, permitting a high level of client service and close involvement by all three partners. "We are always mindful

TOP RIGHT: The thick walls of the living room provide ample space for concealed shutter panels hinged along the sides of the windows.
Photograph by Walter Smalling

BOTTOM RIGHT: Artwork and multicolored book bindings fill the four walls of shelves in the den, a core room in the plan of the house.
Photograph by Walter Smalling

FACING PAGE: This new limestone farmhouse overlooking the Potomac River was built to convey the story of a house that had been added onto over time.
Photograph by Walter Smalling

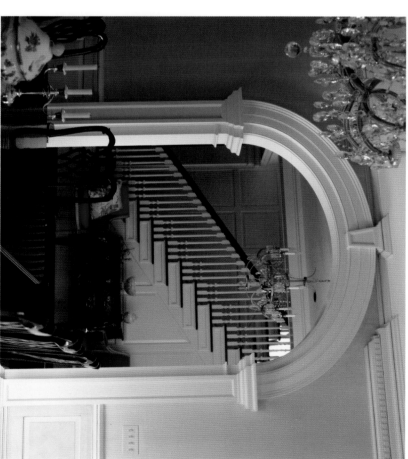

that our architecture practice is a service business," explains Neumann. Designs are specific to the client's personality, circumstances and context. "It is not a one-size-fits-all approach," he adds. They encourage an atmosphere of openness with clients, who are invited to share their ideas and inspirations from the start. The architects use this input to distill a style or character for the design. A team that remains in place from start to finish handles each project, ensuring consistency and ongoing collaboration. Collectively, the nine architects on staff have more than 100 years of professional experience. Each is committed to working closely with clients to shape their individual vision of home.

The work of Neumann Lewis Buchanan Architects has earned numerous design awards, including Washington chapter AIA/Washingtonian Residential Design Awards in 2007, 2006, 1995, 1993 and 1987; Washington chapter AIA Awards of Excellence in 1996 and 1991; and the *Southern Living* Home Award in 1992. Designs have been featured in *Southern Accents, Traditional Home, House Beautiful, Garden Design, Period Homes, Chesapeake Home, Home & Design, The Washingtonian* and *The Washington Post*.

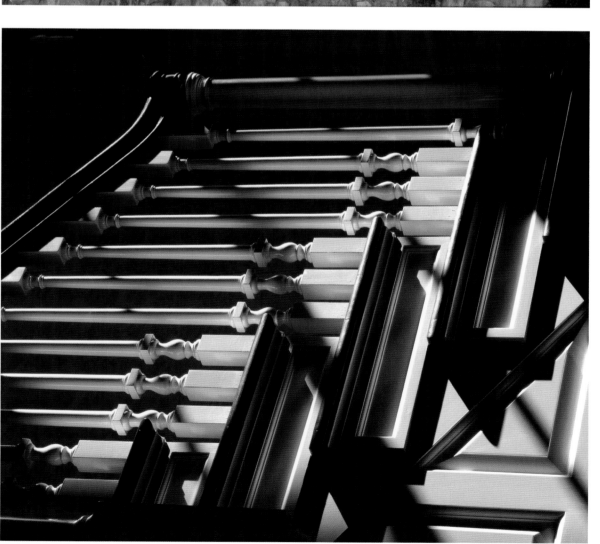

Neumann Lewis Buchanan Architects

David E. Neumann, AIA
805 15th Street NW, Suite 810
Washington, D.C. 20005
202.775.4881

205 East Washington Street, PO Box 1144
Middleburg, VA 20118
540.687.3917
www.nlbarchitects.com

ABOVE LEFT: Natural light enhances the crisp detailing of the turned-wood balustrades and paneled treads of the main stair.
Photograph by Ron Blunt

ABOVE RIGHT: The delicate millwork of the Ionic order entranceway contrasts the rugged texture and color of the fieldstone exterior.
Photograph by Ron Blunt

FACING PAGE LEFT: Carefully situated among mature oaks and poplars, this estate home near Washington, D.C., was inspired by the mid-Atlantic country houses of 18th-century America.
Photograph by Ron Blunt

FACING PAGE RIGHT: An elliptical-arched opening frames the view from the dining room into the entry hall and stair beyond.
Photograph by Ron Blunt

ABOVE: This addition was designed around saving an evergreen tree. Muted colors, natural redwood, aged copper and granite paving and fountain materials blend together softly.
Photograph by Anice Hoachlander/HDPhoto

FACING PAGE: Connecting to nature, this warm, contemplative breakfast nook is linked to a lovely, small garden. High ceiling and windows enhance both light and views.
Photograph by Anice Hoachlander/HDPhoto

REENA RACKI
Reena Racki Associates

Reena Racki has had a lifelong interest in housing. As an architect, urban planner and international practitioner, she has had the opportunity to impact housing conditions for people in several countries around the globe. Her innovative conceptual designs for affordable housing, her creative solutions for private residences and her community planning efforts have all served to meet her promise of "making daily life more serene, organized and peaceful" for people everywhere.

Raised in Cape Town, South Africa, Racki spent her childhood living on the slopes of Table Mountain. Her earliest memories are of the mountaintop above and the sea below. This vantage point offered a dramatic connection to the environment, something that has never left her—or her work. "I always yearn to bring this type of experience of nature to others," she explains. Nature and light are her guiding principles, used to generate architecture and influence the perception of spaces.

Racki earned a six-year Bachelor of Architecture degree from the University of Cape Town. Following work in Africa, France, England and Latin America, she moved to the United States to attend the Massachusetts Institute of Technology. There she studied architecture and city planning, earning master's degrees in both.

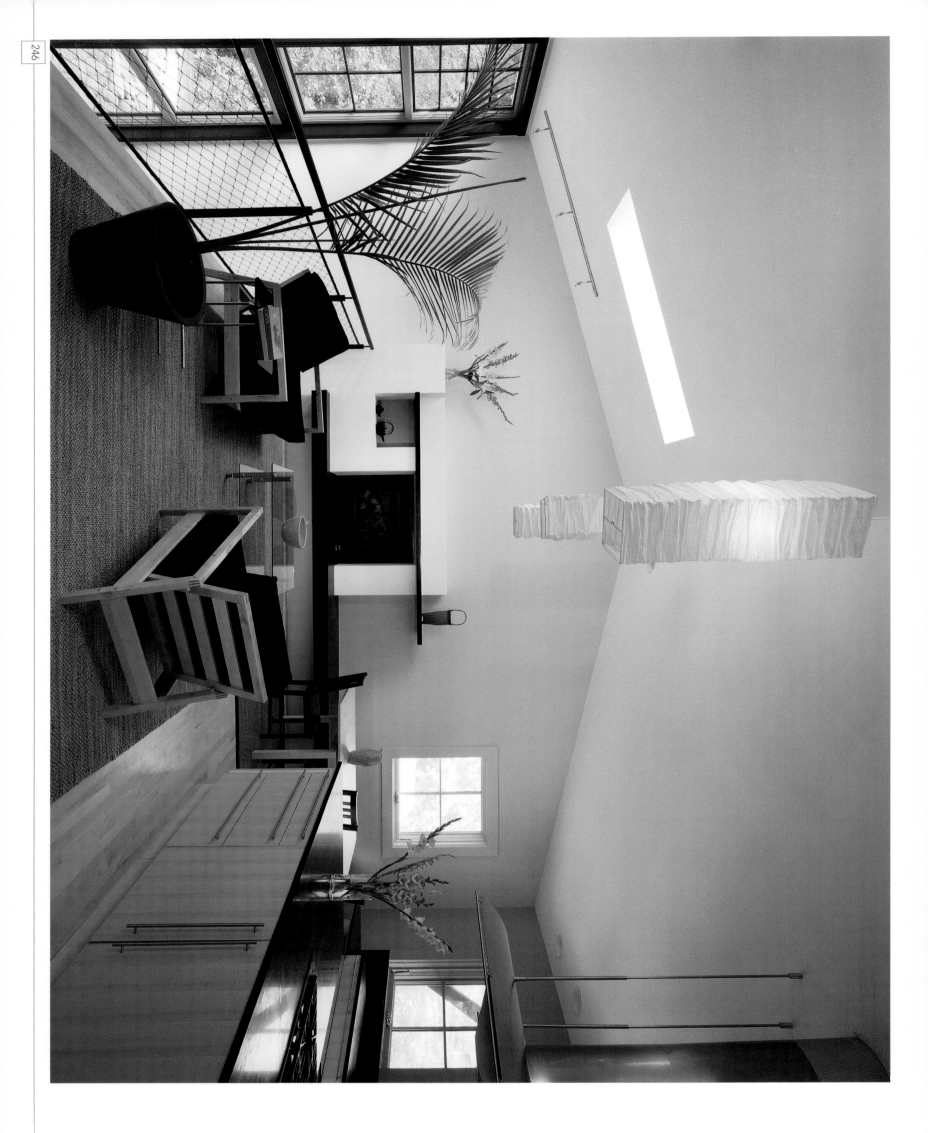

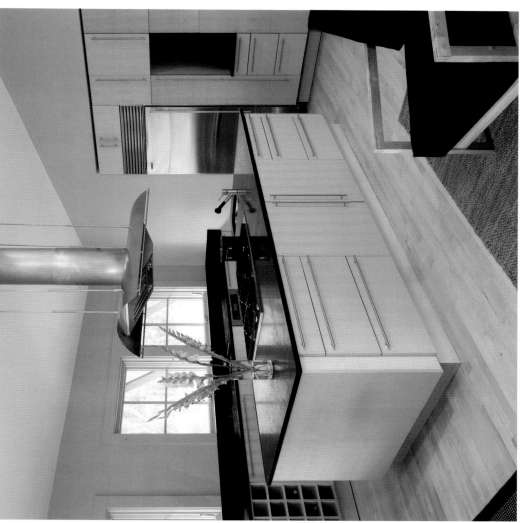

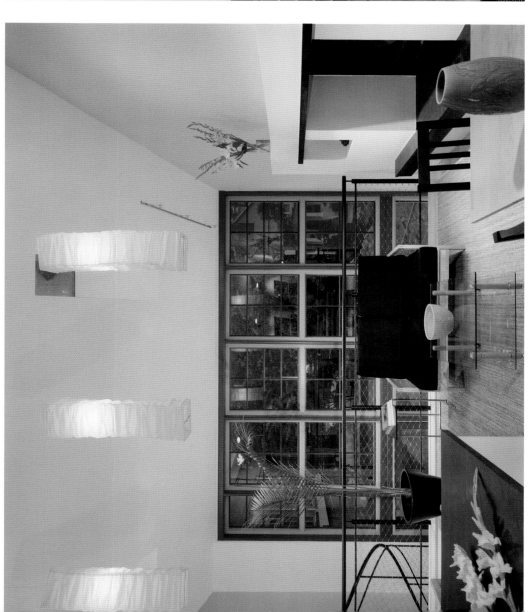

ABOVE LEFT: The spiral stair links this bright kitchen/breakfast/family room to a family art studio and terraces below. Tall red windows capture expansive garden views.
Photograph by Allen Russ

ABOVE RIGHT: Natural maple cabinetry and flooring, honed stone countertops, mantle and bench are contrasted with stainless accents of hood, cabinet pulls and appliances.
Photograph by Allen Russ

FACING PAGE: The fireplace with display and a stone bench are focal points for warm family gatherings. Japanese paper lanterns delicately float from the high ceilings.
Photograph by Allen Russ

Beginning her career in a developing country with fewer resources naturally directed Racki to consider sustainability, passive solar efficiency and materials conservation long before they became popular buzzwords. In fact, when she began her United States practice in 1990, it was called Reena Racki Associates and Sustainable Settlements. Racki recalls with a laugh that people kept calling to ask if she performed real estate settlements, so she dropped the latter half of the name.

Although she abandoned the name, the focus on housing design that benefits both inhabitants and the environment remained strong. Combining the technological resources of the United States with ideas from around the world, Racki regularly incorporates such passive solar features as overhanging sunshades or trellises to control sunlight, and cross ventilation to limit the use of air-conditioning. "We use the latest new materials and methods as they make sense, but combine them with warmth and familiar things that help to make a home," she adds.

Making a home feel welcoming for people is something Racki takes as seriously as sustainability. Her designs engage all of the senses, from the feel of warm sunlight to the sight and smell of the outdoors. In an urban environment, outdoor noise may be blocked; in a more rural environment, wide windows open to pastoral views. Serenity is created with an approach to architecture that engages all of the senses, offering each client a refuge away from the chaos and stress of daily life. The specific lifestyle of each client is carefully evaluated, with practical storage, functional organization and an aesthetic appropriate to each. When a recent client required heart bypass surgery shortly after moving into his new house, he was afraid of the six-week confinement. Instead, he offered Racki one of her greatest compliments by saying he loved being at home. The light and feeling of the house were buoyant, even aiding his recovery. Racki also transformed the home of a breast cancer survivor, bringing life-affirming light and color into every room; the client came into the office to tell the staff how much her warm and inviting house had contributed to the quality of her days spent mostly at home.

Believing it is important to have well-designed housing at all socioeconomic levels, Racki has contributed to concepts for affordable housing. Her earliest professional work was researching affordable housing in South Africa, where she earned her first design award for these efforts. She most recently developed the "Going Home" model for post-disaster housing. Driven to action after Hurricane Katrina, Racki developed and published the design of a series of factory-built, modular houses that serve as emergency, transitional and permanent homes based on the number and configuration of modules. Built in groups to facilitate a sense of community, the "Going Home" designs reinforce a sense of routine daily life that is often lost during disaster recovery.

TOP RIGHT: "Gut remodeling" this 1950s' ranch-style house included opening up the rooms to allow them to flow together, as well as inserting bold, sculptural yet functional storage elements.
Photograph by Robert Lautman

BOTTOM LEFT & RIGHT: The red entertainment/storage objects, yellow and nutmeg kitchen, walls with sculptural cut-outs and big picture windows combine to enliven the simple open spaces.
Photography by Robert Lautman

FACING PAGE LEFT & RIGHT: Racki created a dramatic foyer/gallery by adding skylights, sculptural lighting, opening up the ceilings and painting the tallest wall red. Translucent screens create interesting display spaces.
Photography by Anice Hoachlander/HDPhoto

While primarily working on housing, Reena Racki Associates also contributes to community and neighborhood design—of which houses are the basic building blocks. This work sometimes includes small-scale commercial and mixed-use building types with different scales and budgets. However, the commitment to practical, people-oriented places and solutions, simplicity of forms and a permeating sense of light and community run through all of the work.

Today, Racki's firm has a staff of six and functions as both a workshop and conventional office. Ideas are shared and the process is collaborative. Interns from around the globe regularly join the team, learning about United States architecture as well as on HGTV. Racki has spoken about residential architecture and community planning at The Smithsonian, The National Building Museum, The World Bank, and influencing the local staff with their international perspective.

The work of Reena Racki Associates has been regularly featured in *The Washington Post, Architecture DC, The Washingtonian, Better Homes and Gardens, Preservation Magazine, The Hill Rag, At Home, Ekistics, Trend Magazine* and others, The American Planning Association, and at Catholic University, Harvard University and the University of Pennsylvania. She has also earned awards ranging from the Andrew Mellon Award, Graham Foundation for the Arts Award, Helen Gardner Prize, Sagorsky Award, Natal Building Society Innovative Housing Award and several MIT fellowships. Racki is on the 2006 *Washingtonian* list of top architects and remodelers as selected by their peers.

TOP LEFT: A two-story addition includes this traditional, brightly lit country kitchen/breakfast/family room. Tall ceilings, white-painted wood cabinetry and expansive windows lift the spirits. *Photograph by Allen Russ*

BOTTOM LEFT: The generous island with honed stone countertops, wine cubbies, rustic oak floors and colorful Venetian lights welcomes family and friends to pull up a stool. *Photograph by Allen Russ*

FACING PAGE LEFT & RIGHT: This sunny two-level garden room connects an upper-level kitchen to outdoor terraces below. The inviting fireplace and heated stone floors beckon inhabitants downstairs in winter. *Photography by Robert Lautman*

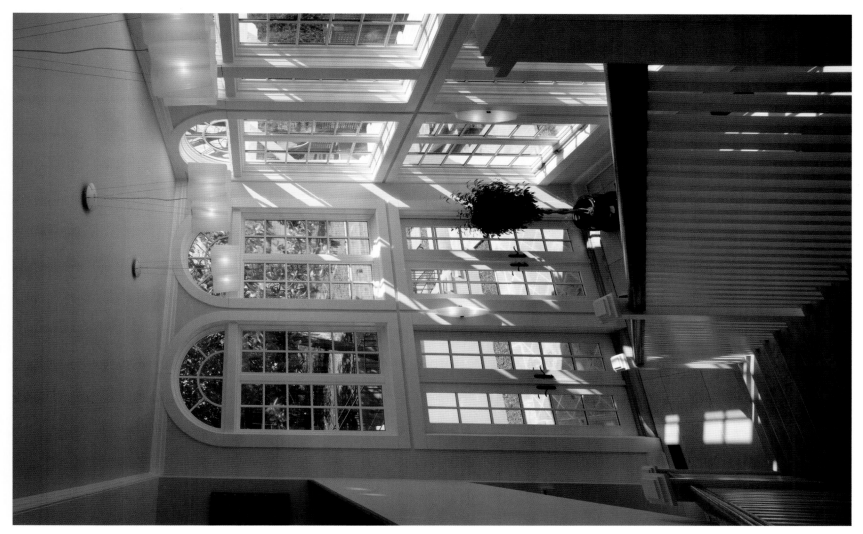

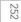

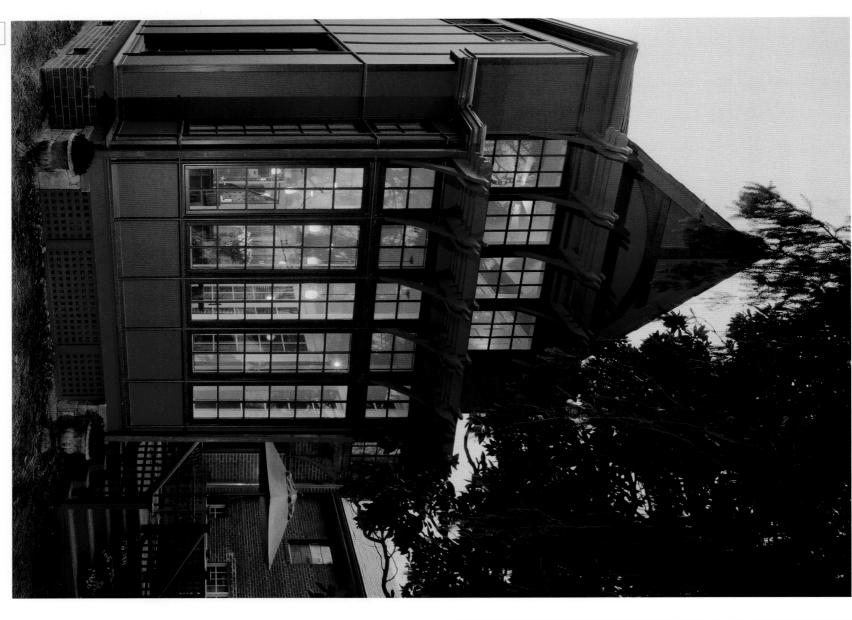

Racki is committed to community both in the broad sense of the word and as it applies to her personally. A resident of the Chevy Chase section of Washington, D.C., she was co-founder of the Historic Chevy Chase, D.C., and Main Street Chevy Chase, D.C., organizations, both of which educate community members about their neighborhood's urban design, the sophistication of its original community design and ways in which the architectural legacy can be preserved for the future. She has also been involved with the coalition of nonprofit housing in Washington and has led Smithsonian study tours to Provence in France to demonstrate the achievable balance between urban and rural life. She was nominated and is a member of the Lambda Alpha International Honorary Land Economics Society "in recognition of her dedication and concern in her worldwide practice for maintaining a close harmony between buildings and their sites and natural surroundings."

Despite her accumulated accolades and completed projects, Racki remains grounded in pragmatism. "The more I know, the more I realize how much there is yet to learn and how much better I want to make the next project or assignment—no matter the challenge or scale."

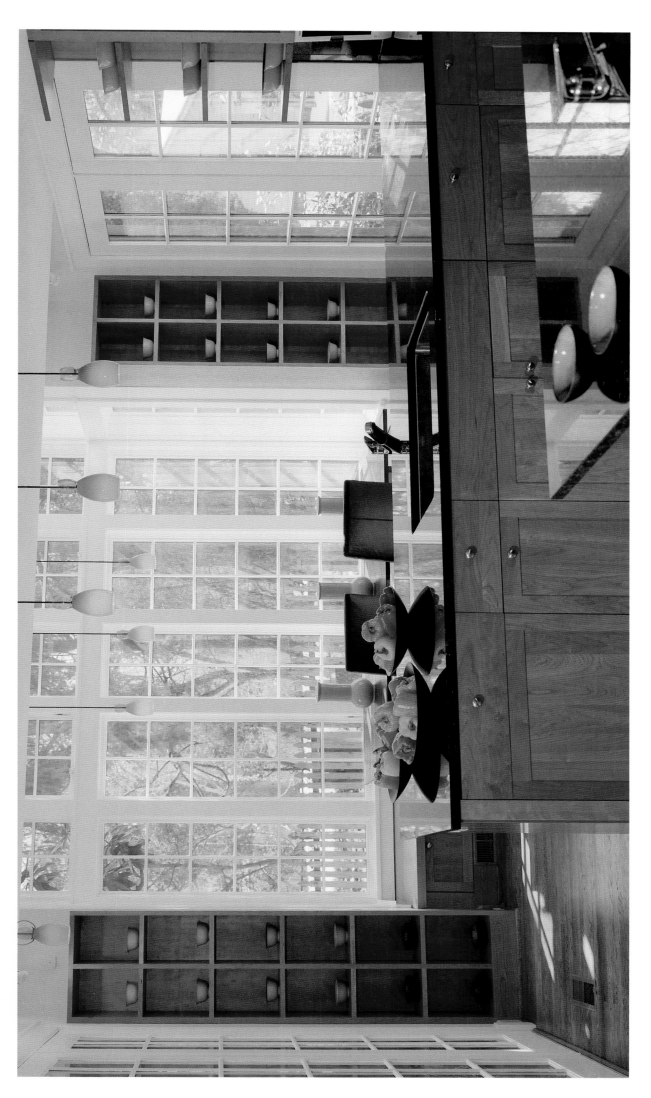

ABOVE: This cherry wood kitchen is illuminated by its full bay windows and French doors. Window seats contain ample storage for toys and table linens.
Photograph by Anice Hoachlander/HDPhoto

FACING PAGE LEFT: The two-story addition faces due south. Craftsman redwood trellises block hot summer rays, yet let in more welcome, low winter sun and warmth.
Photograph by Anice Hoachlander/HDPhoto

FACING PAGE RIGHT: Hand-blown yellow Murano glass pendants create a virtual ceiling of light in addition to natural light from French doors leading to the Ipe wood deck.
Photograph by Anice Hoachlander/HDPhoto

Reena Racki Associates

Reena Racki, AIA

5520 Connecticut Avenue NW, Suite 204
Washington, D.C. 20015
202.363.4739
www.reenaracki.com

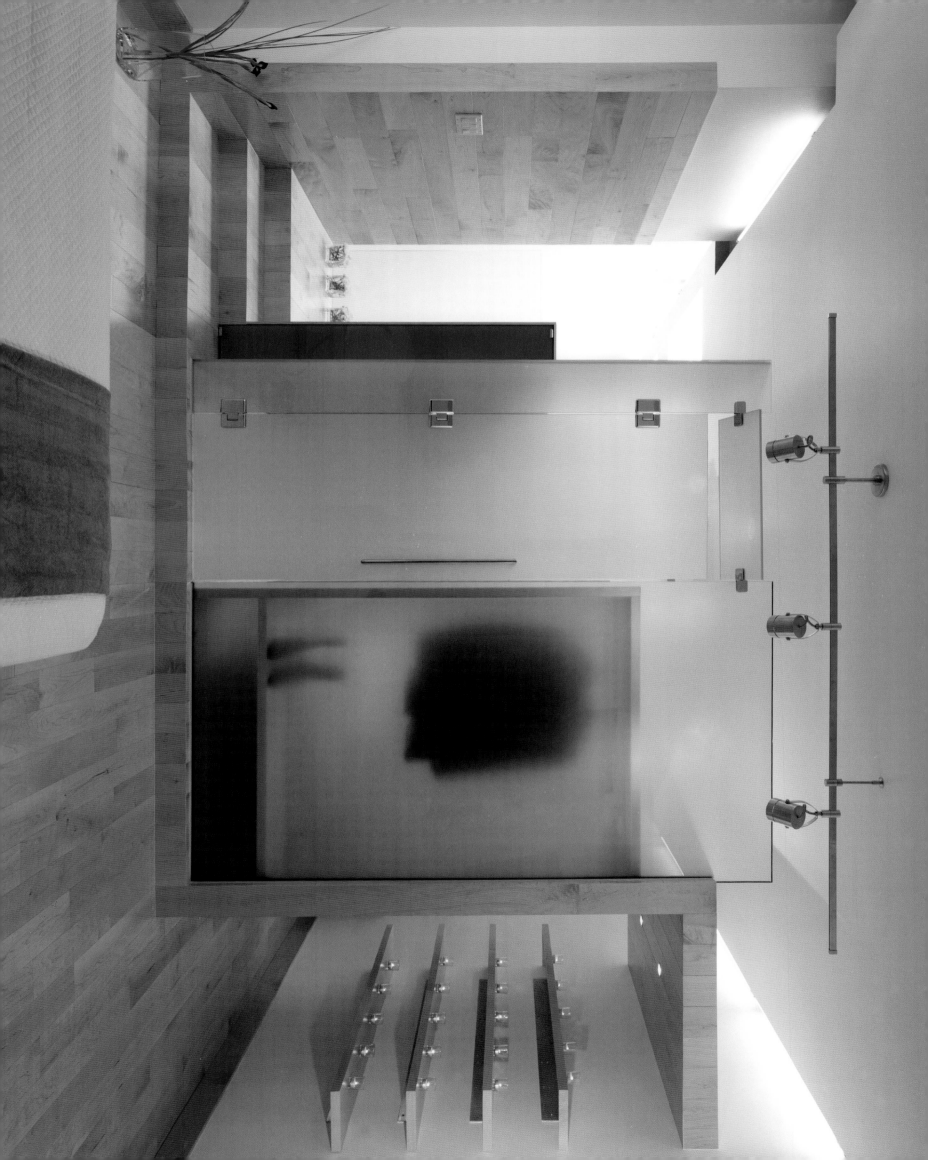

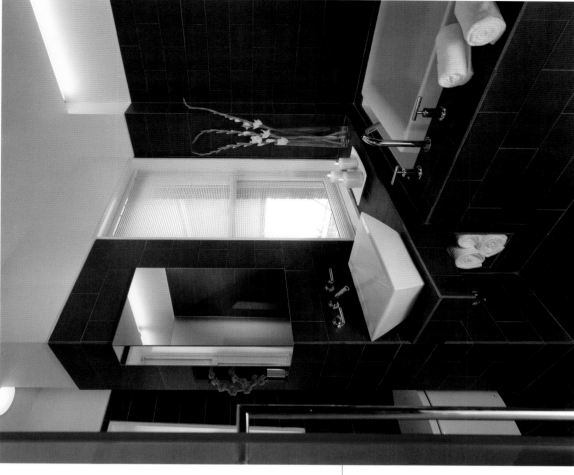

ABOVE: From this serene bathroom in the upper bedroom, one can see the sliding translucent door in the foreground.
Photograph by Anice Hoachlander/HDPhoto

FACING PAGE: This upper bedroom holds the artful interpretation of a closet designed behind the façade of translucent glass. The wood folds to hold the translucent closet volume.
Photograph by Anice Hoachlander/HDPhoto

TODD RAY
JOHN K. BURKE

Studio27 Architecture

S tudio27 Architecture is a "research studio," a collaboration of architects committed to exploring and advancing concepts in design, sustainability and process. The firm designs a broad range of projects, including private residences, institutional buildings and urban plans. The variety of their work fosters a rich cross-fertilization of ideas within diverse project scales and sophisticated material palettes. They often merge architectural form with warmth and texture to achieve a sublime complexity of space. Partners John Burke and Todd Ray explain that each project strives to captures the unique character of its client and context. They bring a personal, customized and creative approach to every project. Ray explains, "The unique combination of site, project and client is key to developing personalized design solutions."

Known for its spatial layering, use of materials and elegant complexity, Studio27's projects are sensitive to each owner's needs, desires and budget. The firm's choice of finishes emerges from a primal sense of materiality: a juxtaposition of raw, natural materials with the polished, machined surfaces. Space for a modern lifestyle is accommodated by rooms that can be used for multiple functions or can be easily converted from one use to another. For Studio27, contemporary architecture is "a warmly humane and comfortable refuge."

The firm explores every challenge throughout the design and construction process. Taking cues from their commercial work, Studio27 developed an innovative "centralized core" for a house in New Jersey. Building systems were combined in the center of the house to reduce plumbing and mechanical runs. The foundation system was simplified, and the house was carefully sized to take advantage of standard-length framing to reduce material-cutting and labor expenses. As a result, the house was built for 15 percent less than similar-sized homes in the area.

"Sustainability is embedded into our idea of good design," Burke explains. Studio27 seeks to make each of its projects environmentally responsible. The firm is presently designing a net-zero energy building expected to achieve the highest level of LEED® certification. Geothermal heating and cooling, a Green roof and carbon dioxide and light sensors are some of the innovations

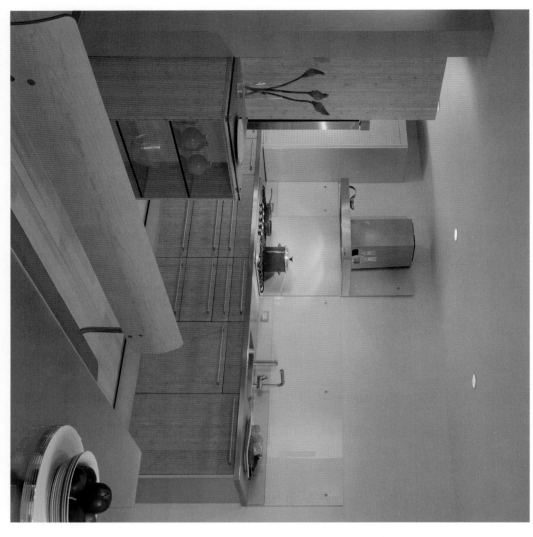

ABOVE LEFT: This minimal kitchen keeps the space open and clean leading into the complementary living area.
Photograph by Anice Hoachlander/HDPhoto

ABOVE RIGHT: A sliding glass panel frames a view to the National Cathedral.
Photograph by Anice Hoachlander/HDPhoto

FACING PAGE: Glass panels expand the master suite, as well as seamlessly integrate the bathroom, providing views to the cathedral from the soaking tub.
Photograph by Anice Hoachlander/HDPhoto

incorporated into an aesthetically sophisticated design, underscoring Studio27's philosophy that sustainable buildings should also have poetic intent.

Studio27's design principals believe, "Projects that evolve through collaboration achieve a higher level of sophistication and care than those with sole authorship," crediting their staff of 10: Raymond Curtis, Associate AIA; Chris DeHenzel; Andrew Graham; Hans Kuhn; Bethan Llewellyn, Associate AIA; Joe Michael; Soledad Pellegrini; Maggie Remudo; Jim Spearman, AIA, LEED® AP; and Lauren Winter, AIA, LEED® AP. The open studio collaboration nurtures everyone—from architectural intern to consultants to client—into an active discussion of project aspirations and vision.

Burke earned a Bachelor of Architecture from Virginia Polytechnic Institute and is a member of the American Institute of Architects. He serves as managing partner for Studio27, handling firm operations in addition to design.

Ray holds a Master of Architecture from the University of Virginia and a Bachelor of Arts in design from Clemson University. He is the 2007 president of the American Institute of Architects D.C. chapter and earned the AIA's 2003 "National Young Architect Award."

Burke and Ray founded Studio27 Architecture in 1999. The studio name emerged from their early days of "two guys working seven days a week." In eight years, projects designed by the firm have earned more than 27 design awards, including the New York City Green Building Design Competition; AIA/ Washingtonian Residential Awards; and competitions held by the D.C., Potomac Valley, Northern Virginia and Virginia Society chapters of the AIA. Projects by Studio27 Architects have been covered in *Residential Architect, Builder, Custom Home, Washington Spaces, Washington Style, Elements of Living, The Washingtonian and Trends*.

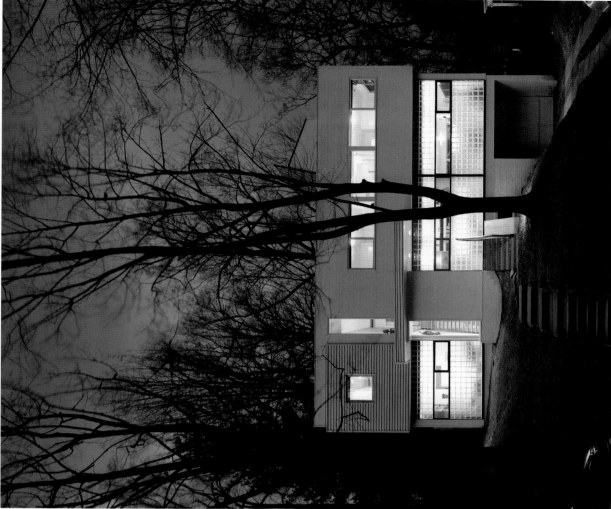

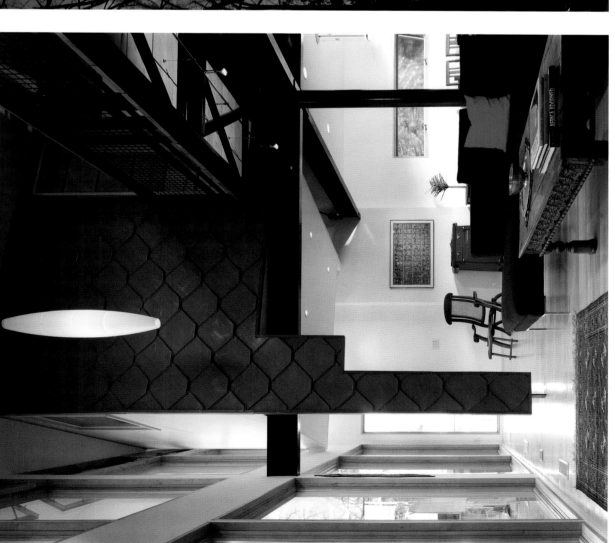

ABOVE LEFT: A volumetric light monitor accentuates a two-story living room.
Photograph by Maxwell MacKenzie

ABOVE RIGHT: The layering of materials reinforces expressions of public and private space as seen in this exterior façade.
Photograph by Maxwell MacKenzie

FACING PAGE TOP: City in the Garden: Kitchen "street" to stair beyond.
Photograph by Anice Hoachlander/HDPhoto

FACING PAGE BOTTOM: This kitchen island is not only functional, it provides an integral design element for the living and dining spaces.
Photograph by Anice Hoachlander/HDPhoto

Studio27 Architecture

Todd Ray, AIA, LEED® AP
John K. Burke, AIA
1600 K Street NW, Suite 202
Washington, D.C. 20006
202.939.0027
www.studio27arch.com

ABOVE: 3303 Water Street condominium, Washington, D.C. (in association with Gary Edward Handel). The gardens can be enjoyed from the two-story "town house" units.
Photograph by Maxwell Mackenzie

FACING PAGE: The side elevation of the same condominium along the C&O Canal.
Photograph by Maxwell Mackenzie

FRANK SCHLESINGER

Frank Schlesinger Associates Architects

Architect Frank Schlesinger is not primarily known for residential work, but is viewed as an icon of American architecture. As both a designer and teacher, he has influenced countless others with his buildings and philosophy. Projects such as National Place, 1301 Pennsylvania Avenue and 3303 Water Street in Washington, D.C., are recognized for modern design and compatibility within individual context. Residences in Pennsylvania, New Jersey, Massachusetts and Maryland capture the essence of site, family and functionality unique to each.

Schlesinger rewords Louis Kahn's definition of architecture as "the thoughtful making of *comprehensible* spaces," explaining that architecture should be about honest aspirations and construction of timeless, understandable buildings. He begins every project with an analysis of the site—the one aspect that remains constant—and creates buildings that appear comfortable within that context. Each design is a response to the environment, with spatial and programmatic variety based on functionality. Responding to a site's topography may mean extending a floor plan outdoors in the form of a terrace, or shaping and directing views and natural daylight with deliberate fenestration.

Courtyards tend to be a common thread through Schlesinger's work. He often uses these indoor-outdoor enclaves as an armature from which to hang the remaining components of a building. He says courtyards help to "pin a building spatially to a specific place."

Schlesinger has a wry sense of humor but speaks with honesty. "I went into architecture because I can't stand the sight of blood and found law boring. I have always liked the idea of being a small practitioner—I like the individuality of it." Viewing architecture as the only other career choice to afford this ideal, he studied at Middlebury College and Rensselaer Polytechnic Institute before earning a Bachelor of Science from the University of Illinois. Schlesinger followed teacher and friend Hideo Sasaki to Harvard's Graduate School of Design where he earned a Master of Architecture degree in 1954. There, he met Hugh Stubbins, for whom he worked after graduation. Schlesinger later worked in the offices of Marcel Breuer and Louis Kahn, beginning his career in the booming, post-WWII economy, when mid-century modern architecture was at its American heyday.

Schlesinger's philosophy and discipline that he carries to this day. As a colleague, Schlesinger worked alongside Kahn on the University of Pennsylvania faculty. He also worked in Kahn's office during the early years of his own practice. "Lou was able to start thinking in a new direction, away from the free plan of modernism. He showed how to organize buildings in a structural way," Schlesinger explains. Evidence of Kahn's influence is clear in Schlesinger's use of clearly articulated plans, structural and material integrity and the purity of geometric volumes.

"Philadelphia School" architect and teacher Louis Kahn influenced

LEFT: A view of the Whitefriars Hall dining room, Washington, D.C. Natural light floods the open, airy space.
Photograph by Robert Lautman

FACING PAGE LEFT: A partial elevation of this Reading, Pennsylvania, residence offers interesting contrasts of lines and hues and the interplay of stone, stucco and metal.
Photograph by Lawrence S. Williams

FACING PAGE RIGHT: A view of the opening to the entry courtyard of the same Reading, Pennsylvania, residence.
Photograph by Lawrence S. Williams

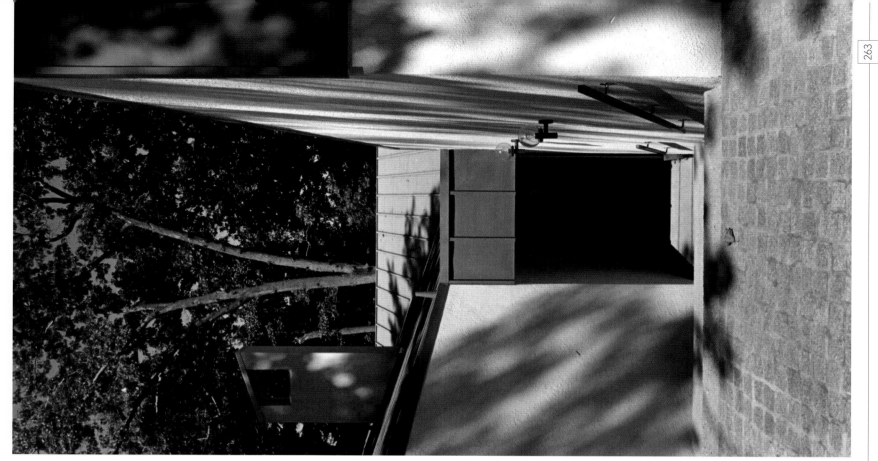

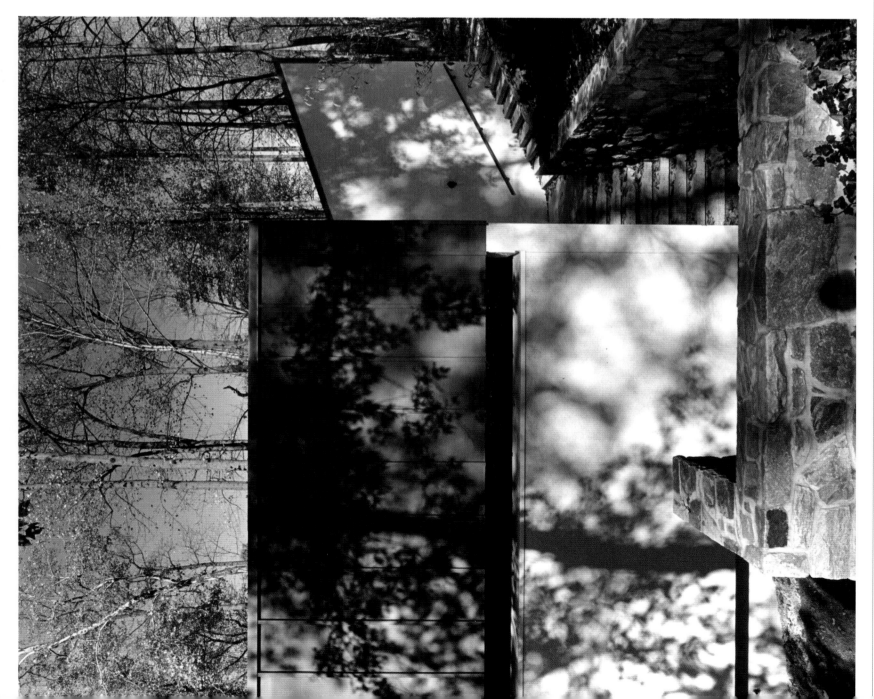

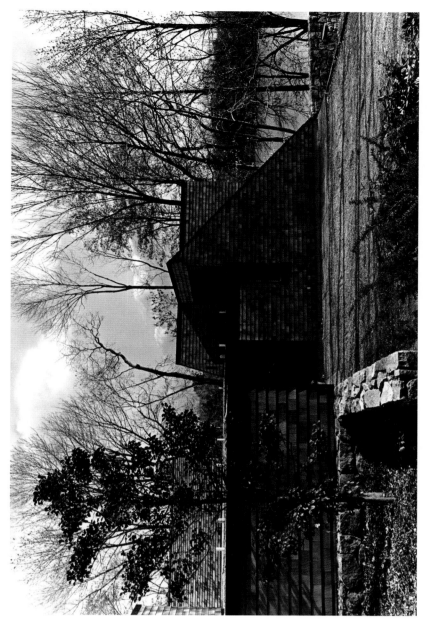

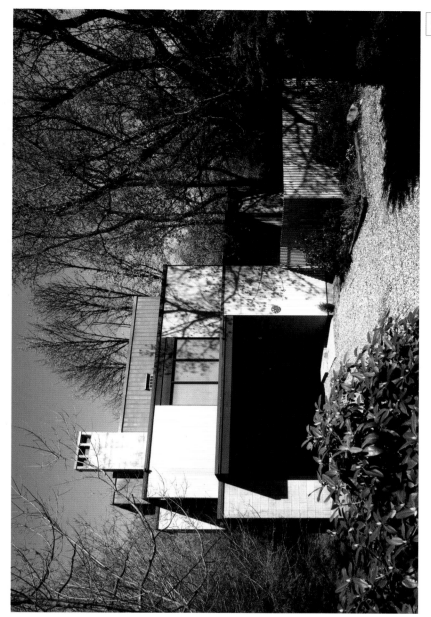

A collection of inspiring teachers not only influenced Schlesinger's practice, but also his academic involvement. He has taught at the University of Pennsylvania, Columbia University and the University of Maryland, where he taught from 1971 to 2001 and is now professor emeritus. The American Institute of Architects recognized his "significant enduring contributions as both a designer and educator" with the 2001 Washington, D.C., chapter Centennial Award, the highest honor the chapter bestows on a member.

When he began his firm, Schlesinger consciously decided to stay true to the small practitioner concept. In 50 years, he has never had more than 10 employees. A wide variety of large-scale work—including institutional, commercial, civic and mixed-use projects—has never daunted his small staff. "In my office, there is no second team," he says, describing how managing only a select few projects at one time allows adequate attention to detail. The hands-on approach is particularly relevant to residential work, where clients bring strong personal requirements and convictions.

Schlesinger's work stretches across a half-century, yet his designs do not appear dated. His careful attention to parti and his enduring commitment to design excellence have earned national and chapter AIA awards and commendation by other professional organizations. He received the Arthur Wheelwright Fellowship

TOP RIGHT: The entry court of a Princeton, New Jersey, residence blends perfectly with its site.
Photograph by Reginald Richey

BOTTOM RIGHT: Another Princeton, New Jersey, residence shows multiple vertical additions.
Photograph by Tom Bernard

FACING PAGE: The side elevation of a Bucks County, Pennsylvania, residence shows the influence of local barns.
Photograph by Marc Neuhof

in Architecture from Harvard; A Distinguished Designer Fellowship from the National Endowment for the Arts; and was named one of the youngest Fellows of the American Institute of Architects.

Following in her father's footsteps is daughter Christy, an architect, who has worked alongside him in practice since 1998. Schlesinger hopes his daughter "will continue the firm's tradition into the next 50 years," abiding by the same close client interaction and fresh approach to design that have served him so well.

In addition to being featured in major design publications, including *Architectural Record* and *Progressive Architecture*, his monograph, *The Architecture of Frank Schlesinger*, is available from

Grayson Publishing. In his foreword to the book, architect Charles Gwathmey, FAIA, provides perhaps the most apt description of Schlesinger and his work. "[He] is an architect's architect. We learn from his work, are inspired and reinvigorated by its durability, both literally and philosophically."

ABOVE LEFT: Cady's Alley residence, Washington, D.C. "Living over the store." A view of living room and terrace to the right. The vaulted ceilings add dramatic height and depth to the space.
Photograph by Julia Heine

ABOVE RIGHT: The dramatic space of the living room opens on to the kitchen and dining areas.
Photographs by Julia Heine

FACING PAGE: A view of the elevation at the C&O Canal shows the courtyard and vault over the living room.
Photograph by Christy Schlesinger

Frank Schlesinger Associates Architects

Frank Schlesinger, FAIA
3210 M Street NW
Washington, D.C. 20007
202.333.0344
www.schlesingerarchitects.com

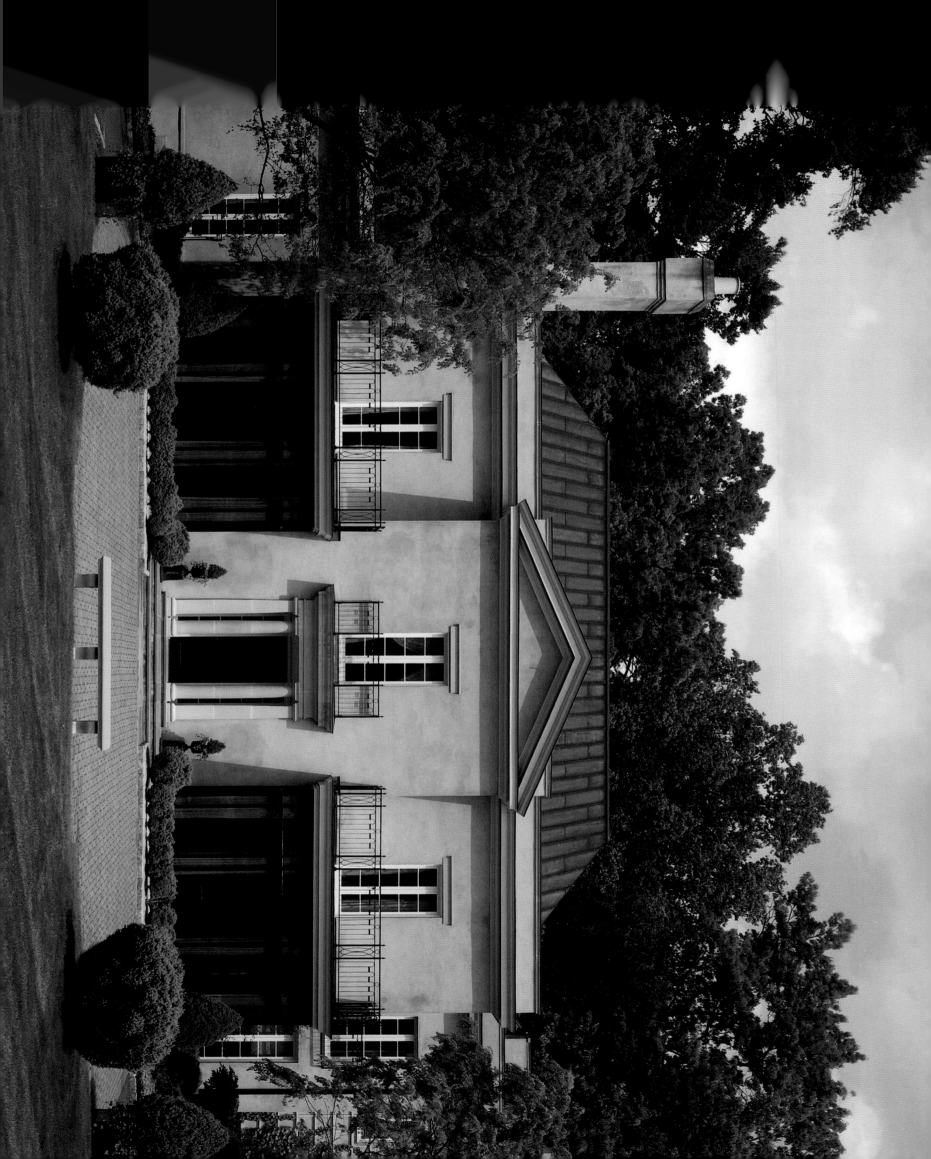

MERLE THORPE

Merle Thorpe Architects, PLLC

As an undergraduate, architect Merle Thorpe, of Merle Thorpe Architects, studied marine biology, and his sensibilities as a naturalist animate his architectural practice.

Just as a marine organism is shaped over time by "a variety of incessant and significant forces," Thorpe notes, the forces and influences shaping the design of a home range from the landscape setting and the way it reveals nature's daily and seasonal rhythms to the clients' aesthetic tastes and patterns of work and leisure.

Thinking of design in these terms, Thorpe explains, leads to homes that are complex yet organically integrated wholes. Thorpe's home designs honor the landscape and the clients' cultural sensibilities while also addressing their practical needs within a context of refined luxury that is never ostentatious.

For Thorpe, the best residential architecture is quiet; it does not shout for attention. He believes good design can manifest itself across the stylistic spectrum, whether in the more traditional and formal idioms—as with the Neoclassical residence illustrated here—or in more modern, abstract modes.

LEFT: Restrained Neoclassical elegance reflected the owners' appreciation for form and order and became the guiding theme for this project.
Photograph by Judy Davis/HDPhoto

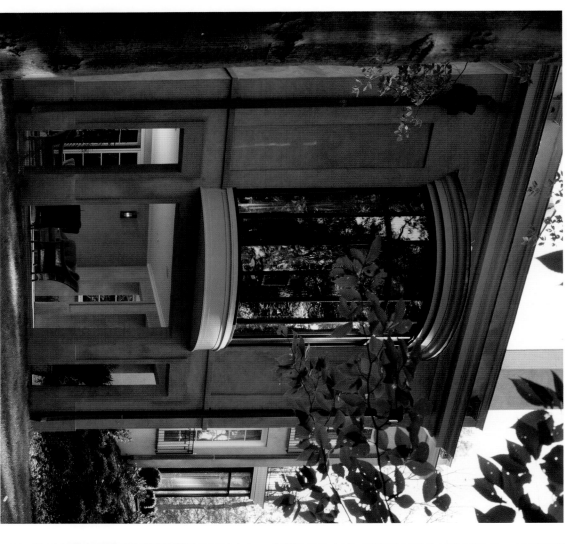

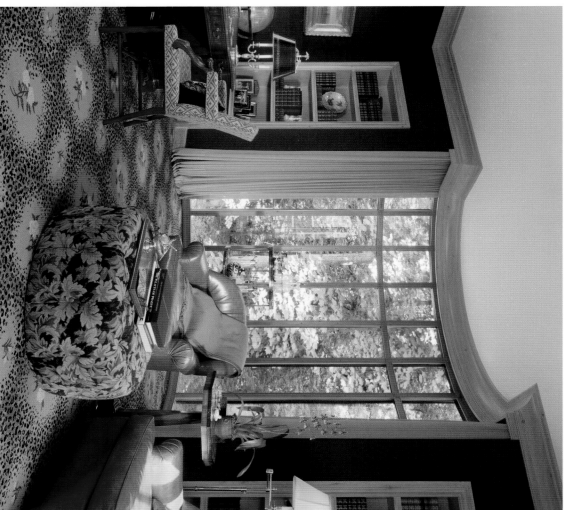

Thorpe subscribes to the architect's ancient aim: to design memorably choreographed sequences of well-proportioned spaces. He believes fine residential architecture has a certain inevitability—it just "belongs" in its setting.

Thorpe's designs draw on regional culture; local topography; climate dynamics; plant life; and diurnal, seasonal and tidal changes. Much of his work is thus rooted in a region's architectural history—and indeed his Neoclassical house's pale-ochre stucco finish and simple exterior geometries were inspired by William Thornton's magisterial Tudor Place mansion in Georgetown, which dates to 1816. But like Thornton, Thorpe seeks to invigorate his classically oriented work with a modern sensibility, which is evident, for instance, in the steel-framed oriel suspended over a garden-front loggia.

Each of Thorpe's residences is integrated with an overall site plan to form a cohesive whole. Thorpe believes grounding an architectural design in its landscape context permits the resulting house to exude a timeless authenticity. "A house can be fairly small yet seem expansive if integrated with the site," he explains. An example of such integration is the romantic interplay between the Neoclassical residence's fanciful English Regency tower and the Chinese elms looming in the foreground.

Thorpe also believes collaboration is essential to the practice of architecture. The most important collaboration is of course with the clients, whose personal interests provide unique points of departure for the design. In addition, he involves landscape and interior designers and other consultants early in the design process. Their contributions ensure that a project is well thought out—in detail and across the board. The staff at Merle Thorpe

Architects shares the same collaborative approach, working as a team to contribute individual knowledge of history, construction and materials.

Thorpe's enjoyment of his work is obvious. "Each client is unique. I am forever inspired by the web of impressions and associations that clients bring to the ultimate design; it helps us help them realize the house of their dreams."

A client's contributions can be found in the subtlest of details. Thorpe recalls an energetic client, who loves waking and looking out a tiny window near her bed to trace the arc of the sun's path. "The window connects her to the wider world, and her place in it," Thorpe observes. Yet, that window seemed inconsequential during design of the master bedroom and was almost eliminated. Thorpe believes that details like this bedroom window are what establish a client's emotional roots in the home, providing what he calls "occasions of surprising connection and recurring delight" for them. "I strive for details like that," says Thorpe.

Clearly, Thorpe's commitment to finely crafted, well-conceived and beautifully detailed homes has paid off. He has won numerous design awards for new construction, restorations, renovations and additions. And his projects have been published in *The Washingtonian, Waterfront Home & Design, House & Garden, Southern Accents* and *Residential Architect* magazines.

RIGHT: The simplicity of exterior forms and surfaces provides a subtle foil for sumptuously detailed interiors, such as this master dressing room. The house's interior design benefited from the knowledge and taste of the late Sam Morrow of Robinson, Morrow Associates.
Photograph by Gordon Beall

FACING PAGE LEFT: The steel-framed oriel punctuates the exterior surfaces of the study. The piers supporting the study define a covered loggia on the lower level, giving terrace access from the game room.
Photograph by Charles Rumph

FACING PAGE RIGHT: Abundant glazing in the oriel draws the surrounding woodland setting into the study. Regency-era trims, casework and moulding designs are carefully integrated with felt wall coverings.
Photograph by Gordon Beall

ABOVE: The master bath and octagon (at right) are detailed with faux-painted trims and casework on common North American wood species. Rigorous planning and attention to detail maximize the functionality of the space.
Photograph by Gordon Beall

RIGHT: The octagon vestibule to the master dressing room and bath has a custom-designed, hand-set mosaic floor. The mosaic tesserae, or tiles, are of stone and glass.
Photograph by Gordon Beall

FACING PAGE LEFT: The fanciful, pagoda-shaped roof and copper pennant ornament define the English Regency tower. Its mass is carefully shadowed by Chinese elms, which draw the structure more closely to the surrounding woodlands.
Photograph by Judy Davis/HDPhoto

FACING PAGE RIGHT: French doors allow access from the breakfast room to the rear terrace through a steel-framed bay. The rear terraces are held by an assortment of surrounding planted and lawn terraces before transitioning to the surrounding woodland forest.
Photograph by Judy Davis/HDPhoto

272

Merle Thorpe Architects, PLLC

Merle Thorpe
3235 P Street NW
Washington, D.C. 20007
202.298.7771
www.merlethorpearchitects.com

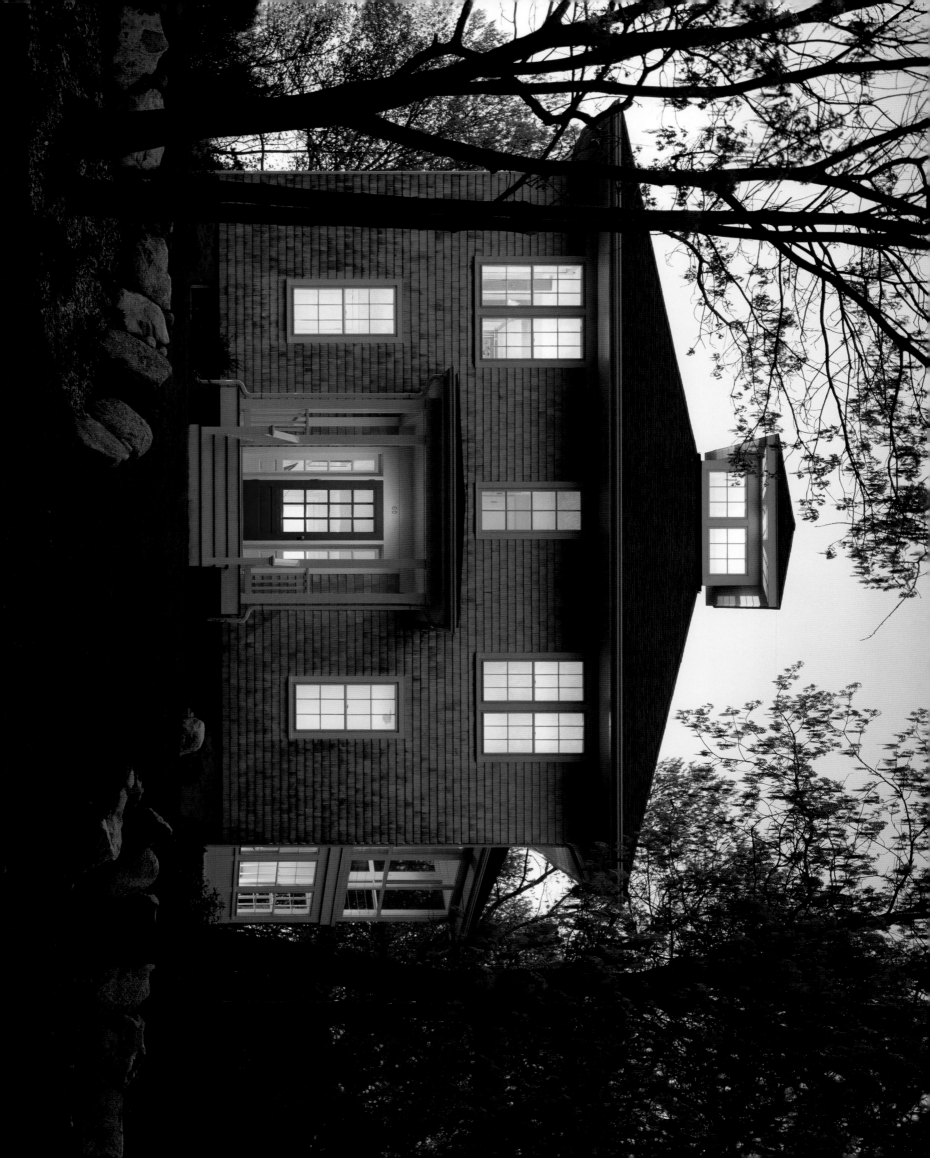

ABOVE: A screened porch "prow" directly off of the second-floor living room captures prevailing breezes and a distant view of Sandy Neck, Cape Cod.
Photograph by Maxwell MacKenzie

FACING PAGE: A cupola brings light into the main rooms of an "upside-down" house in the King's Highway Historic District of Cape Cod.
Photograph by Maxwell MacKenzie

JANE TREACY
PHILLIP EAGLEBURGER

Treacy & Eagleburger Architects, PC

Husband-and-wife partners Jane Treacy and Phillip Eagleburger of Treacy & Eagleburger Architects take an improvisational approach to architecture. They like to combine the given elements of any project—such as site, program or existing architecture—with the addition of a few simple ideas to generate houses that have vibrancy. "Improvisation means we aren't tethered to any specific style, but we can pick and choose what is appropriate for each situation," Treacy explains. In its work, the firm strikes a balance between classic and contemporary design languages.

Recipients of design awards from the American Institute of Architects, D.C. and Northern Virginia chapters, *Inform* and *Remodeling* magazines, *Home Book* and others, Treacy & Eagleburger Architects has been recognized for creative transformations and imaginative new designs. Commenting on the firm's design of a house on Cape Cod, a design juror said, "You 'get' the design easily." Both Treacy and Eagleburger agree that simplicity is a concept for which they strive. "We try to make houses feel effortless and comfortable," says Eagleburger.

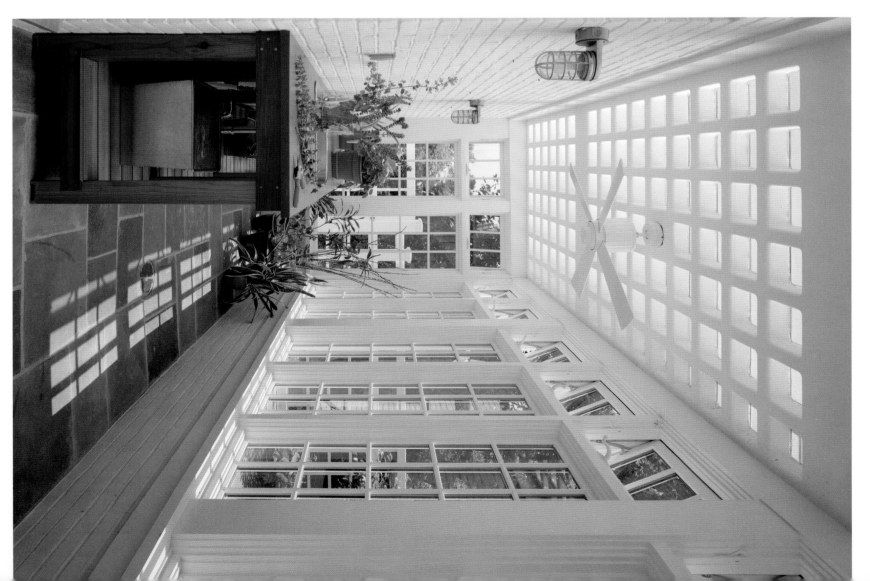

The partners emphasize functionality, connectivity between spaces and engaging elements of the environment to accentuate the architecture. Capturing "found objects" within a house or its landscape is often the basis for the firm's refreshing creativity. In the case of a recent renovation and addition project, Treacy & Eagleburger incorporated an existing stone stairway on the property. The subtle beauty of the stairs became the focal point of a strategy to link the house, its addition and the landscape together.

Founded in 1989, Treacy & Eagleburger Architects has designed and built a wide range of projects in locations across the country, including the greater D.C. area, New England, Illinois and Pennsylvania. A full one-third of the firm's work has been for repeat clients, demonstrating the strong client relationships both partners emphasize. "It is a nice feeling to know clients are comfortable with us and our design process," explains Treacy. That process includes active involvement by the firm's four staff members who share ideas in a collaborative studio environment.

Jane Treacy attended the University of Maryland, where she earned a Bachelor of Architecture degree and presently serves as a board member of the School of Architecture Alumni Association. Phil Eagleburger earned an undergraduate degree in art from Williams College before attending the Harvard Graduate School of Design for a Master of Architecture degree. Both partners have been active in Cleveland Park—their home neighborhood— for several years as members of the Historical Society and in other volunteer capacities. Eagleburger also serves on the local Architectural Review Committee.

RIGHT: A large skylight, ceiling fan and masonry piers anchor each bay of an "outdoor room" at a home in Washington, D.C.
Photograph © Celia Pearson

FACING PAGE LEFT: A rear breakfast room and loggia lead to a carriage house axially situated at the top of an original, stone garden stair.
Photograph by Maxwell MacKenzie

FACING PAGE RIGHT: A potting shed/greenhouse features a precast concrete and glass block ceiling, which doubles as a walkable, exterior terrace for the carriage house above.
Photograph by Maxwell MacKenzie

Treacy & Eagleburger Architects, PC

Jane Treacy, RA

Phillip Eagleburger, AIA

3335 Connecticut Avenue NW, Second Floor

Washington, D.C. 20008

202.362.5226

www.treacyeagleburger.com

ABOVE: Clean lines, natural materials and spare furnishings complement the Dowling residence living room in Washington, D.C. Fir ceiling planks, finished with a thin coat of bleaching oil, add a warm, airy feel to the space.
Photograph by Max MacKenzie

FACING PAGE: Located near Antietam, Maryland, outside Washington, the Lippman house was conceived as an assemblage of vernacular forms, inspired by its rural setting, married to a modern program. Hydrothermal heating and cooling is accomplished via a series of deep wells.
Photograph by Max MacKenzie

BEN VAN DUSEN

Van Dusen Architects

In the book *How Buildings Learn* by Stewart Brand, the author describes how successful architecture has the ability to evolve and adapt over time. Architect Ben Van Dusen supports this belief, using the term "lived-in modern" to characterize his work. Favoring a warm, colorful approach that appreciates the raw essence of materials and the diverse nature of clients, Van Dusen has designed residential, commercial and mixed-use projects at a variety of scales for the past 20 years. "For me, the interesting part of architecture is solving puzzles," he explains.

A registered architect for 23 years, Van Dusen did not expect to end up in the capitol region. The Michigan native attended Tulane University, earning Bachelor and Master of Architecture degrees. After graduation, he stopped in D.C. to visit friends and never left. "I've been lucky over the years to have had some very fruitful collaborations with clients," he describes. His extremely involved project relationships have been an advantage in small private practice, turning many clients into close friends.

Van Dusen appreciates any opportunity to push his architecture beyond the ordinary, and often finds a way to incorporate art into his designs. For a public art installation at the New Carrollton Station parking garage, he and artist Heidi Lippman designed glass-and-stone mosaic murals that wrap and accentuate the

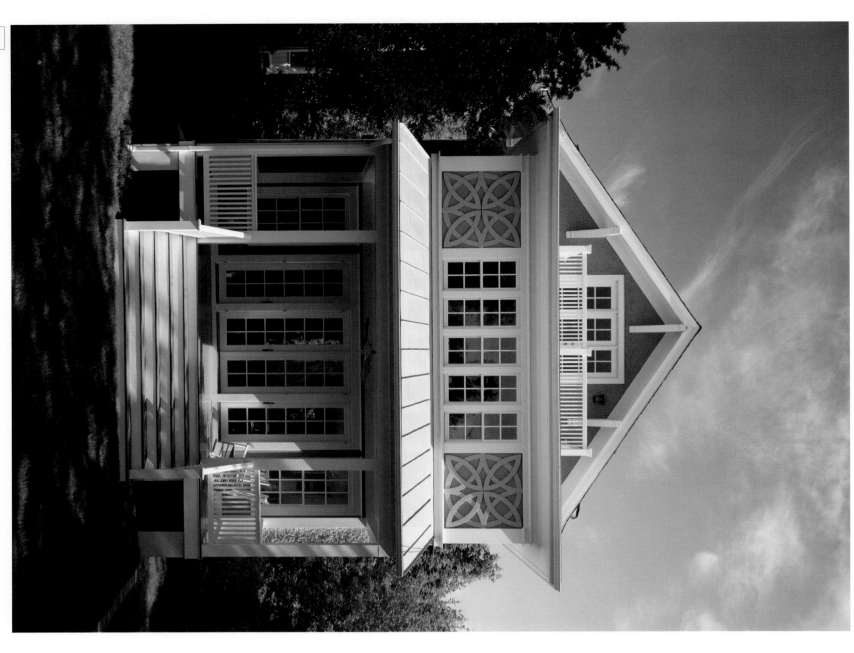

building's stair towers. Van Dusen has always loved to craft things, from furniture to models. "Nothing expresses an architectural idea like a hand-built model—something you can walk around or hold in your hand." He recently designed and built a guitar with his son, and has publicly exhibited his ceramic art. Van Dusen's inspirations come from travel, music, reading and images and snippets of information he has collected. He surrounds himself with this creative clutter, but says having it around helps him generate spaces that are functional and clean.

Van Dusen Architects has been recognized on *The Washingtonian* magazine's list of 15 Top Architects and has earned two D.C. chapter AIA awards for Design Excellence. The five-person firm is comprised entirely of architects who work collaboratively within a studio environment. Instead of a signature style, the firm concentrates on the "macro image" of each project, emphasizing how forms merge and connect, and how interior spaces segue from one to another. "The seamless segue matters in Neoclassical or contemporary work," Van Dusen explains. His firm chooses design clues to merge old and new architecture, and often incorporates built-ins for aesthetic cleanliness and functional storage.

In addition to his work, Van Dusen has been a pro bono consultant to a D.C. private school for the past five years, serving as liaison between the school's building committee and the design team for construction of a new 11-acre campus.

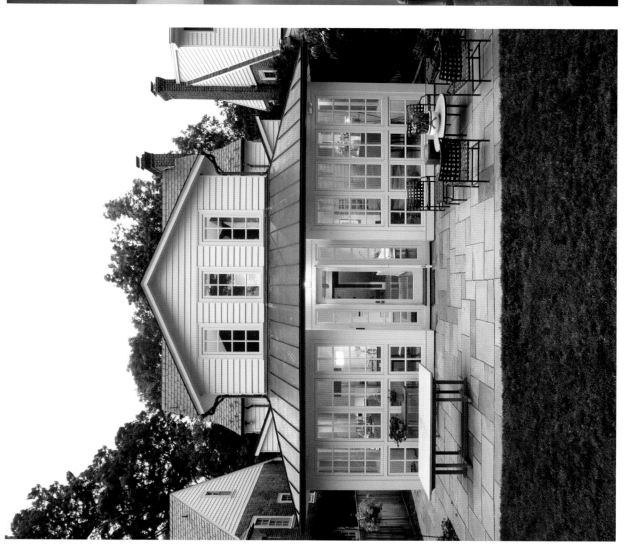

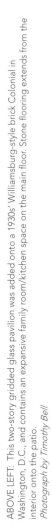

ABOVE LEFT: This two-story gridded glass pavilion was added onto a 1930s' Williamsburg-style brick Colonial in Washington, D.C., and contains an expansive family room/kitchen space on the main floor. Stone flooring extends from the interior onto the patio.
Photograph by Timothy Bell

ABOVE RIGHT: A beam-and-plank ceiling encircles the interior space, which features a colorful blend of wood, steel and stone.
Photograph by Timothy Bell

FACING PAGE: Located in the historic Cleveland Park neighborhood in Washington, D.C., this renovated home has direct views of close-by National Cathedral, which inspired the layered medallions featured on the south-facing rear elevation.
Photograph by Max MacKenzie

Van Dusen Architects
Ben Van Dusen, AIA
1711 Connecticut Avenue NW, Suite 202
Washington, D.C. 20009
202.332.3890
www.vandusenarchitects.com

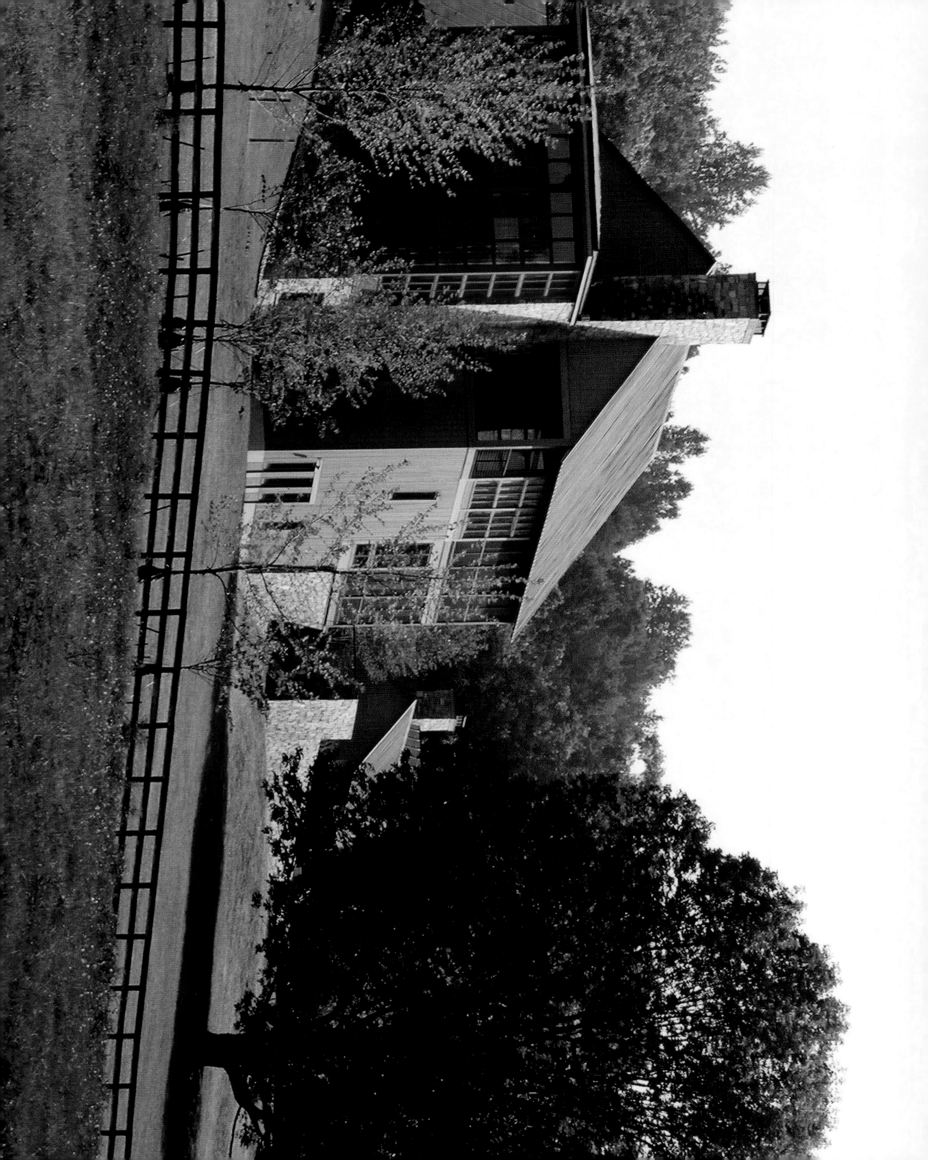

ABOVE: The living/dining space enjoys unbroken vistas of the nearby mountains and meadows, and is anchored to the earth by a massive stone wall.
Photograph by Richard Williams, AIA

FACING PAGE: This retreat in the Blue Ridge Mountains of Virginia consists of a main house and guest house on a high knoll against a wooded edge, looking out over valley views.
Photograph by Richard Williams, AIA

RICHARD P. WILLIAMS

Richard Williams Architects

Architect Richard Williams believes strongly that "one can design contextually with a modern attitude." Through projects across the country, the five-person practice has established a reputation for appropriateness—overtly modern at times and historically sensitive at others—and is always respectful of the environs. A former trustee of the D.C. Preservation League, Williams greatly appreciates historic buildings and preservation, and has completed major restoration and renovation projects that fit seamlessly within traditional settings. A modernist at heart, he is also capable of designing contemporary buildings imbued with timelessness and a sense of belonging. The firm's sensitivity to landscape and versatility of style has been aptly noted, and his buildings praised for "the making of place."

A consistency of attitude is the underlying factor in Williams' work. Original aesthetic choices derive from the same initial considerations: a thorough analysis of the client's programmatic needs and a keen appreciation of the site. From these starting points, opportunities and challenges are identified and help shape each project's built form. Williams' clients are highly involved in the intensely collaborative process.

Williams tries to be emphatic in his assertion that good design can transform lives. "We set goals higher in terms of quality rather than size," he explains. "Design is the best investment, and is far and away the best value in the construction process." His philosophy that better does not always mean bigger is based on a feeling of responsibility to his clients and the environment: Homes that are crafted well, of quality materials, appropriate to their purpose and landscape will stand the test of time. His designs make interior and exterior connections that enhance a sense of spaciousness without the need for added building area. This approach has garnered the support of many clients disheartened by the trend toward "mansionization." They see Williams' smaller yet more sophisticated designs as a ready solution to an acute problem.

Professional organizations and the media have taken notice of the firm's sensitive, contextual work. "Clean Drinking House"—Williams' personal residence in Maryland—earned awards from the D.C. chapter of the AIA and *Residential Architect* and *Washingtonian* magazines. The renovation of "Salona," a National Register-listed Virginia property earned an AIA award for excellence in historic resources, while "Mountain Cay Farm" in the Blue Ridge Mountains won a D.C. chapter AIA award for its more contemporary design.

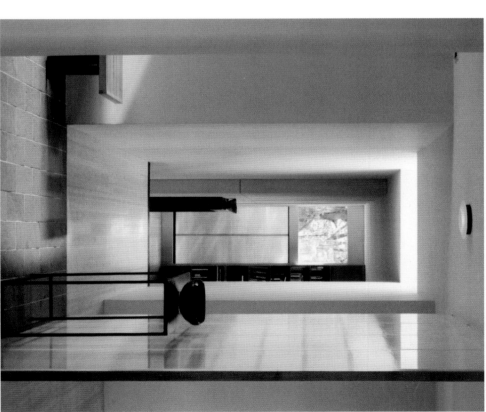

Williams holds a Bachelor of Arts degree from Harvard University, studied at the University of Edinburgh graduate department of urban design and regional planning and earned his Master of Architecture degree from the University of Virginia School of Architecture. He has been included in *Architectural Digest*'s AD 100 International Directory of Top Architects and Interior Designers.

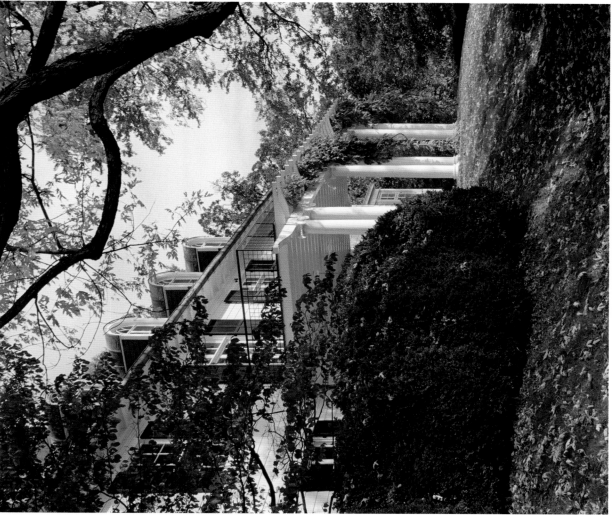

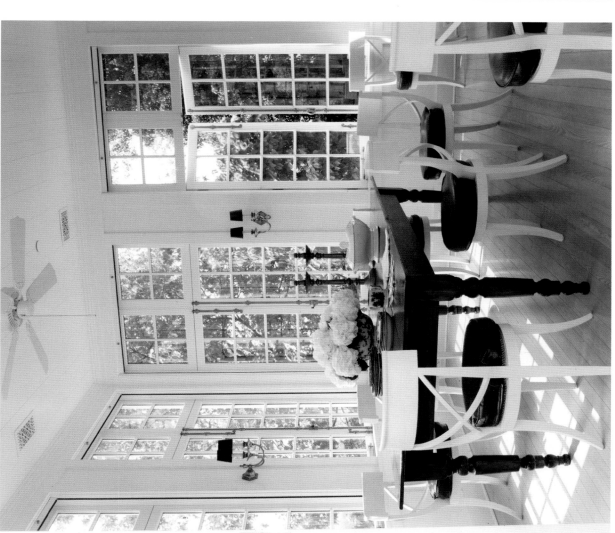

ABOVE LEFT: This sun-filled breakfast room addition was all that was needed to enhance this fully renovated circa 1880 Maryland Hunt Country estate.
Photograph by Pieter Estersohn

ABOVE RIGHT: The Hunt Country house overlooks beautiful vistas across a stream valley from the vantage of a new pergola and paved stone terrace.
Photograph by Richard Williams, AIA

FACING PAGE LEFT: "Clean Drinking House": the solidity of the stucco wall on the street façade is offset by translucent wall and roof panels and a bank of clerestory windows.
Photograph by Scott Robinson

FACING PAGE RIGHT: Natural light from multiple sources reaches deep into "Clean Drinking House," revealing a spare materials palette of bamboo, green slate, glass, steel, concrete and polycarbonate panels.
Photograph by Richard Williams, AIA

Richard Williams Architects
Richard P. Williams, AIA
1909 Q Street NW, Suite 200
Washington, D.C. 20009
202.387.4500
www.richardwilliamsarchitects.com

Brian G. Carabet, Publisher
John A. Shand, Publisher
Phil Reavis, Executive Publisher
Kathryn Newell, Senior Associate Publisher

Beth Benton, Director of Development & Design
Elizabeth Gionta, Editorial Development Specialist
Julia Hoover, Director of Book Marketing & Distribution

Michele Cunningham-Scott, Art Director
Mary Elizabeth Acree, Graphic Designer
Emily Kattan, Graphic Designer
Ben Quintanilla, Graphic Designer

Rosalie Z. Wilson, Managing Editor
Katrina Autem, Editor
Lauren Castelli, Editor
Anita M. Kasmar, Editor
Ryan Parr, Editor
Daniel Reid, Editor

Kristy Randall, Managing Production Coordinator
Laura Greenwood, Production Coordinator
Jennifer Lenhart, Production Coordinator
Jessica Garrison, Traffic Coordinator

Carol Kendall, Administrative Manager
Beverly Smith, Administrative Assistant
Carissa Jackson, Sales Support Coordinator
Amanda Mathers, Sales Support Assistant

PANACHE PARTNERS, LLC
CORPORATE OFFICE
1424 Gables Court
Plano, TX 75075
972.661.9884
www.panache.com

WASHINGTON, D.C. OFFICE
Kathryn Newell 856.316.6069

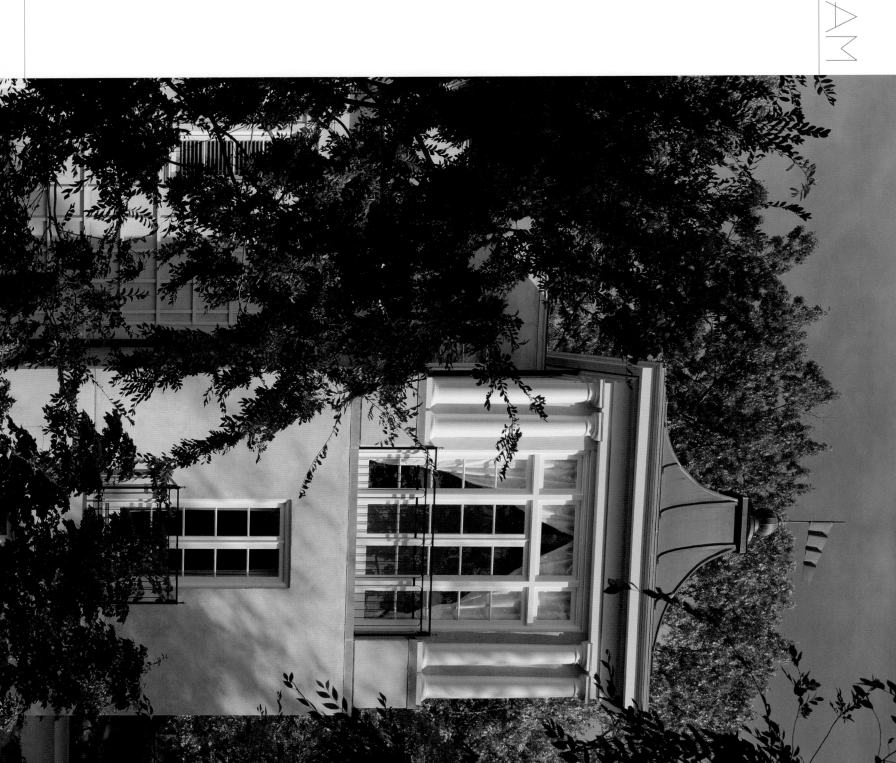

THE PANACHE COLLECTION

Dream Homes Series

Dream Homes of Texas
Dream Homes South Florida
Dream Homes Colorado
Dream Homes Metro New York
Dream Homes Greater Philadelphia
Dream Homes New Jersey
Dream Homes Florida
Dream Homes Southwest
Dream Homes Northern California
Dream Homes the Carolinas
Dream Homes Georgia
Dream Homes Chicago
Dream Homes San Diego & Orange County
Dream Homes Washington, D.C.
Dream Homes Deserts
Dream Homes Pacific Northwest
Dream Homes Minnesota
Dream Homes Ohio & Pennsylvania
Dream Homes California Central Coast
Dream Homes Los Angeles
Dream Homes Michigan
Dream Homes Tennessee
Dream Homes New England

Additional Titles

Spectacular Hotels
Spectacular Golf of Texas
Spectacular Golf of Colorado
Spectacular Restaurants of Texas
Elite Portfolios
Spectacular Wineries of Napa Valley

City by Design Series

City by Design Dallas
City by Design Atlanta
City by Design San Francisco Bay Area
City by Design Pittsburgh
City by Design Chicago
City by Design Charlotte
City by Design Phoenix, Tucson & Albuquerque
City by Design Denver
City by Design Orlando

Perspectives on Design Series

Perspectives on Design Florida

Spectacular Homes Series

Spectacular Homes of Texas
Spectacular Homes of Georgia
Spectacular Homes of South Florida
Spectacular Homes of Tennessee
Spectacular Homes of the Pacific Northwest
Spectacular Homes of Greater Philadelphia
Spectacular Homes of the Southwest
Spectacular Homes of Colorado
Spectacular Homes of the Carolinas
Spectacular Homes of Florida
Spectacular Homes of California
Spectacular Homes of Michigan
Spectacular Homes of the Heartland
Spectacular Homes of Chicago
Spectacular Homes of Washington, D.C.
Spectacular Homes of Ohio & Pennsylvania
Spectacular Homes of Minnesota
Spectacular Homes of New England
Spectacular Homes of New York

Visit www.panache.com or call
972.661.9884

PANACHE
PANACHE PARTNERS, LLC

Creators of Spectacular Publications for
Discerning Readers

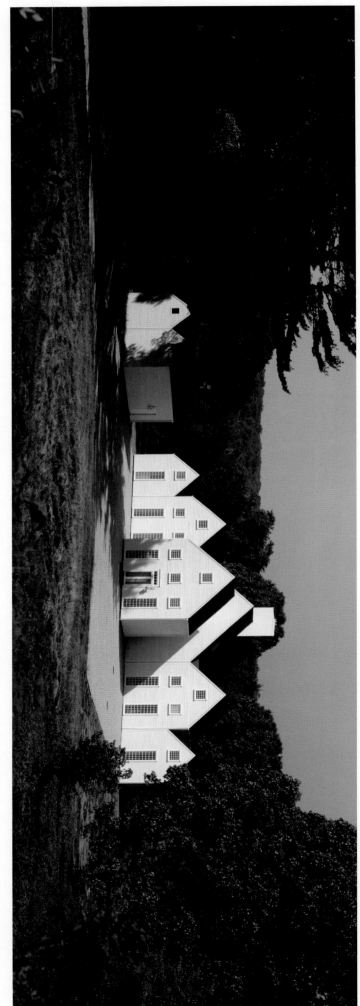

Hugh Newell Jacobsen, FAIA, Architect, PLLC, page 213